THE COMPLETE WOODCUTS OF ALBRECHT DÜRER

THE COMPLETE WOODCUTS OF ALBRECHT DÜRER

Edited by
Dr. WILLI KURTH

DÜRER'S HOUSE AT NUREMBERG.

ECHO POINT BOOKS & MEDIA, LLC
Brattleboro, Vermont

Published in 2022 by Echo Point Books & Media
Brattleboro, Vermont
www.EchoPointBooks.com

The Complete Woodcuts of Albrecht Dürer
ISBN: 978-1-63561-919-5 (casebound)
 978-1-63561-918-8 (paperback)

Cover design by Kaitlyn Whitaker

Cover images: Located on page 89, plate 109

INDEX

Date		Plate	Page
1488	Brother Claus	1–5	43
c 1489	The Priest of Kalenberg. Schr. 4410	6–12	44
1489	Horologium devotionis. Schr. 3141	13–14	44
1489	Eine allerhailsamste Warnung Schr. 5455	15–17	45
1489	Oratio Cassandre. Schr. 3675	18	46
1489	Title page to the Würfelbuch Schr. 5490	19	46
1489	Gerson. Schr. 4103	20	47
1490	A Teacher with four pupils Schr. 3079	21	47
1492	S. Jerome in his study. P. 246	22	48
c. 1492	Illustrations to the Comedies of Terence	23–35	49–53
1493	Illustrations to the Ritter vom Thurn	36–48	54–57
1494	Illustrations to the Ship of Fools	49–62	58–61
1494	A series of small pictures of saints and biblical scenes	63–80	62–63
1494	The Poet Sebastian Brant kneeling	81	64
c. 1493	The Virgin venerated by Albrecht von Bonstetten	82	64
c. 1493	Illustrations to the Mirror of true Rhetoric	83–84	65–66
c. 1493	Canon woodcut and Head of Christ from the Opus speciale missarum	85–86	67
1495	Lamentation for Christ	87	68
1495	The Crucifixion	88–89	69–70
c. 1496	The Martyrdom of S. Sebastian. P. 182	90	71
1496	S. Christopher	91	72
1496	The Syphilitic. P. 198	92	73
1496	The so-called Albertina Passion (B. app. 4)	94–97	74–77
1496	The Martyrdom of the Ten Thousand B. 117	98	78
1496	Hercules. B. 127	99	79
c. 1497	Knight and Landsknecht. B. 131	100	80
c. 1497	The Men's Bath. B. 128	101	81
c. 1498	The Martyrdom of S. Catherine B. 120	102	82
1498	Samson fighting the Lion. B. 2	103	83
1498	The Holy Family with three Hares B. 102	104	84
1498	Heading to the Trilogium animae of Ludovicus Pruthenus	93	73
1498	The Apocalypse. B. 61–75	105–120	85–100

Date		Plate	Page
1500	Seven Woodcuts to the Great Passion. B. 6,8–13	121–127	101–107
c. 1500	Illustrations to the Revelations of Saint Bridget. P. 194	128–142	108–115
		PLATE 141 IS ON PAGE 108	
c. 1500	Illustrations to: Opera Hrosvitae P. 210–277	143–144	116
1501	Three Nuns before a Crucifix. (Lucia de Narnia)	167	120
1501	S. Jerome. P. 188	168	120
1501	S. Sebald on the pillar. B. app. 20	169	121
1501	Mount Calvary. B. 59	192	142
1501	The Holy Family with Angels. B. 100	193	143
1501	S. Christopher. B. 104	194	144
1501	S. Francis receives the Stigmata B. 100	195	145
c. 1502	Illustrations to the Quatuor libri amorum by Celtes. P. 217 and B. 130	145–146	117
c. 1502	Book-plate of Pirckheimer. B. app. 52	170	122
c. 1502	Two series of woodcuts for Nuremberg Prayer Books	147–166	118–119
c. 1502	S. John the Baptist and Onuphrius B. 112	196	146
c. 1503	The Hermits S. Anthony and S. Paul B. 107	197	147
1503	Nude Woman with Signs of the Zodiac from the Prognosticon of Stabius	172	123
1504	Title-page to Messahalah, a seated Astronomer	171	123
1504 (1500)	Seventeen illustrations to the Life of the Virgin. B. 77–92	175–191	125–141
1504	S. George. B. 111	198	148
1504	The Ecstasy of the Magdalen. B. 121	199	148
c. 1505	The Madonna with Joseph and five Angels. B. 99	200	149
c. 1505	Two illustrations to the Story of Judith, from the Beschlossen Gart	173–174	124
1505	S. Stephen, S. Sixtus and S. Lawrence. B. 108	201	149
c. 1507	The three Bishops Nicholas, Ulrich, and Erasmus. B. 118	202	150
c. 1507	The Six Knots. B. 140–145	203–206	151–154
1509	Two illustrations from the Little Passion. B. 32, 37	238, 243	172, 173
1510	Two illustrations from the Little Passion. B. 18, 38	224, 244	168, 173
c. 1510	The Coat of Arms of Michel Behaim. B. 159	207	155

Date		Plate	Page
1510	Christ on the Cross. B. 55	208	156
1510	The Schoolmaster. B. 133	209	156
1510	Death and the Landsknecht. B. 132	210	156
1510	The Penitent. B. 119	211	157
1510	The Beheading of S. John the Baptist. B. 125	212	158
1510	Four woodcuts to complete the Great Passion. B. 5, 7, 14, 15	215–218	161-164
1510	Two woodcuts to complete the Life of the Virgin. B. 93, 94	220–221	166-167
1511	The Apocalypse in book form with a new title-page. B. 60	213	159
1511	Title-page to the Great Passion in book form. B. 4	214	160
1511	Title-page to the Life of the Virgin in book form. B. 76	219	165
1511	The Little Passion. B. 16-52	222–258	168-177
1511	Christ on the Mount of Olives. B. 54	259	177
1511	The Head of S. John the Baptist brought to Herod. B. 126	260	158
1511	Cain slaying Abel. B. 1	261	178
1511	The Adoration of the Magi. B. 3	262	179
1511	The Mass of S. Gregory. B. 123	263	180
1511	The Trinity. B. 122	264	181
1511	S. Christopher. B. 103	265	182
1511	S. Jerome in his Cell. B. 114	266	183
1511	The Holy Family with Joachim and Anne. B. 96	267	184
1511	The Holy Family with Saints and Angels. B. 97	268	185
1512	S. Jerome in the Cave. B. 113	269	186
1513	Title border for Pirckheimer's Translation of Plutarch	270	187
1513	Madonna in a Circle (with the landscape). P. 177	271	188
1513	S. Sebald	272	189
1512-1515	The Triumphal Arch for the Emperor Maximilian. B. 138	273–292	190-206
1512-1515	The Patron Saints of Austria. B. 116	293	207
1512-1515	Saint Coloman. B. 106	294	208
1512-1515	The Northern Hemisphere of the Celestial Globe, for Stabius. B. 151	295	209
1512-1515	The Southern Hemisphere of the Celestial Globe, for Stabius. B. 152	296	210
1512-1515	The Eastern Hemisphere of the Terrestrial Globe (mappa mundi). P. 201	297–298	211-212
1512-1515	The Rhinoceros. B. 136	299	213
1512-1515	The Owl fighting other birds. P. 199	300	214
1515	The Virgin with Carthusian Monks. P. 180	301	215
1516	Christ on the Cross (from the Eichstätt Missal). B. 56	302	216
1516	The Book-plate of Hieronymus Ebner. B. app. 45	303	217
1517	Illustrations to Freydal. P. 288-292	304–306	218-220
1518	The Virgin crowned by two Angels. B. 101	307	221
1518	Saint Sebald in the Niche. B. app. 21	308	222
1518	The so-called Small Triumphal Car (the Burgundian Marriage). B. 229	309–311	223-225
1518-1522	The large Triumphal Car of Emperor Maximilian. B. 139	312–317	226-231
1519	Portrait of the Emperor Maximilian. B. 154	318	232
1520	The Coat of Arms of the Roggendorfs. R. 239	319	233
1520	The Coat of Arms of Lorenz Staiber. B. 167	320	234
1520	The Coat of Arms with three Lions' Heads. B. 169	321	235
1520	The Coat of Arms of Johann Stabius. B. 166	322	236
1521	The Coat of Arms of Johann Tscherte. B. 170	323	237
1521	The Coat of Arms of Don Pedro Lasso. P. 216	324	238
1521	The Coat of Arms of the Town of Nuremberg. B. 162	325	239
1522	Portrait of Ulrich Varnbühler. B. 155	326	240
1523	The Coat of Arms of Dürer. B. 160	327	241
1523	The Last Supper. B. 53	328	242
c. 1523	Christ on the Cross with three Angels. B. 58	329–330	243-244
1524	The Tapestry of Michelfeld. B. app. 34	331–332	245-246
1525	The Armillary Sphere. P. 202	333	247
1525	Illustrations to the Treatise on Measurement	334–340	248-251
1526	The Madonna on a grassy bank. B. 98	341	252
1526	Portrait of Eobanus Hesse. P. 218	342	252
1527	Illustrations to the Treatise on Fortification	343–345	253-255
1527	Illustrations to the Treatise on Proportion	346	256

List according to Bartsch and Passavant

No. acc. to Bartsch	No. in this book	No. acc. to Bartsch	No. in this book	No. acc. to Bartsch	No. in this book	No. acc. to Bartsch	No. in this book	No. acc. to Bartsch	No. in this book
1	261	37	243	74	118	111	198	159	207
2	103	38	244	75	119	112	196	160	327
3	262	39	245	76	219	113	296	162	325
4	214	40	246	77	175	114	266	166	322
5	215	41	247	78	176	116	293	167	320
6	121	42	248	79	177	117	98	169	321
7	216	43	249	80	178	118	202	170	323
8	122	44	250	81	179	119	211		
9	123	45	251	82	180	120	102	B. app.	No.
10	124	46	252	83	181	121	199	4	94–97
11	125	47	253	84	182	122	264	19	272
12	126	48	254	85	183	123	263	20	169
13	127	49	255	86	184	125	212	21	308
14	217	50	256	87	185	126	260	34	331/32
15	218	51	257	88	186	127	99	36	304
16	222	52	258	89	187	128	101	38	305
17	223	53	328	90	188	130	146	45	303
18	224	54	259	91	189	131	100	52	170
19	225	55	208	92	190	132	210		
20	226	56	302	93	220	133	209	Pass.	No.
21	227	58	329/30	94	221	136	299	177	271
22	228	59	192	95	191	137	343/45	180	301
23	229	60	213	96	267	138	273–92	182	90
24	230	61	105	97	268	139	312–17	188	168
25	231	62	106	98	341	140	203	194	128–42
26	232	63	107	99	200	144	204	198	92
27	233	64	108	100	193	145	206	199	300
28	234	65	109	101	307	146	337	201	297/98
29	235	66	110	102	104	147	338	202	333
30	236	67	111	103	265	148	339	205	270
31	237	68	112	104	194	149	340	210	343
32	238	69	113	105	105	151	295	216	324
33	239	70	114	106	294	152	296	217	145
34	240	71	115	107	197	154	318	218	342
35	241	72	116	108	201	155	326	246	22
36	242	73	117	110	195	158	129/30	277	143/44

The Years of Apprenticeship at Nuremberg 1486—1490

The opinion that Dürer's beginnings as a designer of woodcuts in the circle of Nuremberg book illustrators date from his admission into Wohlgemuth's studio in 1486, is of recent date and is built on criticism which has groped cautiously and not without hesitation on its obscure path. Beside the question which underlies Dürer's years of apprenticeship at Nuremberg, naturally arises — in consequence of the recognition of the work for book illustration which he produced in Basle during his years of travel 1490—1494 — the second question of the beginning of his work in woodcut. The opponents of the various series of the Basle illustrations in their zeal have indirectly influenced the promotion of this hypothesis. They not only show a similarity in style between those Basle works and some of the Nuremberg book illustrations of the period 1488—1491, but by extending the comparison to details in motive and drawing, they have involuntarily become the strongest witnesses for Dürer's activity as a woodcut artist at Nuremberg.

In reviewing the results of up-to-date investigations, the problem may be stated as follows. About the year 1488 a new style appears in Nuremberg book illustration, unexpected and perceptibly differing from the prevailing tradition, grafting Schongauer's delicate feeling for line on the harder and coarser stock of Wohlgemuth. This style is first apparent in the Nuremberg Lives of the Saints printed in 1488 by Koberger. A close resemblance in style to the Ulm Master of the Lirar Chronicle and the Eunuch of Terence has been universally recognised. (The first to point out this resemblance was Kristeller, Holzschnitt und Kupferstich in vier Jahrhunderten, p. 46, then Dörnhöffer, Kstg. Anz. 1906, p. 81 and Stadler, p. 191). The style and personality of this Suabian master, who has been made into "the real support of the Schongauer influence in Nuremberg", seem to have had effect on a whole school and to have influenced the large woodcuts of the Wohlgemuth studio which were in preparation, and particularly the work of Wilhelm Pleydenwurf. (Burckhardt. Pr. Jhrb. 1907, p. 172). Thus the influence of Schongauer's style in Nuremberg book illustration was revealed to a certain extent to the eyes of the youthful Dürer. Weisbach, who in his book on the young Dürer (1906) ignores Kristeller's reference to a change of style influenced by the Ulm master, brings two woodcuts out of this Nuremberg circle of illustrations into close connection with Dürer. Cf. the title page of the small book "Wie der Würffel auff ist kumen" and the representation of Hell in the Last Judgment in the book "Eine allerheilsamste Warnung vor der falschen Liebe dieser Welt" (ill. 19 and 16). Weisbach in his depreciation of the Nuremberg book-illustrations had overlooked the stylistic connection of Dürer's two woodcuts with a group of illustrations which Dörnhöffer in his review (Kstg. Anz. 1906, p. 82) of Weisbach's book considered "indissolubly bound up" with these two prints. But Dörnhöffer denies Dürer's authorship, as there seems to him to be a yawning chasm between the woodcuts and the style of the authentic Dürer drawings of this period.

It is only necessary to point out here on general principles the danger involved by ignoring the psychological premises of their respective aims even in such formally homogeneous appearances as drawing and woodcut. The attribution of the two above mentioned woodcuts to Dürer was favourably received by Seidlitz (Pr. Jhrb. 1907, p. 40), later by Pauli (Kstchr. 1921, p. 65), by Weixlgärtner (Graph. Kst. 1906, p. 65) in whose opinion "much may be said" for the ascription of the cut representing Hell, and by Römer (Der Sammler, June 1921). To these direct attributions may be added the indirect, contributed especially by the opponents of the series of the Basle illustrations. After Dörnhöffer had proved a similarity in style between the two woodcuts assigned by Weisbach to Dürer and a group of six book illustrations, through an exhaustive and detailed criticism of style he connected this group with the Basle works, which Weisbach had attributed to the so-called Master of the Bergmann Printing-house. Through these comparisons the Nuremberg

productions appeared as preliminary steps to the work in Basle. Stadler carried them further (p. 191, note 2). Also Pauli (Kstchr. 1921, No. 26) recognised the obvious analogy with the Basle series; as the result of this attribution of the Basle works to Dürer arose the question of the same artist for the Nuremberg group. The idea was accepted by Römer (Der Sammler 1921, June) and he is holding in reserve a more extensive survey of Dürer's youthful works.

1.–5. BRUDER CLAUS, by Nikolaus von der Flühe, Max Ayrer, Nuremberg 1488. Another edition n. p. d., attributed to Wagner, Nuremberg. 10 woodcuts. Cf. Stadler, p. 121. — 43

In opposition to Weisbach, Dörnhöffer (Kstg. Anz. 1906, p. 810) in connection with the Lives of the Saints 1488 to which it has much similarity, particularly owing to the light and shade of the hatching technique, points out the excellent quality of the work. Stadler attributes the cuts to his Master of the Horologium. Römer found a close connection with the Gerson (Der Sammler, 1921).

1. Brother Claus in front of the hut. / 2. Second work of Mercy: reception of the pilgrim in his house. Cf. the pilgrim with Gerson (ill. 11). / 3. Fourth work of Mercy: Pity for the man too severely punished. / 4. Sixth work of Mercy: Care for the burial of a fellow man. / 5. The seven angels with a cross and the six keys, with which they have opened Heaven to the six works of Mercy, receive a soul into Heaven.

6.–12. Cuts from Philipp Frankfurter, DIE GESCHICHTE DES PFARRERS VON KALENBERG, n. p. d. (Nuremberg, printed by P. Wagner) Schreiber 4410. Stadler (P. 105) dates this about 1490 and mentions the connection with an Augsburg edition, among others. The 36 woodcuts are all by one hand. Weisbach was inclined to attribute five of the cuts to another hand, whereas Stadler is of the opinion that there were three different men drawing after one master; he recognises this vivacious talent, of which no other draughtsman in Nuremberg can boast, in the designer of the Lives of the Saints. The only extant copy is at Hamburg. Pauli (Kstchr. 1921, No. 26) wrongly separates this series from theABnuremberg group; he believes there are traces of a less promising hand than in the other series. With ill. 11 compare particularly the Cavalcade (Bremen). The merry pranks of the priest are portrayed. — 44

6. Hie nach decken die pawern den Koer an der Kirchen un das langk haus beleibt ungedecket. (The peasants are roofing the choir of the Church while the nave remains unroofed.) / 7. Hie haben sie geperg un der pfarrer ligt auf dem rain un ein rab sitzt auff einem hohlen stein und schreit. (The priest is lying in the meadow, a raven is croaking on a hollow stone). / 8. Hie fert die hertzogin auff dem wasser für den Kalenberg, do wusch der pfarrer sin nyderkleid. (The duchess is in a boat on the water where the priest is washing his undergarments.) / 9. Hie traidt der pfarrer sein schuch zu den goltschmidt. (The priest taking his shoe to the goldsmith.) / 10. Hie hat der pfarrer den sack auff einem wagen und man scüt im den habern ein. (The priest has a sack on a waggon and oats are being put into it.) / 11. Hie rait der fürst an das raidt. (The prince on horseback). / 12. Hie treibt der pfarrer in dem messgewant das vieh auss un die kelnerin get vor im. (The priest in his vestments driving out cattle and before him goes the handmaiden).

13.–14. From Bertoldus: HOROLOGIUM DEVOTIONIS (Nuremberg, Creussner 1489. Schreiber 3141). Dörnhöffer already pointed out that of the 24 illustrations only a few may be assigned to this group; and Stadler, p. 119, wrongly detached the three last cuts, as being obviously taken from an older book, the other 21 cuts having been drawn on the block by two different men. Röttinger (Wiener Jhrb. 1907, p. 45) attributes all the woodcuts to one hand. — 44

13. Christ before Caiaphas. / 14. The Baptism of Christ in the River Jordan.

15.–17. From EIN ALLERHAILSAMSTE WARNUNG VOR DER FALSCHEM LIEB DIESER WELT. (n. p. d. Peter Wagner, Nuremberg, before 1490, Schr. 5455). — 45

Weisbach was the first to attribute the second of these three woodcuts "Hell" to Dürer (Der junge Dürer. 1906, p. 17). Comparing this with the drawing of Hell in the Last Judgment in the British Museum

(L. 224) there was in his opinion a similarity in the two works, particularly in the individual imagination found in both, which surpassed the traditional type. The relation of the two is, however, merely general, while the drawing is considerably later. Weixlgärtner was inclined to agree with the attribution to Dürer (Graph. Kste. 1906. p. 65). Seidlitz agreed as to the Dürer-like character of the work, but thought it the work of Dürer's "double". Stadler (p. 113) attributes the cut to his Master of the Kalenberg Story, in whom we surmise Dürer.

Pauli (Kstchr. 1921. Nr. 260) then came to the happy conclusion of ascribing the other two woodcuts, the first and the third, the Banquet and the Reward of the Chosen, also to Dürer. Stadler separated these two cuts from the Hell, attributing them to his Master of the Cassandra (p. 126), whom we also merge in Dürer. 15. The joys of the world and the warning of death. 16. The eternal lamentation of the damned. 17. The reward of the chosen, represented by the crowning of Mary surrounded by the Saints.

18. Woodcut on the title page of: ORATIO CASSANDRE VENETE (n. p. d. Peter Wagner, after December 1488, cf. Weisbach op. cit., p. 10, note 2, Schr. 3675). Weisbach overlooked the new strength of this style, in which the vigorous movement characteristic of the Basle works seems to be stirring, as Burckhardt notices (Pr. Jhrb. 1907, p. 173).

19. Title woodcut to: WIE DER WÜRFFEL AUFF IST KUMEN (Nuremberg, Max Ayrer 1489. Schr. 5490). The cut, which is divided into two parts, shows above: the Devil tempting a knight to gamble, the outbreak of a quarrel at the gaming table punished by death on the wheel. Below: other executions as the result of gambling. Weisbach (p. 16) was the first to propose Dürer for this; he was followed by Seidlitz (Pr. Jhrb. 1907, p. 4) and Weixlgärtner did not object (Gr. Kste. 1906, p. 65). Stadler attributes the cuts to his Master of Kalenberg.

20. GERSON. Title woodcut in the second part of the Works of Jean Charlier de Gerson (n. p. d. 1489, Georg Stüchs, Nuremberg. Schr. 4103). Gerson, Chancellor of the University of Paris (1363—1429) suspected of leanings to reform, fled after the Council of Constance to Rattenberg in Tyrol, and is perhaps for this reason always portrayed as a pilgrim.

E. Römer recognised the cut as a work of Dürer (Der Sammler, 1921, June) and pointed to the Joseph in the drawing at Coburg as a twin brother to this; and (at the May meeting of the Berlin Kstg. Gesell. 1925) made a happy allusion to the drawing which is regarded as the headpiece to the Andria of Terence, with the lake and bridge, the town gate and the wall with the characteristic gradations (cf. Burckhardt, ill. 1); Stadler ascribes the cut to his Master of the Horologium.

21. A TEACHER WITH FOUR SCHOLARS, from: Alexander Gallus. Prima Pars doctrinalis (Nuremberg, Creussner 1491, Schr. 3079). E. Römer drew my attention to this woodcut. Although Dürer left Nuremberg in 1490, the fact that this book was published a year later need not exclude Dürer as the artist. Such belated use of illustrations on the part of the printers is often to be noticed in the case of Dürer. The quickly diminishing perspective of the background and the prominence of the figures in the foreground is characteristic of the Nuremberg period.

On the different editions cf. Stadler (p. 128, note 1) who attributes the cut to his Cassandra Master, whom we identify with Dürer. Cf. also Schreiber, Die deutschen Accipies und Magister cum discipulis-Holzschnitte, Strassburg, Heitz 1908, No. 55. The copies which appeared in books printed by H. Quentell at Cologne 1495—1500 are common.

The Years of Travel 1490—1494

PAGE

In the year 1490 Dürer started on his travels equipped for illustrative printing. He was away for four years, and remained during that time connected chiefly with the business of printing. At all events industry in the workshop enabled him to earn what he needed, since he could not, as an apprentice, work independently. There is authentic evidence of a sojourn in south-west Germany between 1492 and 1494, and of visits to Colmar, Basle and Strassburg. The question as to where he stayed during his first two years of travel is still unanswered. A probable direction, among the many divergent hypotheses, has been given by Meder, who has suggested a route accordant with the conditions of travel prevailing at that time (Wiener Jahrbuch, 1911, XXX, p. 183). This route by Ulm, thence by the Lake of Constance to Basle, further north to Colmar, possibly Freiburg and eventually Strassburg, presumes Basle to have been the chief goal. There is no external reason why we should not suppose him to have been at Basle soon after 1490. Work here would not be without attraction for the book illustrator, especially as it is more than likely that Dürer's position was favoured by the help of his god-father Koberger, who had business relations with the Basle printers Amerbach and Kessler. The probability of a rather lengthy sojourn at Basle before 1492 would also diminish the difficulty of crediting him with the authorship of over 225 drawings for woodcuts, which is often used as an argument by the opponents of these works (cf. Pauli, Kstchr. 1921, No. 26). If we accept the probability of Dürer's travels taking him to Frankfurt and to places along the Rhine where books were printed, then we must be prepared to trace the style of the young Nuremberg artist in the book illustrations produced at these presses. The importance of the trade route between Frankfurt and Nuremberg, and the activity of those printing works—also Scheurl's reference to Dürer's Memorandum (cf. Höpfner, Intern. Wochenschr. 1910, IV. No. 26) which mentions Dürer's arrival at Colmar before it mentions Basle in 1492—though without exact dates—all these considerations would be in support of the theory that Dürer's journey led him along the Rhine.

22. S. JEROME IN HIS STUDY. P. 246. D. 1. Through the discovery by Daniel Burckhardt of the wood block for this cut in the Museum at Basle (A. Dürer 1892, p. 4—8) the fact of Dürer's activity at Basle became a certainty. The genuineness of the handwriting on the back of the block "Albrecht Dürer von Nörmergk" is indisputable. Haack's argument against Dürer's authorship has rightly been rejected. (Funde und Vermutungen zu Dürer, Erlangen 1916.) The cut appeared on the title page to the first part of the letters of Saint Jerome, "Epistolare beati Hieronymi", printed by Nicolas Kessler at Basle, 8th August 1492. A later edition of the book (1497) by the same printer already contains a copy of the woodcut, in which the bottle-glass window over the bookshelf is missing and the title is on the back. The enlarged edition of the letters published by Koberger, Lyon 1508, gives a different copy before all three parts of the book. (For copies and modern impressions, refer to R. Schrey, Graph. Kste. 1908. Mitteilungen, p. 40.)
The connection of this woodcut with the Nuremberg works is emphasized not only by Burckhardt, but also by Stadler (p. 227), who draws attention to the view down a street in the Oratio Cassandre (ill. No. 9). The pendant to this, S. Ambrose in his study, in the Works of S. Ambrose printed in 1492 by Amerbach at Basle, (Schr. 3264) has up to the present been little noticed in connection with Dürer. Although the more objective conception and the simpler execution of the woodcut seem to differ considerably from the austere grandeur and the peculiar new modelling of form—particularly the small folds of the garment, which in the S. Jerome undoubtedly points to Dürer's own hand in the cutting of the block— Pauli's opinion (Kstchr. 1921. No. 26) must not be disregarded, who recognises Dürer's work also in the

48

S. Ambrose, and rightly warns against the hypothesis of a new "alter ego", which has now been done away with. Röttinger (p. 48) was inclined to suppose Wechtlin as the artist; but recently (Dürer's Doppelgänger, 1926) has come round to Pauli's opinion as to Dürer's authorship.

The discovery of the Saint Jerome woodcut by Burckhardt threw a new light on Dürer's work in woodcut for book illustration. He recognised a breaking away from the Basle tradition not only in the S. Jerome, but also in the uncut wood-block drawings for the Comedies of Terence (Basle, Museum), the woodcuts for the Ritter von Turn 1493 and the Narrenschiff 1494. Friedländer and Pauli and also Schillings (Kiel Dissertation, 1919: Die graph. Anfänge) have agreed in attributing these series of illustrations to Dürer, and I also am of the same opinion, also recently E. Römer (Pr. Jahrb. 1926). Weixlgärtner—of his excellent article on this vexed question (Graph. Kste. 1920, p. 40) writes—"this theory of Friedländer and Pauli has prematurely come to the throne, even provided it is true"; but it only needed his excellent presentation of the case to unbend the bow, and through the minute criticism of style one possibility after another is brought to light which all speak for Dürer's authorship.

On the other side we may mention the construction of a "Master of the Bergmann Printing-house", whom Weisbach (1896), seconded in this by Dörnhöffer, distinguished from Dürer, and in whom Stadler (1913) saw Dürer's double—he is supposed to have left Nuremberg with Dürer and to have returned there with him—; further the work of the Strassburg master Hans Wechtlin whom Röttinger (Vienna Jahrbuch, 1907) believes to have been active at Basle simultaneously with Dürer and then to have followed the latter to Nuremberg where he, the one-time giver and teacher, deteriorated into a recipient pupil, and even copyist. Nevertheless this study places the materials in a better order and contains a more thorough examination of their style than anything else which this opponent of the Dürer hypothesis has written. Recently he has admitted himself convinced by Weixlgärtner's arguments (Dürer's Doppelgänger 1926, p. 28) as to Dürer's authorship.

49-53 The drawings for woodcuts to the COMEDIES OF TERENCE, which have been especially exposed to 23.—35. the criticism of the opponents. It is hardly possible, they say, that such a practised hand could be that of Dürer at twenty years of age (Stadler, p. 228). It is true there are traits of real virtuosity in the pliability of the pen line, which finds pleasure in the forms of elegant girls and youthful dandies. But it is more than likely that the pen line drawn on the wood block was not such a direct and first hand expression as when drawn on paper. It may be taken for granted that the repetition on the block of the original sketch was not carried out with equal care, that calligraphy came in, and now and then, the vacancy and lameness of a tracing, as is also noticeable in Botticelli's drawings for Dante's Divine Comedy. This may explain the contention as to different hands. Burckhardt believes the work to be from two different hands, and attributes to Dürer all the blocks for "Andria" and most of those for the "Eunuch", whereas Schmid (Rep. 1893, p. 138) thinks the work to have been the joint production of a whole group or workshop. But Weisbach, Friedländer and Pauli rightly recognise the work as that of one hand. The "playing, trifling" may be attributed to imagination hampered by the dialogue form of the pieces. The monotonous grouping of the figures on the first plane of the stage recalls Nuremberg traditions, only that the space is more clearly made out here than in the „Brother Claus". It is certain that the Terence is the earliest of the three Basle series and as already shown should be dated prior to the Saint Jerome. Weinberger (Nürnb. Mal. 1921, p. 117) recently pointed this out, and also showed that this dating threw a better light on the whole development. Wölfflin, who does not attribute the Terence set to Dürer, is inclined to date it after 1496, whereby a transition would be found to the delicate manner, with elegant lines, of the second series of the Nuremberg devotional prints of about 1500 (Kstchr. 1918, p. 366). He grounded this theory on Max Hermann's "Forschungen zur deutschen Theatergeschichte d. Mitt. u. Ren." (1914, p. 329). Hermann tries to prove that the general view of the theatre (ill. 14) would not have been possible without the frontispiece of the Strassburg edition of Terence, 1496, as prototype. It is hardly possible to imagine two things more diverse from one another: in the Basle drawings we see an interior,

PAGE

in the Strassburg woodcut the exterior view of a tower-like building. Thus Hermann can only produce the resemblance of the king in the middle and the carpet hanging down in front of his throne, which is merely one of the motives required by the subject. Weixlgärtner rejected the probability of the date as later than 1496 (Graph. Kste. 1920, p. 41), and two dissertations (Scharf, Beitr. z. Gesch. d. Bühnenbilds im XV.–XVII. J. Freiburg, 1925, and Lenz. Entw. der Terenz-Darst., München 1924) have strongly opposed Hermann's opinion.

The solution of the question as to authorship has been considerably furthered by the discovery by S. M. Peartree in the Hamburg Kunsthalle of a pen drawing of a pair of lovers (Preuß. Jhrb. 1904, p. 120). Peartree succeeded in showing that the costume of the young man has special local peculiarities of Basle which also occur particularly in the Terence series, and, supported by this, Weixlgärtner finds a close and convincing connection of the drawing with the Basle series.

The 131 wood blocks in the Print Room of the Public Art Collections in Basle are now in course of publication by Römer (for the Jhrb. d. Pr. Kst.-Samml.). They are divided between six comedies of Terence: Andria 25, Eunuch 21, Heauton timoroumenos 19, Phromio 22, Hekyra 18, Adelphoi 21; in addition to these are four extra prints to the four last series and a title page. Twelve wood blocks have been cut in a wretched manner. Weisbach's supposition that this is a mutilation of more recent date is probably based on truth. As far as I am aware no old prints are in existence, but only modern impressions of the 19th Century. The twelve cut blocks, of which eight are reproduced here, are divided between four comedies and mostly illustrate the later acts.

24. Eunuchus I, 1. The Eunuch laments to his slave Parmeno that he suffers from the whims of the Hetaera Thais. / 25. Eunuchus III, 5. Antiphon, who does not know that his friend Chereas has exchanged parts with the Eunuch, is astonished at his friend's non-appearance at the pre-arranged banquet. / 26. Eunuchus IV, 2. Phaedria, deep in thought, goes past his country house, where he intends spending a few days. / 27. Eunuchus V, 6. Parmeno meets Laches, the father of Phaedria, and imparts bad news to him. / 28. Andria (the Maid of Andros) III, 4. Suno relates to his slave Davus, that the marriage of his son Pamphilus was only a sham. / 29. Andria V, 6. Pamphilus tells the slave Davus about his love affair with the daughter of Chremes. Charinus joins them and begs Pamphilus to beg Chremes on his own behalf for his daugther's hand. / 30. Heauton timoroumenos. (The self-tormentor) IV, 1. Clinil and Syrus, the slave of Clitipha, discuss the marriage of Chimias and Clitipha, his master. / 31. Heauton timoroumenos IV, 1. Chremes and Syrus discuss the love of his son Clythios for Bacchis. / 32. Heauton timoroumenos V, 2. Clitypho, Meneremus, Chremes and Syrus. Chremes reproves his son Clitypho for his levity. / 33. Adelphoi (The Brothers) I, 2. Demea tells his brother Nucio about the amours and drinking bouts of his son Aeschinus. / 34. Hecyra. (The mother-in-law) V, 3 (4). The slave Parmeno tells his master Pamphilus that Myrrhina has found her ring at the house of the courtesan Bacchis. / 35. Phormio III, 4. Antipho in anxiety regarding his love affairs.

36.–48. BOOK OF THE "RITTER VON TURN", concerning Examples of Godfearing and honesty. Printed by Michael Furter, Basle, 1493. Composed by the Chevalier de la Tour Landry for his daughter as a guidance for a virtuous life. The reward of virtue and the punishment of sin are shown by examples. 54-57

The style is more assured, the figures more lively than in Terence. The representation of space and landscape is not only more developed in itself, but also worked out with a higher sense of unity in relation to the human figure. The narrative is lively and rich in variety, and successfully leads us into the realm of drama. This series of illustrations outvies not only Basle, but even Strassburg. This new style goes further than Schongauer. A good analysis of the differences in style between the Terence and the Ritter von Turn is given by Stadler (p. 202 ff). Burckhardt already called attention to an obvious correspondence of motive in Ritter von Turn 11 a, the angry husband, and Terence, Eunuchus IV, 7, the lovers in the room.

45 Woodcuts. The technique of the cutting is very good, only a few blocks inferior to the rest. All the woodcuts are reproduced by R. Kautzsch: Die Holzschnitte z. R. v. Turn, Strassburg 1903 (St. zur deutsch. Kstg. Vol. 44).

36. Dedication page, Repetition of the second illustration. After his dream (cf. ill. 36) the knight goes out from his garden and commands two scribes and two priests to compile this book. / 37. First illustr. The knight in meditation is joined by his two daughters. / 38. Ninth illustr. The noble lady in waiting who fed her dogs so well, but allowed the poor to famish, after her death is licked by the dogs till she becomes black as coal. / 39. Fifteenth illustr. The Fall. / 40. Seventeenth illustr. The destruction of Sodom and Gomorrha. / 41. Eighteenth illustr. A knight of the Israelite army kills another knight whom he finds with a heathen paramour (IV Mos. 25). / 42. Nineteenth illustr. A rope maker sees a monk leaving the chamber of his unfaithful wife. / 43. Twenty-fourth illustr. King Jehu causes his wife to be beheaded on account of her infidelity. / 44. Twenty-fifth illustr. Delilah cuts off Samson's hair. / 45. Thirty-first illustr. The five year old Prophet Daniel lays bare the false witness of the two priests, through which Susanna had been condemned to be stoned. / 46 Thirty-fourth illustr. The three Marys at Christ's Grave. / 47. Forty-first illustr. Master Katho on his death-bed gives good instructions to his son. / 48. Forty-second illustr. Katho's son redeems an evil doer from execution.

ILLUSTRATIONS TO THE NARRENSCHIFF OF SEBASTIAN BRANT. Printed by Bergmann von Olpe 1494. That the designer of these cuts must be identical with the artist of the Terence series as well as that of the Ritter von Turn, has always been acknowledged. Only those critics who were not prepared to see Dürer's hand in those series of illustrations were somewhat embarrassed when confronted by the Ship of Fools, and had to admit Dürer's close proximity, "as if he had sometimes looked over the shoulder of the artist, sometimes even taking the pencil out of his hand." (Wölfflin.) Burckhardt (Dürer in Basel, p. 28) when he again referred to Dürer as the artist, could with satisfaction point out that already other critics had expressed this surmise, and quoted Rumohr and Seidlitz. Weisbach consistently attributed the prints to his Bergmann Master. Recently Weixlgärtner (Die Graphischen Künste 1920, Mitteilungen, p. 41) withdrew his earlier opinion in favour of Dürer.

The second edition which immediately followed the first in the year 1495, contains three more woodcuts; they replace repetitions of the first edition of chapters 73, 83, and 95. Weisbach saw in this an argument against Dürer, who in 1495 was already back again at Nuremberg, which argument, however, Koegler exhaustively disproved (Rep. XXX, 1907, p. 199); this applies also to the fourth woodcut which was first used in the edition of 1497.

In the carrying out of the cutting four hands may be recognised; most clearly in the group (from which our illustrations are taken), which Weisbach claims to be the work of his Bergmann Master (B. M., p. 23). But nevertheless the hand of a single master may be presumed even in the weaker cuts (cf. Stadler, p. 200). Weixlgärtner (Gr. Kste., p. 41 ff.) has devoted a detailed criticism to the peculiarities of style and has added to the number of comparisons which are always brought forward with the other Basle series as well as with the Nuremberg productions.

Brant's share in the designs for the illustrations, which formerly was believed to have been considerable, has now been rightly reduced by Weisbach to specifying those parts of the text which were to be the subjects of Dürer's illustrations.

49. Chap. 8. Those who do not follow good advice: Viel sind von Worten weise und klug / Die ziehen doch den Narren Pflug. / 50. Chap. 14. Arrogance becomes an ass: Wer spricht, dass Gott barmherzig sei / Allein und nicht gerecht dabei / Der hat Vernunft wie Gänse und Säu. / 51. Chap. 22. The Teaching of Wisdom: Wer gern die Weisheit hört und lehrt / Gänzlich zu ihr sich allzeit bekehrt / Der wird in Ewigkeit geehrt. / 52. Chap. 31. He who seeks postponement: Der ist ein Narr... / Der singt Cras Cras, der Rabensang / Und weiss nicht ob er lebt so lang. / 53. Chap. 34. A Fool before and afterwards: Ein Narr ist... / Als ist eine Gans geflogen aus / Und kommt mit gagack wieder nach Haus. / 54. Chap. 52. Who takes a wife for her fortune: Der ist ein Narr... / Dass er ein alt Weib nimmt zur Eh' / Einen guten Tag er hat und keinen mehr. / 55. Chap. 54. Impatience when punished: Ein Sackpfiff ist des Narren Spiel / Der Harfen achtet er nicht viel. / 56. Chap. 58. Forgetfulness of

self: Wer löschen will eines anders Feuer / Und brennen lässt sein eigen Scheuer / Der ist gut auf der Narren Leier. / 57. Chap. 61. Of Dancing: Aber, so ich gedenk dabei / Wie Tanz mit Sünd entsprungen sei / ... das es der Teufel hat aufbracht / Da er das golden Kalb erdacht. / 58. Chap. 79. Knight and Clerk: Schreiber und Ritter man auch spott / Die singen in der Narren Rott / Sie begnügen sich beinahe mit gleicher Nahrung / Der schindet heimlich, der offenbarer (den feisten schlichten Bauernsmann). / 59. Chap. 94. On hoping for inheritance: Ein Narr ist, wer sich darauf spitzet / Dass er eines andern Erbe besitzet / Mancher hofft ein tragen hin zu Grab / Der mit seinem Gebein wirft Birnen ab / 60. Chap. 106. Disregard of Misfortune: Der ist ein Narr, der nicht versteht / dass er nicht wisslich schick darein / Unglück will nicht verachtet sein.

63.—80. A SERIES OF SMALL PICTURES of single Saints and Biblical scenes. Burckhardt (D. i. B., p. 29, and Kstchr. 1892, p. 174) had already connected some of these prints with the Basle series and thus with Dürer. Weisbach (B. M., p. 39) added to the series and, consistently with his theory assigned them to his Bergmann-Master. To Koegler must be given the credit of having completed the series (Rep. 1907, p. 195), He left no doubt as to Dürer's authorship by proving that the whole series must have been completed by 1494. He proved that two numbers of the series, viz. the Madonna in the Sun and the Annunciation, were already printed in 1494. This was sufficient proof of the incorrectness of Weisbach's argument against Dürer, for Weisbach had only known books of later date than 1494 in which the cuts were used. All the cuts were made for Bergmann von Olpe and appeared at his press down to 1499. Koegler compares the style of this series in detail with the Ship of Fools (p. 209. N. 3).

The first two above mentioned woodcuts appear in a work of the humanist Jakob Wimpheling: De conceptu et triplici Mariae virginis gloriosissimae candore, Basle 1494. In his Epitome rerum Germanicarum (Strassburg 1505) section 68 with the heading "de pictura et plastice" contains "one of the most beautiful wreaths of fame ever dedicated to Dürer, and was destined to introduce him into the literature of the world as an historical figure" (so writes Höpfner, Intern. Wochenschr. IV, 1910, Sp. 804). This connection between Wimpheling and Dürer must not be overlooked.

The dating of the series at 1494 can only be looked upon as terminus ante quem. Pauli (Kstchr. 1918, No. 26) is inclined to place them before the Ship of Fools. In any case from the point of view of style the series cannot be separated from the latter and its relation to the series of the Nuremberg Prayer-book cuts of about 1500 has pertinently been compared to the relation of bud to blossom (Friedländer).

Of the twenty woodcuts up till now known through Koegler, fifteen have been reproduced here.

63—64. The Virgin Mary in the Sun and Annunciation. Appeared first in Wimpheling: De conceptu et triplici Mariae virginis gloriosissimae candore, Bergmann von Olpe 1494 (copy at Basle). / 65—68. The Nativity (65), The Mass of St. Gregory (66), St. Sebastian (67), St. Onuphrius (68) from: In laudem gloriose virginis Marie multorumque sanctorum varii generis carmina Sebastiani Brant, Basle, Bergmann von Olpe (without date, probably 1494). The St. Sebastian was first published by Burckhardt (reproduced D. i. B., p. 29), the Onuphrius by Röttinger (Vienna Jahrbuch 1907, p. 38). To the same edition belong the two other Saints; Valentine and Ivo (copy at Basle). / 69. St. Jerome from: Locher's Theologica emphasis Dialogus super eminentiä quatuor doctorum ecclesie Gregorii, Hieronymi, Augustini, Ambrosi (Bergmann v. Olpe, Basle 1496). / 70. St. Catherine from: Locher's Ad lectorem Epigramma de diva Katharina (Basle 1496). / 71—73. David praying (71), Adoration of the Magi (72), Meeting between the Living and the Dead (73) from: Diurnale secundum chorum ecclesie Basiliensis (Bergmann v. Olpe 1499, copy at Carlsruhe). / 74—75. St. Margaret and Dorothy from: Hortulus animae (Michael Furter, Basle 1515, into whose hands the blocks possessed by Bergmann had passed; Koegler p. 197. Copies at Freiburg and Einsiedeln). / 76—80. St. Christopher (76), St. Lawrence (77), St. Martin (78), St. Nicholas (79) and St. Mary Magdalene (80) from: Hortulus animae, by Nicolaus Lamparter, Basle, 1518. Copy at Tübingen. To this edition belongs also a St. Christopher.

PAGE

62-63

PAGE		
64	THE POET SEBASTIAN BRANT kneeling. Woodcut on the title-page of Varia Carmina von Sebastian Brant, Basle 1498. Weisbach consistently attributes it to the Bergmann-Master (B.M. p. 42, ill. 14); Koegler contradicts him, and assigns the work to an artist who proceeded from the local Basle school, but who had close contact with the art of the Bergmann-Master (Repertorium, 1907, p. 203, where a list of book illustrations by this master is given). We should like here — it is true without a close examination of Koegler's list—to agree with Weinberger's contradiction (Nürnb. M. 1921, p. 246, Nr. 48) and give back the print to the Bergmann-Master and consequently to Dürer.	81.
64	THE VIRGIN MARY WORSHIPPED BY ALBRECHT BONSTETTEN from: Septem hore canonice virginis matris Mariae. Printed by Riederer, Freiburg i. Breisgau, 1493 (Schr. 4574). Recognised as Dürer's work by Römer (Sitzungsber. d. Berliner Kst.-G., Dec. 1919.) Probably drawn at Freiburg on the way to Basle.	82.
65-66	THE MIRROR OF TRUE RHETORIC. Printed by Riederer at Freiburg i. Br., 11 Dec. 1493 (Schr. 5096). Attributed to Dürer by E. Baumeister (Monatshefte f. Kstw. 1914, p. 330), this opinion is shared by Pauli (Rep. 1921, p. 1 ff.), but Weinberger disagrees (Nürnb. Mal., p. 123). 83. Title Page with publisher's sign. This sign appears once more at the end of the book. The curious distribution of the lettering in the writing of the title page, also the fact that it is not quite straight, leads to the conclusion that there were two blocks. The angels, reminiscent of Schongauer (cf. the Angels of the Madonna under the canopy, L. 300, Louvre), are badly cut, but incomparable is the elasticity and swing of the writing. The supporter of the coat of arms in the publisher's sign is better cut, and is rightly compared by Baumeister with the girl in the Bonnat Collection (L. 346). The reverse side is not by Dürer. / 84. The Fall of Icarus. Leaf XI. The boldness of the composition and the landscape (probably the Lake of Constance) also the motive of flying show a very high degree of artistic comprehension.	83.—84.
67	CANON CUT FROM: OPUS SPECIALE MISSARUM; Strassburg, 13. Nov. 1493, printed by Grüninger (who in 1517 used the woodcut for his edition of the Sermons of Kaisersberg) Recognised by Peartree and Dodgson as Dürer's work (Dürer Soc. IX, 1906). The transition of style to a more pronounced severity and clarity has been rightly noticed (Dodgson, Friedländer, Weixlgärtner): Weinberger alone (p. 120) sees a superficiality of style and assigns the print to a master of the Grüninger Printing press; Röttinger, on the contrary, attributes it consistently to Wechtlin. Dodgson's attempt to prove Dürer's authorship by pointing out the repetition of the S. John in the woodcut of 1510, B. 55 (Burl. Mag. XX, 95) was rejected by Röttinger as a mere accident, but then later in his "Doppelgänger" (p. 30) after a most valuable comparison of style, he comes to the conclusion that there can no longer be any doubt that it is a work of Dürer's.	85.
67	THE HEAD OF CHRIST from the before mentioned work. In spite of the faulty technique of the cutting, it is easy to recognise the penetrating gaze, which is so familiar to us in Dürer's later portrayals of Christ, (Dürer Society IX, 1906).	86.

The first Italian Journey and the Years 1495—1500 at Nuremberg

PAGE

No references have been found which may be taken as external proof of Dürer's having started on his journey to Italy in 1495. Venice, which was then the chief centre of printing and the book trade in Italy, would no doubt have had a certain fascination for a book illustrator. Kolb, from Nuremberg, had a publishing office there. But the conception we have in our minds of Dürer as he must have been during the years prior to and simultaneous with the Apocalypse, a conception which often stands in the way of a true understanding of his work during his travels, makes it difficult to imagine him here in Italy again in the bonds of the printing trade. So we need not hesitate to find pleasure in seeing how he managed to meet the exigencies of daily life by the efforts of his own genius alone. It is clear from a letter of eleven years later that Pirckheimer was in Italy from 1489 to 1495; Dürer was undoubtedly with him in Venice and would have received encouragement as well as material support from him.

Friedländer (p. 26 and 30) has called special attention to the change of style noticeable in the Strassburg canon cut. Perhaps the construction and manner of the Venetian canon woodcuts were not without influence on this work of Dürer's. (It is certain that at this period there were a number of Strassburg wood cutters working in Venice). But the sunlight of Mantegna was required to bring the inner germinating power to its full expression.

We find this new faculty for visualisation plainly exemplified in three large woodcuts. Their size alone proclaims them as having broken away from book form, and their independent conception shows they were no longer bound by the limitations of a text. The many Italian motives and forms, derived especially from Mantegna, justify us in connecting them closely with the sojourn in Italy, and on no consideration can they be dated later than 1498. In support of the theory that these three prints formed a special group is the supposition that drawings by Dürer almost certainly served as originals for all three woodcuts; probably they were drawn on the blocks in Italy and cut by local cutters, which would explain the appearance of certain peculiarities characteristic of Italian work, particularly the somewhat coarse, straggling lines.

87. LAMENTATION FOR THE DEAD CHRIST. (Our reproduction is somewhat reduced in size; original size 39,5 by 29,2 cm). A unique print acquired by the British Museum in 1918 from the collection at Northwick Park. Published by C. Dodgson, and by him included in the circle of works of this period connected with Dürer (Notes on Dürer, Burl. Mag. 1922, p. 18). Certain motives of the composition are reminiscent of the well known pictures at Nuremberg and Munich. But the rigidity of the figure of the dead Christ is unusual, and never occurs in Dürer's later works. Perhaps it is taken from the schools of northern Italy, where it is of frequent occurrence. Characteristic of north Italian art are also the strange tears of the mourning women; these only occur elsewhere in Dürer's work in his Ecce Homo heads. Perhaps these tears, like the ornamental elaboration of the haloes, are additions, which the woodcutter in Italy chose to make. But I find it impossible to agree with Dodgson's theory that we are confronted here either with a plagiarist or an imitator of Dürer. In what other works of this early period could we look for these elements? There can be no question of anything but direct originals by Dürer. In the head of S. John we find clear influence of Mantegna in the expression and in the classic treatment of the hair. The upper part of the town gateway with its triple round arched finish may have been taken direct from Venetian buildings; also the "aedicula" ornamentation of the door. Dodgson affirms that Dürer's landscapes did not develop along these lines of geological structure. This is true with regard to his work after 1496, but prior to this date we find examples, as a glance at the Marys at the Grave of the Knight of Turn will show

68

PAGE	
	(see ill. 46). The technique of the cutting is peculiar. Notice how the shadow on the ground on the left and at the foot of the block is produced. The surfaces are broken up into short groups of lines of which the ends run together; it is the same with the St. Sebastian and the large Crucifixion. Later, in the large woodcuts before the Apocalypse and in this itself, white spaces divide the different hatchings. In pen drawings of Dürer we come across ink lines running into one another, which were then found by Dürer or by the cutter working under him, to be graphically ineffective, with the result that the introduction of these white intervals was adopted. From this, it would seem to follow that the cutter did not work under Dürer's eyes in Nuremberg.
69-70	CRUCIFIXION (reduced, original size 57×38,9 cm; the section ill. 89 is in the original size). At present only two copies are known, at Berlin and in the British Museum. Weisbach included this large woodcut in the work of Dürer (Der junge Dürer, p. 73). But he only knew the copy in the Berlin collection, not the wood block of this copy from the Derschau Collection, which is also in the Berlin Kabinett. It consists of two parts, (one above the other) and contains childish additions in the background (cf. the ills. in the Amtliche Berichte der Preuss. Kunstsammlungen, Jan. 1920). Then the two parts have been halved vertically and the additions cut away. Prints of these different states are also in the Berlin Kabinett. The „Original" of this copy which Friedländer published in the above mentioned Amtl. Ber., was acquired by the Berlin Kabinett in 1920 from the Vincent Mayer Collection. Here there are no disfiguring additions in the background, also the iconographic peculiarity of a sword standing vertically on the breast of Mary, which is seen in the copy, is lacking in this original. This Berlin woodcut, however, must not be looked upon as the original cut of a design drawn on the wood block by Dürer; it most likely represents a drawing, doubtless intended for a woodcut, which Dürer made during his Italian journey. Considering that the originals of other works known to be copies (after 1496) have been preserved, but none of this group of three works, the Lamentation for the dead Christ, the Crucifixion, and the Martyrdom of S. Sebastian mentioned below, then we can hardly assume originals for these to have existed in the sense that there were other woodcuts of which these are copies. The group of mourners standing beneath the Cross in its central construction is closely related to Italian principles of composition. In this the group in question resembles the Lamentation, and both show direct influence of Italian art. Friedländer's opinion that "it is only possible to fix the date as shortly before 1500 in Nuremberg", is but weakly supported by a general comparison with the Crucifixion of the Great Passion. The composition, spread out in the manner of a sculptured relief, with its symmetrical grouping round the Cross, cannot be compared with the abundance of figures compactly grouped in the manner of a painter, which is characteristic of the later print. The influence of Dürer's studies in Italy is also plainly seen in the single figures: the cramped movement of the thief on the left with the head falling back on the drawn up shoulders and the disordered hair distinctly recalls Pollajuolo (cf. Berenson, Florent. Drawings Plate 16, Vol. I); then again the somewhat affected pose of the standing mourners makes us think of the drawings of Credi; while the S. John is closely related to the art of Mantegna. The domed building in the background is a reminiscence of S. Mark's, Venice. Röttinger considered the horsemen in the background as particularly characteristic of Wechtlin, and recently in his new „Doppelgänger" (p. 45) of the "Birgittenmeister", whom he identifies with Peter Vischer the Elder. Friedländer has already called attention to the difference in the quality of the technique of the cutting of the two parts, and has clearly pointed out that the cutting cannot have been done under Dürer's direct supervision, but that Dürer delivered the drawing to a publisher while far away from Nürnberg. Friedländer mentions Venice together with Basle or Strassburg.
71	MARTYRDOM OF S. SEBASTIAN. P. 182. H. 2027. D. 2. No unanimity of opinion has been reached regarding this print, which is without a monogram. The conception is not unworthy of Dürer. But the composition is lacking in concentration and swing. Single figures with a great deal of movement are balanced one against the other. Pollajuolo and Mantegna were the chief influences for this work. The

Right margin: 88.—89.

Right margin next to Martyrdom entry: 90.

technique of the cutting is not so foreign as in the other two prints; the way in which the ends of the lines run into one another in the shading of the ground is considerably modified. Here again there can be no doubt that only a drawing served as material for the designer of the print; for, as with the other prints of this group no original is known, whereas for the other copies of about 1497—1498 we possess original woodcuts with the monogram. This opinion was also shared formerly by Dodgson (Cat. 268,2), but curiously enough recently, in connection with the Lamentation for the Dead Christ, he has surmised the work to be that of a plagiarist or imitator (Burl. Mag. 1922, p. 18). Weixlgärtner also only recognises Dürer elements, whereas Friedländer supposes a copy after Dürer; so does Dörnhöffer. After Schmidt (Rep. XVI, 305) had brought the work into connection with Schäufelein, and Röttinger with Wechtlin (and now with his new "Doppelgänger") we have lately got quite off the track again; Braun (Gr. Kst. 1924, p. 14) recognises the hand of Baldung and dates it about 1505—1506; Weinberger (N. M.) ascribes the cut to the Benedict Master, as it occurs again in the Nuremberg Prayer Book, and in so doing brings it again, for us, into connection with Dürer, only this cut, together with the other two, must be dated earlier, in the immediate neighbourhood of the Italian journey.

91. S. CHRISTOPHER. Like the drawing in the National Gallery of Budapest (Meder, Albertina Nr. 428), this is a copy after Dürer. The figure is a repetition of the Bacchus in Mantegna's engraving.
Tietze-Conrat (Graph. Kste. Mittlg. 1924, p. 66) has pointed out the close connection with Mantegna, Nicoletto da Modena and the Paduan Fresco. Stahl (Christophoruslegende in der Graphik des 15. und 16. Jahrh. 1920, p. 198) has called attention to the introduction of the figure into stained glass windows. Judging by the style the work should be placed in the year 1495 near the drawing of the same subject published by Schillings in the Altdeutsche Zeichnungen der Sammlung Lahmann (1925, Pl. 8). This woodcut without doubt goes back to an original drawing which has been lost. — 72

92. THE SYPHILITIC. P. 198. 1495 or 1496. D. p. 268. This appeared as a single sheet on August, 1st, 1496 (Schr. 1926) with a poem by the Frisian doctor Ulsenius. Above the shoulders of the man, who is covered with ulcers, are the arms of Nuremberg; above is a sphere with the Zodiac, below is the sun.
The first to call attention to the print was H. A. Cornill d'Orville (Naumann's Archiv 1856, II, 10). Thausing rejected the idea of Dürer, also Weisbach (Der junge Dürer, p. 73); Dörnhöffer ascribed it to Dürer (Kst. Anz. 1905, p. 50). Dodgson believed this to be „probable", which Weixlgärtner again denied; Stadler (p. 222) gave it to the Bergmann Master — and so according to us, to Dürer, until this was again denied by Haberditzl (Einblattdrucke d. Wiener Hofb. 1920), who on pl. 174 reproduces a second state (Vienna), in which nearly 2 cm of the lower edge are cut away and a new inscription is given. — 73

93. HEAD FOR THE PURPOSE OF THE STUDY OF PHRENOLOGY, from Lodovicus Pruthenus, Trilogium animae, printed at Nuremberg by Koberger, 1498. This interesting illustration for a kind of phrenology has been attributed by Dörnhöffer to Dürer (Kst. Anz. 1906, p. 84) and he calls attention to the likeness of the head to Dürer's friend Pirckheimer (cf. the ill. in the Vienna Jhb. 1911, p. 238). — 73

94.—97. THE ALBERTINA PASSION. Up to the present only four numbers of this series are known. Weisbach puts them in the same group as the illustrations to Roswitha and Brigitta (abut 1500) which he cannot regard as being by Dürer. Weinberger gives the same date to the series, and believes them to be from the hand of his Master of the Belisarius (in connection with the Berlin drawing) whom he identifies with the young Schäufelein, who was able to "plunder Dürer's portfolios of drawings pretty well as he liked" (N.M., p.169) — unfortunately we are not told whether this was with the permission of the master or not. Recently it has been thought that the style of this second early pupil of Dürer's, whom Weinberger differentiates from the Benedict-Master, but to whom Röttinger assigns the series, is recognisable in that of the young Baldung (about 1502), and in consequence these four scenes from the Passion have been attributed to him (Braun, Gr. Kste. 1924, p. 15). — 74-77

These dates imply that this series originated after the Great Passion, although it was pointed out that this Belisarius Master in his „plundering" went back to drawings which Dürer brought with him from Italy (Weinberger), and that there are vistas in the backgrounds which recall the Basle series. It will therefore not be incorrect to date the series prior to the Great Passion, and to see in the style of these prints a preliminary stage for the great Passion. It would be wrong, however, to assume these unsigned cuts to have been actually drawn by Dürer on the wood block and still more to think that the very rough cutting was done under his eyes. Röttinger, in his new "Doppelgänger", also brings these woodcuts into close connection with the three big woodcuts which were so nearly related to Italian art, but Röttinger attributes them to the Doppelgänger (Dürer's Double) and dates them after 1500, later therefore than the Great Passion. 94. The Crowning with Thorns. Bartsch seems to have known only this print (B. VII, p. 174, app. Nr. 4). The figure of the executioner reminds Weinberger (p. 169) of the carpenter of the Bonnat collection. This is not a bad comparison and brings us to the year 1496. But according to Weinberger all this is not by Dürer himself, but by that Belisarius-Master, who carried out the work after a lost design of the Master. / 95. Flagellation. Of this only a late impression is known, in the Albertina, Vienna. / 96. Christ bearing the Cross. Of this only a late impression is known, in the Albertina, Vienna. The figure of the youth in the right-hand corner reminds Weinberger faintly of Venice, particularly of Carpaccio. And as this, of course cannot be by Dürer, although he "certainly" (!) brought back a drawing which is not known to us, as it has been lost, then it must be by the Belisarius-Master. / 97. Crucifixion. Only late impressions are known, in the Kupferstich-Kabinett, Berlin, and the British Museum.

78 THE MARTYRDOM OF THE TEN THOUSAND CHRISTIANS under King Sapor. About 1496. B. 117. 98. H. 1881. R. 117. D. 3. Dodgson has rightly put this in the series of large woodcuts prior to the Apocalypse (Cat. p. 269). He calls attention to the primitiveness of the print. Pauli's discovery of the drawing of the carpenter with the borer (Pr. Jhrb. 1912, p. 109), and the fact that this figure occurs in the cycle of paintings of the Dresden Passion gives us a terminus post quem for the woodcut, as the somewhat meaningless variation in the man on the left in the foreground must have been produced later. But I cannot agree with Pauli in dating the woodcut as late as towards 1500. The copy is referred to further on.

79 HERCULES. About 1496. B. 127. H. 1893. R. 24. D. 5. H. Klaiber (Rep. 1911, p. 478) has tried to explain 99. this curious cut. Hercules is fighting for Iole, the daughter of Eurytos, whom, after his victory in the archery contest, he was permitted to woo, but nevertheless the father refuses his consent. Hereupon Hercules wins Iole by force and kills the father Eurytos. According to Klaiber, the old man with the ass's jaw is intended to personify Iole's feelings of distress. The composition and the rendering of form may certainly be brought into close connection with the Italian journey. The outline and formation of the head of Hercules distinctly recall the Rape of the Women by Pollajuolo, which Dürer copied (1495). Weisbach had already compared the fighting woman with Mantegna (Der junge Dürer, p. 50).

80 THE KNIGHT AND THE LANDSKNECHT. B. 134. H. 1895. R. 25. D. 6. About 1497. It has been sug- 100. gested that the subject is Saul on the way to Damascus. With regard to the connection of the woodcut with the drawing in Berlin of the Pair of Lovers on Horseback (L. 3) see Friedländer (p. 32); also Pauli (Z. f. b. Kst. 1912, p. 115 note).

81 THE MEN'S BATH. B. 128. H. 1897. R. 18. D. 4. About 1497. Hausmann called attention to the drawing 101. in Bremen of the Women's Bath of 1496 (L. 101) (A. D. Kupferstiche, 1861). Friedländer assigned the print to the year 1498, but it would seem more correct to bring it nearer to the date of the drawing of the Women's Bath. Weisbach is right in his comparison of the obese drinker with Mantegna's Bacchanal (Der junge Dürer, p. 46), but Secker's allusion (Z. f. b. Kst. 1918, p. 132) to Mantegna's frescoes at Padua is justified merely from a general point of view of style. Scherer's explanation of the man on the left of the

	PAGE

foreground as a portrait of Wohlgemuth brings but little conviction (Kl. d. Kst., note to p. 56); also other suggestions that the young man on the left behind the fence is a portrait of Dürer himself are only based on vague suppositions.

102. THE MARTYRDOM OF S. CATHERINE of Alexandria. B. 120. H. 1883. R. 22. D. 7. About 1498. The print is closely related in style to the Apocalypse. — 82

103. SAMSON KILLING THE LION. B. 2. H. 1102. R. 23. D. 8. Date is 1498. We do not share Dodgson's opinion (Dürer Soc. I, p. 25) that the print should be dated before the Apocalypse. David (M. f. Kstw. 1912 p. 129) has tried to prove that the composition is derived from an engraving by Meckenem. — 83

104. THE HOLY FAMILY WITH THREE HARES. B. 102. H. 1815. R. 26. 1498. With the exception of ill. 102 and 104, copies of these large woodcuts are known in which Dürer's monogram is lacking. Now, after Dodgson's researches (D. S. VII and Cat. p. 269), they are considered to be copies. Dodgson recognises in these copies the same hand as in the Apocalypse of 1502, printed at Strassburg and published by Hieronymus Greff at Frankfurt (H. 1653). — 84

105.—120. THE REVELATION OF S. JOHN (Apocalypse). The first and only German edition in book form appeared in 1498; but in the same year came out an edition with Latin text, not mentioned by B. and H. The text on the back is taken from Koberger's German Bible (Nuremberg 1493) and printed in two columns. At the end of the series Dürer mentions himself as the printer. In the Nuremberg illustrated Bible, Koberger took over the woodcuts of the Cologne Bible of 1480. Dürer adopted the scheme and iconographic details of these illustrations of the Apocalypse for his own work (cf. Thode, Pr. Jhrb. III, p. 115). But Dürer was the first to become permeated with the overwhelming inner meaning and the superhuman power of expression of the poet-evangelist, and the first to epitomise the drama of the world's destiny in the revelation of a personal spiritual creed, thereby giving this book the first place in German illustrative art, "and promoting the whole of German art to a higher position within the artistic efforts of the European peoples" (Dvorak). In recent year the following critics have referred to the poetic licences of the Apocalypse: K. Schellenberg (D. Apok. München 1923) and H. Kauffmann (D. Rhythmische Kunst, Leipzig 1924); on its place in regard to the general history of the intellect, see Dvorak (1921; published in "Kunstgeschichte als Geistesgeschichte", Munich 1924, p. 193ff.). But it is hardly possible to add anything new to the explanations given by Wölfflin in his Dürer book of Dürer's artistic mentality and his gift for reproducing form. — 85-100

The date for at least a part of the cuts must be put as early as 1496. Following Springers's attempt (Berl. Kst. Gesellsch. 1904) to divide them into two classes, Römer (Rep. f. Kst. W. 1917, p. 228) suggested four divisions, and Stechow (Göttingen Dissert. 1921) suggested three. An attempt to differentiate so widely a series of problems, compressed within a comparatively short span of time, can hardly succeed in reconciling interest in forms, the point of view of a graphic artist, and technical equipments. One must therefore be content with two fixed boundaries, and at the beginning put B. 67, 73, 68, 74, and at the end B. 62, 64, 70 and 72, in this way following the graphic development, which progresses from small arrangements of light and shade to coherent effects of mass.

105. Title of the German Edition of 1498: Die heimlich offenbarung iohnis (The Revelation of S. John). Title of the Latin Edition of 1498: Apocalipsis cum Figuris. / 106. The Martyrdom of S. John the Evangelist. B. 61. According to Thausing the torture but not the death of the saint is represented; this torture took place in Rome before the Porta Latina during the persecution of the Christians by Domitian, but S. John suffered no harm, for he was the only one of the apostles to die a natural death. / 107. S. John's Vision of Christ and the seven candlesticks. (Revel. B. 12 ff). B. 62. / 108. S. John and the twenty-four Elders in Heaven (Rev. IV, 1—10; V, 1—8). B. 63. / 109. The Four Riders of the Apocalypse (Rev. IV, 2—8). B. 64. (Cf. v. Oechelhäuser's Apok. Reiter, Berlin 1885). / 110. The opening of the fifth and

PAGE		
	sixth Seals, the distribution of white garments among the martyrs and the fall of stars. (Rev. IV, 9—15). B. 65. / 111. Four Angels staying the winds, and signing the Chosen. (Rev. VII, 1—3). B. 66. / 112. The seven Trumpets are given to the Angels, and the results of the first four trumpet calls. (Rev. VIII, 2—13). B. 68. / 113. The Battle of the Angels. (Rev. IX 13—19). B. 69. / 114. S. John devours the book. (Rev. X, 1—5, 8—10). B. 70. / 115. The Woman clothed with the Sun, and the seven-headed dragon. (Rev. XII, 1—16). B. 71. / 116. S. Michael fighting the dragon. (Rev. XII, 7—9). B. 71. / 117. The Sea Monster and the Beast with the lamb's horns. (Rev. XIII, 1—13; XIV, 14—17). B. 74. / 118. The Adoration of the Lamb and the Hymn of the Chosen. (Rev. XIV, 1—3; XIX, 1—4; VII, 9—13). B. 67. Schellenberg (Dürer's Apok., 1923, and Monatsh. f. Bücherfr. u. Graphik. 1925, vol. 5) points out that Bartsch's insertion of this print into Chap. VII of the Revelation, and Wölfflin's into Chap. XIX does not do full justice to its subject matter, but that it is a piecing together of the above mentioned three places in the text. / 119. The Whore of Babylon. (Rev. XVII, 1—4; XVIII, 1—21; XIX, 11—15). B. 73. / 120. The Angel with the Key hurls the dragon into the abyss, and another angel shows S. John the New Jerusalem. (Rev. XX, 1—3; XXI, 9—12; XXII, 8). B. 75.	
101-107	Seven Woodcuts for THE GREAT PASSION. About 1497—1500. The whole series of twelve cuts did not appear till 1511 (see below ill. 192—196). Dürer considered the Passion to be the subject most worthy of representation in pictorial art, and he portrayed it five different times — a sixth version remained unfinished owing to his death. The subject, untrammelled by the strange pictorial apparatus of the Apocalypse, allows of a clearer expression of form and intention, and it is therefore easier to determine the dates. Taking the date of the appearance of the Apocalypse as a fixed point, then the seven woodcuts can be arranged in three stages: before, about, and after 1498, from which would follow that the beginning would have been in 1497 and the end about 1500. It is generally admitted that certain of these seven woodcuts show similarities of style to the earlier prints of the Apocalypse, and must therefore be taken as the first of the seven; these are, the Flagellation, the Mount of Olives, the Entombment and then the Lamentation. Opinions as to the Ecce Homo are not always unanimous, but agree again as to The Bearing of the Cross and the Crucifixion, which must be dated 1498. 121. Christ on the Mount of Olives. B. 6. / 122. Flagellation of Christ. B. 8. / 123. Christ before the people. B. 9. / 124. Christ bearing the Cross. B. 10. / 125. The Crucifixion. B. 11. There is a slight study for the hind part of the horse which Dodgson (Dürer Soc. XII, 2) connects with this woodcut. No other studies are known either for the Great Passion or for the Apocalypse. / 126. The Lamentation for Christ. B. 12. / 127. The Entombment. B. 13.	121.—127.

The Life of the Virgin and minor works of the period 1500—1505

PAGE

128.—142. Illustrations to: REVELATIONES SANCTE BIRGITTE, Nuremberg. A. Koberger, 21st Sept. 1500, 108-115
with Latin text, p. 194. There also appeared a second edition with German text, also printed by Koberger, 12th July 1502, and a third edition (with Latin text), printed by Peypus, Nuremberg 1517.
The book contains 58 woodcuts on 18 pages, only seven being of the full size of the page, while the others are composed of from two to eight parts. Through repetitions in different combinations the number of 58 woodcuts is produced from 30 blocks. Under the influence of the Knight Waldauf von Waldenstein, the order was given by Kaiser Max for the publication of the work; (see Vienna Jhrb. XXXII, 1915). Unfortunately it is not possible from the documents to determine at what date this order was given. An older edition of the book, Lübeck 1492, served as pattern.
The dispute as to Dürer's authorship is in full swing, and the various opponents seem to find even more difficulty in coming to an understanding than was the case with regard to the Basle series of illustrations (Weixlgärtner). Bartsch only mentions the cut with the imperial coat of arms, issued later as a single print with Dürer's monogram and the date 1504, whence it was incorrectly supposed that an edition was published in that year. Passavant was the first to attribute all the woodcuts to Dürer (III, 183) Friedländer (Rep. 1896, p. 389) then also declared himself in favour of Dürer, and through comparisons of style with the Basle series of illustrations made an earlier date probable for the appearance of the book than the year 1500; Dodgson (Cat. p. 264) also sees traces of Strassburg influence. Later in 1919 (p. 37) Friedländer proposed 1495 as a definite date. But the attribution to Dürer and especially the dating met with opposition.
It has been correctly emphasised that the placing of the date between the Apocalypse and the Life of the Virgin, which was begun in 1500, gives rise to stylistic difficulties. But at the same time we must not forget that we have to do here with a commission, which can only count as work ordered by a publisher for which Dürer delivered the drawings, and that his handwriting would be effaced not only by the cutter but also by the draughtsman who transferred it to the wood block, and that in addition to this the Lübeck pattern would at least be a hindrance to invention. With those limitations, however, the critics cannot support an assertion that we have here a style which is earlier than Dürer (Weixlgärtner, Gr. Kste. 1920, p. 46). Dodgson (D.-S. 1906, p. 23) separated this so-called "Brigittenmeister" from the "Benediktmeister" and then later brought them together again (Holzschn. zu zwei Nürnbg. Andachtsb, Graph. Gesell. 1909), similarly also Weixlgärtner (Gr. Kste. 1906, p. 65). Through an exhaustive critical study Röttinger identified this master as Wechtlin, but recently (Dürer's "Doppelgänger" 1926, p. 31) with an absolute refusal to consider Dürer's authorship, he attributed the work to Peter Vischer the Elder.
There has been great difference of opinion especially with regard to the woodcut of the Crucifixion. Dodgson (Cat. p 264) divided it from the other works and assigned it to a younger Nuremberg artist, whereas Friedländer is inclined to leave it to Dürer, owing to the striking similarity with the Strassburg Missal woodcut; Röttinger ("Doppelgänger", p. 33) suggests a copy; he again is contradicted by Weixlgärtner, as the drawing of the nude recalls Mantegna's new characteristics of form. The absolute antithesis of opinion is found in Stadler, who is reminded of the young Cranach (p. 347), and in Weinberger (N. M., p. 151) who sees here the hand of Kulmbach.
128. Leaf 1. St. Bridget divides her work amongst nuns and monks. / 129. Leaf 2. The five Imperial Escutcheons (D. p. 276, as King of the Romans). B. 158, H. 2118, R. 45. A second state with Dürer's monogram and 1504, Dresden, Friedrich Aug. Collection. The five escutcheons, surrounded by the "Order of the Golden Fleece" are the following: above, the imperial arms, Archduke of Austria, King

PAGE		
	of Hungary, Duke of Burgundy (in the middle front to left), the arms of the Tyrol (below). For the meaning of the arms of Maximilian as King of the Romans see Dodgson (p. 276). / 130. Leaf 3. (on the back of leaf 2) The Arms of Florian Waldauff. H. 2151. R. 46 (D. p. 276). Recognised as Dürer's work by Retberg. The arms are surrounded by the Order of the Swan. On Waldauff's initiative Koberger undertook the publication and through him obtained the patronage of Maximilian for the work (see Dodgson, p. 277). Thausing and Weisbach do not admit Dürer's authorship. / 131. Leaf 4. Illustration of the whole page with four wood blocks. St. Bridget as intercessor, with a married couple praying. / 132. From Leaf 5. Peter of Almastra and St. Bridget. / 133. From Leaf 6. Magister Matias of Lincopenus and St. Bridget. / 134. From Leaf 7. Men and women at prayer. / 135. From Leaf 8. Knights and Soldiers. / 136. From Leaf 9. Three bishops and two monks. / 137. From Leaf 10. St. Bridget in her chamber handing her work to a bishop. / 138. From Leaf 7. The Coronation of the Virgin. / 139. Leaf 11. St. Bridget and the Virgin interceding for the damned. / 140. Leaf 12. St. Bridget while riding to her castle of Vadstena with retinue and multitude of people, has a vision of Magister Magnus ascending to Heaven. / 141. Leaf 16. St. Bridget gives her works to the Emperor, Kings and Princes. / 142. Leaf 11. The Crucifixion.	
116	Illustrations to: OPERA HROSVITAE virginis et monialis germane gente Saxonica orte nuper a Conrado Celte inventa. Nuremberg, Koberger 1501. The contents of the book by Hrosvitha (or Roswitha), a nun of the Benedictine Abbey of Gandersheim, include: six comedies (prose imitations of Terence), eight Lives of Saints in verse, and a Hymn of Praise to the Emperor Otto. The work was printed for the Sodalitas Celtica, a society of humanists under the leadership of Conrad Celtes, who had discovered the work of Roswitha in the Convent of St. Emmeran at Regensburg. Two frontispieces by Dürer, unsigned; Weinberger cautiously attributed the other four to a special Celtes-master (N. M. 1921, p. 192). Formerly Dodgson assigned them to Traut (Gr. Kste. 1906, p. 50), but later dismissed this idea. Röttinger attributed the cuts to Wechtlin, then later in his "Doppelgänger" (p. 37) gave them to Peter Vischer the Elder. For the literature with regard to an intended edition at Basle in 1495 refer to Friedländer (p. 139). Burckhardt's opinion that the work must be dated shortly before the journey to Italy (1495), because the portrait of Frederick the Wise, who sojourned in Nuremberg from October 20th to 25th, 1494, must have been taken from nature, has found but little response (Pr. Jhrb., XXVIII, p. 174). Heller and Retberg (who mentions only the second print) were contradicted by Passavant and Thausing Through the sketch for the second woodcut — the Handing of the Book to the Emperor Otto I., which Giehlow (Dürer Soc. 1898, plate VII) discovered on the back of a drawing in the Bonnat Collection (L. 348) a sure foundation for Dürer's authorship was obtained: (Dodgson, Cat. p. 260). 143. Conrad Celtes handing his edition of the Roswitha Comedies to the Elector Frederick of Saxony. H. 2088, P. 210, 277a. Wustmann's (Z. f. bild. Kst., XXII, p. 193) supposition that the three onlookers are portraits of Wohlgemuth, Koberger and Dürer has found no support. The cutting is bad and hasty so that a fold on the arm of the young man (black triangle) was left. / 144. Roswitha in the presence of her niece Gerba, the abbess of Gandersheim, presents her works to the Emperor Otto I. H. 2092, P. 277 b. R. 47.	143.–144.
117	CONRADI CELTES...QUATUOR LIBRI AMORUM. Nuremberg 1502. Printed for the Sodalitas Celtica. Two woodcuts by Dürer; the other ten blocks have been absolutely mutilated in the cutting. Of these, Thausing attributes the cut "Apollo and Daphne" (p. 273) to Dürer; for these as well as for the other cuts previous works must have served as material to work from. Dodgson ascribes them to Traut, Röttinger all to Wechtlin, recently in his "Doppelgänger" (p. 37) only two of them to Peter Vischer the Elder. 145. Celtes presents his work to the Emperor Maximilian (P. 217, H. 2089, D. 23). In a later state Burgkmair replaced the two portrait heads by new ones, as Dörnhöffer has proved (Beitr. z. Kstg. F. Wickhoff gew. 1903, p. 111). Above are the imperial arms, below Vienna, on the left Austria, on the right Flanders. / 146. Philosophy. B. 130. H. 2063. R. 48. D. 24. With regard to the subject, cf. the exhaustive explanation by Dodgson (Cat. p. 282). The four heads of the winds in the corners represent the four elements and	145.–146.

temperaments: above on the left: Fire and the Choleric temperament, above on the right: Air and the Sanguine temperament, below on the left: Earth and Melancholy, below on the right: Water and the Phlegmatic temperament.

147.–166. FROM TWO NUREMBERG PRAYER-BOOKS. One hundred and six woodcuts are known, which are divided into two series. The first series contains 41 illustrations for the Sunday Gospels, the second 63 for a Salus animae; the latter were used for an edition in book form of 1503, printed by Hieronymus Höltzel, Nuremberg (three copies known, one being in the Vienna Nationalbibliothek). With regard to later uses and copies cf. Dodgson (Holzschn. zu zwei Nürnberger Andachtsb., Graph. Ges. XI, 1909), who was the first to publish the complete series with critical notes. Dodgson assigned them to the Benediktmeister. Thus were Seidlitz' theory (Pr. Jhrb. VI, 28) as to the authorship of Schäufelein and Röttinger's attribution to Wechtlin (p. 30) both annulled, and the cuts brought into closer connection with Dürer. In this case also, the date 1503 as the year of publication can only be considered as a terminus ante quem. Many points of resemblance in some of the single cuts to Dürer's work of 1500—1503 do not necessarily prove in the Prayer Book series a dependence on earlier productions. It is far more likely that in this work done to order, certain drawings were quickly made use of which Dürer had in hand, and which he had intended to work out more in detail for later purposes. On the other hand, Wölfflin (Kstchr. 1918, p. 365) sees a resemblance in style to the two series of Basle illustrations, and he considers both series to be the later works of the Basle illustrator, (who, in his opinion, is not Dürer) in order to show that the date 1503 is impossible. In answer to this, Friedländer (Kstchr. 1918, p. 385) insisted that this could be only a terminus ante quem, and put the date as far back as 1499.

In consideration of the quality of the work Friedländer is disposed to recognise the work of two different hands, especially for the Salus animae series (p. 37), and Weixlgärtner is of the same opinion (Gr. Kste. 1920, p. 49). Curjel attributed the Salus animae series to Baldung (Kstchr. 1918, p. 417), and is followed in this by E. W. Braun (Gr. Kste. 1924, p. 14), whereas Weinberger (N. M. p. 150ff.) attributes them to Kulmbach and dates them 1505; and recently Röttinger in his "Doppelgänger" (p. 38) sees the work of Peter Vischer d. A. A complete copy is in the possession of Mr. Barlow of Manchester; on each print a small Dürer monogram is stamped.

Thus on the compass of Dürer criticism the needle oscillates from pole to pole, till it is brought to rest in Dodgson's faith: "when the dust of controversy has settled and we look with clearer eyes, undistracted by attributions of now discarded rubbich, we may all recant our doubts, and agree that the missing name is Dürer after all" (Burl. Mag. 1918, XXXII, p. 51).

From the series of the Sunday Gospels: (proof impressions in Basel und Berlin, 36 cuts in each place; the whole series, unequal in quality of printing, is at Hamburg).

147. The Adoration of the Shepherds. / 148. The Adoration of the Magi. / 149. Christ among the doctors. / 150. The Miraculous draught of fishes. / 151. The Parable of the Sower. / 152. Christ heals one possessed with a devil. / 153. The Feeding of the five thousand. / 154. Christ shows his disciples the signs in the heavens. / 155. The Resurrection of Christ. / 156 The Stigmatisation of St. Francis. Unique cut at Hamburg. / 157. Saint Dorothea. Unique cut at Hamburg. (With regard to this being one of the series of the Sunday Gospels cf. Dodgson, p. 16). From the Salus Animae series (proof impressions — 36 in number — at Berlin): 158. Mary as Queen of Heaven (in the sun). / 159. St. James the Great. / 160. Saint Anthony. / 161. Saint John the Baptist. / 162. Saint Sebastian. / 163. Saint Anne. / 164. St. Helen. / 165. St. Catherine. / 166. St. Veronica.

167. THREE NUNS BEFORE A CRUCIFIX, from: Lucia de Narnia, Spiritualium personarum feminei sexus facta admiratione digna, Nuremberg 1501 (Höltzel). A German edition also came out in the same year: Wunderperliche gschiten von gaystlichen weybes personen. Dodgson (D.-S. IX, p. 22) was the first to connect this with the so-called Brigittenmeister; Springer (Kst. Ges., Berl. 1904, p. 29) also believed it to

PAGE		
	be by Dürer. This was contradicted by Weisbach, Dörnhöffer and Weixlgärtner. The style shows distinct resemblance to that of the Bridget Book and must not be dated later than 1499. Weinberger (N.M. p.146) believes it to be by Kulmbach, Röttinger ("Doppelgänger", p.43) attributes it to Peter Vischer the Elder.	
120	SAINT JEROME. H. 2016. P. 188. R. A. 63. D. 356,20. Dodgson calls this "a puzzling woodcut, nearer, perhaps to W. Traut than to any other artist of the school whom I can name". We would rather call it near to Dürer, even if not actually carried out by him as a woodcut. It has the most resemblance with the St.Jerome of the second series of the Prayer Book, Dodgson, ill.77). Röttinger („Doppelgänger", p.25) considers it as a new treatment of this latter, for which a drawing by Dürer engraved by Hollar (Parthey 166) served as the original. In a number of books printed by Höltzel from 1511 onwards it occurs as an illustration.	168.
121	SAINT SEBALD ON THE COLUMN. B. app. 20. H. 1865. R. 91. D. 22. Single sheet with a Hymn by Conrad Celtes in praise of Saint Sebald, which first appeared in: Celtes, De Felicitate; Norimbergae 1501. First state (unique in the Albertina, Vienna) with a heading of three lines (see Dodgson 22 and Dodgson, Oesterreichisches Jahrbuch, XXIII, p. 7). After Retberg had attributed the print to Beham, Thausing and Muther to Wohlgemuth, Dodgson attributed it to Dürer and dated it 1501 — perhaps a little earlier — as terminus ante quem. Weinberger (Nürnb. M.) sees in the drawing and in the finish of the cutting the hand of his Celtes-Master. The arms are: above, left, Denmark; above, right, France; below, left, Schreyer, "Probst" of the Church of Saint Sebald at Nuremberg, a model of which the saint holds in his hands; below, on the right, Celtes. "There are two editions in existence with differences in the text." C. Dodgson: Oesterr. Jahrb. XXIII, p.7.	169.
122	PIRCKHEIMER'S BOOKPLATE. B. app. 52, H. 2139, R. 50, D. 25. Dodgson (D.S. VI Pl. XXI) and Friedländer have pointed out the close connection with the Celtes book "Quatuor Libri"; therefore the date must be fixed as 1500. The arms are those of Pirckheimer and his wife Christina, née Rieter. Röttinger puts the date as late 1504 or 1505 ("Doppelgänger", p.48).	170.
123	ASTRONOMER. Titlepage to Messahalah, De scientia motus orbis, printed by Johann Weissenburger, Nuremberg 1504. Röttinger attributed the cut to Wechtlin, but recently in his "Doppelgänger" (p. 43) to Peter Vischer the Elder, whereas Weinberger is inclined to the opinion that it is by Kulmbach (M.N. p.196).	171.
123	NUDE WOMAN WITH THE ZODIAC. Single sheet with the Prognosticon of the Astronomer Stabius for the year 1503—04. Title: Prognosticon Joanni Stabii... ad annos MDIII—IV. Printed by Weissenburger at Nuremberg. Röttinger first ascribed the cut to Wechtlin, then later in his "Doppelgänger" (p. 43) to Peter Vischer the Elder, dating it 1502. Weinberger (p. 197) attributed it to Kulmbach. The cutting is very poor (an impression at Munich).	172.
124	Two woodcuts from "DER BESCHLOSSEN GART DES ROSENKRANTZ MARIAE", printed for Dr. Ulrich Pinder, Nuremberg 1505 (Vol. II, fol. 42 and 44). Two of the four most important cuts in this richly illustrated work — subjects from the story of Judith — were attributed to Dürer by Muther (640 ff.), and he was seconded in this by Dodgson (D.S.IX, pl. XXXII, and X, pl. VII). Vollmer divided up the illustrations amongst five designers (Rep. 1908, p. 158). With regard to style and finish of the cutting the prints stand in close relationship to the preceding ones as also with the Calvary which follows (Ill. 192); which fact also caused Weixlgärtner to accept Dürer's authorship. Weinberger (Nürnb. M. p. 182), who makes a special comparison between the horses of the Calvary and these prints, thus bringing the artist close to Dürer — the other two prints he attributes correctly to Baldung—identifies this artist with the Benedict Master, therefore with Kulmbach. But the close resemblance to the Calvary (B. 59) points directly to Dürer. Röttinger in his "Doppelgänger" sees here again the hand of Peter Vischer the Elder (p. 43).	173., 174.

173. Holofernes fighting the Jews. / 174. Judith is taken to the camp of Holofernes.
Beside these series of works produced for scholars and publishers between 1499 and 1504, there appeared another large book, the Life of the Virgin, with Dürer's monogram, therefore finished under his personal supervision.

175.–191. SEVENTEEN CUTS FROM THE LIFE OF THE VIRGIN. A development in form and graphic treatment discernible in these cuts gives more aid in dating them than is to be found in the Apocalypse, a series more compact and less differentiated in style. Heidrich was the first to arrange them in the sequence which I also adopt (Rep. 1906, p. 227) with a few changes and reservations made by Friedländer (p. 53) and Pauli (Kstchr. 1921, No. 26). The illustrations follow the contents of the story, as told in the edition in book form of 1511. 125-141

175. The High Priest rejects Joachim's offering. B. 77. H. 1694. R. 64. Heidrich and Friedländer 1504. / 176. The Angel brings the message to Joachim. B. 78. H. 1698. R. 65. Heidrich 1504. Friedländer 1505. / 177. The Meeting of Joachim and Anne at the Golden Gate. B. 79. H. 1703 R. 66. The only cut with Dürer's monogram and the date 1504. / 178. The Birth of Mary. B. 80. H. 1709. R. 67. Heidrich 1503 also Friedländer. A study for the composition is at Berlin. (L. 7). / 179. Presentation of the Virgin in the Temple. B. 81. H. 1715. R. 68. Heidrich between 1504 und 1505; Friedländer dates it 1502. / 180. The Marriage of the Virgin. B. 82. H. 1720. R. 69. Heidrich 1505, Friedländer 1504. There is a coloured sketch for the bridesmaid in the big coif in the Albertina in Vienna (L. 464) with the inscription: Also geht man zw Nörmerck in die Kirchn (thus they go to Church in Nuremberg). / 181. The Annunciation. B. 83. H. 1725. R. 70. Heidrich 1500/01; Friedländer also makes it the first cut (1502). There is a sketch of the composition, slightly tinted with water-colour, at Berlin (L. 442). / 182. The Visitation. B. 84. H. 1730. R. 71. Heidrich and Friedländer 1503. A study for the composition is in the Albertina, Vienna. (L. 473). / 183. The Adoration of the Shepherds. (The Nativity). B. 85. H. 1738. R. 72. Heidrich 1505, Friedländer 1502. We were confronted by the same contradiction as regards the date in the "Presentation in the Temple" (B. 81). In the treatment of light these two prints have a similar cool uniformity, which is not characteristic of the prints placed by Heidrich in the year 1505. At this date one would expect to find the contrast of the light inside the stable handled quite differently. / 184. The Circumcision. B. 68. H. 1745. R. 73. Heidrich and Friedländer date it 1505. / 185. The Adoration of the Magi. B. 87. H. 1754. R. 74. Heidrich dates it 1500/01; Friedländer also puts the cut near the beginning, but in 1502. Pauli in connection with his dating of B. 95 "The Adoration of the Virgin", dates this back to 1500; but I am not able to share this view. The drawing of a head of the Madonna (Berlin, L. 6) with the date 1503 cannot be regarded as a direct study for the Virgin, as Wölfflin supposed. A study for the composition is in the Bonnat Collection (Bayonne) L. 348. / 186. The Presentation of Christ in the Temple. B. 88. H. 1759. Heidrich and Friedländer date it 1505. / 187. The Flight into Egypt. B. 89. H. 1764. R. 76. Heidrich dates it 1505, Friedländer (with whom we agree) 1503. Pauli seems inclined to date the cut earlier. / 188. Repose on the Flight into Egypt. B. 90. H. 1770. R. 77. Heidrich dates it 1504, Friedländer 1505. / 189. Christ among the Doctors in the Temple. B. 91. H. 1775. R. 78. Heidrich and Friedländer both date it 1503. / 190. Christ taking leave of his Mother. Heidrich was inclined to date the print after the second Italian journey 1507/08. The austerity of the mental conception which is particularly noticeable in comparison with the gay imagination of the other prints, is due without doubt to the subject matter, and the pose and the classical treatment of the drapery in the figure of Christ, so reminiscent of sculpture, needed no fresh inspiration from southern art. The handling of form in its relation to space leaves no doubt as to the date being about 1505, as is proved by a glance at the painting "The Adoration of the Magi" in Florence of the year 1504, this cut standing in a similar relation to this picture as the other prints of the Life of the Virgin do to the Paumgartner Altar. We must agree with Friedländer, who dates the print 1505, at the end of the series. / 191. The Virgin worshipped by Angels and Saints (S. Joseph, S. John the Baptist, S. Anthony, S. Jerome, S. Paul and S. Catherine). B. 95, H. 17a, 7. R. 82. To place this print at the

end of the whole book, after the later prints of 1510, does away with the unity of the subject matter. There is much to be said for the theory that at some time it was thought of as a frontispiece. Wölfflin (p. 81) saw characteristic signs of early work in the "crowded and confused composition with the absolutely broken up background". Pauli (Kstch. 1921, Nr. 26) is inclined to fix the date as early as 1497/98, calling attention to a perspective study in the Hamburg Kunsthalle on account of the similarity of type of the playing children on the parapet of the foreground, which he brings into connection with the altar piece at Dresden. One might also add to this, on account of similarity, the figure of the kneeling S. Catherine in the large woodcut of her martyrdom of the year 1498; but on the other hand the representation of the figure in reverse in the "Adoration of the Virgin" may be taken as an argument for a repetition. Although we are not convinced by Pauli's arguments for such a very early date, at the same time we cannot agree with Heidrich and Friedländer who date the print 1504. The particular care which "the master never expended on the work of a woodcut either in earlier or in later years" (Friedländer), has not yet attained the more perfect economy in artistic contrasts which is peculiar to the prints of 1504, but has remained concentrated more or less on each single object. This may therefore be regarded as the first cut of the Life of the Virgin, on which Dürer worked, and there is no necessity for assuming an earlier date than 1500.

142-150 A SERIES OF POPULAR PICTURES OF SAINTS belong to the years 1500—1504 and some to a 192.–202. later date, the work going alongside with that of the "Great Book", the Life of the Virgin. There can be no doubt that Dürer did not give the same care to these works, which like those executed for scholars and publishers were intended to defray daily expenses, as to the woodcuts of the large series. We are probably not wrong in identifying them with the "bad work on wood", of which Dürer speaks in his Netherlands diary. (Lange-Fuhse, p. 140).

192. Calvary. B. 59. H. 1640. R. 62. D. 26. Dodgson (Cat. p. 284) has rightly called attention to the primitive drawing and correctly dates the print just after 1500, unless one places it nearer to the central panel of the altar-piece at St. Veit (near Vienna) with the date 1502. Particularly in the landscape analogy may be found with the Judith prints (ill. 172/4). / 193. The Holy Family with two angels in a portico. About 1500. B. 100. H. 1806. R. 61. The close connection with the Life of the Virgin is plainly seen in conception, background and framework. Heidrich, on account of the poor finish of the cutting and because of the ornamental figures of Adam and Eve, was inclined to see the work of a studio companion, who "was allowed to use only the monogram of Dürer" (Gesch. d. D. Marienbildes 1906, Anh. VII), a theory which was rightly rejected by Weixlgärtner (Kstg. Anz. 1906, p. 89), and later was withdrawn by Heidrich himself (Rep. 1906, p. 237). Quite unnecessarily Weinberger tried to make Kulmbach responsible for the ornamental figures (N. M. S. 199). The relation of the figures to the space is badly carried out; not only this but the block is cut down on the right side / 194. Saint Christopher. B. 104. H. 1823. R. 56. About 1501. / 195. Saint Francis receiving the Stigmata. B. 110. H. 1929. R. 57. About 1502. / 196. Saint John the Baptist and Saint Onuphrius. B. 112. H. 1869. R. 58. About 1502. / 197. The Hermits Saint Anthony and Saint Paul. B. 107. H. 1867. R. 59. A study for this in the Blasius Collection, Brunswick (L. 141) 1502/03. / 198. Saint George. B. 111. H. 1832. R. 86. About 1504/05. / 199. The Ecstasy of Saint Mary Magdalene. B. 121. H. 1885. R. 60. About 1504/05. Dodgson (Cat. 285) has made it clear that we have here not a representation of an "Assumption" of St. Mary Magdalene, but of her Ecstasy. Dürer follows exactly the Golden Legend and portrays the end of her thirty years penance in the mountains of Provence, where she relates to a hermit the story of the transport that she experienced seven times daily. He can hear her voice but, dazzled by her transformation in a celestial light, is unable to see her form. Heidrich is not convincing in his attempts to date this print after the Italian journey 1507/08 (Gesch. d. D. Marienbildes, p. 186). / 200. The Madonna with Joseph and five angels. B. 99. H. 199. R. 89. About 1505. With regard to this also I am not able to share Heidrich's opinion as to date. / 201. SS. Stephen, Sixtus and Lawrence. B. 108 H. 1876. R. 123. 1505. Dodgson (Cat. p. 287) points out that since Bartsch all catalogues have wrongly designated the Saint in the middle as St. Gregory, but

we have a better witness in Vasari who speaks of a woodcut by Dürer representing SS. Stephen, Sixtus and Lawrence. / 202. The three Bishops SS. Nicholas, Ulrich, and Erasmus. B. 118. H. 1874. R. 122. 1507/08. The powerful build of the figures, the disposition of light and shade and the freedom of technique of the drawing are novelties which separate this work distinctly from the other group. In the architecture with its effects of light and shade there are anticipations of the engraved Passion (cf. B. 3) as also of the Little Passion woodcuts (cf. ill. No. 251).

203.—206. From the series of the so-called "SIX KNOTS". B. 140—145. H. 1926—1932 D. 54—59. Patterns for embroidery, which were direct copies of Italian engravings from the circle of the Academy of Leonardo da Vinci (cf. Pass. 5, 182). Dürer's monogram first appears on later impressions. But his authorship seems to be beyond doubt owing to the note in the Diary of the Journey to the Netherlands. "I presented the six knots to Meister Dietrich, Glazier" (Dirk Vellert is meant), (Lange und Fuhse, p. 148). Presumably they originated during the second journey to Italy (1505—07); early impressions are on Italian paper. The points of differentiation are most easily found in the central shields. 151-154

203. B. 140. H. 1928. With heart-shaped centre-piece and angular pattern. / 204. B. 144. H. 1930. With long hexagonal centre-piece and round scrolls. / 206. B. 145. H. 1932. With a small black circle in the centre which is repeated six times.

The Classical Period of the woodcut 1509–1512

PAGE

Dürer's persistent striving with the art of painting had received new stimulus in Italy, and in his letters to Jacob Heller (Lange-Fuhse, p. 42—58) we hear of his hard struggle in his efforts to produce large pictures. But "das fleissig Kleibeln gehet nit von statten; darumb will ich meines stechens ausswarten" (in spite of diligent efforts it makes no progress, therefore I will stick to my engraving). It is a fact that after this outcry of the year 1509, the narrator's imagination, pent up by his studies in painting, and also owing to the necessity of a more economic mode of life, was impelled to express itself in the woodcut, and the hand was freed from "Kleibeln". After the beginnings of the year 1509, in 1510 the production increases to five single cuts and six supplementary cuts to the Great Passion and to the Life of the Virgin, and reached its climax in the year 1511, in which appeared besides the edition of the three big works with new title pages and eight big separate woodcuts, the Little Passion with its thirty-seven woodcuts of which only three belong to the years 1509 and 1510.

155 THE COAT OF ARMS OF MICHAEL BEHAIM (Councillor of Nuremberg). B. 159. H. 1937. R. 128. 207.
The escutcheon is without monogram, but Dürer's authorship is made certain by the autograph inscription on the back of the wood-block (now at New York)—in 1897 still in the family archives of the Behaims—, which Dürer added on returning the block to Behaim, who had demanded some improvements (see Lange-Fuhse). From this it is clear that Dürer only transferred the drawing on to the block, but left it to the person who gave the order to get the cutting carried out. In this case the work had been done very indifferently. The death of Behaim in 1511 gives us a terminus ante quem. Retberg dates it 1509.

156 CHRIST ON THE CROSS WITH THE VIRGIN AND ST. JOHN. B. 55. H. 1632. R. 169. D. 93. With 208.
the date 1510. Heading to a sheet with a poem in two columns (printed by Höltzel at Nuremberg). With regard to an earlier arrangement of the text in four columns (copies at Stuttgart and Coll. Friedr. Aug. at Dresden), also with regard to a second edition with orthographic alterations of the title, cf. Dodgson, Cat. p. 298. Dürers monogram is at the end of the text, proving that he was also the author of the verses (cf. the copy of the poem in Lange-Fuhse, p. 87). Friedländer (p. 26) following Heidrich and Dodgson (Burl. Mag. 1911, XX., 95) pointed out that the figure of St. John is a repetition from the Missale speciale of 1493. Röttinger (p. 26) introduced the print into the reconstruction of his "Doppelgänger" and attributes it to Peter Vischer the Elder.

156 THE SCHOOLMASTER. B. 133. H. 1900. R. 170. D. 99. With the date 1510; the monogram at the end 209.
of the verses printed in two columns proves Dürer to have been the author (the poem is printed by Lange-Fuhse, p. 95). About the arrangement of the columns see Dodgson, Cat. p. 299. Here again Röttinger sees Peter Vischer the Elder.

156 DEATH AND THE LANDSKNECHT. B. 132. H. 1901. R. 17. D. 98. With the date 1510 and the mono- 210.
gram at the end of the verses (in two columns; see Lange-Fuhse, p. 90. With regard to editions cf. Dodgson, Cat. p. 298 (The first state reprod. Dürer Soc. XV, pl. XXIV from the Copy at Stuttgart).

157 THE PENITENT. B. 119. H. 1866. R. 168. D. 100. With monogram and date 1510. The subject without 211.
referring to any particular saint seems to have been a purely personal conception. And this individual tone rings through a poem of fifteen lines by Dürer himself:

	PAGE

Albrecht Dürer tut euch sagen,
Ihr sollt euer Sünd beklagen,
Eh Lätare herfür kummt,
Dass dem Teufel sein Maul werd gestummt, etc.
(cf. Lange-Fuhse). The pen drawing in London (L. 237) is a copy.

212. THE BEHEADING OF ST. JOHN the Baptist. B. 125. H. 1851. R. 172. Date 1510. 158

213. THE MADONNA APPEARS TO ST. JOHN. Title page to the second Latin edition of the Apocalypse 159
of the year 1511. B. 60. The divergences of the Latin text on the back of the second edition from that of the first edition are registered exactly by Hausmann, p. 55. The Latin title of the first edition (ill. 105) was used again. The quality of the printing of the second edition is inferior to that of the first of 1498. There exist good copies without text, of which the quality is often better than those of the edition of 1498, but it does not follow that these were proof prior to that edition, as has been proved by Hausmann with reference to the watermarks, which bring them nearer to the year 1511.

214.–218. FIVE CUTS TO COMPLETE THE GREAT PASSION, for the complete edition in book form of the 160-164
year 1511. Executed in 1510. The title: Passio domini nostri Jesu per Fratrem Chelidonium collecta cum figuris Alberti Dureri – Nostri Pictoris. Nuremberg 1511. The tiresome verses of this "lover of the muse", as the liberal minded Benedictine monk Schwalbe (Chelidonius) calls himself in the title, are printed in two columns on the back of the woodcuts. For the impressions without text which immediately preceded this edition, and for the kinds of paper used, cf. Hausmann, p. 61.
214. Title Page: The Mocking of Christ. B. 4. 1510. A first state with longer rays is in the Ashmolean Museum, Oxford. / 215. The Last Supper. B. 5. (with 13 Apostles!) 1510. / 216. Christ taken captive. B. 7. 1510. / 217. Christ in Limbo. B. 14. 1510. / 218. The Resurrection of Christ. B. 15. 1510.

219.–221. TITLE PAGE AND SUPPLEMENTARY PRINTS TO THE LIFE OF THE VIRGIN. The Title, ill. 219, 165-167
Nuremberg 1511. The verses on the back, like those of the Great Passion, are by Chelidonius. The proof without text judging by quality and watermark belong to an earlier date than the edition in book form (cf. Hausmann, p. 47ff).
219. Title Page: The Virgin in Glory. B. 76. / 220. The Death of the Virgin. B. 93. A sketch in the Albertina, Vienna. (L. 474). / 221. The Coronation of the Virgin. B. 94. A sketch is at Berlin (L 27).

222.–258. THE SMALL PASSION. 1511. Title: Passio Christi ab Alberto Dürer Nurenbergense effigiata cū variis 168-177
carminibus Fratris Benedicti Chelidonii Musophili. Nuremberg 1511. Amsterdam, London and Stuttgart have proofs which are earlier than the book edition. With regard to the impressions after 1511 without text on the back, cf. Hausmann, p. 64; regarding the great number of copies of this best known book of Dürer's cf. Heller Nr. 1142–1621 and p. 605–610; as to the fate of the blocks see Hausmann, p. 64, and Dodgson, Cat. 296/7 (here also with regard to the different hands employed in the cutting).
Two cuts: B. 32 (ill. 238) and B. 37 (ill. 243) are dated 1509, two other cuts: B. 18 (ill. 224) and B. 38 (ill. 244) bear the date 1510.
222. Title page: The Man of Sorrows. B. 16. The illustration shows the first state (unique proof in the British Museum, first published by the Dürer Society 1902 with the grammatical error "passionis"). The book edition has the title quoted as a heading above the figure. The text below the figure in the book edition is badly set up and has slipped out of place. / 223. The Fall. B. 17. There is a first state among the proof prints; ten small lines of hatching across the back of the figure of Eve. A sketch twice the size is in the Albertina, Vienna, L. 518. / 224. Expulsion from Paradise. B. 18. / 225. The Annunciation. B. 19. / 226. The Nativity. B. 20. / 227. Christ taking leave of his Mother. B. 21. / 228. Christ's Entry into

PAGE		
	Jerusalem. B. 22. / 229. Christ driving the Merchants from the Temple. B. 23. / 230. The Last Supper. B. 24. / 231. Christ washing Peter's feet. B. 25. / 232. Christ on the Mount of Olives. B. 26. / 233. Christ taken captive. B. 27. / 234. Christ before Annas. B. 28. / 235. Christ before Caiaphas. B. 29. / 236. The Mocking of Christ. B. 30. / 237. Christ before Pilate. B. 31. / 238. Christ before Herod. / 239. The Flagellation. B. 33. / 240. Christ being crowned with thorns. B. 34. / 241. Christ shown to the people. B. 35. / 242. Pilate washing his hands. B. 36. / 243. Christ bearing the Cross. B. 37. / 244. The Sudarium of Saint Veronica. B 38. / 245. Christ being nailed to the Cross. B. 39. / 246. Christ on the Cross. B. 40. / 247. Christ in Limbo. B. 41. / 248. The Descent from the Cross. B. 42. / 249. The Lamentation for Christ. B. 43. / 250. The Entombment. B. 44. / 251. The Resurrection. B. 45. / 252. Christ appears to his Mother. B. 46. / 253. Christ appears to Mary Magdalene. B. 47. / 254. Christ and the disciples at Emmaus. B. 48. / 255. The incredulity of St. Thomas. B. 49. / 256. The Ascension. B. 50. / 257. The Descent of the Holy Spirit. B. 51. / 258. The Last Judgment. B. 52.	
177	CHRIST ON THE MOUNT OF OLIVES. B. 54. H. 1625. R. 166. D. 60. The block is badly cut and in the small Passion its place is taken by B. 26. Dodgson (Cat. 293) correctly places it among the earliest compositions of the series; at the same time one cannot agree with him in putting back the date as early as 1507/08, and one cannot date the beginning of the whole series earlier than 1509.	259.
158	THE HEAD OF ST. JOHN THE BAPTIST BROUGHT TO HEROD. B. 126. H. 1860. R. 173. D. 109. 1511.	260.
178	CAIN KILLS ABEL. B. 1. H. 1101. R. 186. D. 114. Date 1511. Weixlgärtner (Kstg. Anz. 1906, P. 31, note 3) has called attention to Dürer's economy in workmanship, as the figure of the servant of Malchus in the drawings of "Christ taken captive" at Turin (L. 409) and in the Albertina (L. 477) — occurs here almost without alteration as Abel.	261.
179	THE ADORATION OF THE MAGI. B. 3. H. 1103. R. 187. D. 115. Date 1511.	262.
180	THE MASS OF ST. GREGORY. B. 123. H. 1833. R. 190. D. 117. Date 1511.	263.
181	THE TRINITY (the Throne of Grace). B. 122. H. 1646. R. 193. D. 116. Both drawing and cutting are at the height of technical perfection.	264.
182	SAINT CHRISTOPHER. B. 103. H. 1818. R. 192. D. 121. Date 1511. Without monogram, but magnificently cut.	265.
183	ST. JEROME IN HIS CELL. B. 114. H. 1840. R. 191. D. 118. Date 1511.	266.
184	THE HOLY FAMILY WITH JOACHIM AND ANNA. B. 96. H. 1800. R. 189. ("With the dancing child"). D. 119.	267.
185	THE HOLY FAMILY WITH SAINTS AND ANGELS. B. 97. H. 1802. ("The Holy Family with the zither"). R. 188. Heller mentions the print as "quite excellently cut". This can only be applied to the purely technical finish, to the fineness of the lines. On the other hand, Wölfflin's criticism of it as "flüchtig", i. e. "hasty, superficial", cannot be considered correct. This can only be said with regard to lack of care in the carrying out of the original lines in Dürer's woodcut design. An adjustment between the two contrary opinions is to be found in the fact that Dürer's did not transfer the drawing himself on to the block, but that the lines were traced by a dull copyist; these lines, however, were rendered with technical perfection by the cutter.	268.

	PAGE

269. SAINT JEROME IN THE CAVERN. B. 113. H. 1845. R. 197. D. 122. Date 1512. The first state has on the back the text: "Beschreibung des heyligen Bischoffs Eusebii" (given in full by Heller), printed at Nuremberg by Hieronymus Höltzel. 14th Feb. 1514. The second state is without the date 1512. (With regard to copies cf. Dodgson 122c.) — 186

270. TITLE PAGE to Pirckheimer's translation of Plutarch's treatise: De vitanda usura. Nuremberg, printed by Peypus 1513. Pass. 205. H. 1936 (knew only edition of 1516 and 1517). Dodgson attributed it to Springinklee (Cat. 379), but now regards it as Dürer's work, whereas Röttinger in his "Doppelgänger" (p. 15) gives it to Peter Vischer the Elder. — 187

271. THE MADONNA IN A CIRCLE (with a landscape). H. 1808. P. 177. R.-A. 60. D. 123. Without monogram. Dodgson (D.-S. 1902, Nr. 27) rightly decides in favour of Dürer. Dodgson (Cat. p. 305) dates the woodcut 1512; Heidrich (Gesch. d. Dürerschen Marienbildes, p 102) is inclined to suppose it based on a drawing of Dürer's probably executed after 1514; Friedländer seems also inclined to this date (p. 149). — 188

272. SAINT SEBALD. Woodcut for the Title page of the: "Hystori des lebens, sterbens und wunderwerck des heyligen Peichtigers und grossen nothelffers Sant Sebaldus", printed by Höltzel in Nuremberg in 1514. After Bartsch and Passavant had expressed doubts as to the authorship of this woodcut, Schmidt (Rep. XVI, 308) suggested Springinklee, and Dodgson at first agreed with this theory (p. 381), but recently he has changed this opinion in favour of Dürer, which is certainly correct. — 189

Dürer's Work in the service of the Emperor Maximilian, and other works, 1512—1518

PAGE

AT the moment when through Dürer's efforts the woodcut had reached its classic height, and when the publication of his three "Great Books" had made a conquest for wood engraving of the kind of art that really appealed to the people, it fell a victim to the will of a potentate who had no real feeling for this democratic art, but intended to make its technical perfection serve his own ambitious purposes. The woodcut had begun as a substitute for the miniature, as a miniature for the humble, and now after a century, the man who had brought this art to its height of power and freedom was destined to occupy the subordinate position of a copyist of miniatures. The woodcut had reached the steps of the throne, and the Emperor was tempted to entrust to this democratic form of art the portrayal of personal and dynastic matters, which hitherto had been the exclusive domain of the more aristocratic miniature.

Dürer took part in five big imperial enterprises, and for four works translated the subjects into the language of the wood block. It is true that he worked with the skill of all great translators, being more familiar with his own tongue than with the foreign one. Only in one work there was no need for him to suppress his own personality, and this was in the designs for the marginal illustrations for the Emperor's Prayer Book which, however, although intended for woodcuts were never actually cut.

190-206 THE TRIUMPHAL ARCH. No doubt the first discussions regarding this took place during the Emperor's 273.—292 visit to Nuremberg February 4—12, 1512. Johann Stabius the historiographer and court astronomer handed over to Dürer the learned programme and the architectural plan, which had been designed in paintings on vellum by the Innsbruck court painter and architect Kölderer, while to Dürer remained the rôle of making the drawings, so that on the steps of the Triumphal Arch beside the large escutcheon of Stabius and the middle sized one of Kölderer, his own could only appear in a small size. The date 1515 at the foot of the two corner towers refers to the date at which the work was finished, and in July of this year Dürer appeals to a friend to request the Emperor to pay him and points out that "I have served His Imperial Majesty for three years, suffered loss of fortune, and had I not exerted all my industry, the beautiful work would never have been finished in such a way". (Lange-Fuhse, p. 60.) With regard to the origin of the work cf. Giehlow, Festschrift für Wickhoff, p. 19, and C. Dodgson, Cat. p. 311. About Kölderer's share in the work cf. C. Fischthaler, Ferdinandeumszeitschrift, Innsbruck 1902.

Stabius contributed an explanation which, printed in two columns, was added below the Triumphal Arch. It divides the contents of the whole composition into: 1. three gateways: Honour (in the middle), Praise (left), Nobility (right); 2. middle tower, i.e the tower over the chief gateway; this contains the genealogical tree of the Emperor, flanked by 57 escutcheons; 3. the deeds of Maximilian in 24 scenes above the two gateways, on each side twelve compartments showing historical scenes from the Emperor's life; and in addition twelve half lengths of Kings of Rome, of Italy and of the Roman empire from Caesar to Sigismund on the left side, and twelve half lengths of contemporary princes on the right side; 4. and 5. busts of emperors and kings on the left, and of kinsmen on the right (with the two outside pairs of columns); 6. the two corner towers with eleven subjects; 7. the ornament (which Stabius describes in the fourth and fifth columns). The whole was erected before the Emperor, says Stabius, "as in olden times the arcus triumphales before the Roman Emperors in the city of Rome".

Besides Dürer's hand we also recognise that of Springinklee, whose work was more closely allied to Dürer's and is easily distinguishable from the rougher work of Traut. Giehlow also attributed some of the work to Hans Dürer, Albrecht's brother. The two corner towers were not carried out at Nuremberg, but at Ratisbon under the direction of Altdorfer. (Cf. W. Schmidt, Chr. d. vervielf. Kste. 1891, p. 9).

The cutting was carried out by Hieronymus Andreae (or Resch), of Nuremberg, as is proved by his signature on the back of the blocks at Vienna, and the work lasted from 1515 to 1517. On the history of the blocks, the progress of the work and editions cf. Dodgson, Cat. 311—328. (Five editions: the first in 1517, second in 1526/28, third in 1559, fourth in 1799, fifth in 1885. For literature cf. particularly E. Chmelarz in the Vienna Jahrbuch, 1886, p. 289—319).

The whole, three metres high, is composed of 92 wood blocks. Dürer's share consisted of: 1. the middle gateway except the genealogical tree, coats of arms and cupola); 2. the big flanking middle columns with the ornamental statues, griffins and drummers; 3. ornamental portions especially the tops of the two side pieces with the big inscription tablets; 4. the fifth scene on the round tower on the left; 5. the 2nd, 15th, 22nd, and 23rd of the historical scenes; 6. three half-length figures in the genealogical tree above the middle gateway; 7. the busts of six emperors.

273. View of the entire Triumphal Arch. B. 138. H. 1915. R. 217. D. 130. / 274. Upper part of the middle gateway: "the gateway of Honour and Might. Reduced in size. From the heavy garland of laurels, from which cranes are picking at berries, hangs a jewel, which is composed of a casket and a winged woman with a crown. There is a sketch for this in the Dürer manuscripts in the British Museum (illustrated in Conway, Literary Remains of A. D., 1889, p. 278 and Dürer-Soc., 1911, pl. XIV). / 275. Part of the centre gateway in its original size. Referring to the carriers of the garlands, crouching on the cornices of the niches, Wölfflin says: "they are the German comrades of Michaelangelo's slaves on the Sixtine ceiling." / 276. Pedestal of the right hand middle column. / 277. Base of the right hand middle column. Cranes with shells, vine leaves with pea pods bursting, sirens (symbolic of the vice of lust, which the Emperor resisted, when he gave the prize to honour), a wreath of lilies of the valley. Above is plainly visible the beginning of another block, cut by a different hand. / 278. Continuation of 276, shaft of a column with vine stems instead of grooves. Scherer (Die Ornamentik A. D., Strassburg 1902, p. 98) is wrong in not attributing to Dürer the drawing of the rams heads with the suspended jugs, which belonged to the chain of the order of the same name (Kannenorden). / 279. Continuation of 277, the top of the column, above the capital and the ornamentation of the niche. The griffin striking fire with iron and flint belongs to the insignia of the order of the Golden Fleece. A sketch for this in the British Museum (D. S. 1911, T. XIII). / 280. Capital and ornament over the niche of the left Central Column. The corners of the capital are not made of volutes but of lions' heads, and in the centre is a crane. Scherer (p. 90 and Pl. VIII) compares capitals in S. Mark's, Venice. The eagle of the escutcheon at the side is badly drawn and not in perspective. / 281. The base of the right-hand corner column. The lower part with the putti riding on dolphins was drawn by a pupil. / 282. Continuation of 280 Capital of the right-hand corner column. / 283. Inscription tablet with the lion skin, from the uppermost section of the left wing. / 284. Inscription tablet with the stag's skin, from the uppermost section of the right wing. Right half of the tablet. / 285. The same as 283. Left half of the tablet. Symmetrical repetition of the drawing with different shading. / 286. Uppermost section of the right-hand corner column. Griffin with the motto "Halt mass", the device of Maximilian. / 287. The Betrothal of Maximilian with Mary of Burgundy. The Second of the historical scenes. / 288. The Betrothal of Archduke Philip with Joanna of Castile. The Fifteenth of the historical scenes, on the right side. / 289. The Congress of Princes in Vienna. On Maximilian's right hand is his grandchild Mary, further on the right Ladislas, King of Hungary with his children, on the extreme right is King Sigismund of Poland. Twenty-third illustration of the historical scenes on the right side. / 290. The Meeting after the Battle of the Spurs. / 291. The Sacred coat of Trier. Fifth subjects on the left hand corner tower. / 292. Fourth set of the Busts of Emperors, left side.

293. THE AUSTRIAN SAINTS. B. 116. H. 1880. R. 219. D. 129. There is a first edition about 1515 with only six saints; the second edition represents eight saints. The two on the extreme right have been added, and have been somewhat carelessly joined on the block. The second edition appeared with Latin verses by

Stabius in three columns; at the end the date MDXVII. The saints portrayed are: Quirinus, Maximilian, Florian, Severinus, Coloman, Leopold, Poppo and Otto. Old impressions are not numerous; new impressions were printed from the block (in the Derschau Collection, Kupferstichkabinet, Berlin) in 1805 and 1920 (Seemann, Leipzig). Schmidt (Rep. XVII, p. 3) has attributed this to Springinklee, but Dodgson rightly does not agree with this (Cat. p. 311). Röttinger in his "Doppelgänger" (p. 6) has ascribed the print to Peter Vischer the Elder.

208 SAINT COLOMAN AS A PILGRIM (as in the series of the Austrian Saints). B. VII, 137, 106. H. 1828. 294. D. S. 382. The Saint is a portrait of Johann Stabius, with whom Dürer kept in touch after the discussions regarding the work for the Emperor Maximilian. Beside the Imperial, the Austrian and the Scotch coats of arms appear underneath those of Stabius. The woodcut appeared in 1513 with a poem in praise of Coloman by Stabius (cf. Pass. III, 161). The block is in the Royal Library in Vienna; in 1781 prints were taken from this under Dürer's name. The doubt expressed by Thausing and Chmelarz (Vienna Jhrb. IV, 301) with regard to Dürer's authorship has been taken up by W. Schmidt, who attributes the print to Springinklee. With this Dodgson is fully in agreement, which, however, does not seem to me correct, at least not as regards the portrait. The portrait seems to occupy a quite legitimate place in this period of Dürer's woodcuts. Also Nicolas Kratzer's letter to Dürer from London in 1524, referred to by Thausing (II, 242 note) in which the woodcut is mentioned, cannot be altogether ignored.

209-212 GEOGRAPHICAL WORKS FOR JOHANN STABIUS. In 1497 Stabius left Ingolstadt and took up his 295.—298. residence in Vienna as Professor of mathematics; he became court astronomer to the Emperor.
295. The Northern Hemisphere of the Celestial Globe. B. 151. H. 1924. R. 216. D. 127. About 1515. In the corners are four astronomers: Aratus Cilis, Ptolomaeus Aegyptius, Manilius Romanus, Azophi Arabus. Above the upper border line in Gothic lettering: Imagines coeli Septentrionales cum duodecim imaginibus zodiaci. / 296. The Southern Hemisphere of the Celestial Globe. B. 152. H. 1925. R. 216. Date 1515. Reduced in size. Regarding the first block and the unique impression at Munich, cf. Dodgson Cat. 309. Above on the left is the coat of arms of Cardinal Lang, Archbishop of Salzburg, and on the right a dedication to him. Below on the left are the coats of arms of Stabius, Conrad Heinfogel and Dürer, and on the right the privilege granted by Maximilian (dated 1515). The heading above the border line is "Imagines coeli Meridionales". / 297.—298. The Eastern Hemisphere of the Terrestial Globe. Mappa mundi. H. 2110. P. 201. R. A. 66. D. 126. Reduced in size. This represents the old world as known at the time of Ptolomy (with extensions taken from Martin Behaim's globe of 1492). The globe is surrounded by twelve flying winds. In the corners are: (above, left) the coat of arms of Cardinal Lang, Archbishop of Salzburg, (above, right) a dedication to Lang by Stabius, (below, left) the coat of arms of Stabius — the privilege granted to Stabius by Maximilian with the date 1515. Bartsch did not include the woodcut, Retberg mentions it in the appendix. Particularly in the divinities of the four winds Giehlow tried to see the hand of Hans Dürer, for whom Röttinger has recently substituted Hans Vischer (Doppelgänger, p. 156); but Dodgson rightly maintains the work to be that of Dürer.

213 THE RHINOCEROS. B. 136. H. 1904. R. 214. D. 125. Monogram and the date 1515. From the drawing 299. in London (British Museum L. 257) and its inscription it is clear that, contrary to Heller's opinion, Dürer himself had never seen such an animal, but had drawn it after seeing a sketch and after descriptions in a letter from Lisbon. This creature which was previously unknown in modern Europe was presented by King Emanuel to the Pope, not as Heller reports to the Emperor; but the animal perished during transport owing to shipwreck (cf. Dodgson Cat. 307/08). The nine editions have different headings (cf. Hausmann, p. 79—82). Our illustration is taken from the third edition. The eighth edition in chiaroscuro appeared at Amsterdam in the 17th century, published by Willem Janssen, with a green, also a brown tone-block.

	PAGE

300. AN OWL FIGHTING WITH OTHER BIRDS. Pass. 199. A single sheet with a poem "Der Eulen seyndt alle Vögel neydig und gram", printed by Hans Glaser at Nuremberg (cf. Muther, Meisterholzschnitte No. 50). The only copy with the text is preserved at Coburg. Röttinger attributes it to Peter Vischer the Elder and dates it 1509—1511 (Doppelgänger, p. 50). 214

301. THE MADONNA WITH CARTHUSIAN MONKS. H. 200. P. 180. R. A. 61. D. 124. Without monogram, dated 1515. Bartsch does not accept the print as Dürer's work, and Retberg sees Dürer's hand only in the Madonna, with which Dodgson rightly disagrees, and he explains doubtful features by his theory that the original drawing was by Dürer but that this was transferred to the block by Springinklee (cf. Dodgson's detailed analysis Cat., p. 306). Dodgson compares the unusual double halos with those of Saint Arnolf and Saint Leopold in the Triumphal Arch (cf. ill. 280). Heidrich does not consider the print to be by Dürer (Gesch. d. D. Marienbildes, p. 118). Röttinger at first attributed it to Wechtlin (p. 11), now to Peter Vischer the Elder (Doppelgänger, p. 6); Scherer (Kl. d. Kst., p. 351) gives it to Schäufelein. 215

302. CHRIST ON THE CROSS B. 56. H. 1633. R. 220. D. 138. Without monogram, dated 1516, in the Eichstätt Missal, printed in 1517 by Hieronymus Höltzel at Nuremberg (on vellum, facing the first page of the Canon). Used a second time in the Nuremberg edition of Luther's Old Testament, printed by Friedrich Peypus in 1524. 216

303. THE BOOK-PLATE OF HIERONYMUS EBNER. B. app. 45 H. 1940. R. A. 53. D. 137. Without monogram, dated 1516. Above is the motto: Deus refugium meum. Ebner, belonging to the family of Ebner-Eschenbach, married to Helena Fürer (coat of arms on the right). Family dates are given by Heller and Dodgson (Cat. p. 333). Dodgson is mistaken in his assertion that the print is not attributed to Dürer in any catalogue except that of Passavant (No. 211). Heller says plainly "it is certainly by Dürer, although Bartsch doubts it". Here again Röttinger sees the work of Peter Vischer the Elder (Doppelgänger, p. 6). 217

304.—306. ILLUSTRATION OF FREYDAL. Of all the Emperors great enterprises, Freydal, the history of his tournaments and masquerades, made the least progress. Here also Dürer was obliged to take miniatures as materials to work from 256 numbers (of these 225 in the Kunsth. Mus. Vienna). Only five of the prints were executed as woodcuts (Pass. 288—292) and the cutting is pretty rough. Leitner (Vienna 1880—82) describes the tournaments and masquerades. Dodgson (Rep. XXV, 1902, p. 447) makes it probable that the date was 1516. A sixth woodcut (B. app. 37) is attributed by Dodgson to Cranach.
304. The German Tournament (Das Anzogen-Rennen). Maximilian (Freydal) has lifted his opponent Nicolas von Firmian out of the saddle; the latter falls headlong from his horse. B. app. 36. P. 289. H. 2098. R.-A. 49. D. 132. / 305. The Foreign Tournament (Das welsche Turnier). Maximilian (Freydal), behind the barrier, has lifted his opponent out of the saddle; the latter falls from his horse; Maximilian's own spear is broken. B. app. 37. H. 2099. Pass. 290. D. 133 (who calls this the best woodcut of the series). / 306. The Masquerade. B. app. 38. H. 2101. P. 292. R. A. 51. D. 135. Three women and three men in a round dance; outside the circle of dancers are the masks; the mask with hat and chain is Freydal. On the balcony is Mary of Burgundy with court ladies and the fool. In this Dürer gives a very free rendering of the subject (No. 88 of the book of miniatures). An impression at Hamburg bears the signature "Jeronimus Formschneider" (Hieronymus Andreae is meant). 218-220

307. THE VIRGIN CROWNED BY TWO ANGELS. B. 101. H. 1811. R. 229. D. 139. Date 1518. 221

308. SAINT SEBALD IN THE NICHE. B. app. 21. H. 2024. P. III. 180, 183. D. S. 358, 24. Thausing considered this to be one of Dürer's best works. Although this opinion is somewhat exaggerated, we agree with Passavant who sees here a genuine Dürer, at all events this is certain with regard to the figure. The 222

PAGE		
	ornament seems rather poor to be by Dürer and was probably the work of Springinklee. Dodgson was formerly inclined to attribute the print to Springinklee, but now gives it to Dürer; whereas Röttinger (Doppelgänger, p. 14) assigns it Peter Vischer the Elder. Later impressions have Dürer's monogram added.	
223-225	THE SMALL TRIUMPHAL CAR OR THE BURGUNDIAN MARRIAGE. B. VII. 229. R. 218. D. 136.	309.–311.

223-225 THE SMALL TRIUMPHAL CAR OR THE BURGUNDIAN MARRIAGE. B. VII. 229. R. 218. D. 136. 309.–311.
From the triumphal procession of Kaiser Maximilian. The question as to which of the 137 woodcuts may be attributed to Dürer, is to-day answered by pointing to these two numbers. (The greater part of the work was by Burgkmair, together with Beck, Schäufelein and Dürer; cf. Schlestag, Vienna Jhrb. 1883, p. 80). In subject matter the triumphal procession is related to the Triumphal Arch, through which the Emperor with his family on the car was to pass. Originals in miniature by Kölderer here again served as guide. Impression of the Burgundian Marriage are to be found only in the first edition of the Triumphal Procession of 1526. About 1518. Röttinger (Doppelgänger, p. 58) believes that Peter Vischer the Elder had at least a decisive share in the execution of the car itself.
309. The first block: Maximilian as Duke and Mary of Burgundy holding the Burgundian coat of arms. Reduced. The block was lost in the eighteenth century. There is a splendid proof impression in the Kupferstichkabinett at Berlin, which shows the wood of the empty spaces still uncut. / 310. Part of the above print in original size. / 311. Victory guiding the triumphal car. The block (Nationalbibliothek Vienna) has on the back the inscription: Jeronimus Andre Form...

226-231 THE GREAT TRIUMPHAL CAR. Originally meant to be part of the Triumphal Procession and no doubt 312.–317.
planned in 1512 at the same time as this and the Triumphal Arch. Earlier designs (Albertina, Vienna, L. 528) about 1514/15 show riders on the horses and the imperial family beside Maximilian. A second study, without family and riders (Albertina, Vienna, L. 555—558) was then chosen. The literary designs were produced by Dürer's friend W. Pirckheimer. The work was carried out in the year 1518 and somewhat later. It appeared after the death of the Emperor, in 1522. (Röttinger, "Doppelgänger", p. 57, attributes to Peter Vischer the Elder, Dürer's "double", the transference of the drawing to the block). At the end is the text: "Diser wagen ist zu Nürnberg erfundē und gedruckt durch Albrechten Thürer, im jar M. D. XXII. Cum Gratia et Privilegio Caesaree Maiestatis". This proves that the Emperor was not the owner of the blocks and that Dürer published them on his own initiative.
The whole consists of eight blocks, of which six have German text printed in columns above the horses, giving a short history of the car as well as explanations of the twenty-two virtues.
On the differences in the five editions see Hausmann, p. 84—86, and Dodgson 338.
312. First sheet: Back part of the imperial car. Victory decorating the Emperor with a laurel wreath. On the feathers of her wings his victories are written. Behind him stand two of the cardinal virtues: Justice and Temperance. In the British Museum is a trial proof, cf. Dodgson, p. 339. / 313. Part of the first sheet in original size. / 314. Second sheet: Front part of the imperial car. The car is guided by Reason. The other two cardinal virtues, Fortitude and Prudence, are standing on two pedestals. / 315. Third sheet: Moderation and Foresight lead the horses. / 316. Seventh sheet: Courage and Magnanimity lead the horses / 317. Eighth sheet: Skill and Experience lead the horses at the front of the car.

232 PORTRAIT OF THE EMPEROR MAXIMILIAN. B. 154. H. 1950. R. 231. D. 140. Dürer made a sketch 318.
from life of the Emperor on June 28th, 1518, at Augsburg. The drawing, which is in the Albertina, Vienna, was the original for the woodcut. (Geisberg, Portrait Maximilians, Preuss. Jhrb. XXXII, p. 236 ff). In the first rare edition the letters "a e" in the word Caesar are separate and enclosed in the C. In a second edition, in which the portrait was transferred on to another block (copy), a and e are separated from C and on later prints is Dürer's monogram; a third edition, a later block (copy), has ae joined together in Caesar; a fourth edition, a later block (copy) with ornamental framework by Hans Weiditz and with Dürer's monogram (a first state without monogram is at Bremen); cf. Dodgson, Cat. 334—336.

The last works of 1520—1528

		PAGE
319.	COAT OF ARMS OF ROGGENDORFF. R. 239. D. p. 336. Reduced. Only one example of this is known and is in the Germ. Museum at Nuremberg, and of this the right hand corner is missing and the upper border is broken. The lithograph copy by Retberg is completed (by Fr. Wolf, Munich) in the second impression. The date 1520 is ascertained by a memorandum in the Diary of the journey to the Netherlands, in which Dürer notes on Sept. 3rd, 1520, that "he ate with two gentlemen von Roggendorff, and I drew him a coat of arms on wood so that it might be cut" (Lange-Fuhse, p. 126—128).	233

320. COAT OF ARMS OF LORENZ STAIBER. B. 167 and 168. R. 240. D. S. 336. The print exists in three fairly similar blocks. From the best block there is only one impression in the Hausmann Collection; now belonging to Frau Dr. Blasius, Brunswick. A block of 1520 is mentioned in the Diary of the journey to the Netherlands (Cologne, Nov. 1520): "ich hab dem Staiber ein Wappen auf Holz gerissen" (I drew a coat of arms for Staiber on wood); a second block, 1521, is mentioned under Antwerp: "des Staibers und noch ein anderes Wappen gemacht" (made Staiber's and another coat of arms). There are two small pen drawings in the London manuscripts, but these are only loosely connected with the wood block (cf. Graph. Kste. 1903, p. 57) Regarding the blocks see Dodgson, Dürer Soc. 1911.
The three states according to Retberg are, 1st: above on left, collar of the order (and other signs), 2nd: collar of the order round an escutcheon (illd. by Scherer, p. 317), 3rd: two flags on the right and left of the lion crest on the helmet (B. 168. R. 240,3). — 234

321. COAT OF ARMS WITH THE THREE LIONS' HEADS. (For Jacob Bannissis). B. 169. H. 1947. About 1520. The block is in the Nationalbibliothek, Vienna. Reprinted in 1781. (With regard to the connection with Bannissis, cf. Kalkhof Rep. XX, p. 462, note). — 235

322. COAT OF ARMS OF JOHANN STABIUS. B. 166. H. 1945. Repetition with slight variations of B. 165. The block is in the Nationalbibliothek, Vienna. Reprinted in 1781 (cf. Graph. Kste. 1903, p. 57). — 236

323. COAT OF ARMS OF JOHANN TSCHERTE. B. 170. H. 1948 (who calls it: coat of arms with the wild man and two dogs), R. 244. D. 143. J. Wussin (in Naumann's Archiv X, 369) identified the arms. Retberg suggested the date 1521, but Dodgson is inclined to correct this to 1518 (cf. Cat. p. 337). Johann Tscherte, a friend of Pirckheimer and of Dürer, made his home at Nuremberg in 1510 and became architect to the imperial court. (In the Bohemian language Tscherte means devil or wild man). — 237

324. COAT OF ARMS OF DON PEDRO LASSO. H. 2125. P. 216. R. A. 71. D., p. 364. Dodgson also admits the possibility that the drawing is by Dürer. The unique original was formerly in the Cornill d'Orville collection (sale catalogue 1900, No. 381). — 238

325. COAT OF ARMS OF THE EMPIRE AND OF THE CITY OF NUREMBERG. B. 162. H. 1942. R. A. 20. D. 144. First issued in the book "Die Reformation der Stadt Nürnberg", printed 21st January 1521 by Peypus in Nürnberg. For later impressions cf. Heller and Dodgson. Without monogram. Retberg does not agree with Bartsch, Heller and Passavant. Although Dodgson points out the mannerisms of the allegorical figures and the unusual background, he is all the same not inclined to see the work of a pupil. Röttinger again attributes the print to Peter Vischer the Elder (Doppelgänger, p. 62), as Dürer was not — 239

PAGE		
	in Nuremberg at the time when the book appeared, which, however, would not be a reason why a wood block should not have been used which had been ready before Dürer's departure.	
240	PORTRAIT OF ULRICH VARNBÜHLER. B. 155. H. 1952. R. 248. D. 146. (Somewhat reduced.) The prints from tone blocks — Heller mentions three different colours in the prints in Ploos van Amstel's cabinet — were executed by Willem Janssens (about 1620) at Amsterdam. In this work Dürer has created a valuable memorial of his friend, who was also a student friend of Pirckheimer, and who became Chancellor of the chief court of justice under Maximilian. The dedication tablet which bears the words "ut quem amet unice" is proof of Dürer's friendship for Varnbühler. The drawing is in the Albertina, Vienna, L. 578.	326.
241	DÜRER'S COAT OF ARMS. B. 160. H. 1938. R. 249. D. 147. With monogram and the date 1523. There is a sketch in the British Museum. L. 264.	327.
242	THE LAST SUPPER. B. 53. H. 1622. R. 250. D. 148. With monogram and the date 1523. Drawings of the years 1521—1523 at Berlin, Florence, and Frankfurt go to show that Dürer was intending to make new illustrations to the Passion in oblong form. The drawing of the Last Supper in the Albertina, Vienna, L. 579, represents Christ sitting sideways.	328.
243	CHRIST ON THE CROSS WITH THREE ANGELS. B. 58. H. 1643. R. A. 9. D. S. 352,8. The first state, the lower part absent, is rare (Berlin, Bremen, Gotha, Stuttgart, Vienna). The second state has the lower angel added in a rough style. The block with the addition from the Derschau Collection is at Berlin. New prints in 1805 and 1920 (Seemann, Leipzig). Two editions are known from the enlarged block, with prayers in 32 and 24 lines, as indulgences. The big, but somewhat empty design, and particularly the type of the angels which often occurs in the heads of the proportion studies, are characteristics which indicate the years 1523—1525. Röttinger, who gives the print to Peter Vischer the Elder (Doppelgänger, p. 54) compares it in style with the Holy Trinity of the year 1511.	329.
244	PART OF NO. 329 IN ORIGINAL SIZE.	330.
245-246	THE TAPESTRY OF MICHELFELD. B. app. 34. H 2059. R. A. 47. D. 149. The inscription says that the figures and the rhymes have been copied from an old tapestry, woven about one hundred years earlier and found in the Castle of Michelfeld on the Rhine, in order to show what men of olden times thought about certain vices which are still prevalent at this day. It is clear that Dürer, by copying this representation in which Fraud rules and the mouth of Truth is closed, intended to show up the bad social conditions of his times. Bartsch and Heller were not convinced as to Dürer's authorship; Passavant and Retberg believe the print to be by Beham, which, however, has been refuted by Pauli (Krit. Verz. d. Kupferst., 1901, No. 1426). The group of professions on the first page is peculiarly Düreresque. At all events there is no doubt that a drawing by Dürer served as original (cf. Dogson). Röttinger (Doppelgänger, p. 18) includes the woodcut among his attributions of Peter Vischer the Elder. The woodcut is printed from three blocks, and in three separate parts. 331. Left-hand side of the Tapestry of Michelfeld. Time and a fox (Cunning) turn the wheel of fortune. The ignoble birds (magpie is king, the jay, and pheasant) rule the roost, the noble birds (Eagle, peacock, and falcon) are overcome. Knights, high officials, citizens, smith, and peasant are allured by fraud on the throne (cf. ill. 331). / 332. Centre part of the Tapestry of Michelfeld. Fraud is seated on the throne, at his feet bound in a cradle is Piety; Justice, Truth, and Reason have been put on the rack. (The third cut on the right shows a scholar and an ecclesiastic who are approaching Fraud.)	331.—332.

	PAGE

333. THE ARMILLARY SPHERE. P. 202. R. 257. D.-S. 342. The globe surrounded by seven circles and twelve wind-gods. From a Latin translation of Ptolemy by W. Pirckheimer, published in 1525 by Grüninger at Strassburg and by Koberger. Dürer's authorship is proved by two letters of the mathematician and architect of Karl V, Johann Tscherte (cf. ill. 322), who plainly mentions Dürer's name as the designer of the Armillary Sphere (cf. Passavant III, p. 190). — 247

334.–340. Illustrations to DÜRER'S WORK ABOUT THE ART OF MEASUREMENT. Title of the first edition: "Underweysung der messung, Nürnberg 1525". The second published after Dürer's death in 1538 by Hieronymus (Andreae) Formschneider, says that also the 22 illustrations which have been added to the first edition were drawn by his own hand. This second edition also includes B. 148 and B. 149 (regarding Dürer as mathematician cf. H. Staigmüller in Progr. d. Realgymn. Stuttgart, 1891). — 248-251
334. From the third book (continuation about columns): Victory Column for a battle-field, which might be erected "from the booty which had been taken". The four corners of the base were to bear powder barrels. The shaft of the column out of a mortar battery and a large cannon. The capital is composed of four breastplates and plumed helmets. There is a pen drawing with the plan at Bamberg (L. 186). / 335. From the third book: Monumental column for a drunkard. "Item welicher einem Trunkenbolds auf sein Begräbnuss ein Gedächtnuss wollt aufrichten, der möcht sich einer solichen nachfolgeten aufgerissenen Meinung gebrauchen." The grave has the date 1525, then there is a beer cask, draught board, two dishes placed one on top of the other, "darin wird fresserei sein" (in which will be food), then a "weit niederträchtigen Bierkrug" (a wide-mouthed common beer mug), then an inverted beer glass and basket of victuals. / 336. Column of Victory for the subjugation of the peasants. (Dürer's book appeared in the year of the peasants' war). On the platform are cows tied up, and sheep and pigs; then four baskets of victuals at the corners of the plinth. (Dürer's irony finds expression in his enumeration of the cheeses, eggs, butter, onions and herbs with which the baskets may be filled "according to will"). Then a bin for oats, a caldron tilted over, cheese dish, butter barrel, milk jug, four wooden forks, sheaves, a hen-coop and a miserable peasant who is pierced through with a sword. On account of the size Dürer was not able to reproduce the plinth and shaft of the monument together in the book, but in the illustrations before us it has at least been possible to show them perpendicularly one below the other. The corner baskets of the plinth did away with the possibility of their being inserted one into the other. / 337. From the fourth book: an artist drawing a seated man on to a pane of glass through a sight-vane. "Solchs ist gut allen denen, die jemand wollen abconterfeien und die ihrer Sache nicht gewis sind" (such is good for all those who wish to make a portrait, but who cannot trust their skill). There is a sketch of the table with the pane in the Dresden Library. (Ill. D. Soc. 1911, I., XVI). / 338. From the fourth book. B. 147. H. 1919. R. 259. A man drawing a lute. / 339. A man drawing a can. B. 148. H. 1921. R. 261. Appeared first in the edition of 1538; but, as is said in the title of the book, it was drawn by Dürer "als er noch auf erden war" (during his life-time). There is a drawing in the Dresden Library. / 340. A man drawing a recumbent woman, in foreshortening through a frame with a network of squares on to a paper also with squares, in order to be able to reduce or enlarge proportionally. Also appeared first in the edition of 1538. B. 149. H. 1922. R. 262.

341. THE MADONNA ON A GRASSY BANK (or the Holy Family). B. 98. H. 1804. R. 263. Heidrich (Gesch. d. Marienbildes, p. 156) does not consider this print, which is of poor workmanship, to be genuine, only in the figure of St. Joseph he finds similarity to the Apostles at Munich. It certainly cannot be claimed as a masterpiece of Dürer's, and the badly carried out proportions cannot be ignored; but conception and design plainly show Dürer's mind and hand. — 252

342. PORTRAIT OF EOBANUS HESSE. H. 2172. P. 218. R. 267. D. S. 245. 1. Without monogram or date. Below the portrait is a stanza of four lines and on the back of the print "In imaginem Eobani Hessi sui — 352

PAGE

ab Alberto Durero huius aetatis Apelle graphice expressam" (by Johannes Alexander Brassicanus). Reproduction of the text in facsimile by Ephrussi (D. et s. Dessins 1882, 334 ff.). Hesse was the author of Dürer's funeral oration. The woodcut is a repetition, reversed, of the drawing in the British Museum, but in fineness of detail does not come anywhere near the latter. The drawing is dated 1526. Dodgson has rightly included the woodcut in a group of woodcuts made from drawings. After Dodgson, Dörnhöffer (Kst. Anz. 1905, p. 50) also pointed out that the woodcut was executed after a drawing. In the woodcut the hands are added, also the wall in the background. Incorrectly described as a single leaf, whereas it belongs to a rare book of the poems of Eobanus Hesse, which appeared in 1526 and 1527 (cf. Dodgson, also with regard to copies and later editions).

252-254 FROM DÜRER'S WORK ABOUT FORTIFICATION. Title: Etliche underricht zu befestigung der Stett, 342.–344.
Schloss und flecken. Nuremberg, Oct. 1527.

253 COAT OF ARMS OF FERDINAND I., King of Hungary and Bohemia. H. 2119. P. 210. R. 268. D. 155. 343.
On the back is Dürer's dedication to King Ferdinand. The large shield repeats the Bohemian (1 and 4) and the Hungarian (2 and 3) coats of arms, the smaller shield the coats of arms of: Austria, Burgundy, Brabant, Spain. The small escutcheon shows the Tyrolese eagle and the Flemish lion. The print is made from three blocks: 1. Shield and crown, 2. Chain, 3. the fleece itself together with the inscription.

254-255 THE SIEGE OF A FORTRESS. B. 127. H. 1903. R. 269. D. 156. Printed from two blocks. Dodgson was 344.–345.
the first to recognise the print as an illustration to the work on fortification (cf. Waetzold, D. S. Befestigungslehre 1916).

256 FROM DÜRER'S WORK ABOUT THE PRINCIPLES OF PROPORTION. Title: "Hierin sind begriffen 346.
vier bücher von menschlicher Proportion durch Albrechten Dürer zu Nuremberg erfunden und beschriben zu nutz allen denen, so zu dieser Kunst lieb tragen. M. D. XXVIII. Nuremberg bey Jeronymus Formschneider auff verlegung Albrecht Dürers verlassen witib" (here are four books about the proportions of the human body, described by Albrecht Dürer of Nuremberg for the use of all who are interested in this art. 1528, in Nuremberg by Hieronymus Formschneider as representing Albrecht Dürer's widow). 31st October 1528. Therefore it was published by Dürer's widow after his death. With regard to Dürer's writings on the theories of art cf. the works of Erw. Panofsky (Dürer's Kunsttheorie, 1915), and H. Kauffmann (Albrecht Dürer's Rhythmische Kunst 1924).

1

2

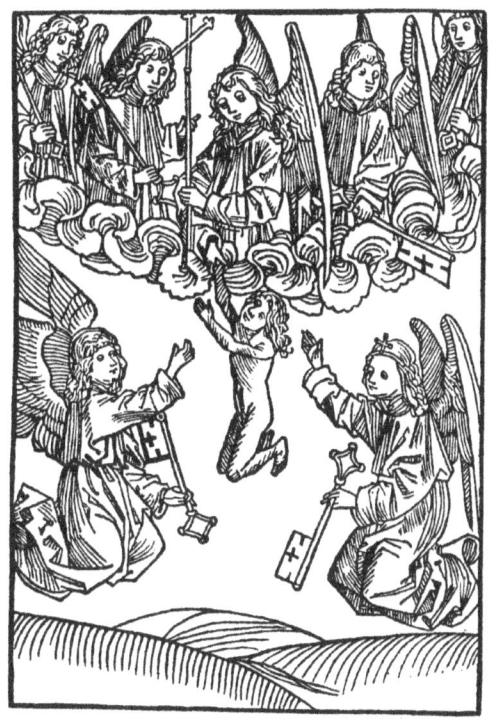

5

3

{ PAGE 43 }

6

7

8

9

10

11

12

13

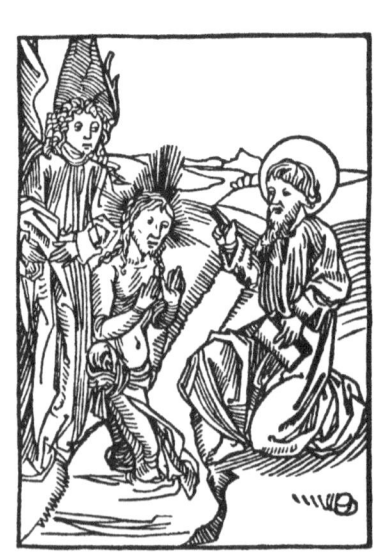
14

{ PAGE 44 }

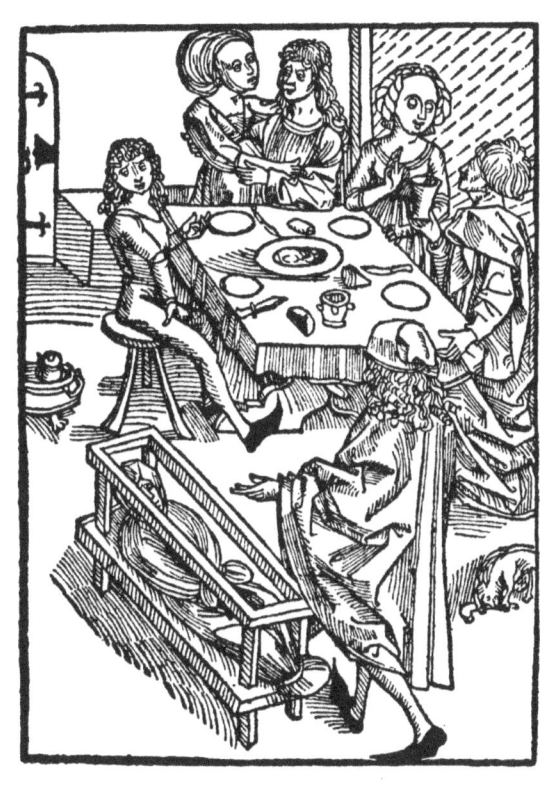

15

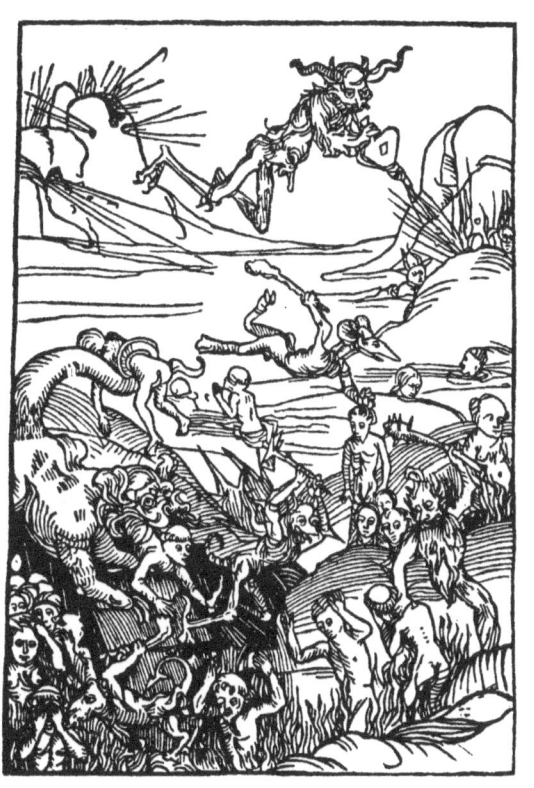

16

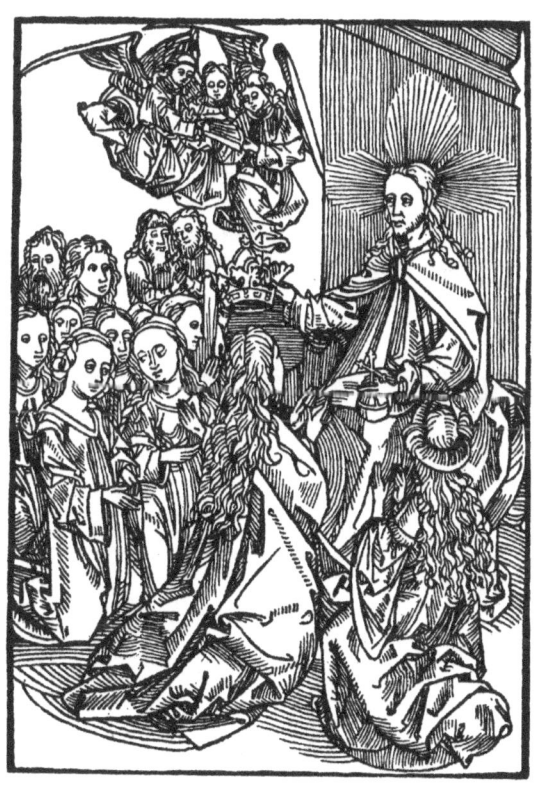

17

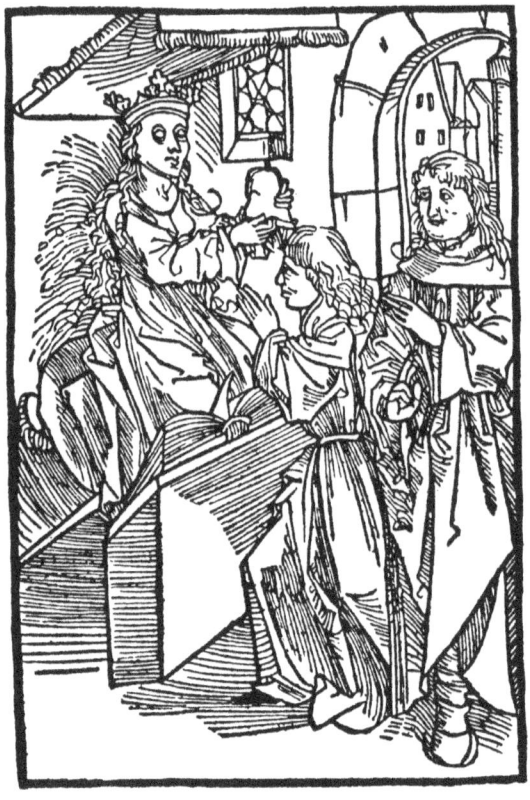

18

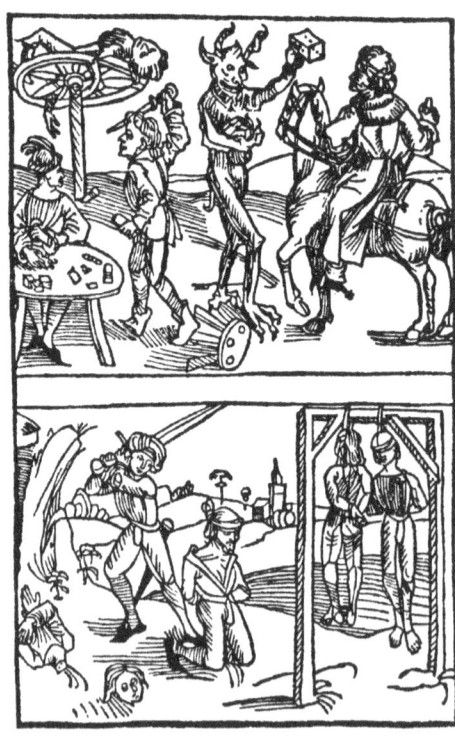

19

20

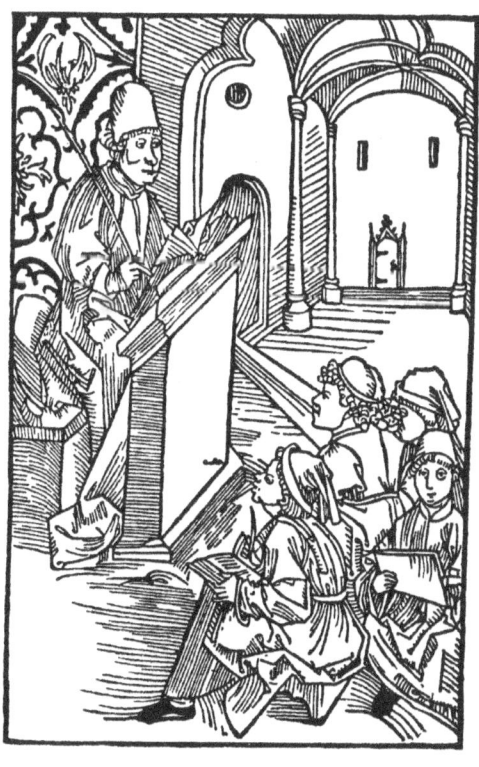

21

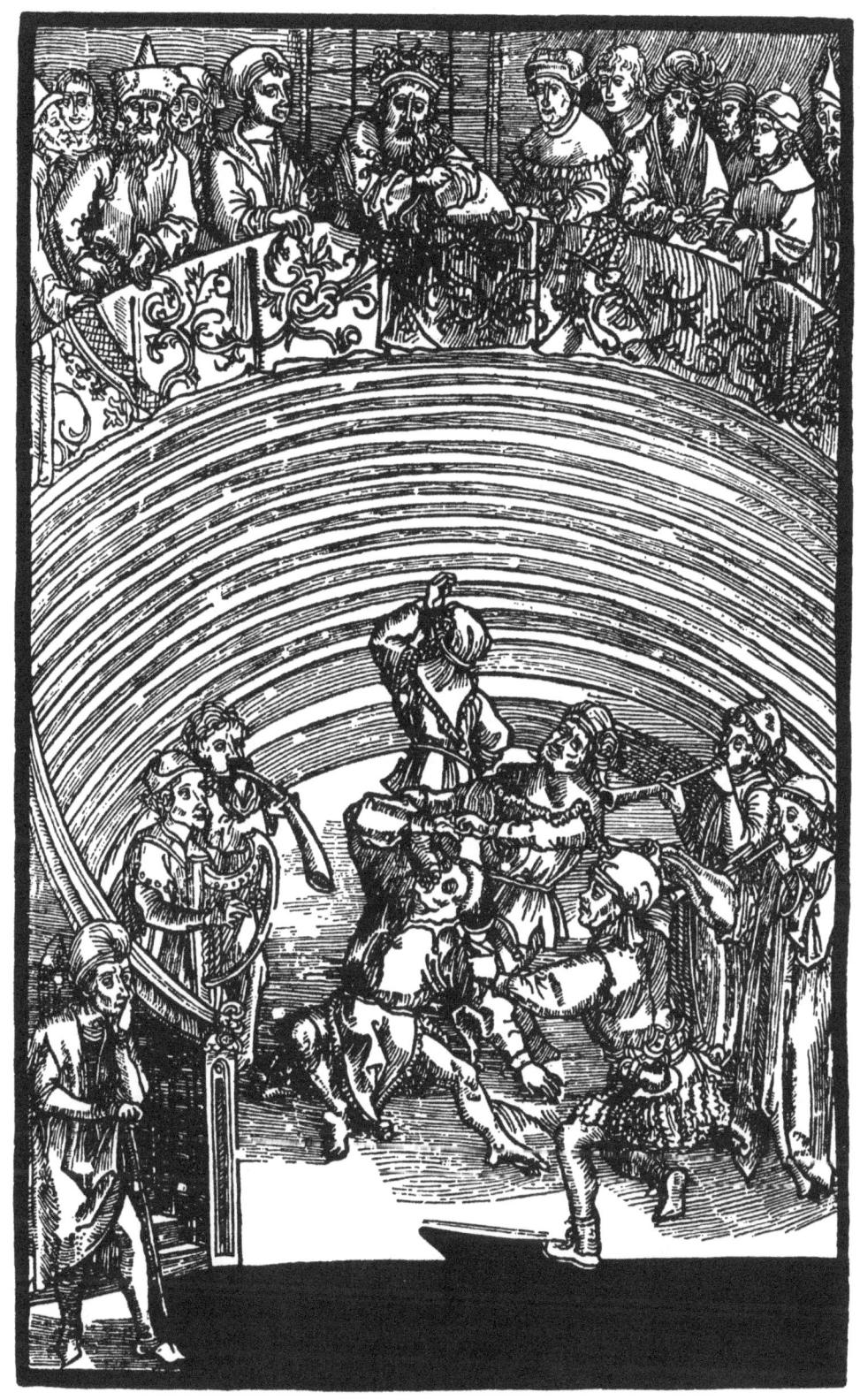

24

25

26

27

28

29

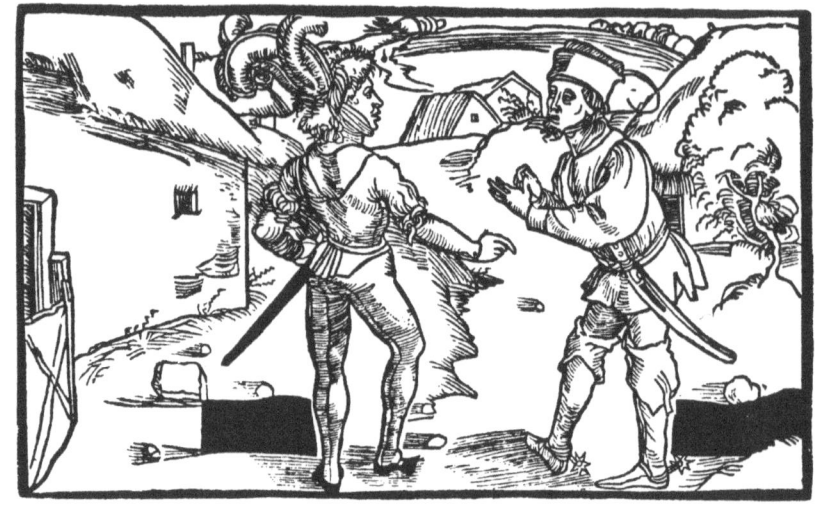

30

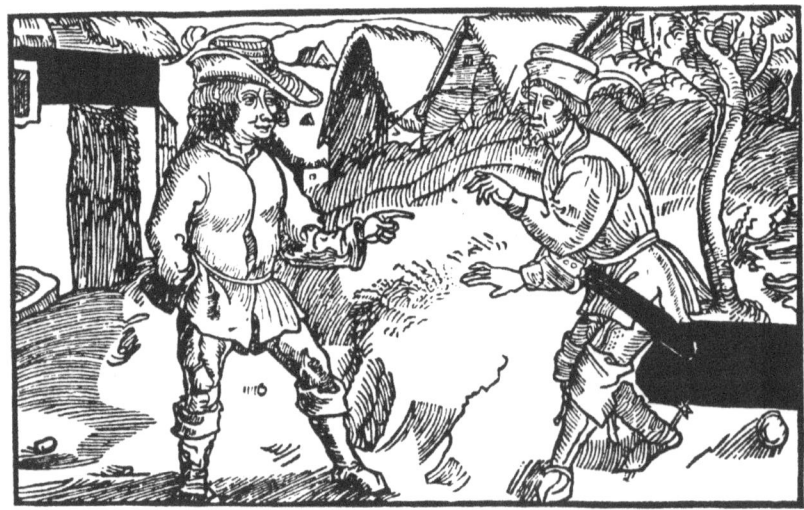

31

32

33

34

35

36

37

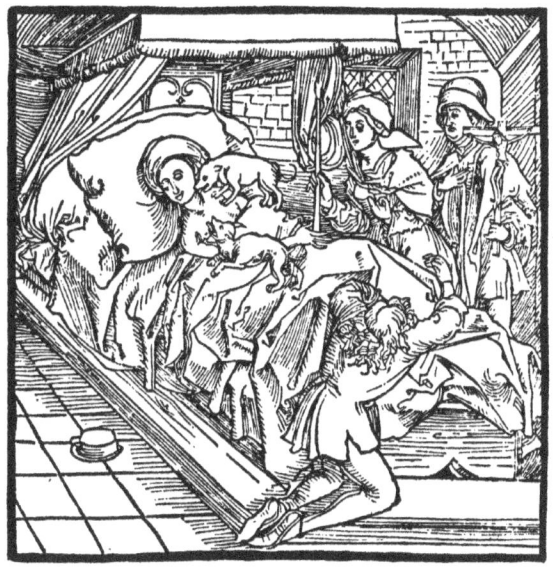

38

39

40

{ PAGE 55 }

41

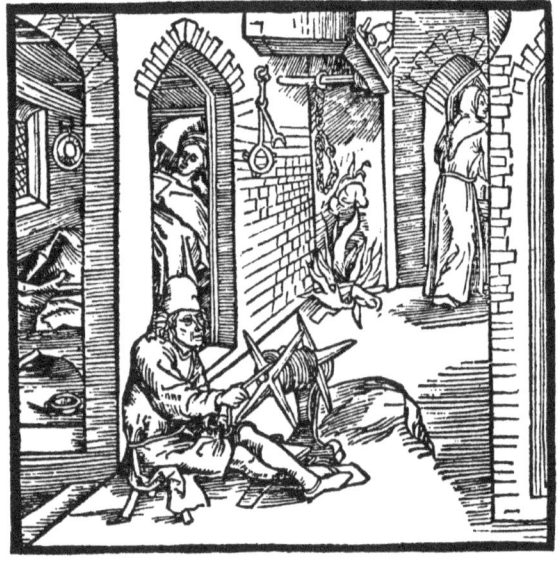

42

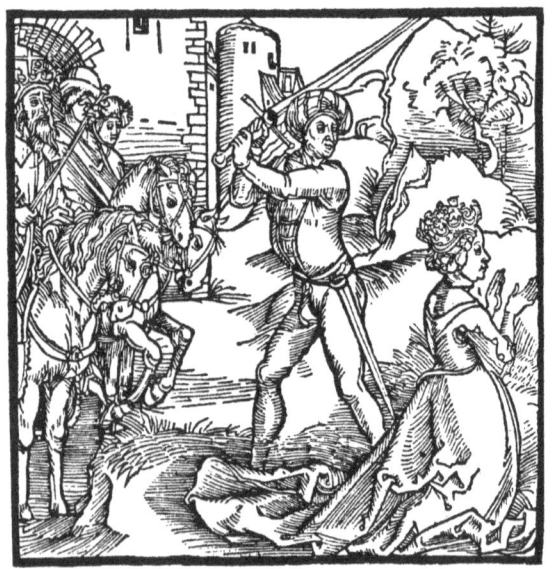

43

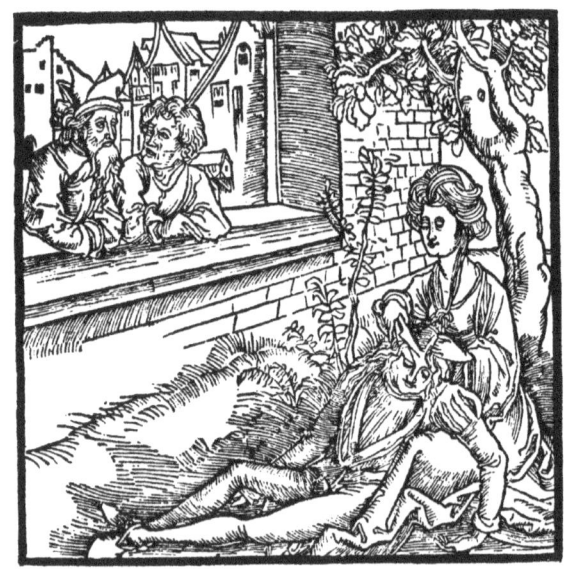

44

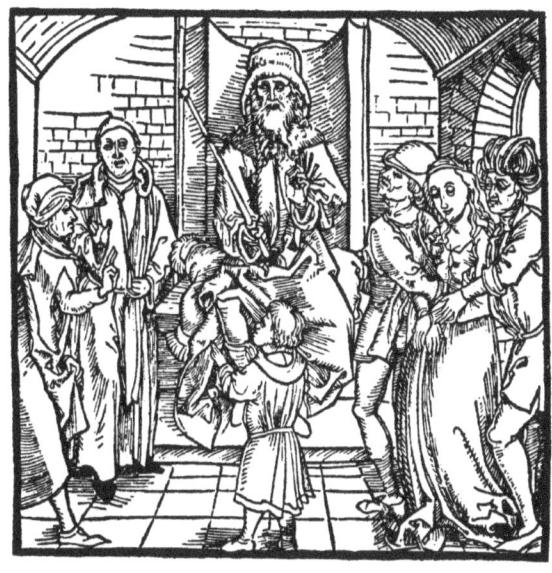

45

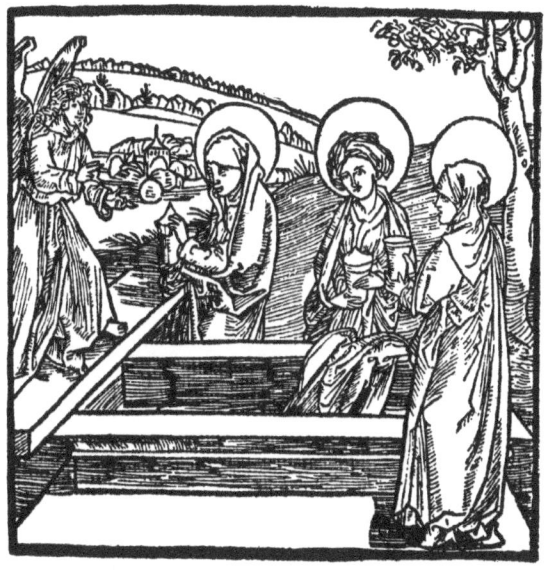

46

47

48

49

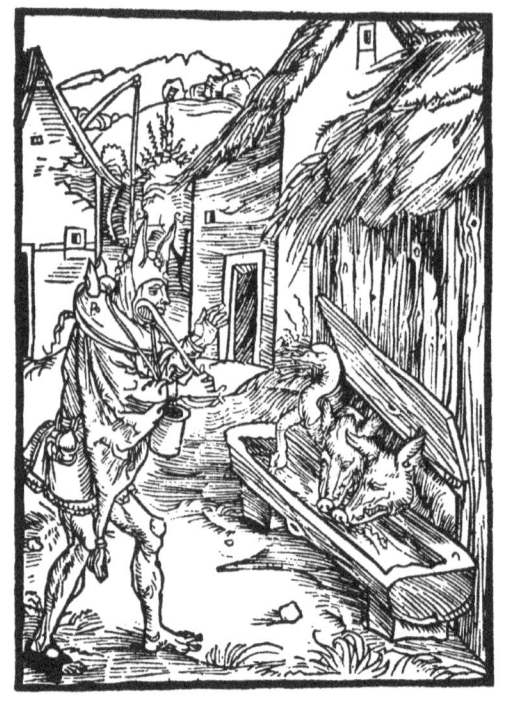

50

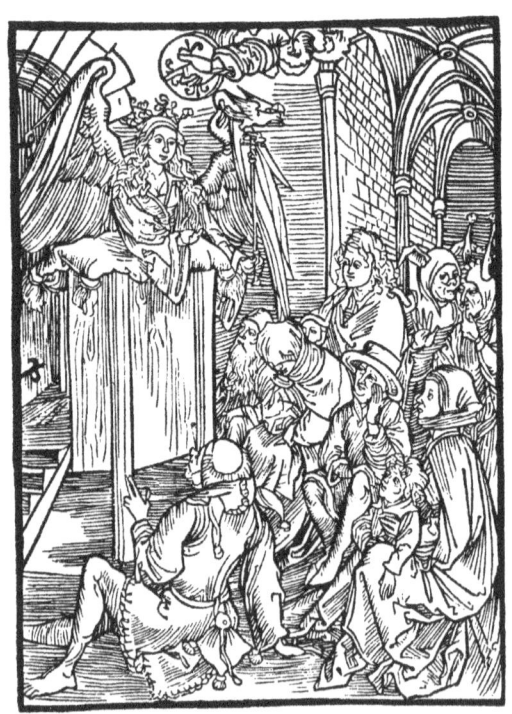

51

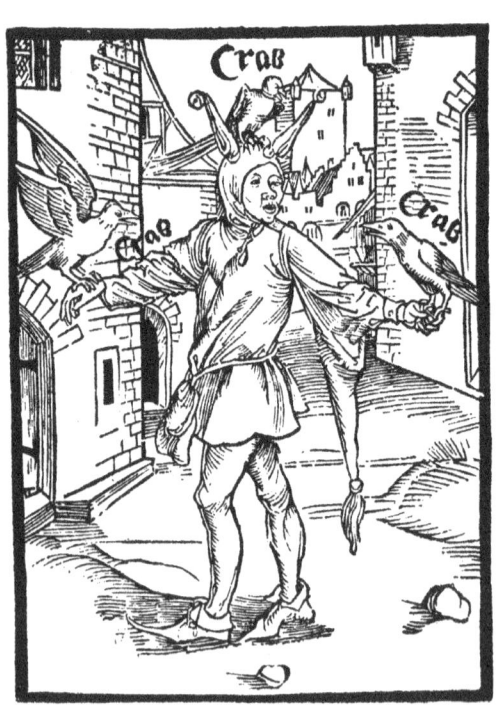

52

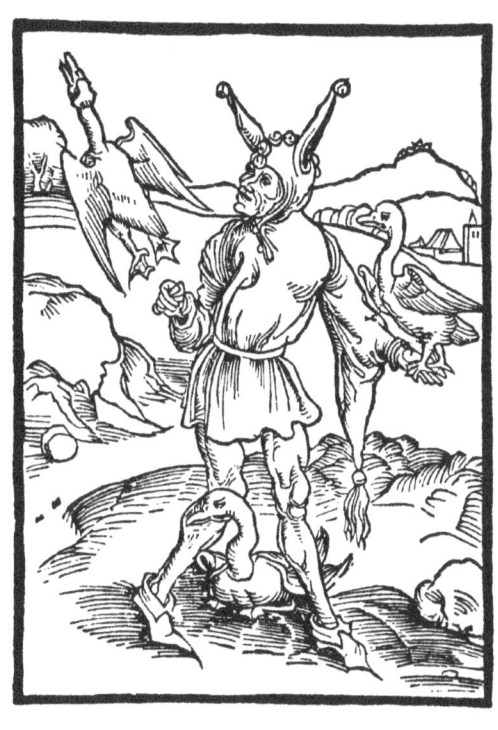

53

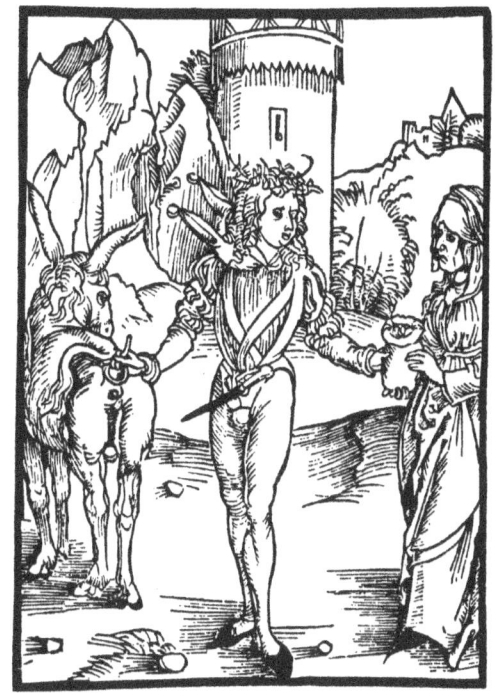

54

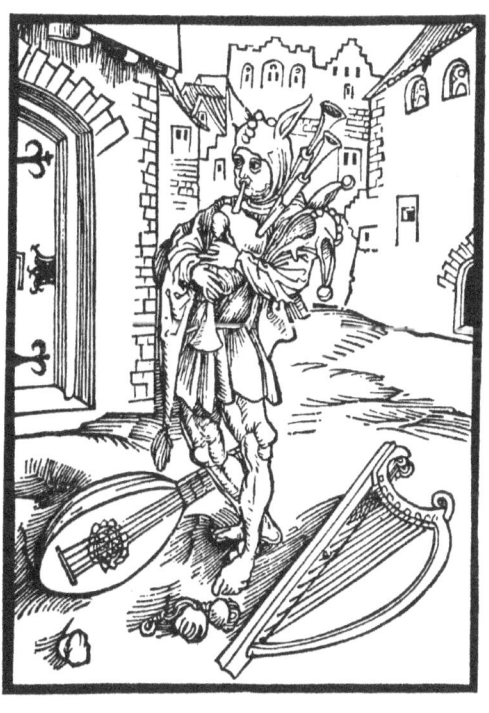

55

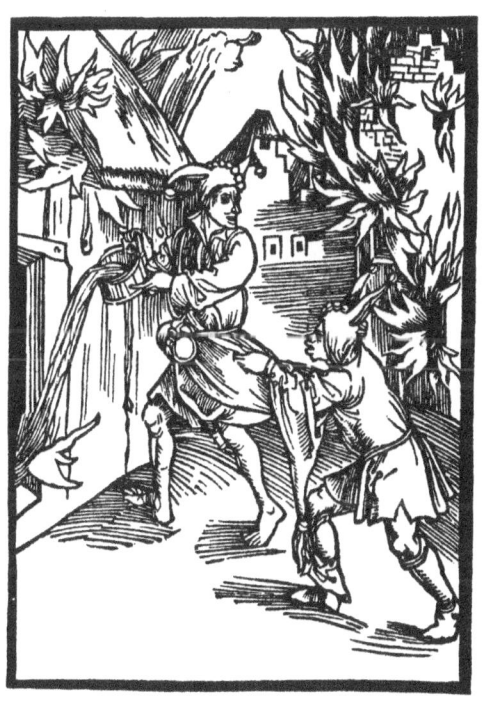

56

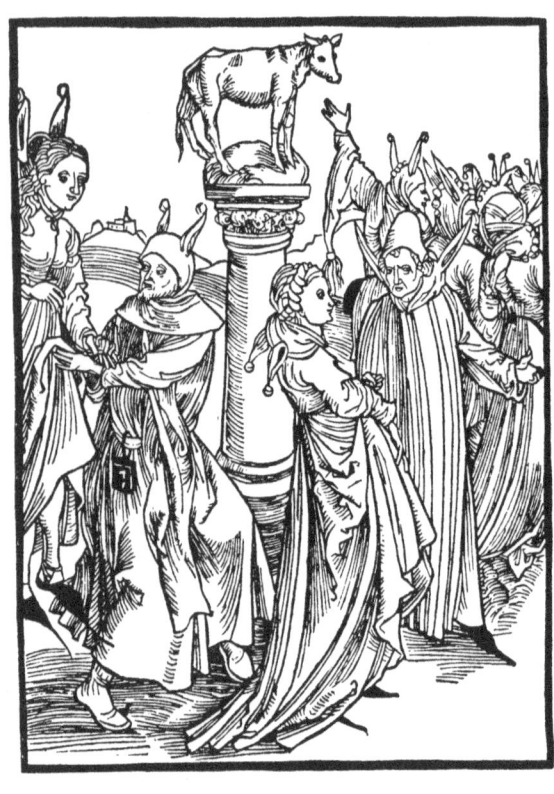

57

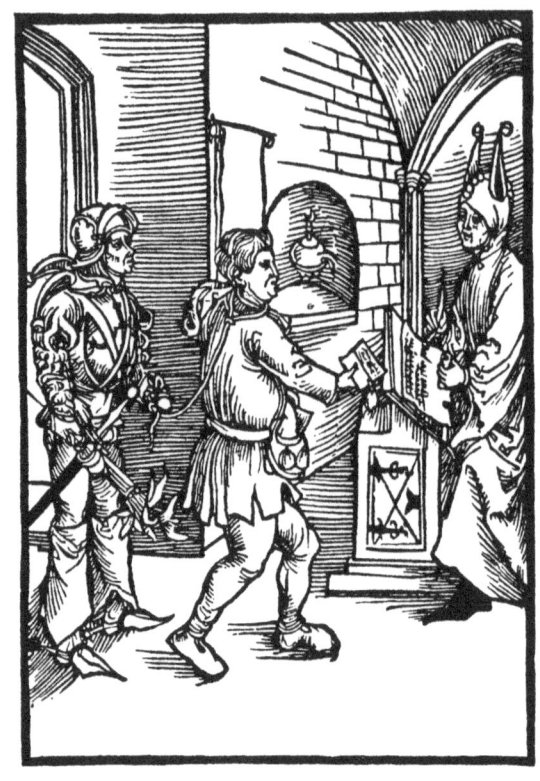

58

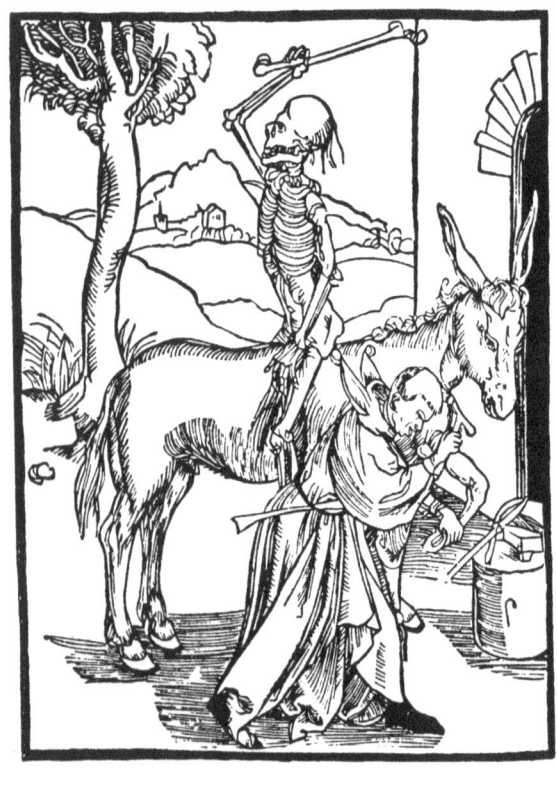

59

60

{ PAGE 60 }

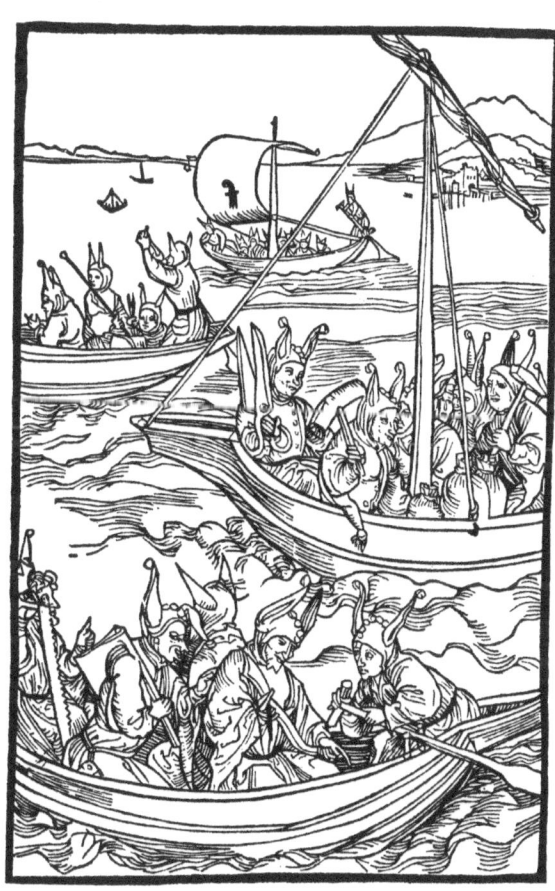

{ PAGE 61 }

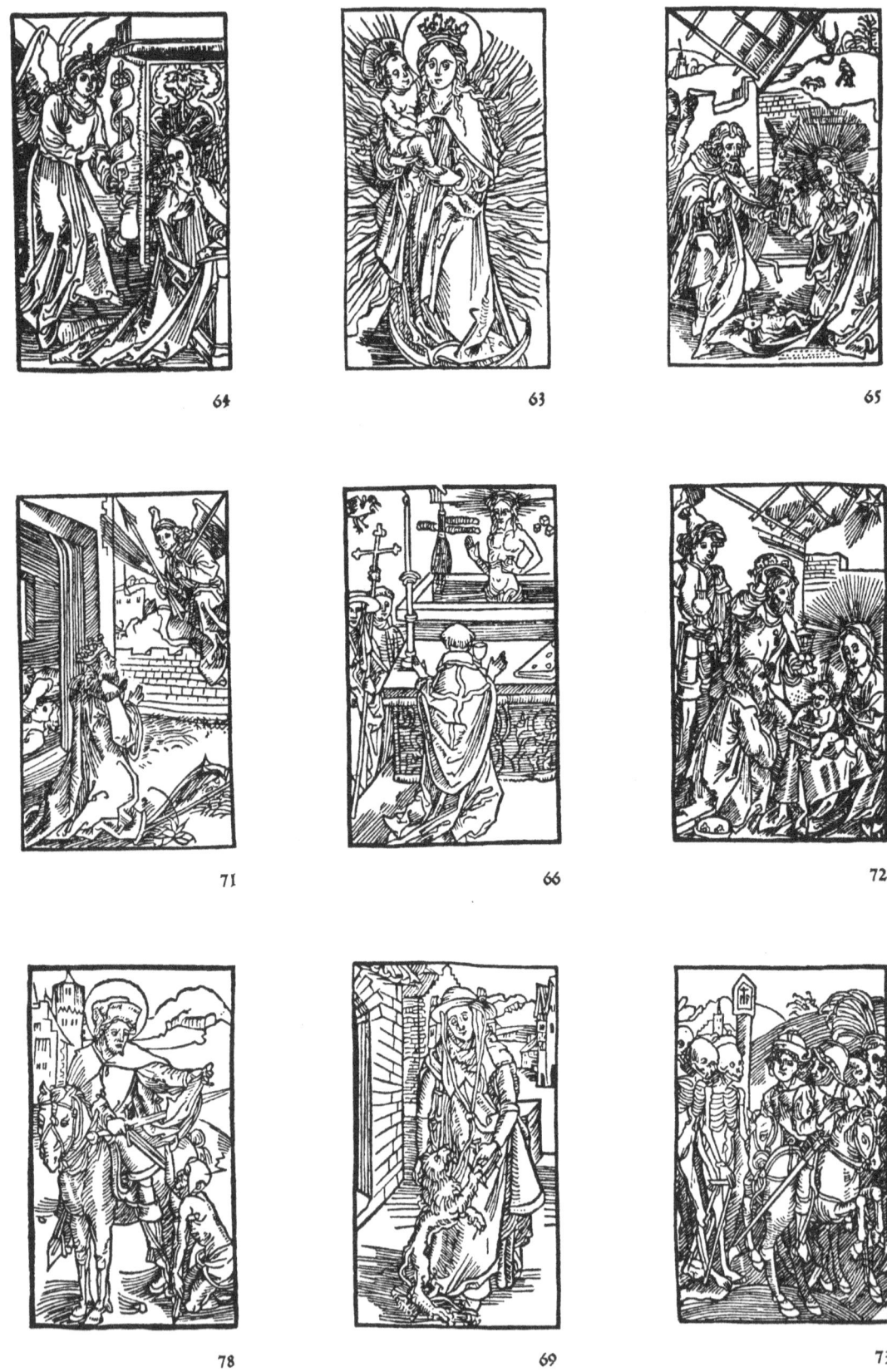

70 74 75

76 80 77

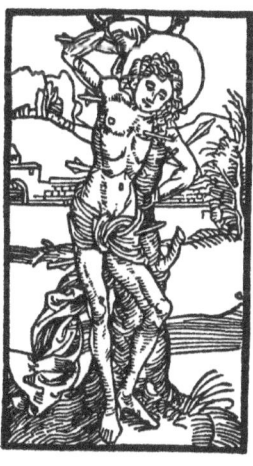 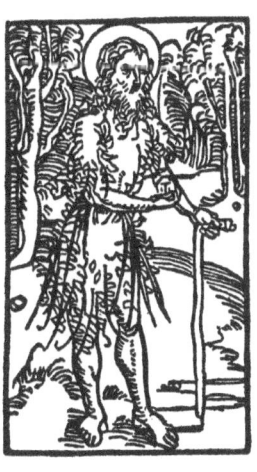

67 68 79

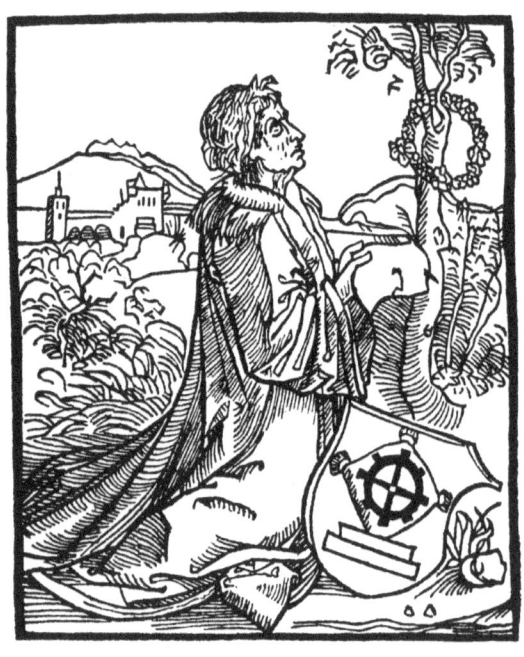

81

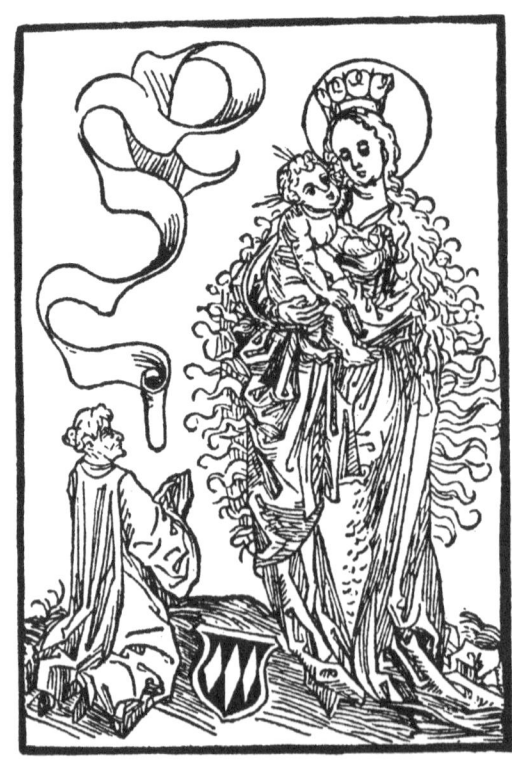

82

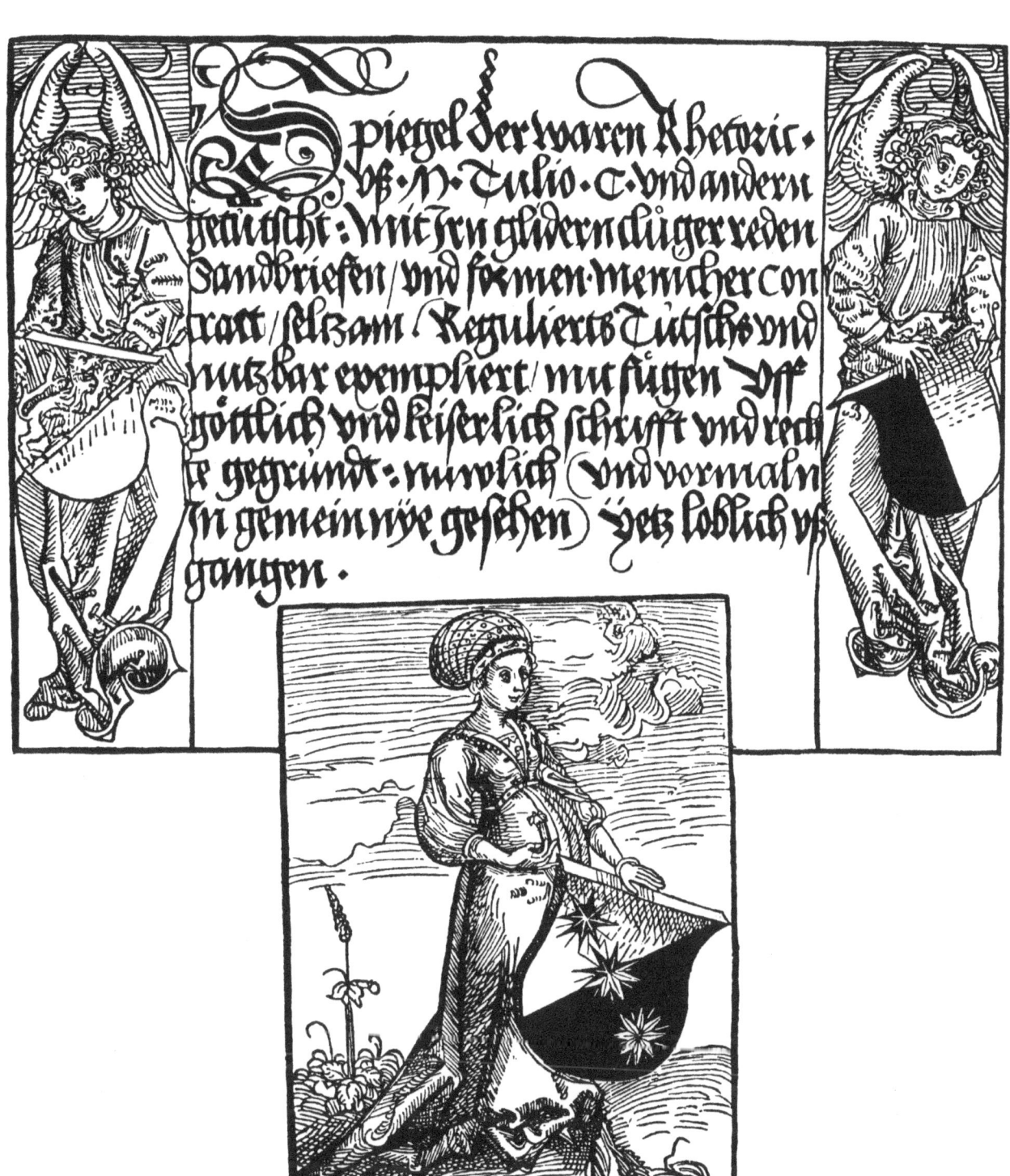

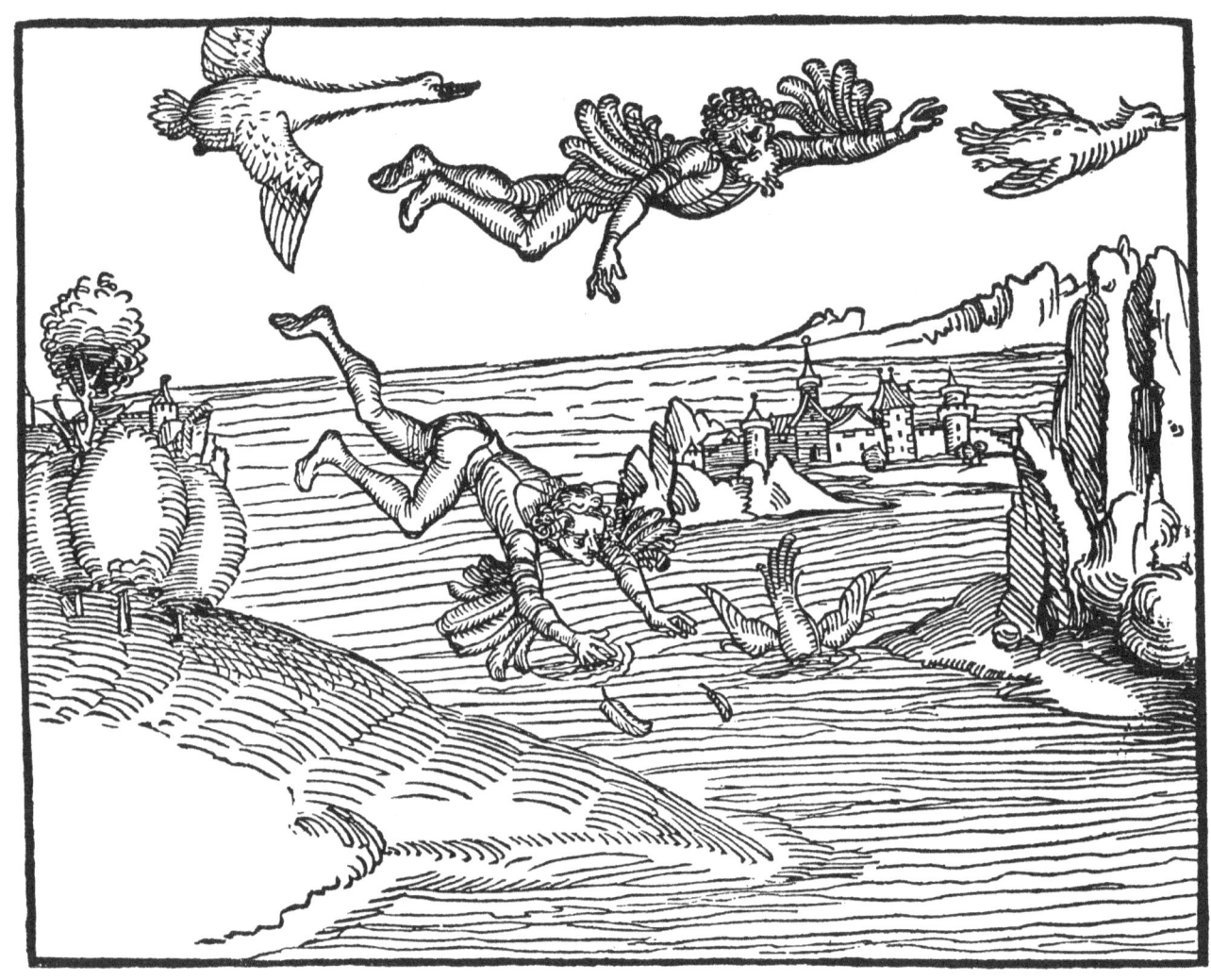

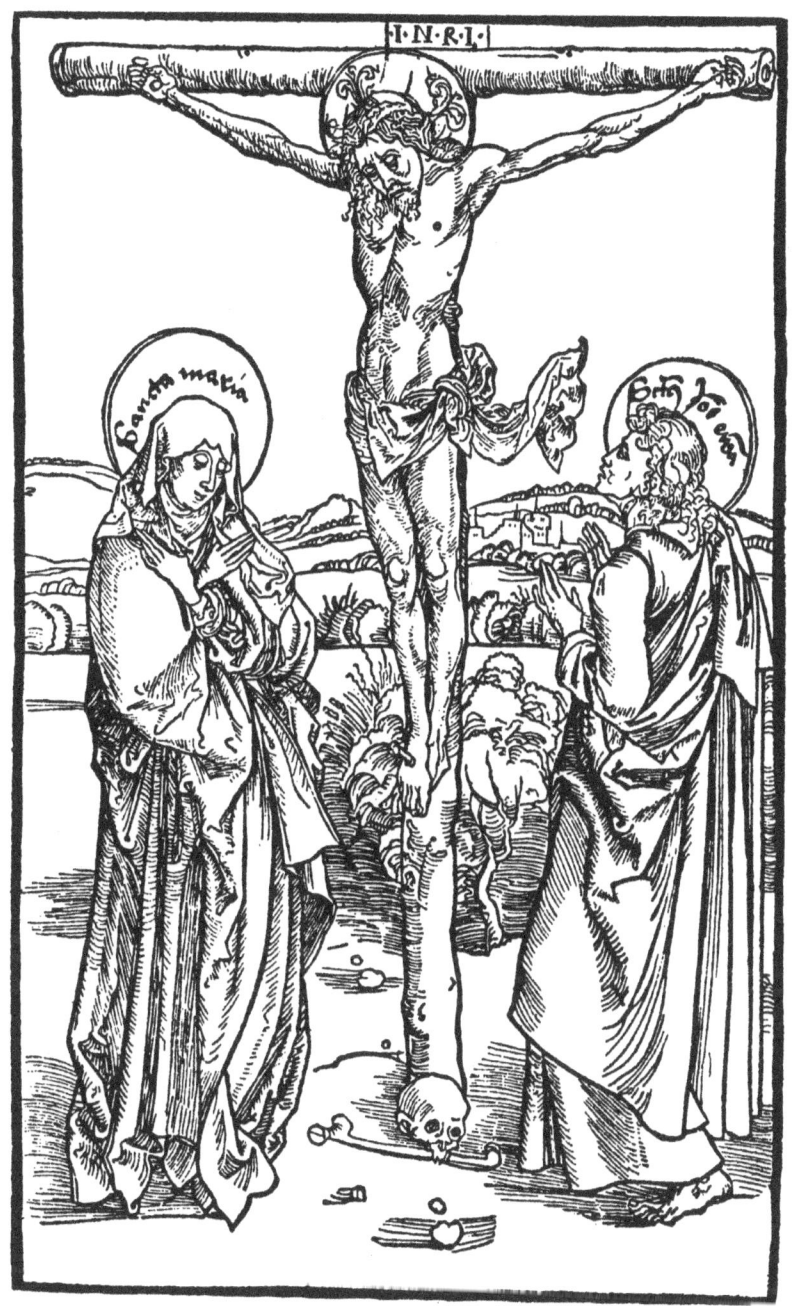

85

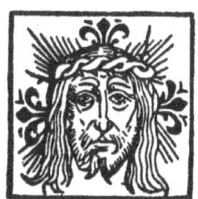

86

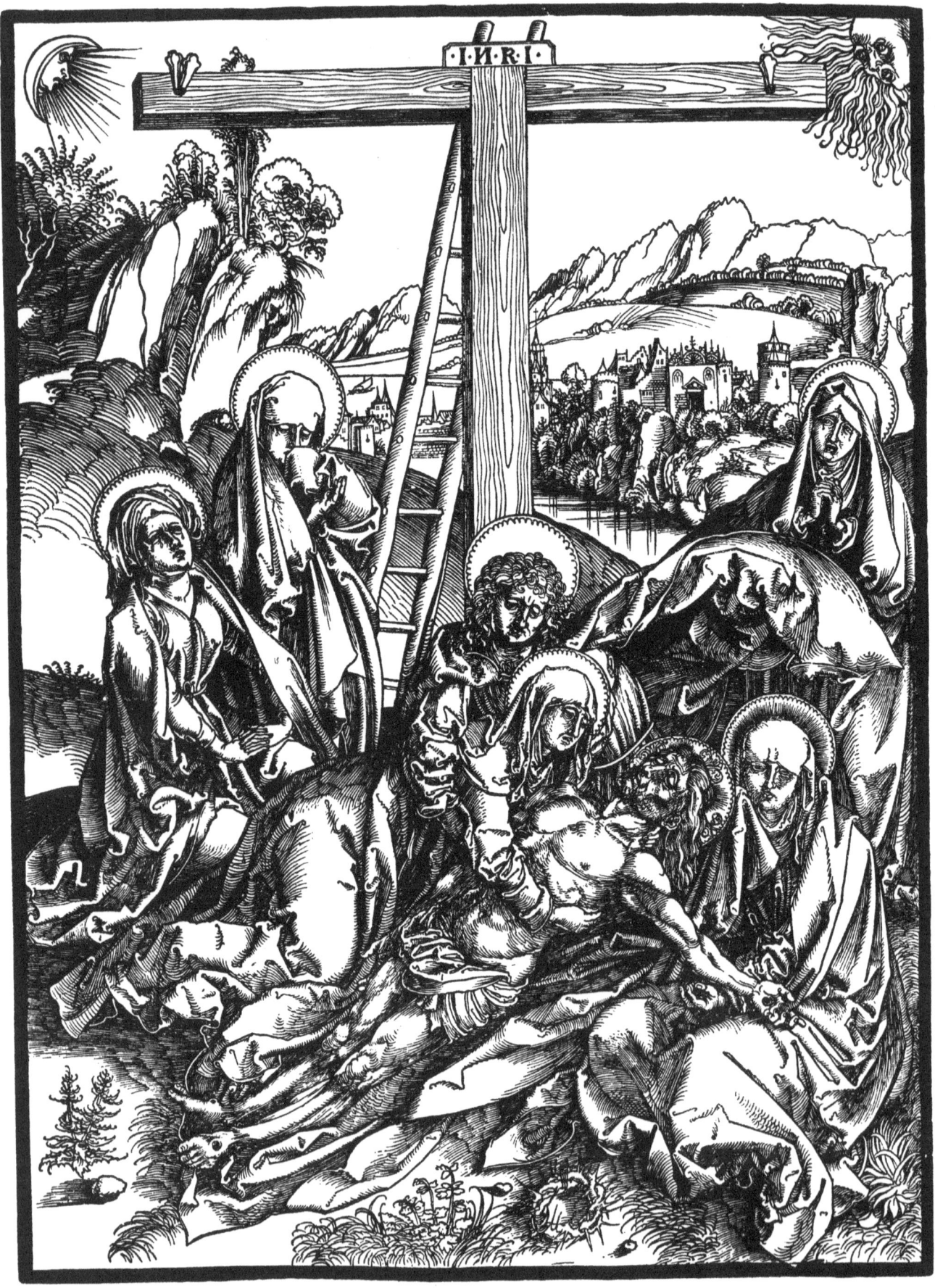

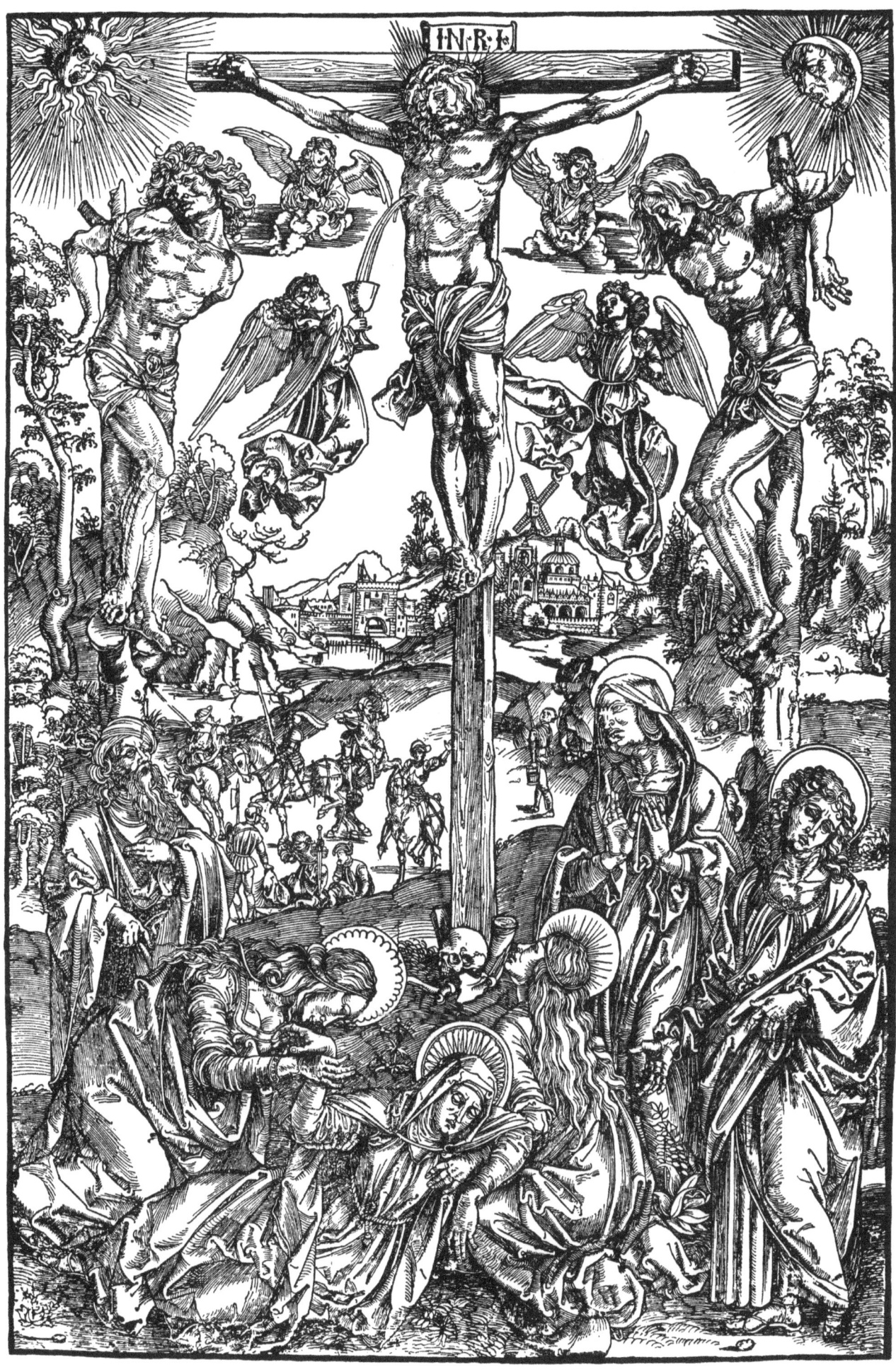

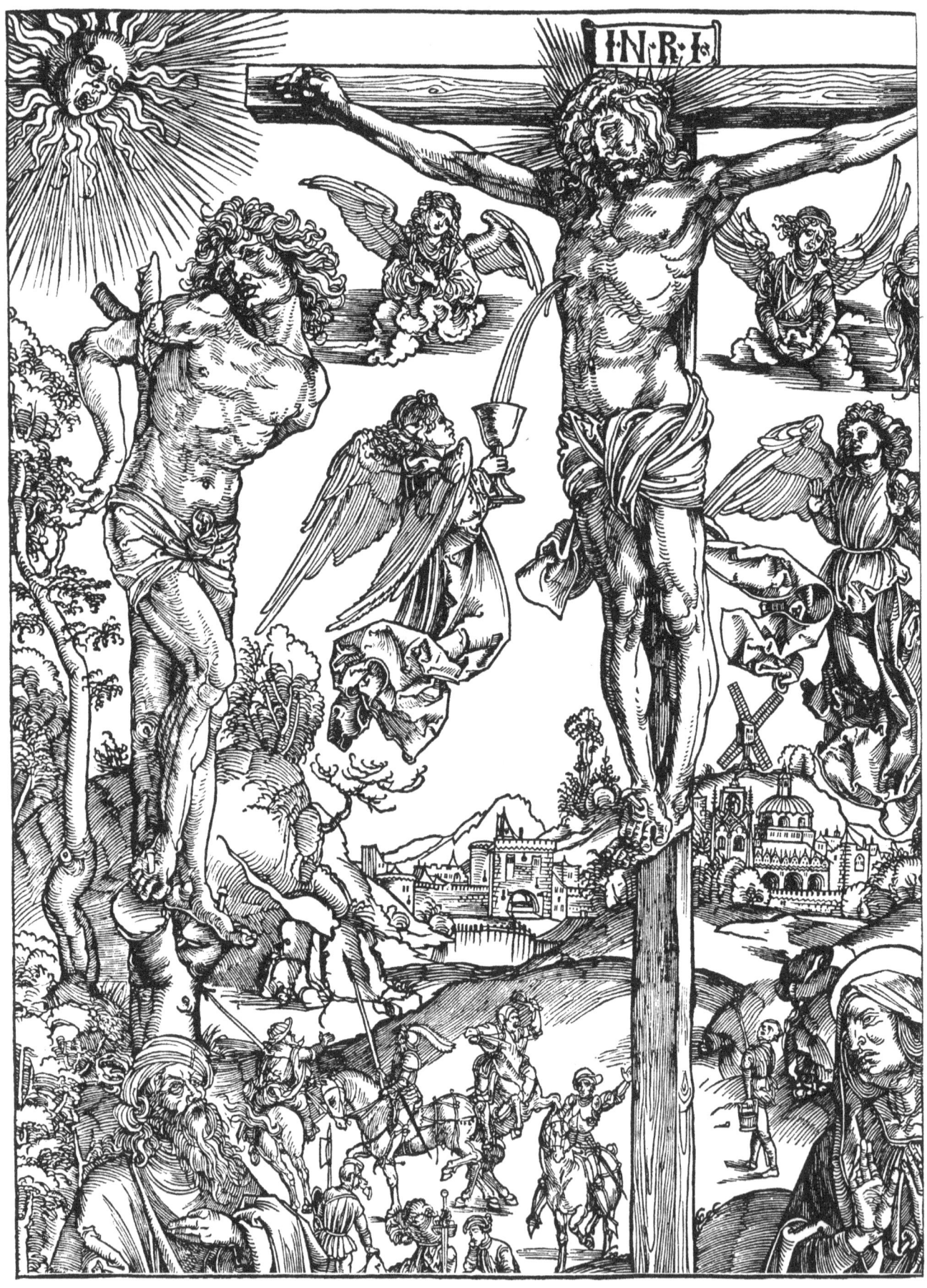
{ PAGE 70 }

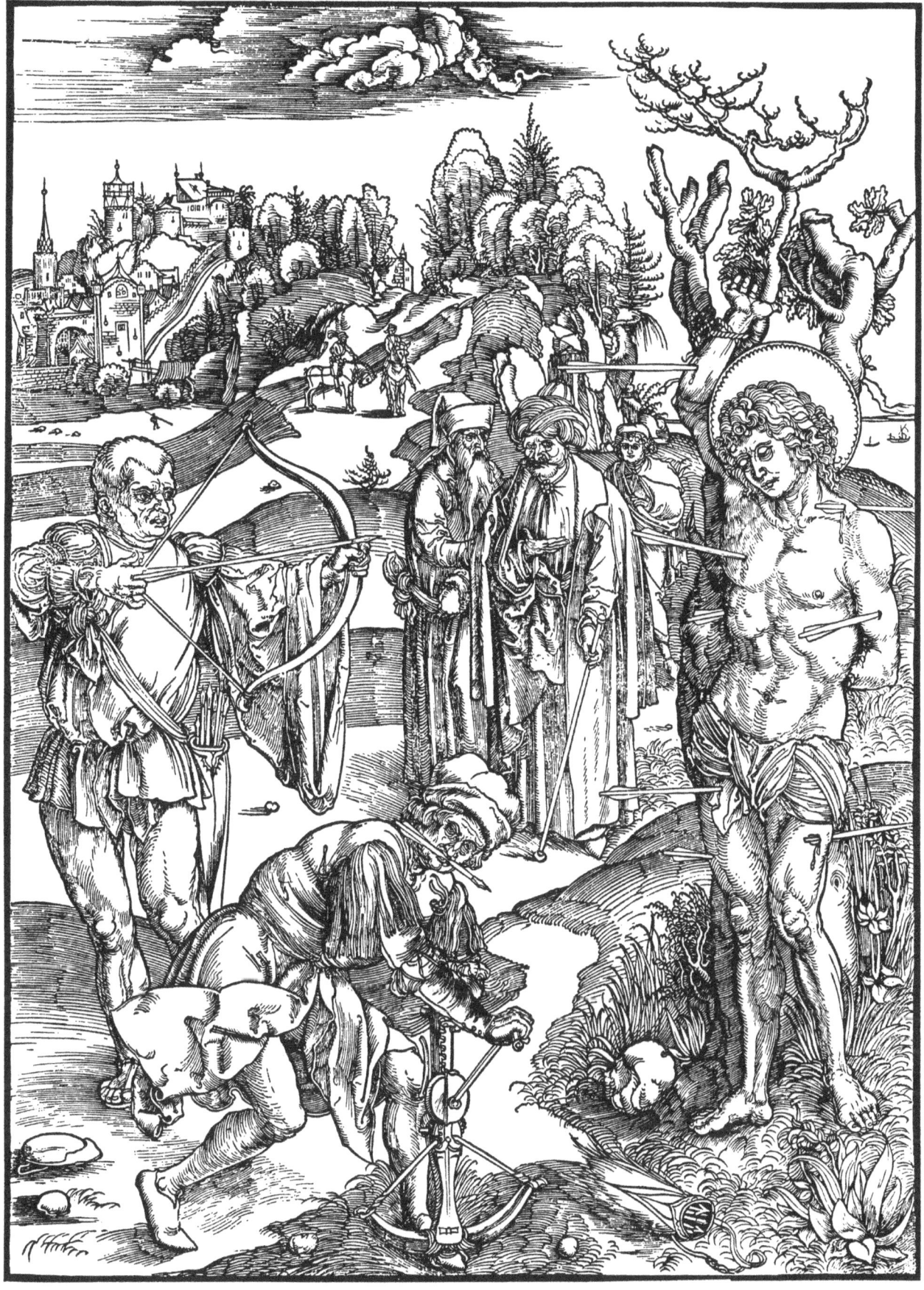

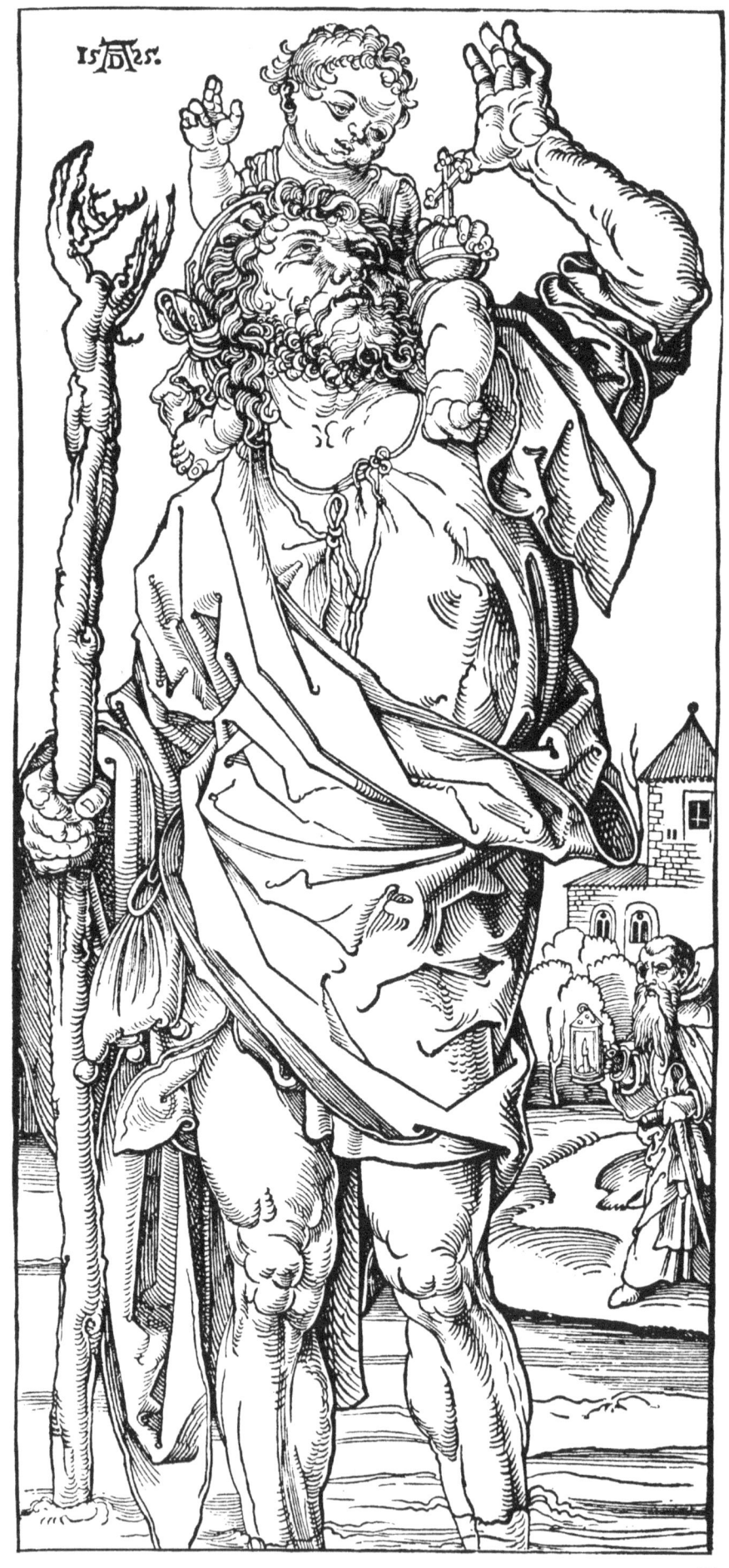

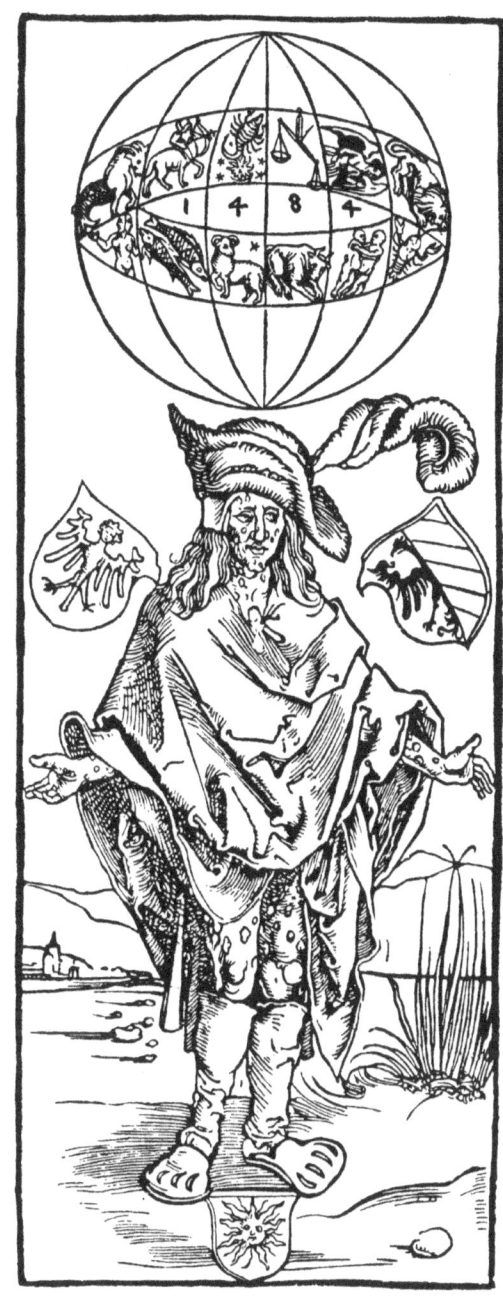

92

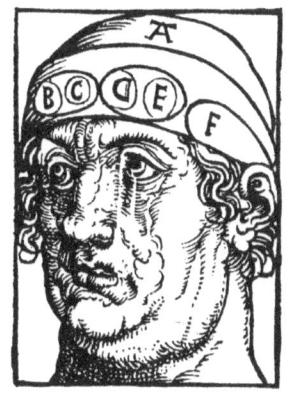

93

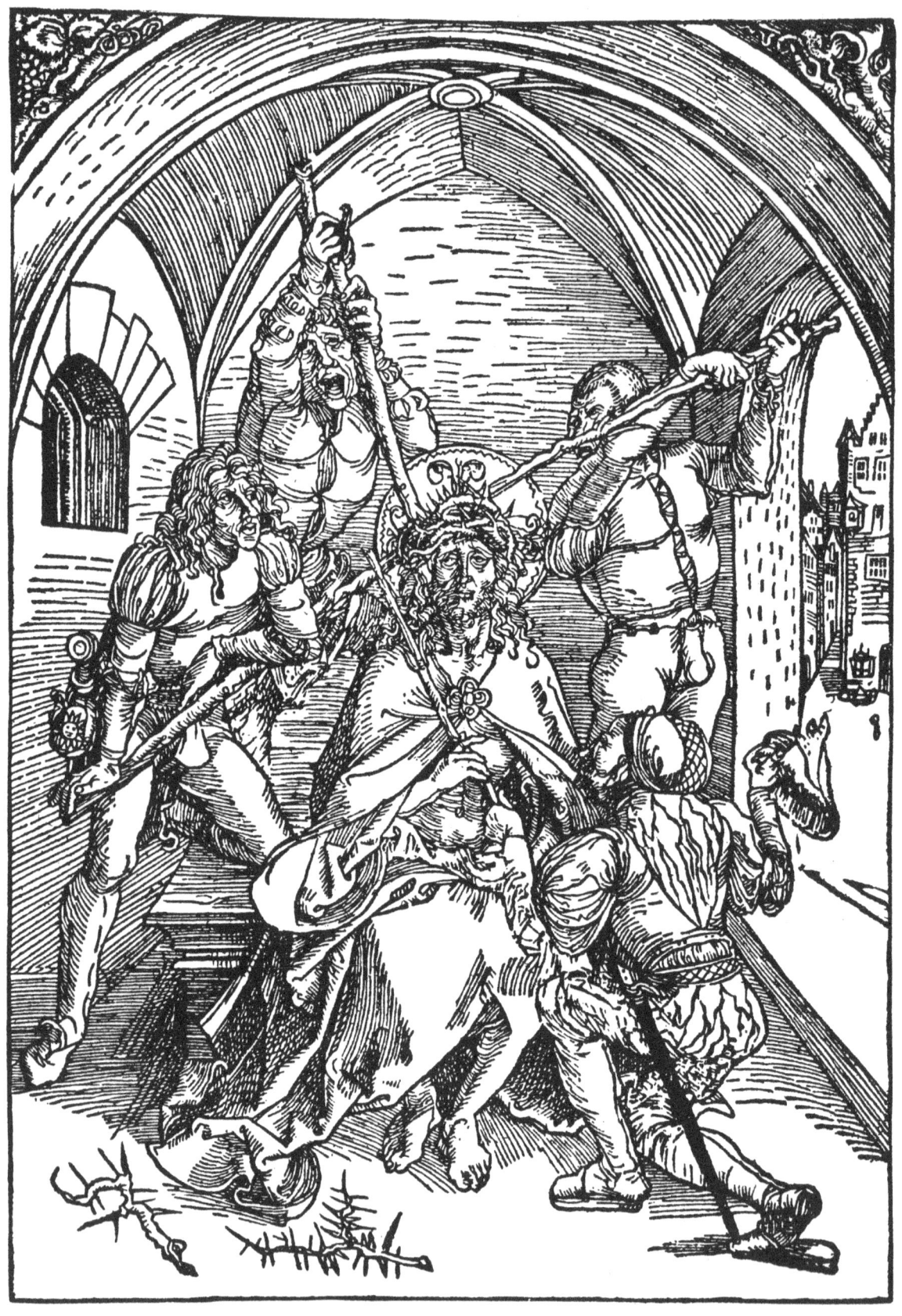

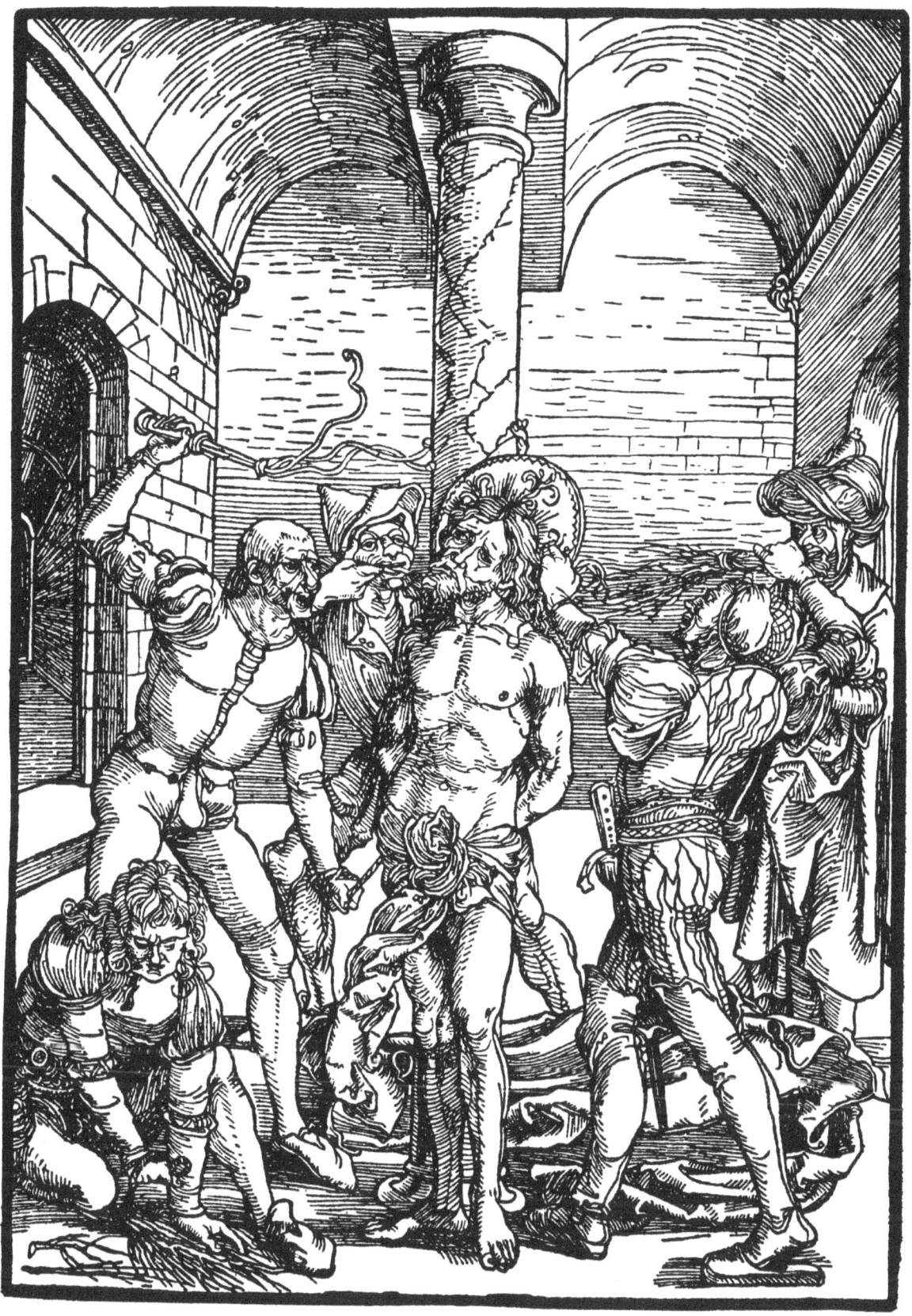

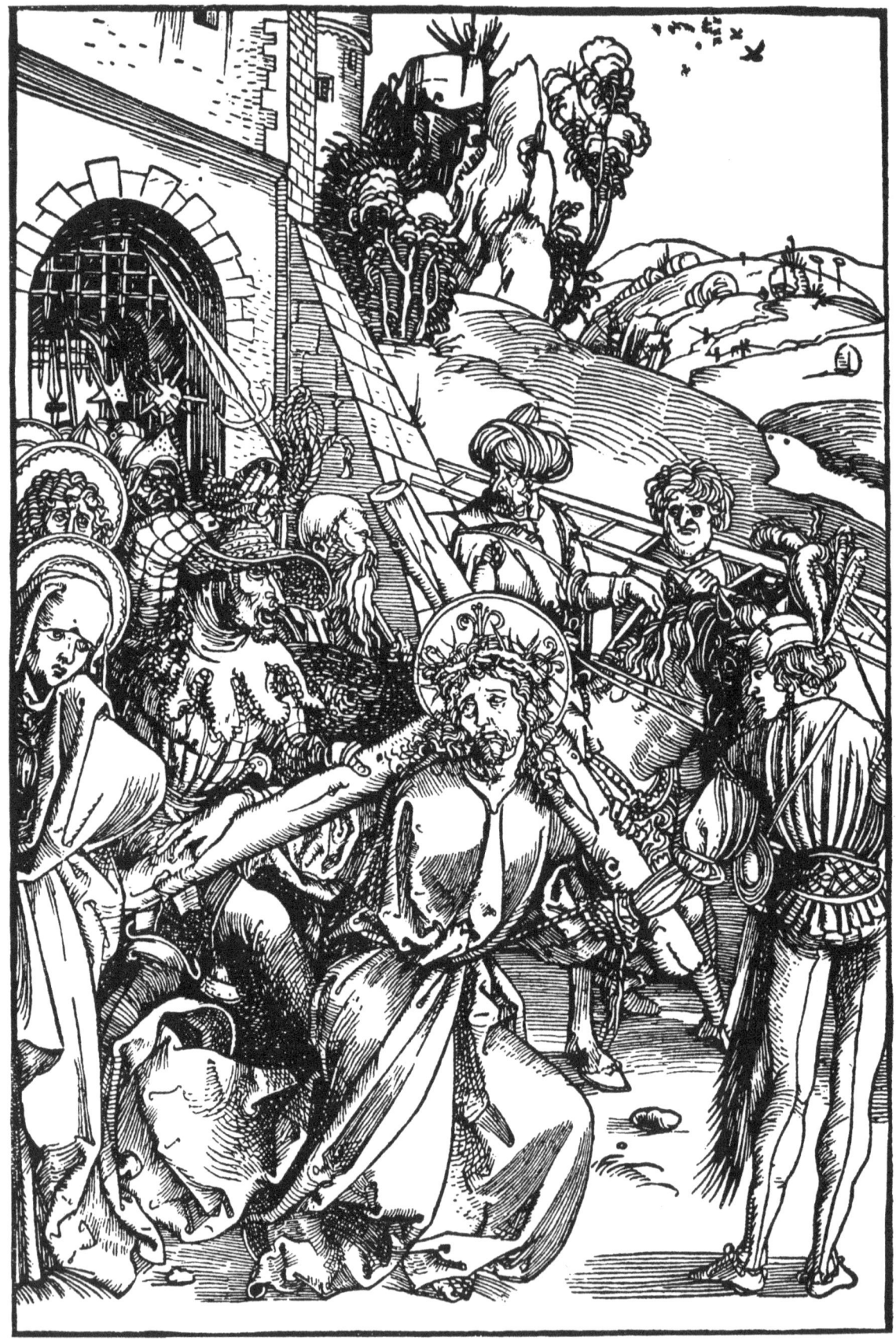

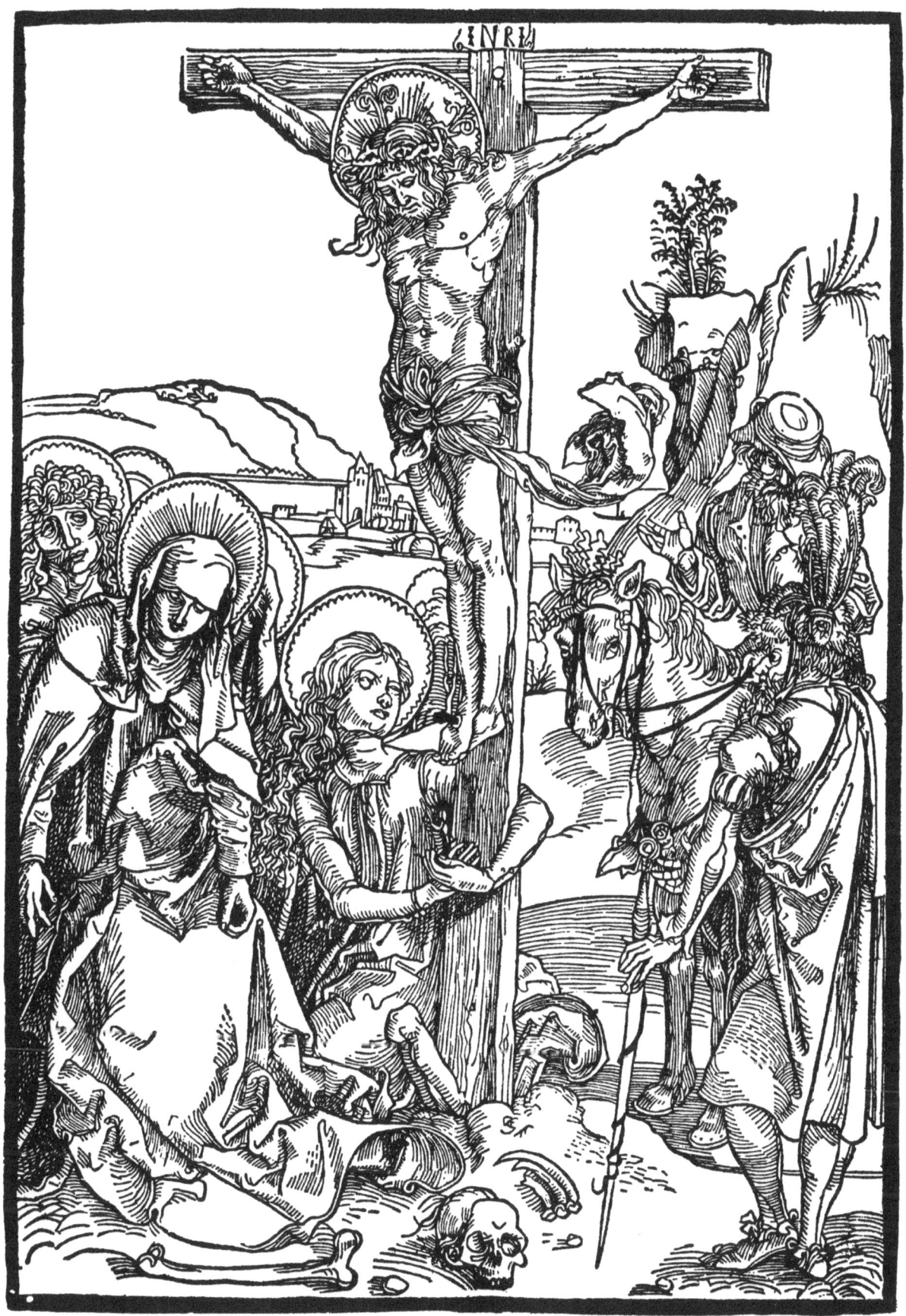

{ PAGE 77 }

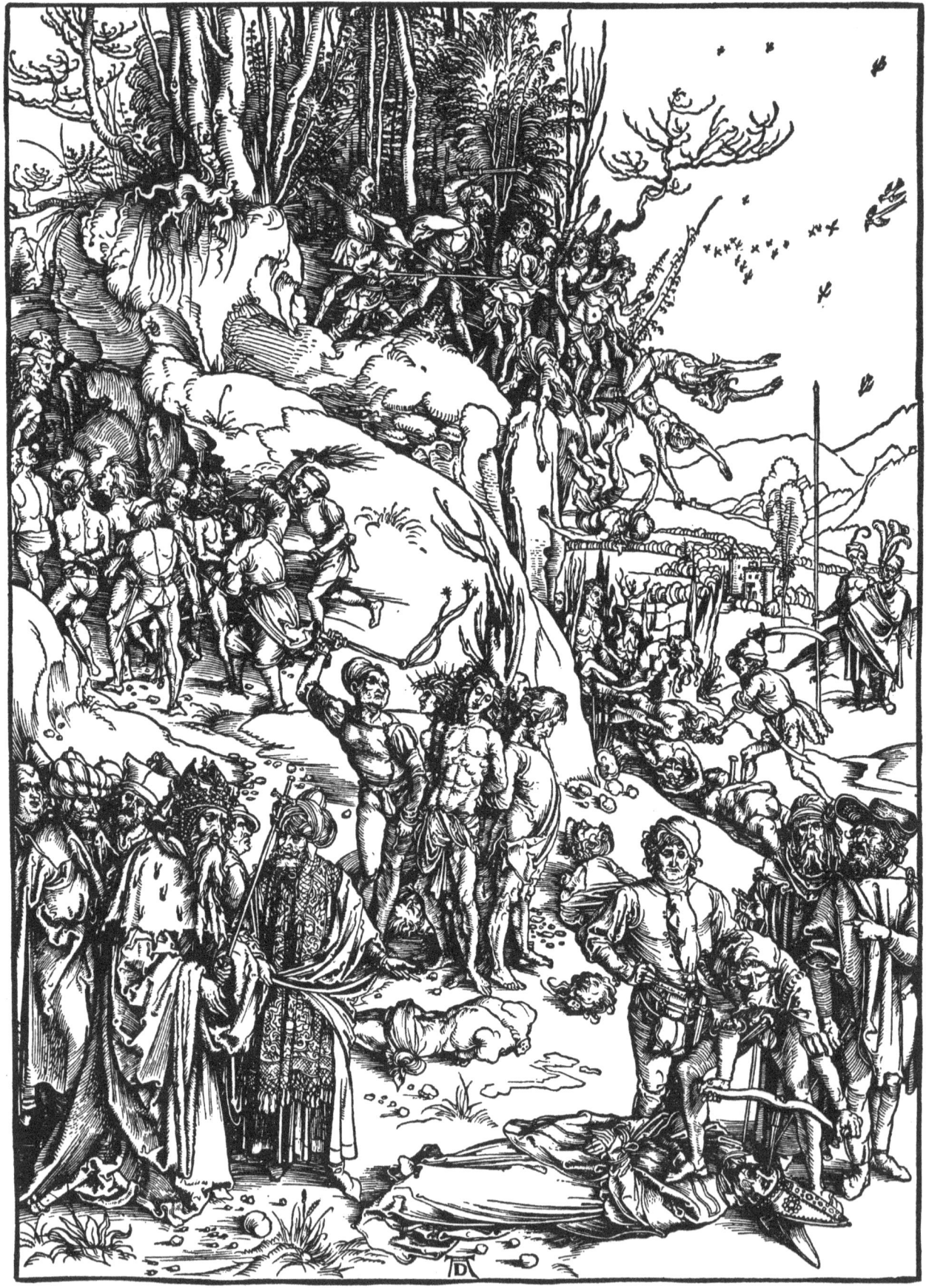

{ PAGE 78 }

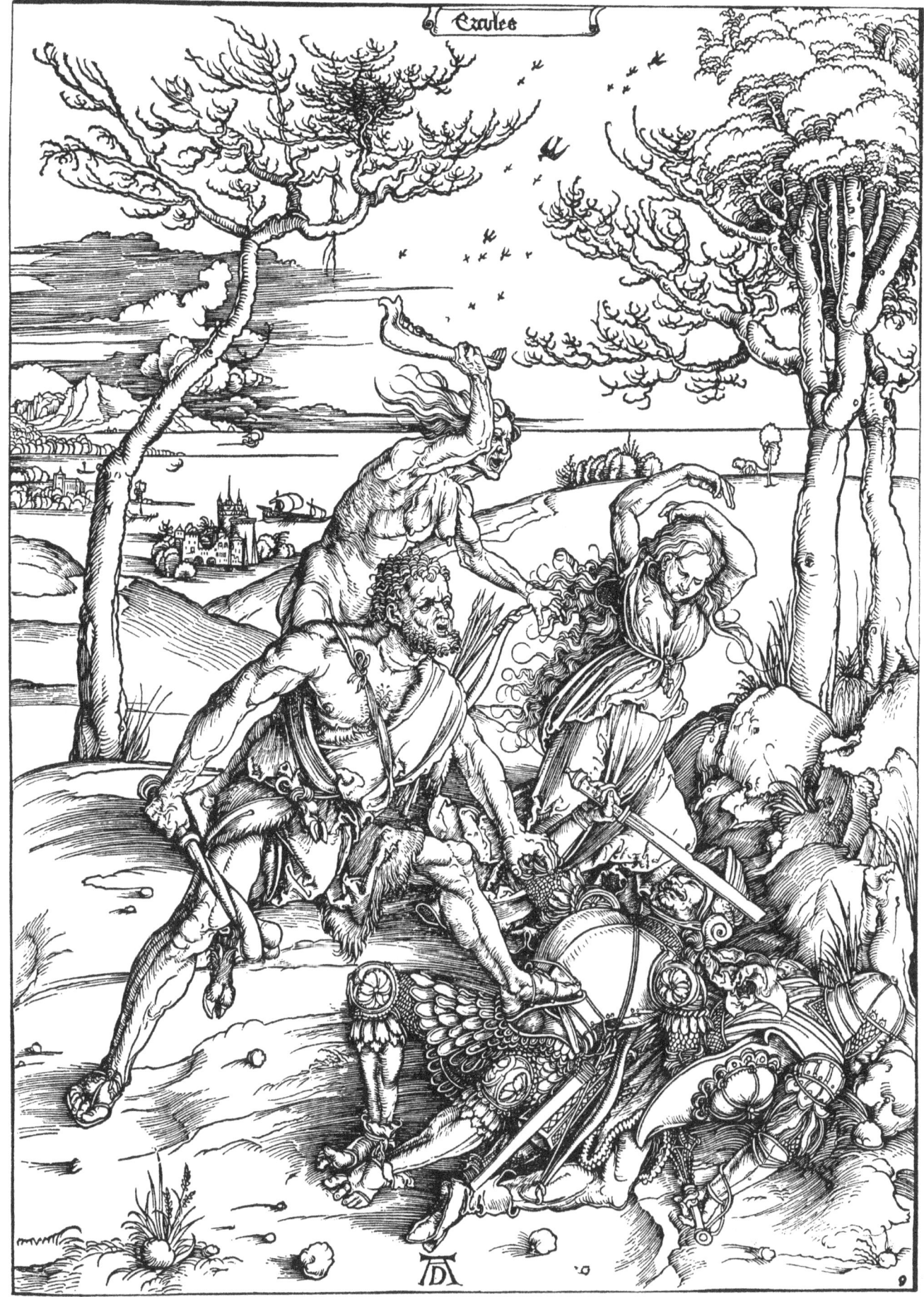

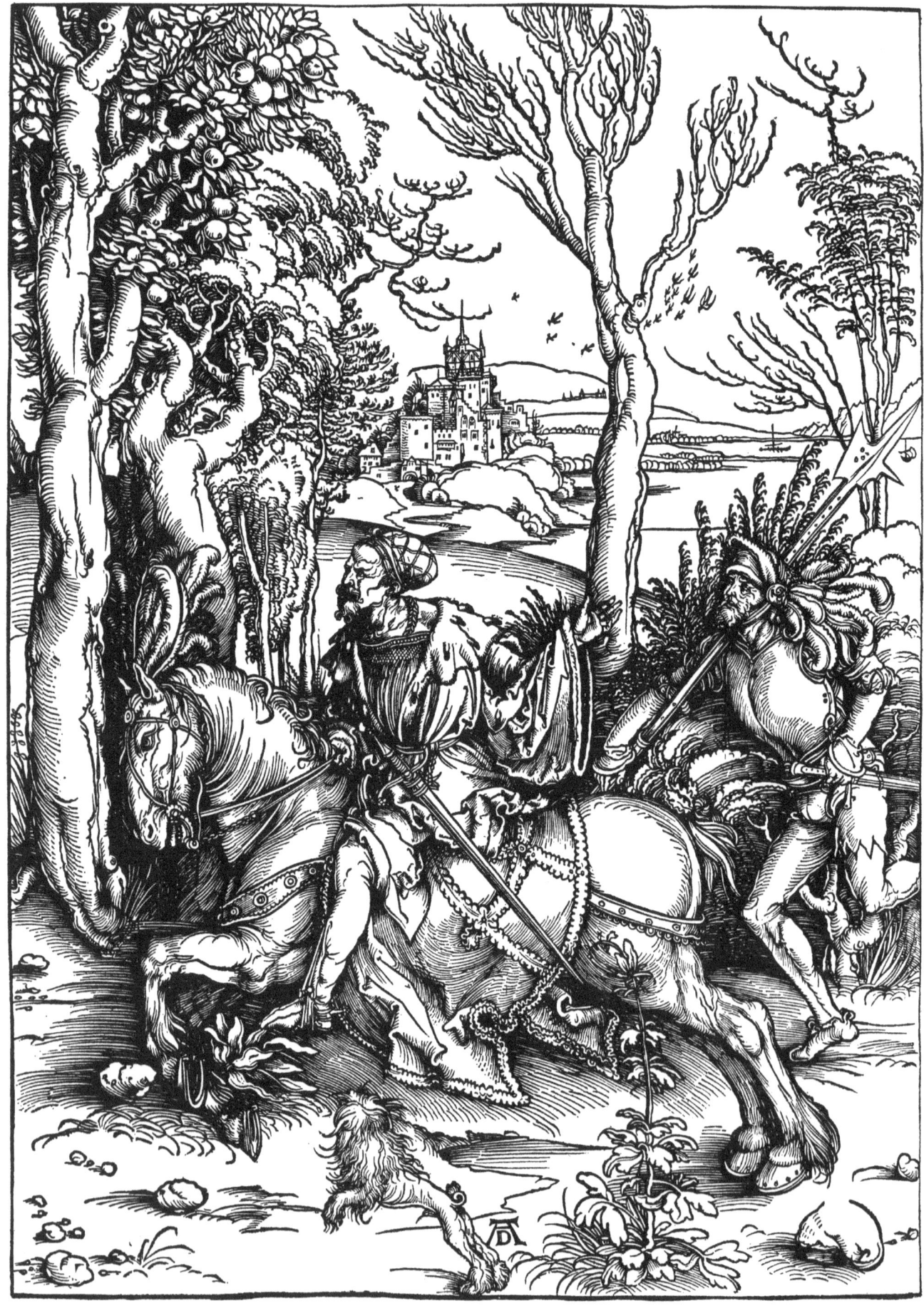

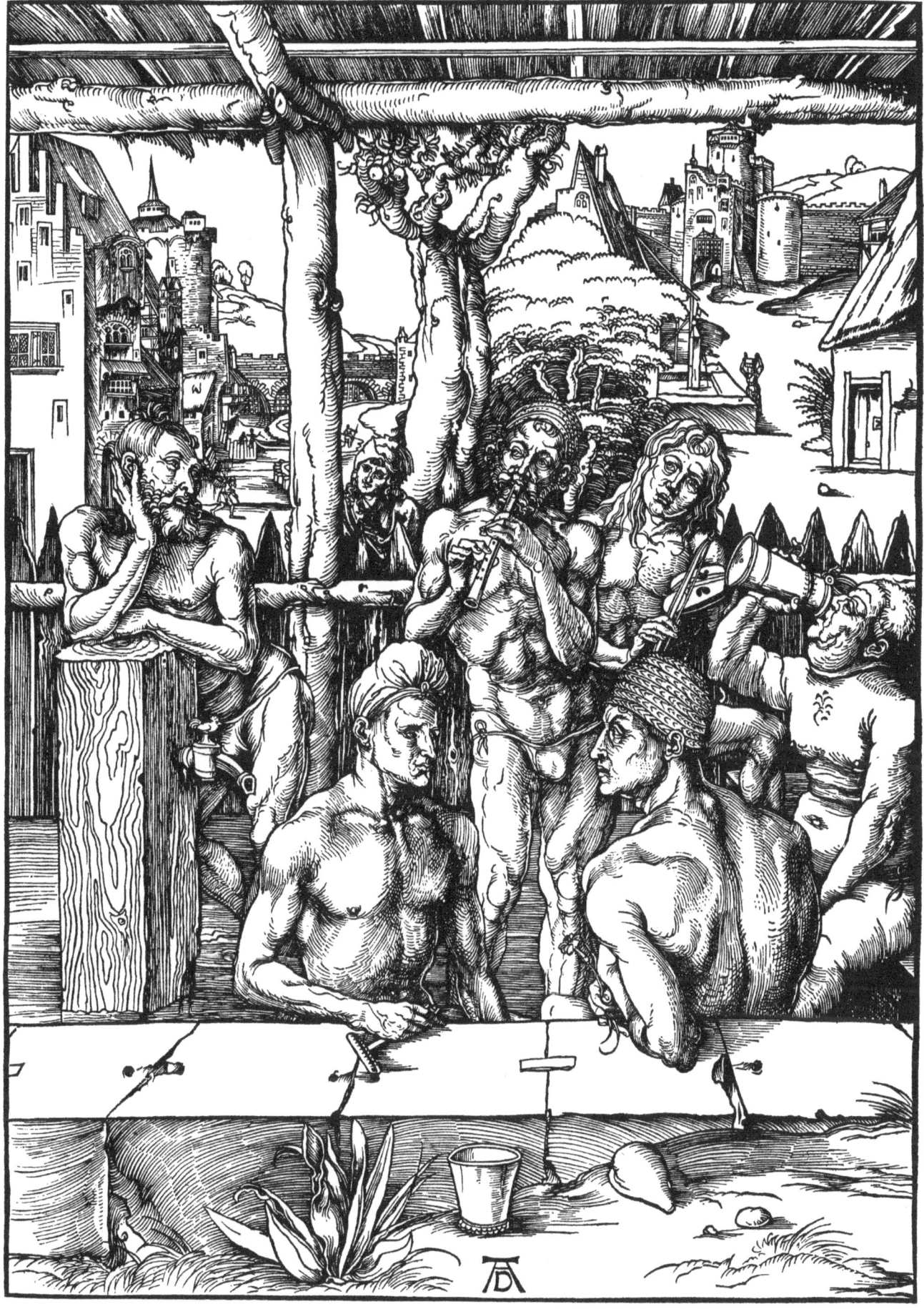

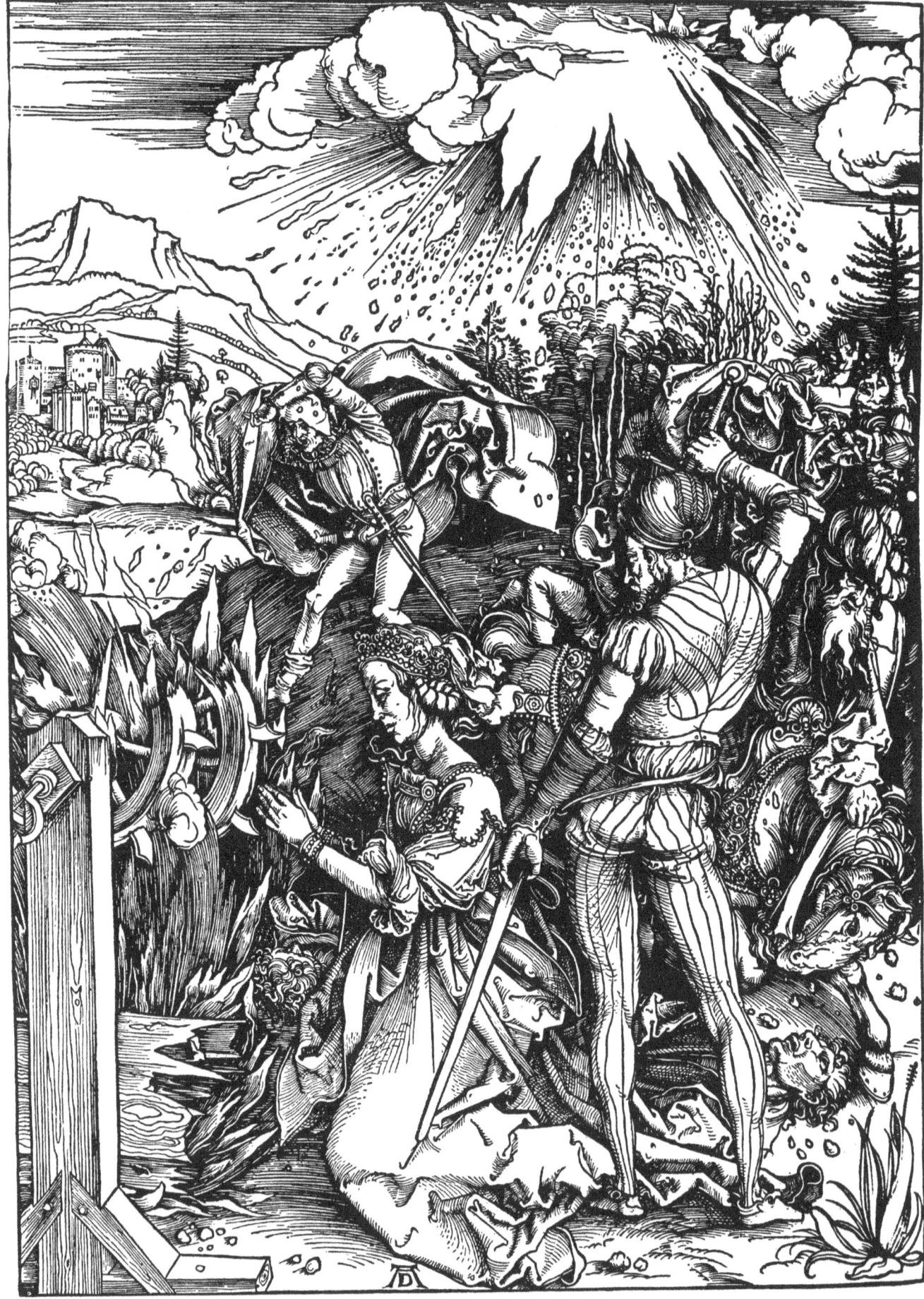

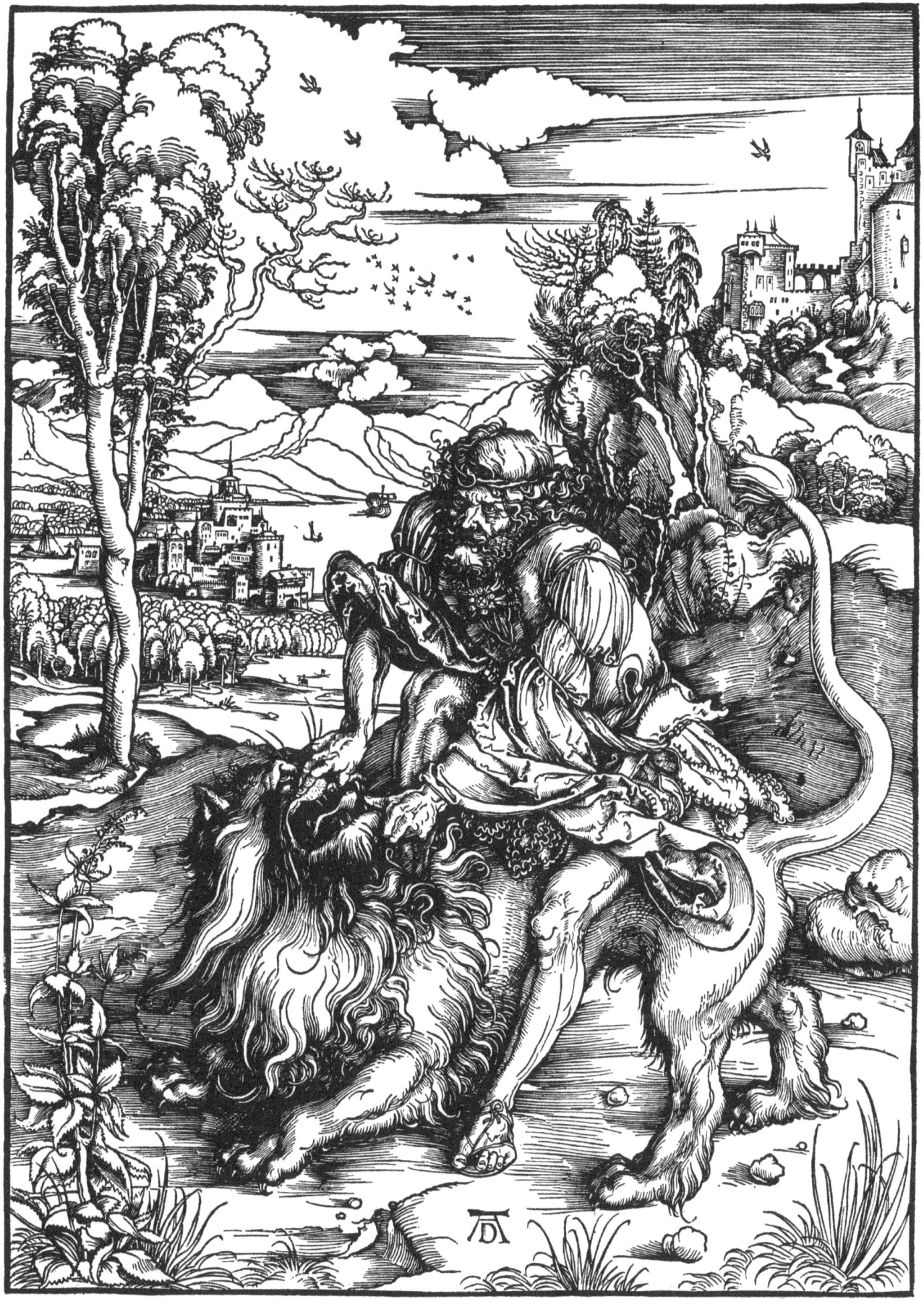

{ PAGE 83 }

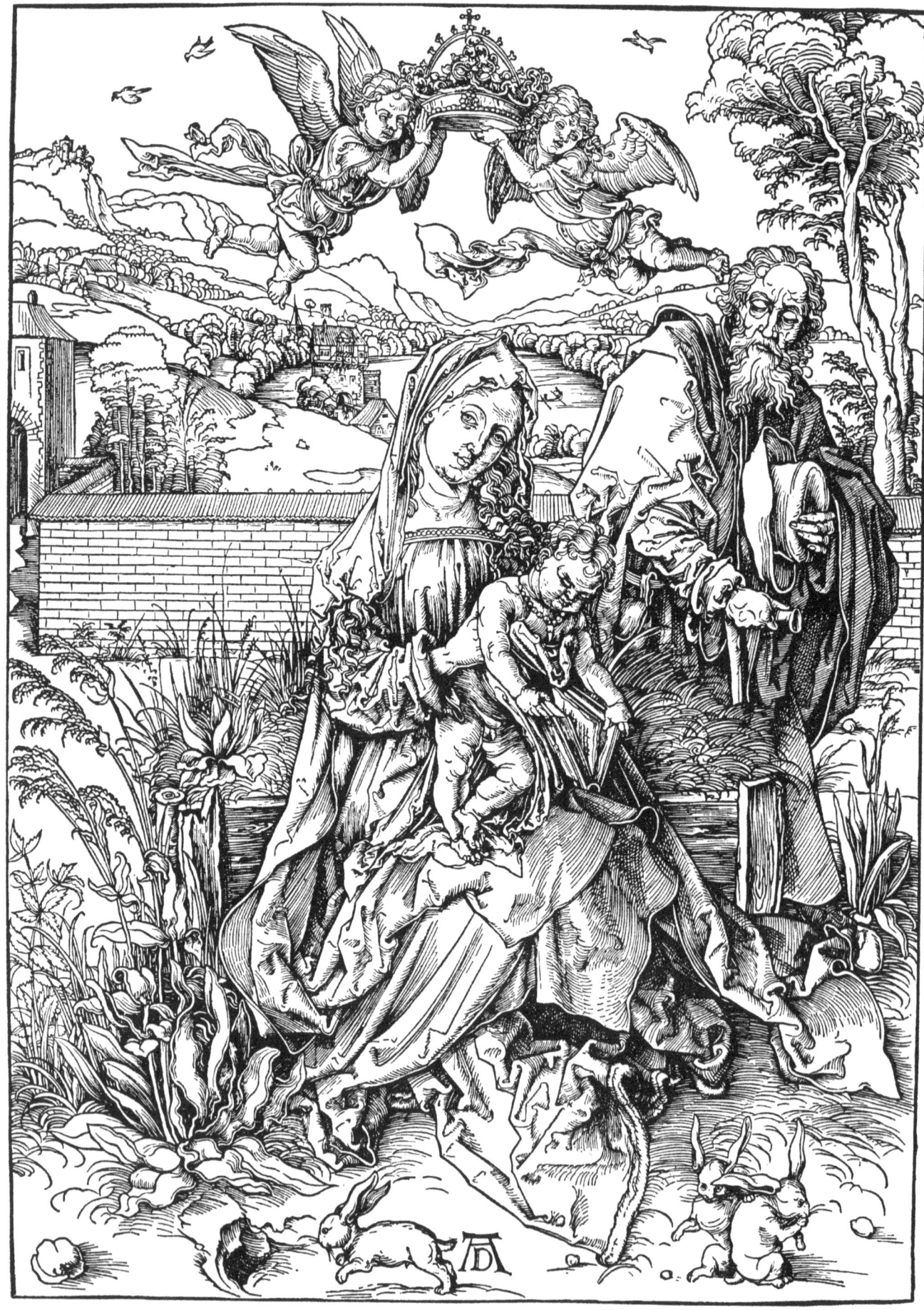

{ PAGE 84 }

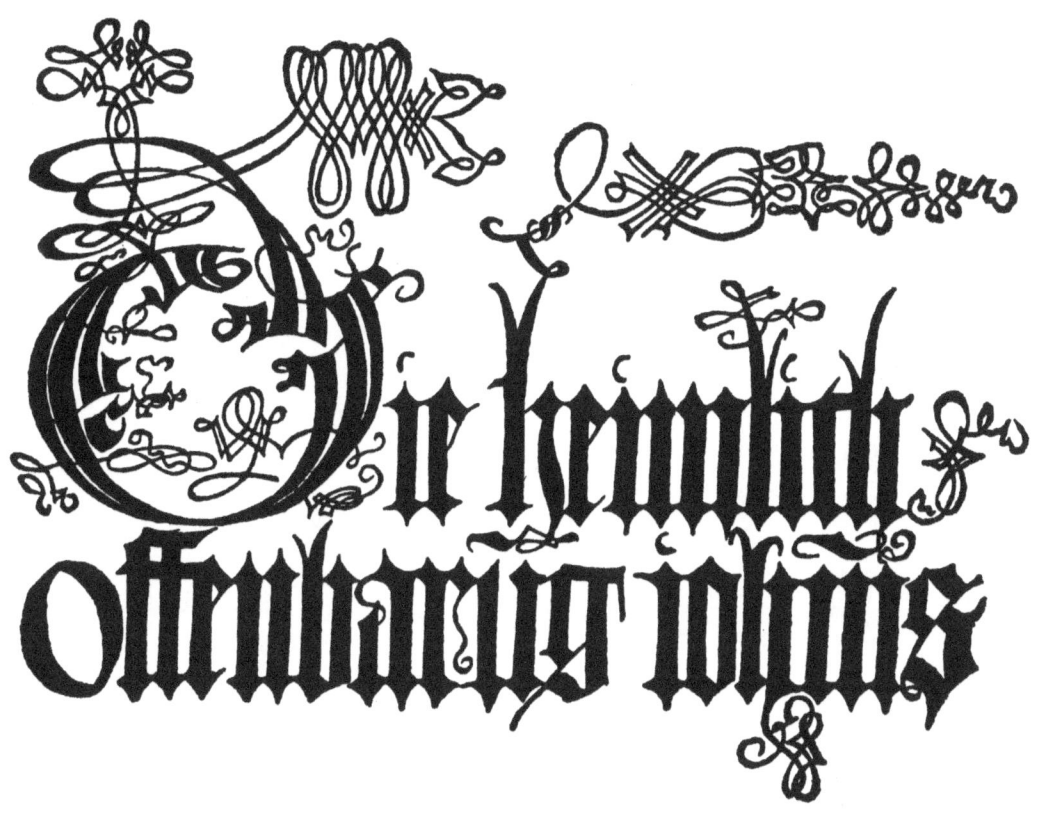

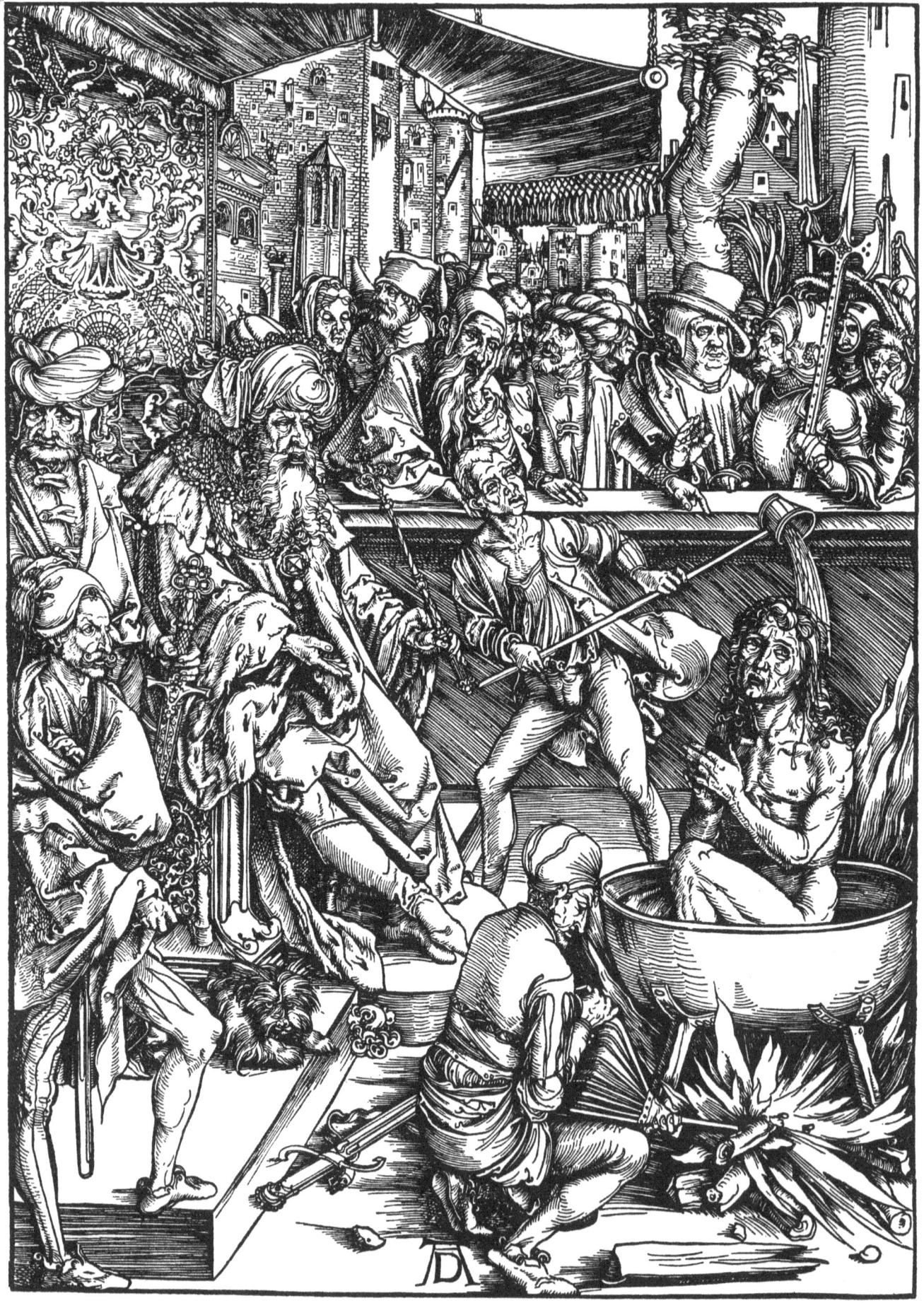

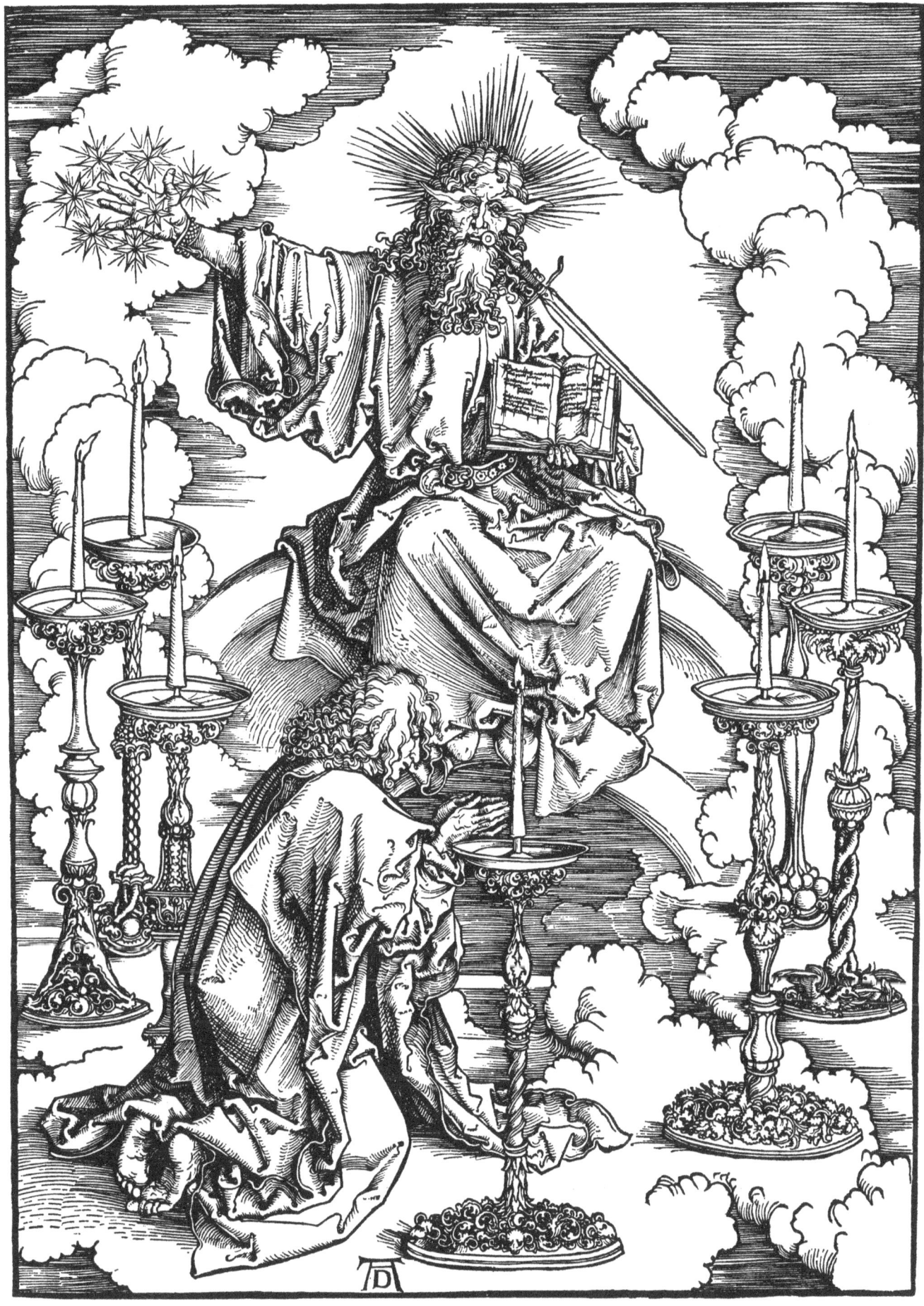

{ PAGE 87 }

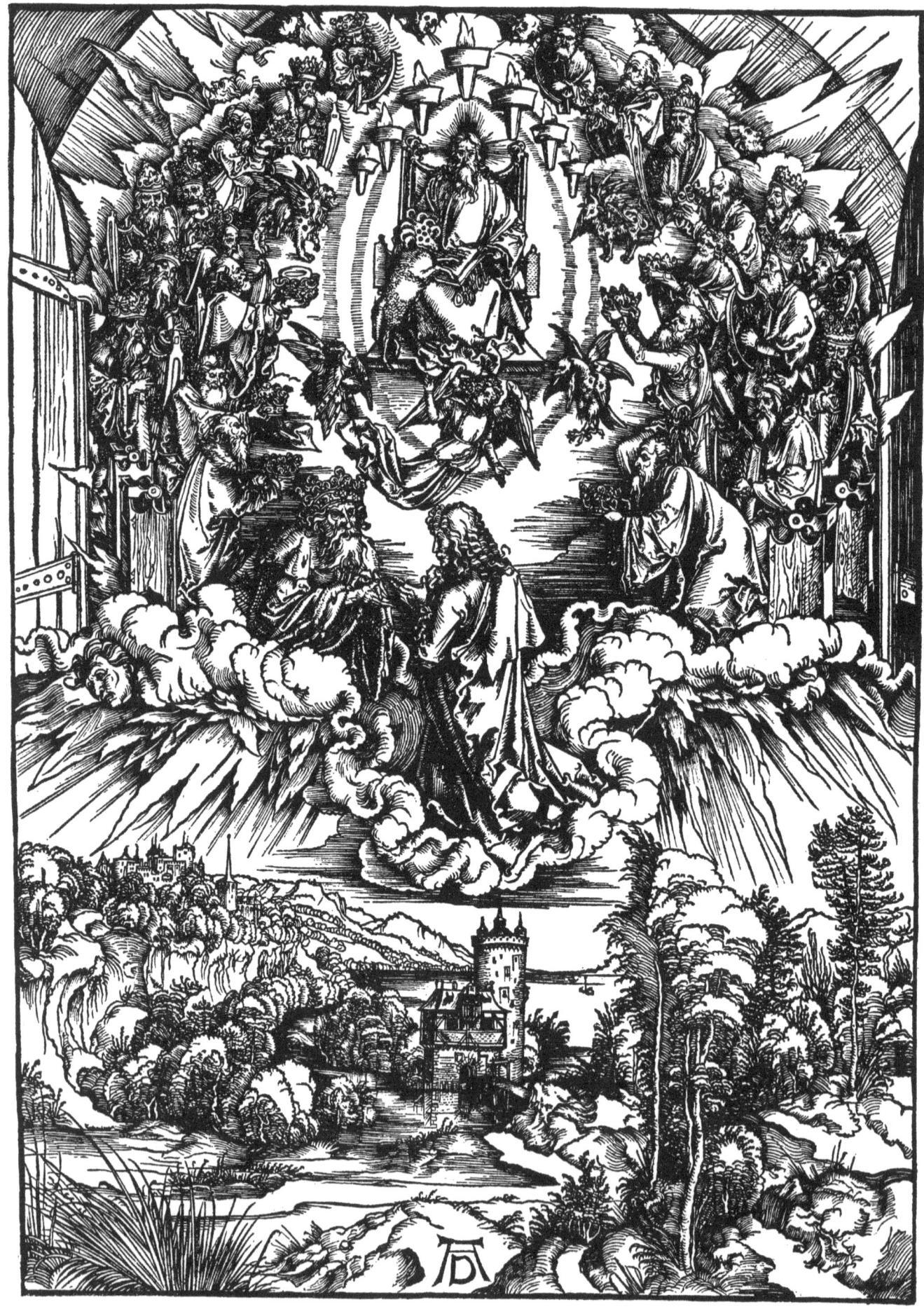

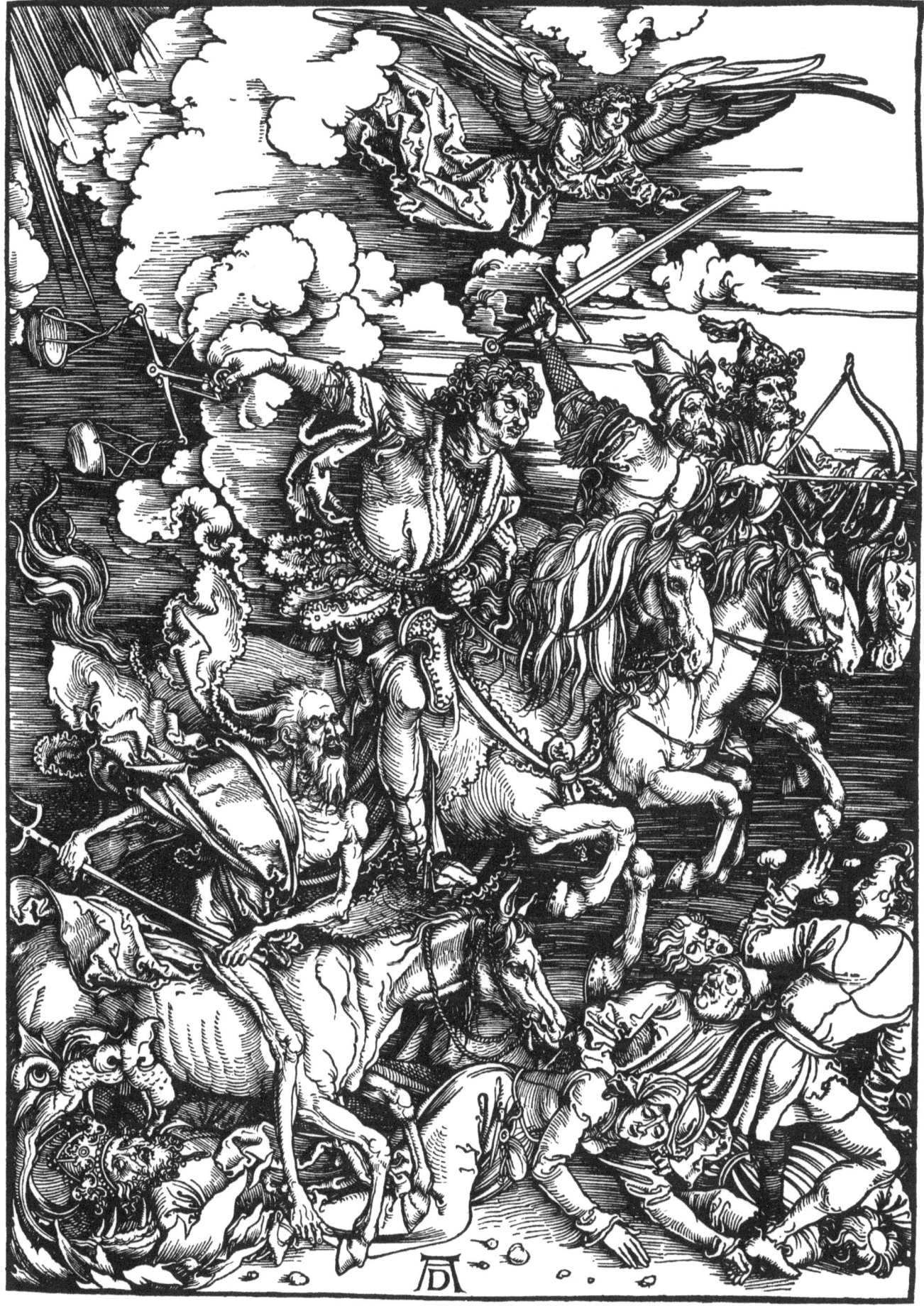
{ PAGE 89 }

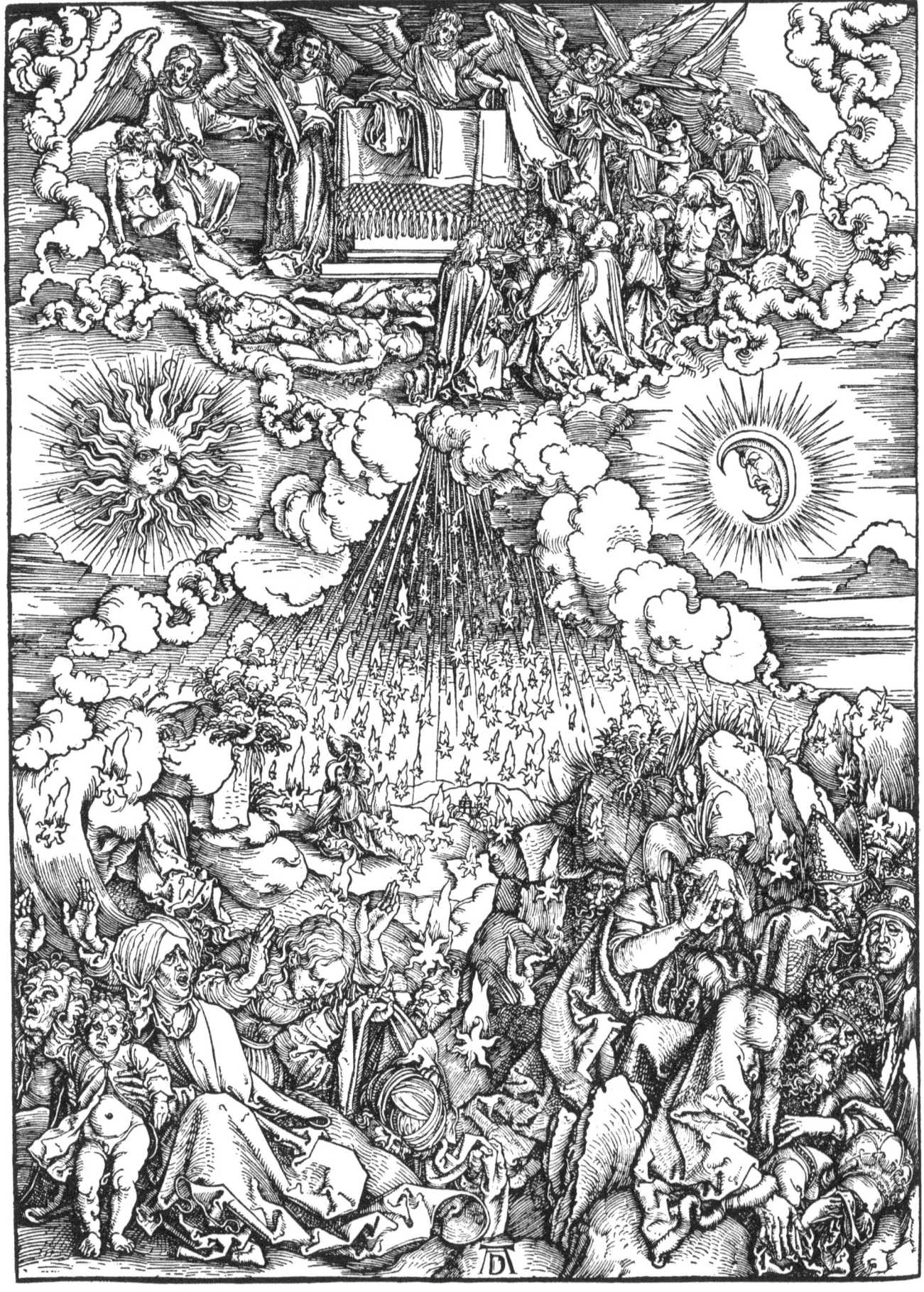

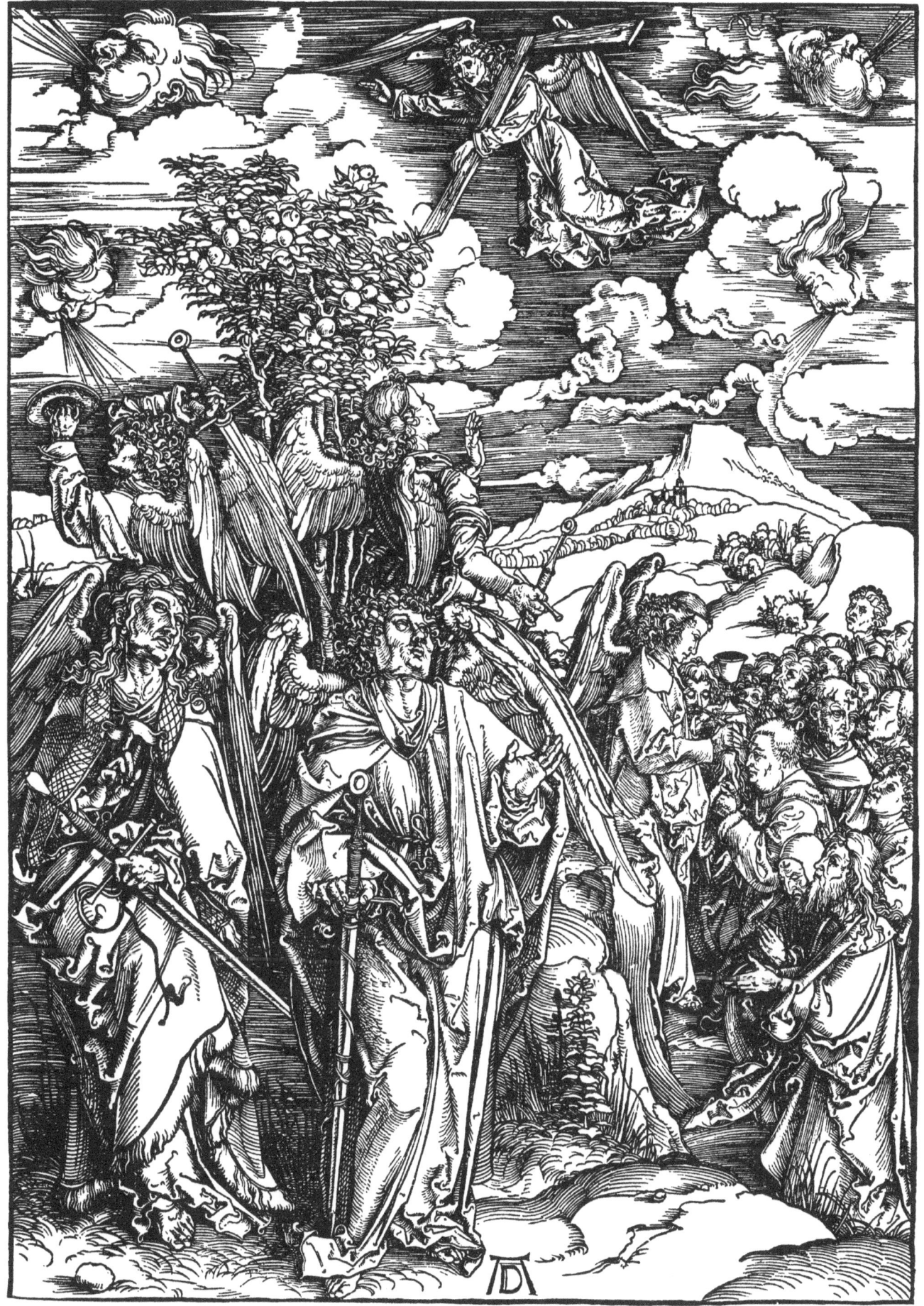
{ PAGE 91 }

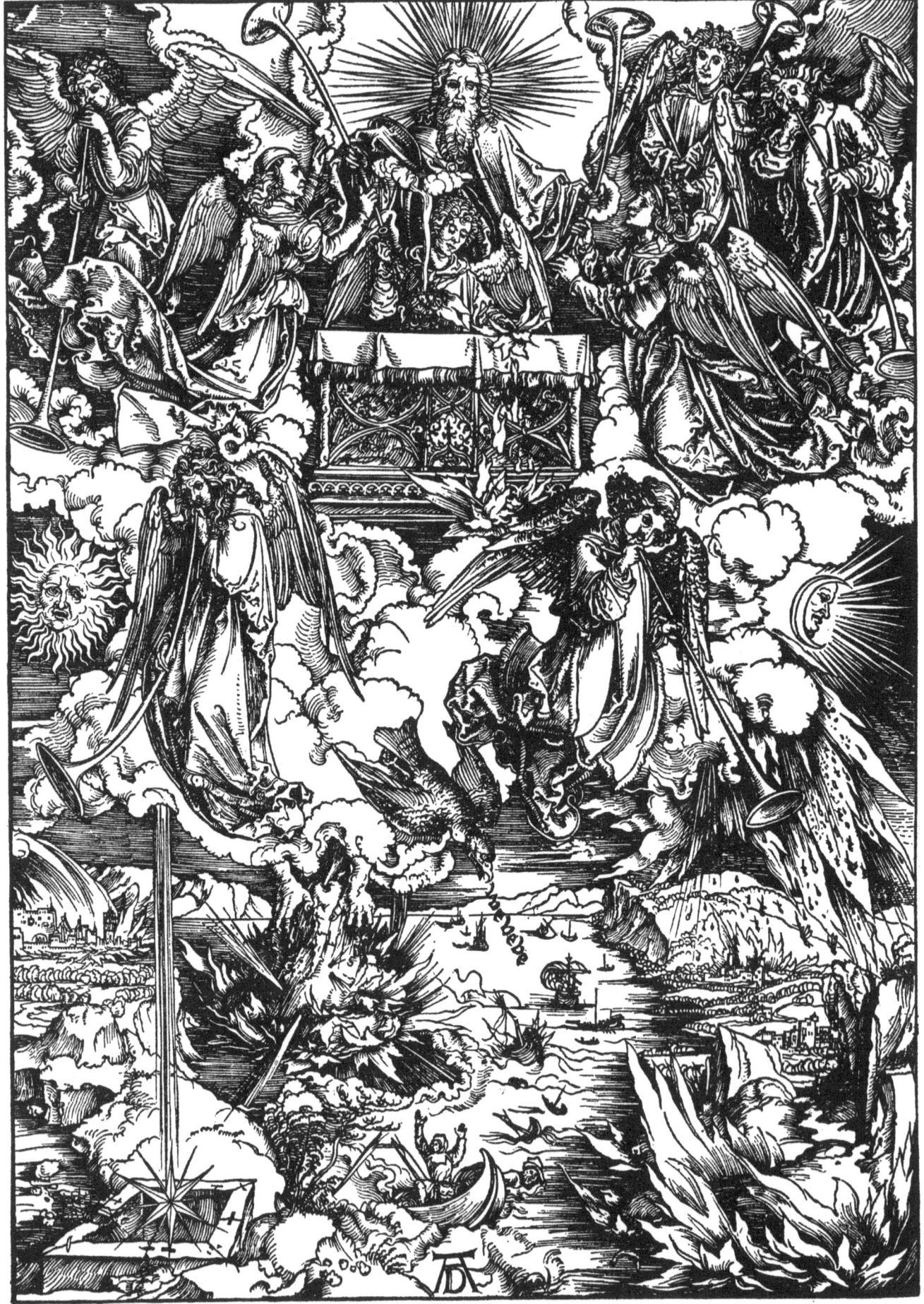

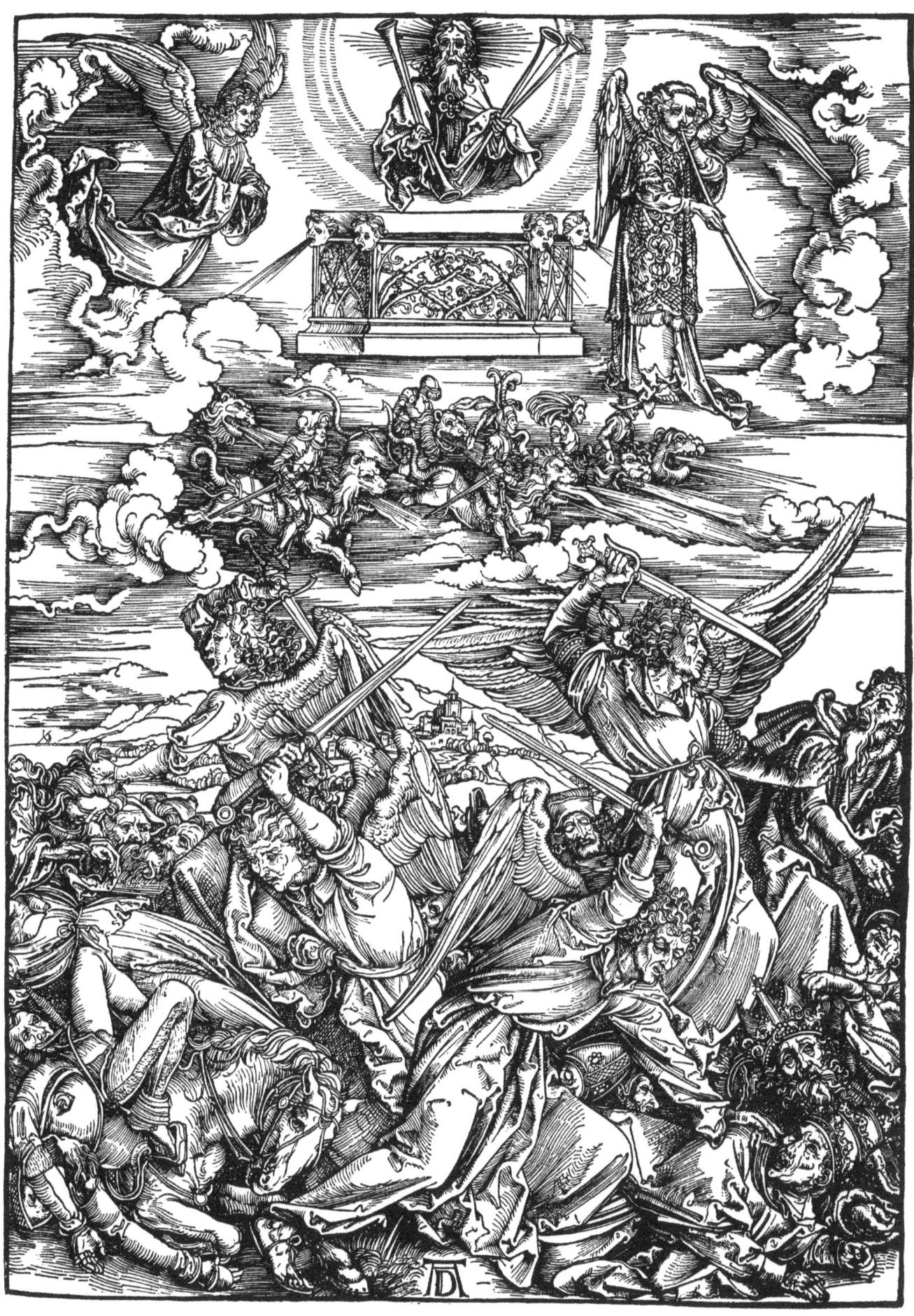

{ PAGE 93 }

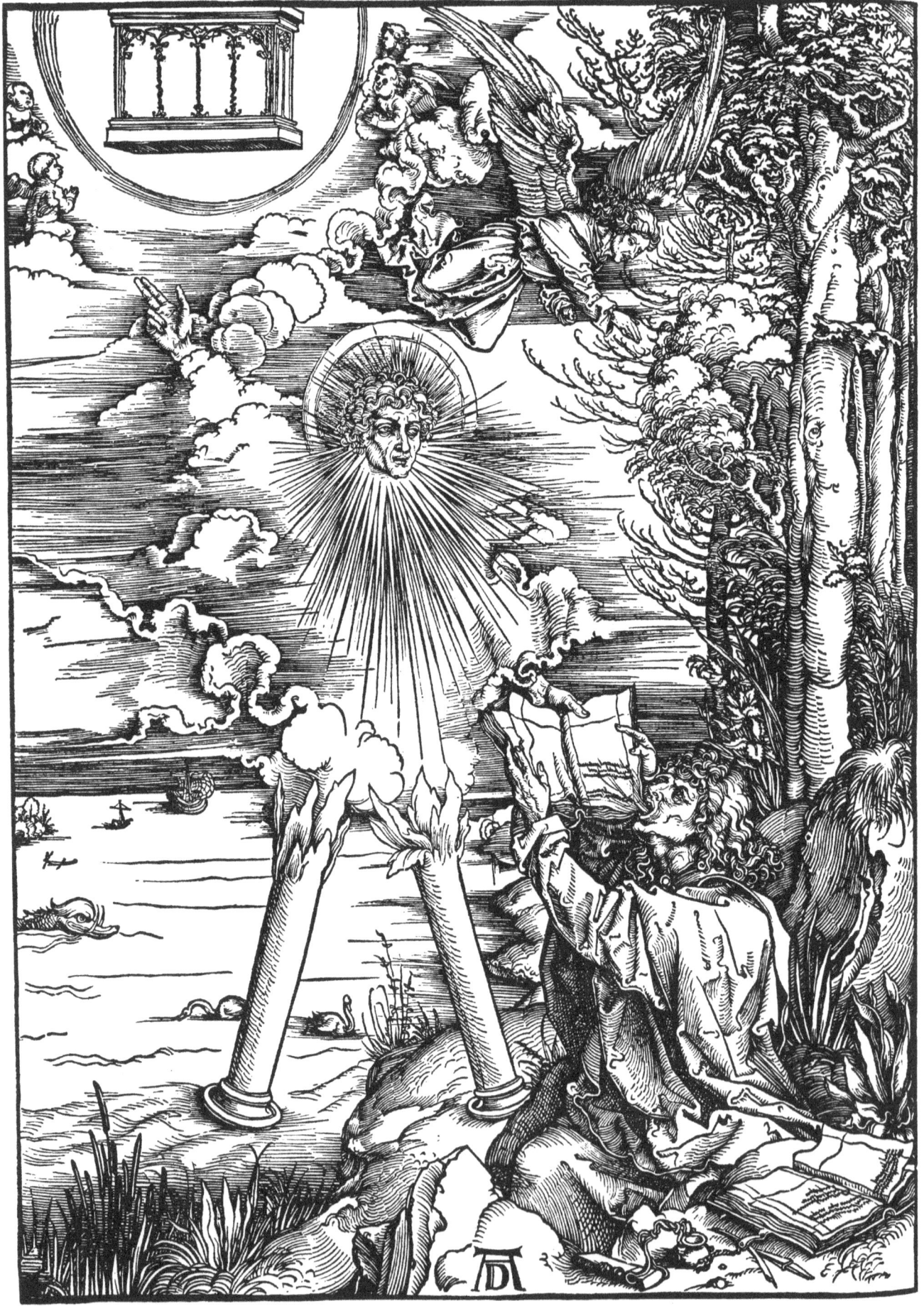

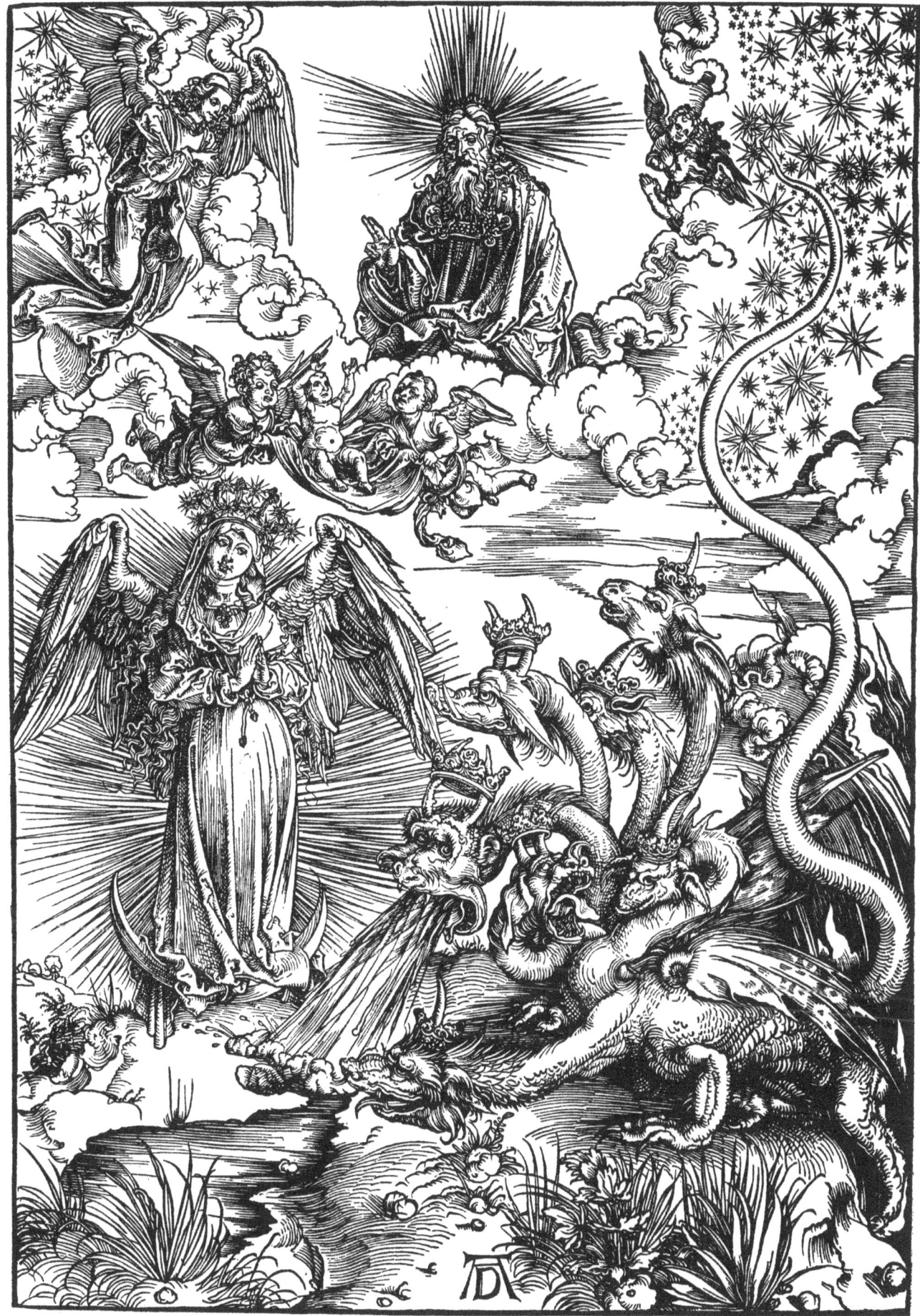

{ PAGE 95 }

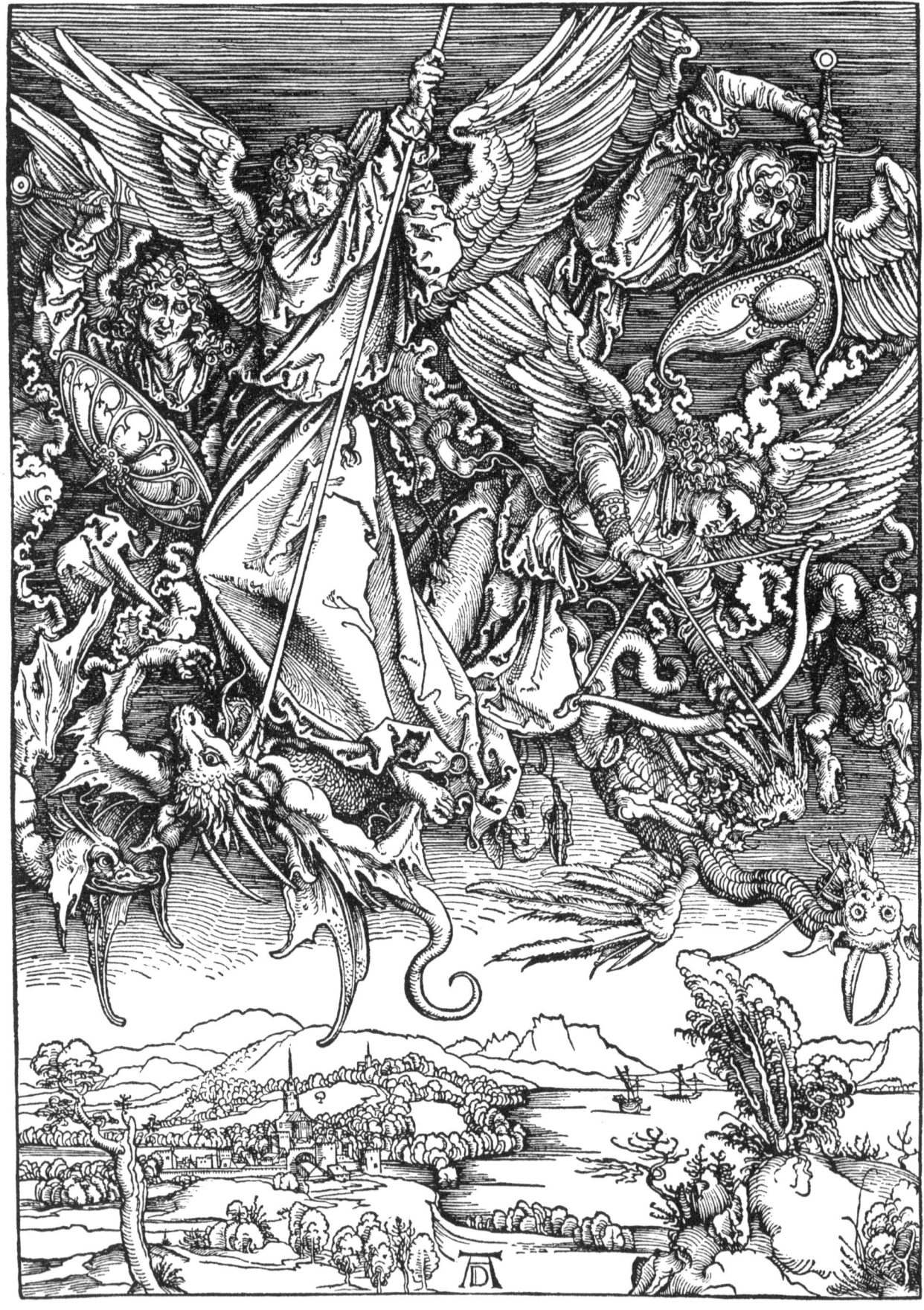

{ PAGE 96 }

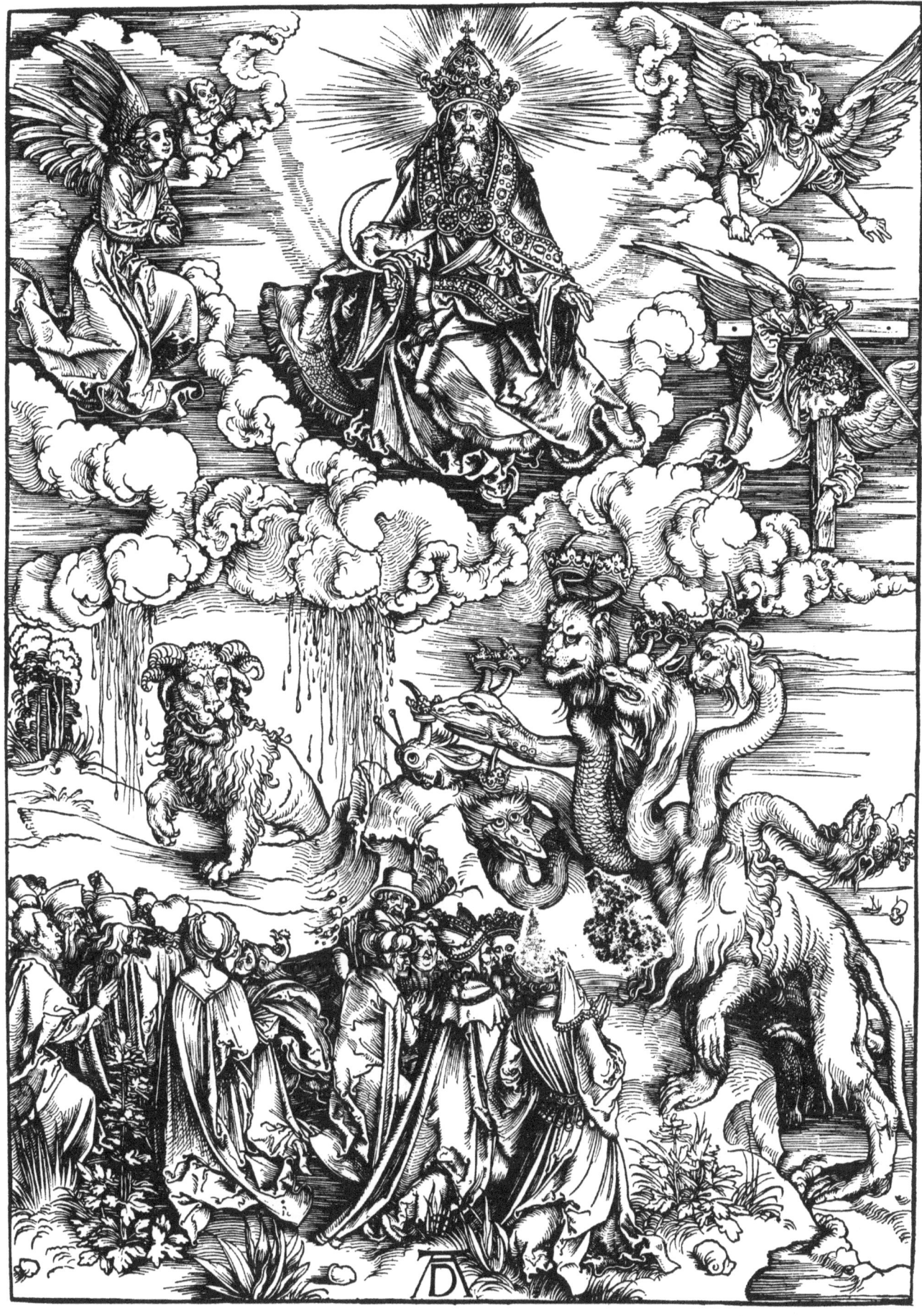

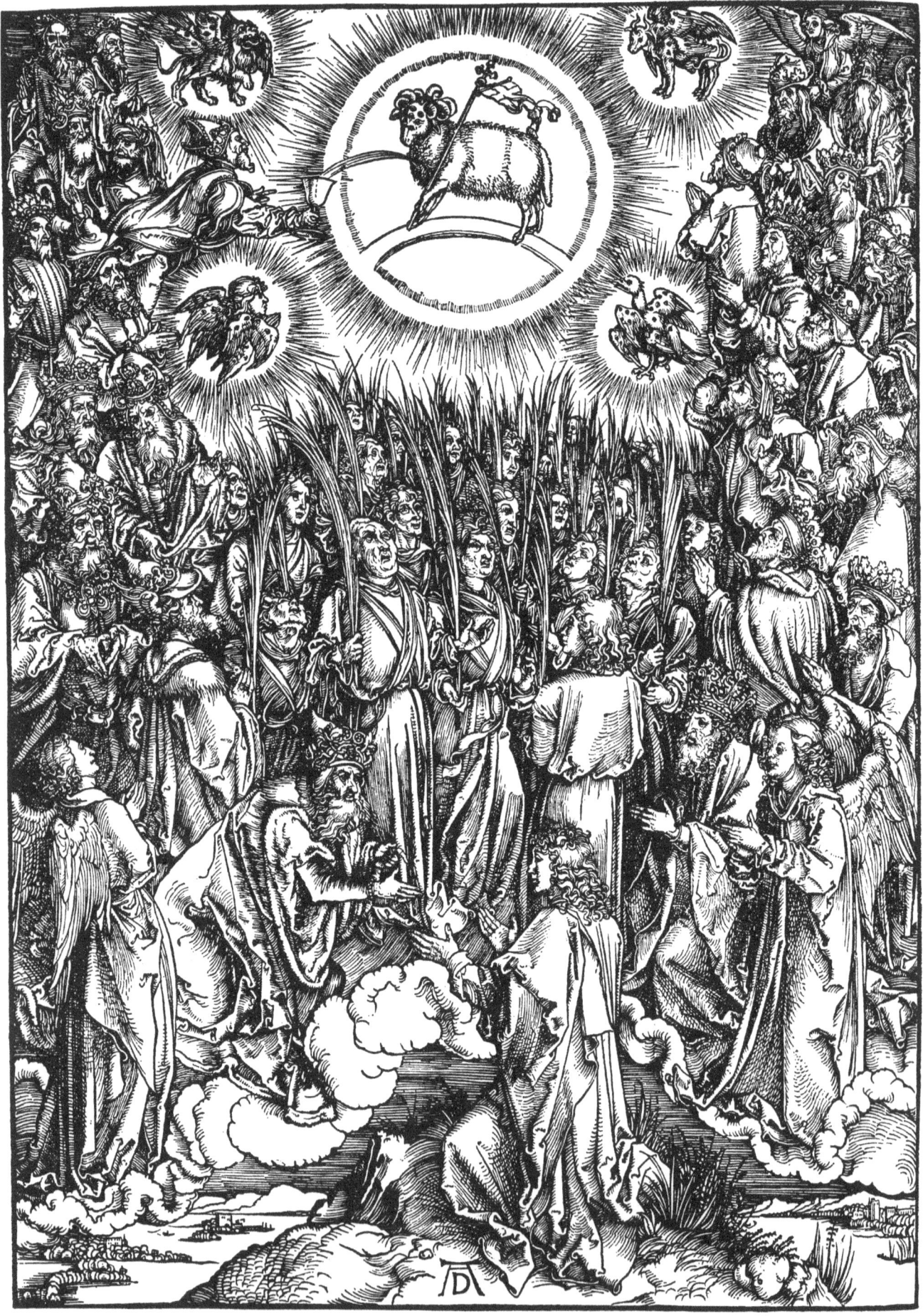

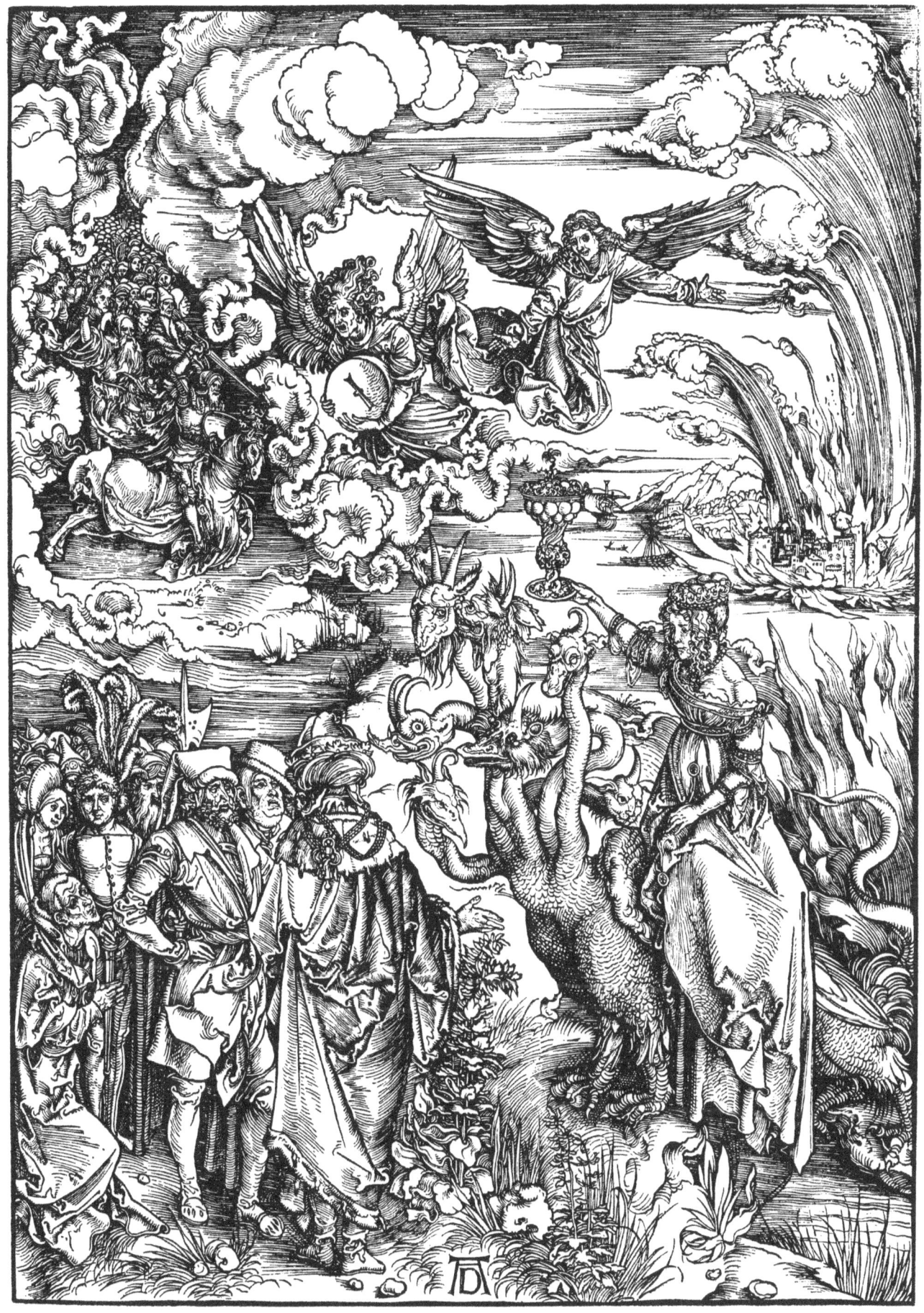

{ PAGE 99 }

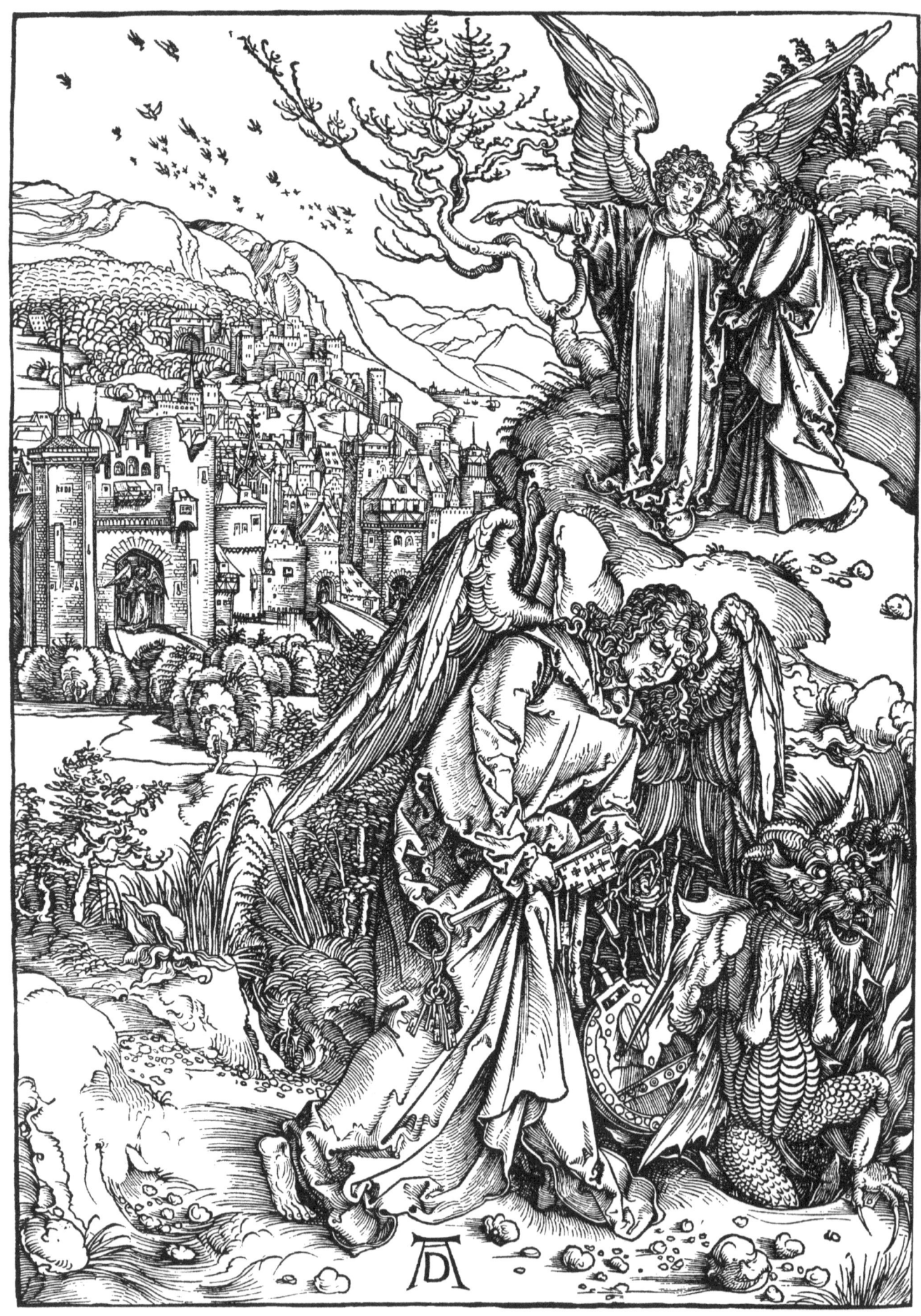

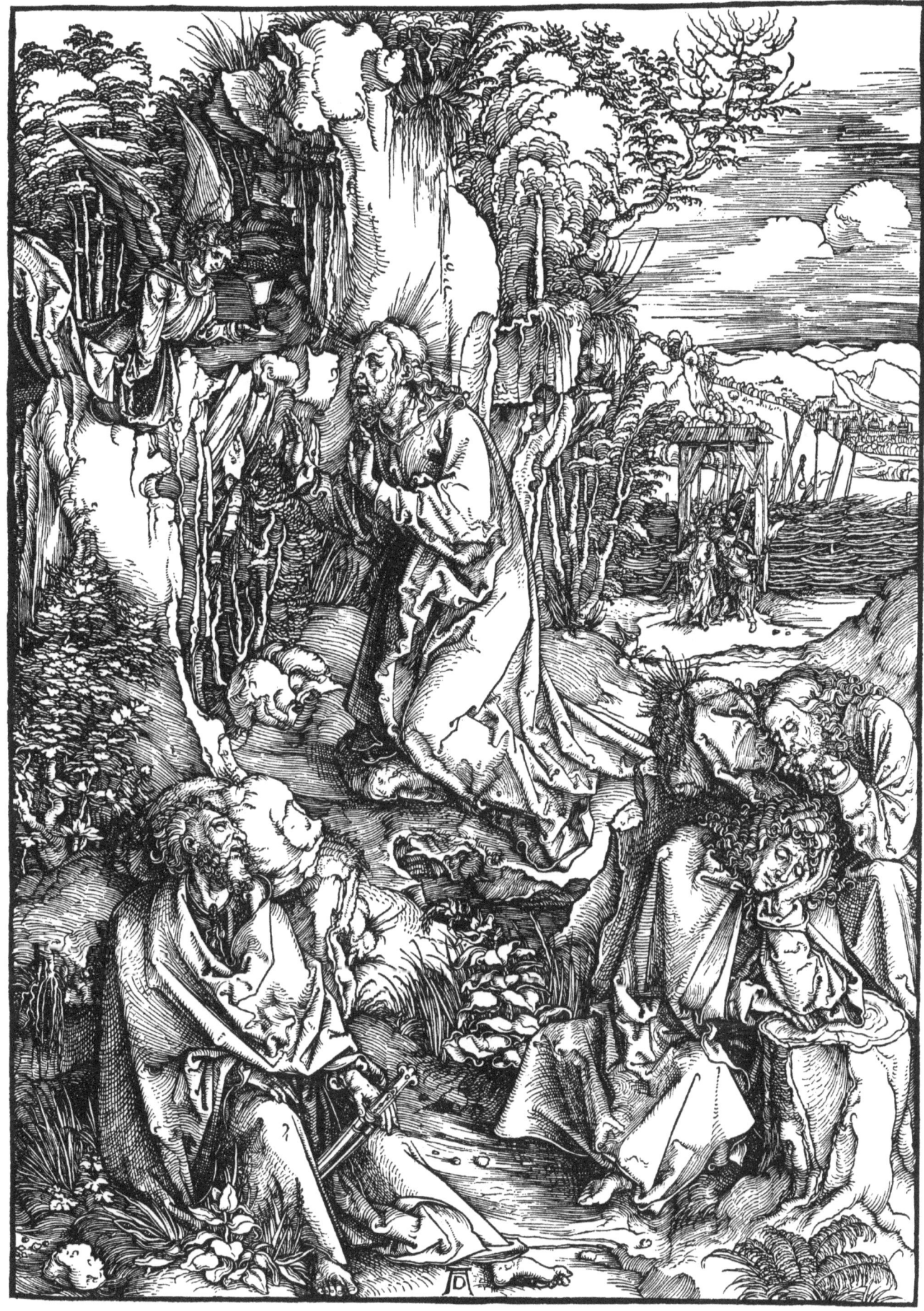

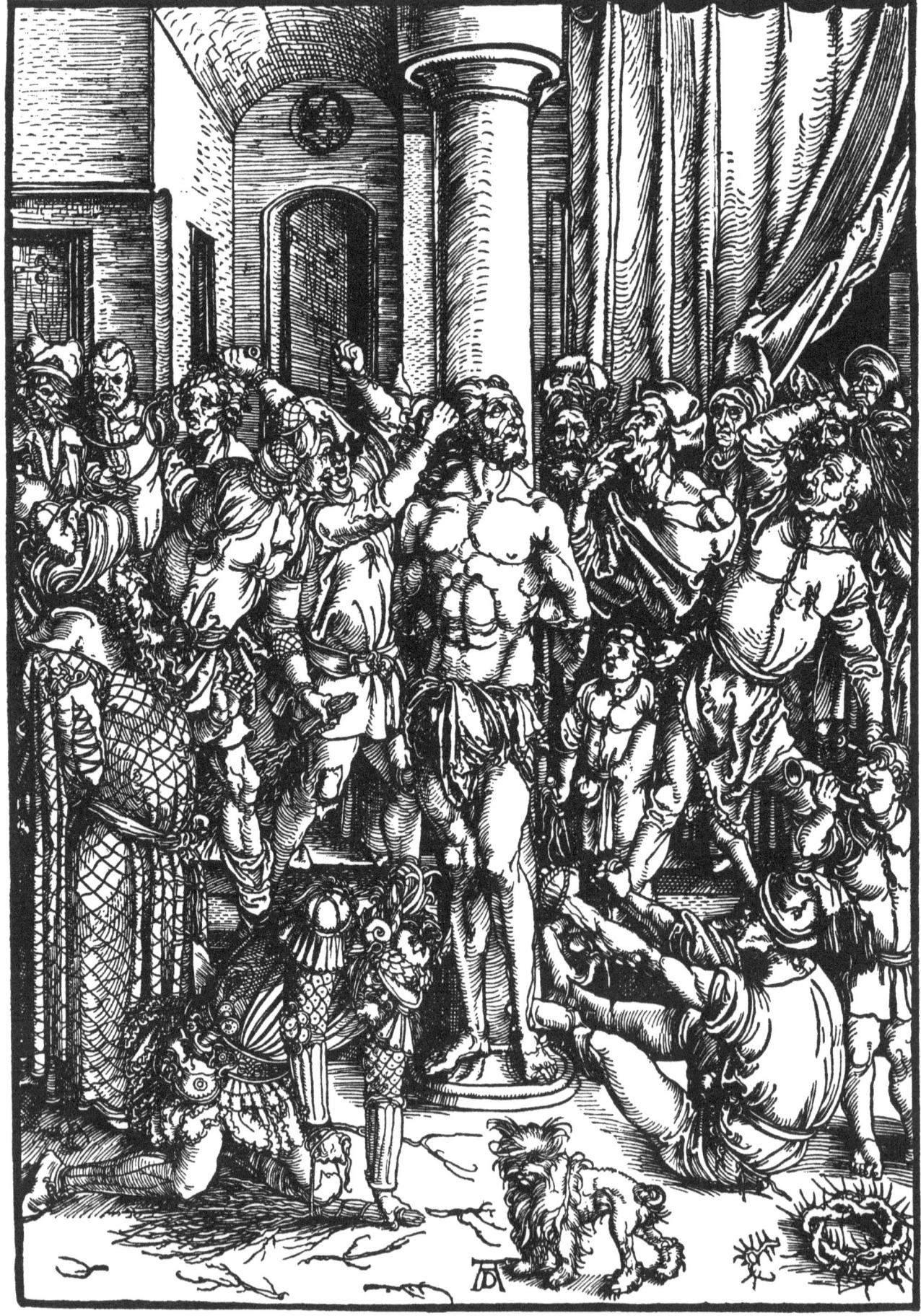

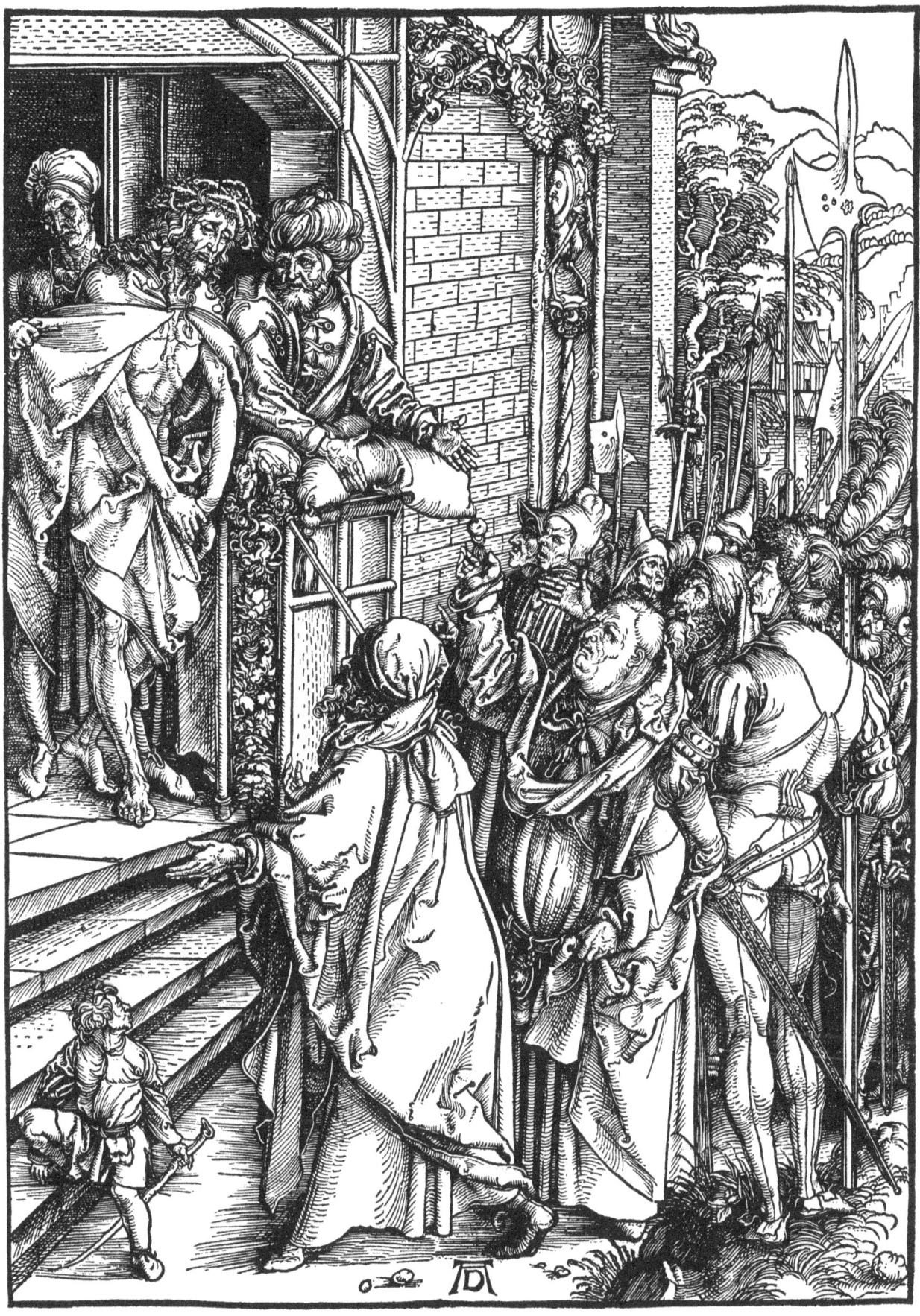

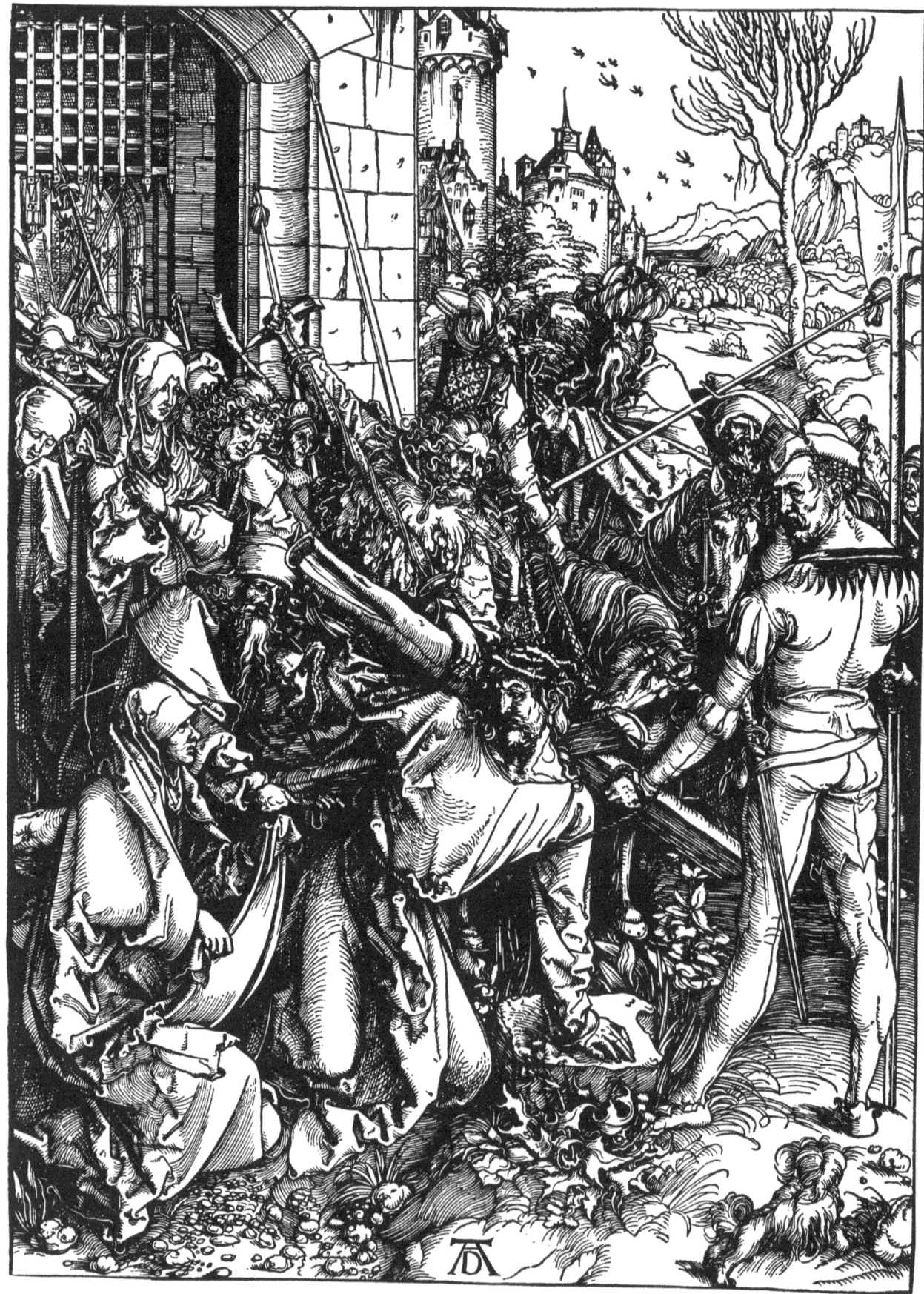

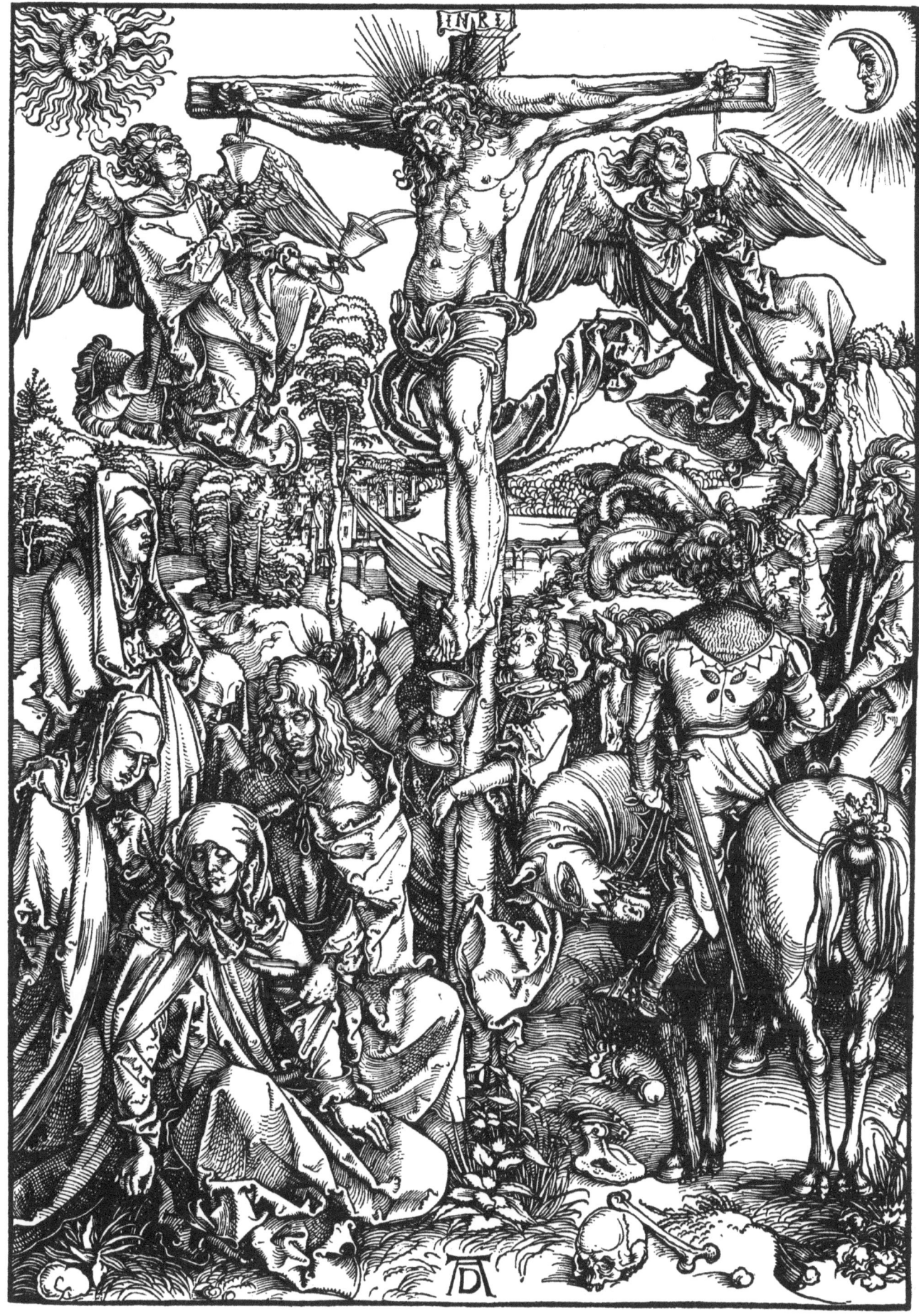

{ PAGE 105 }

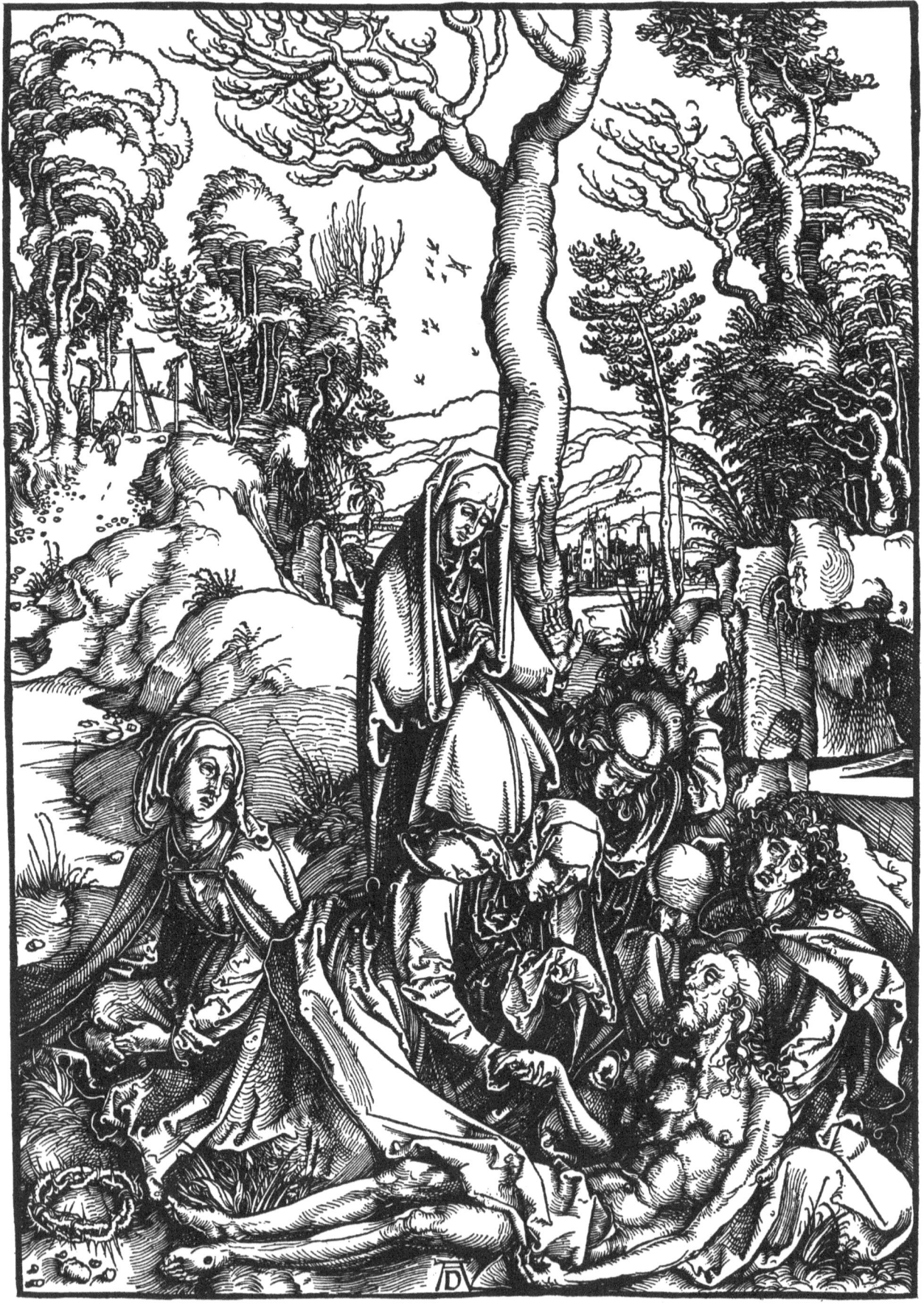

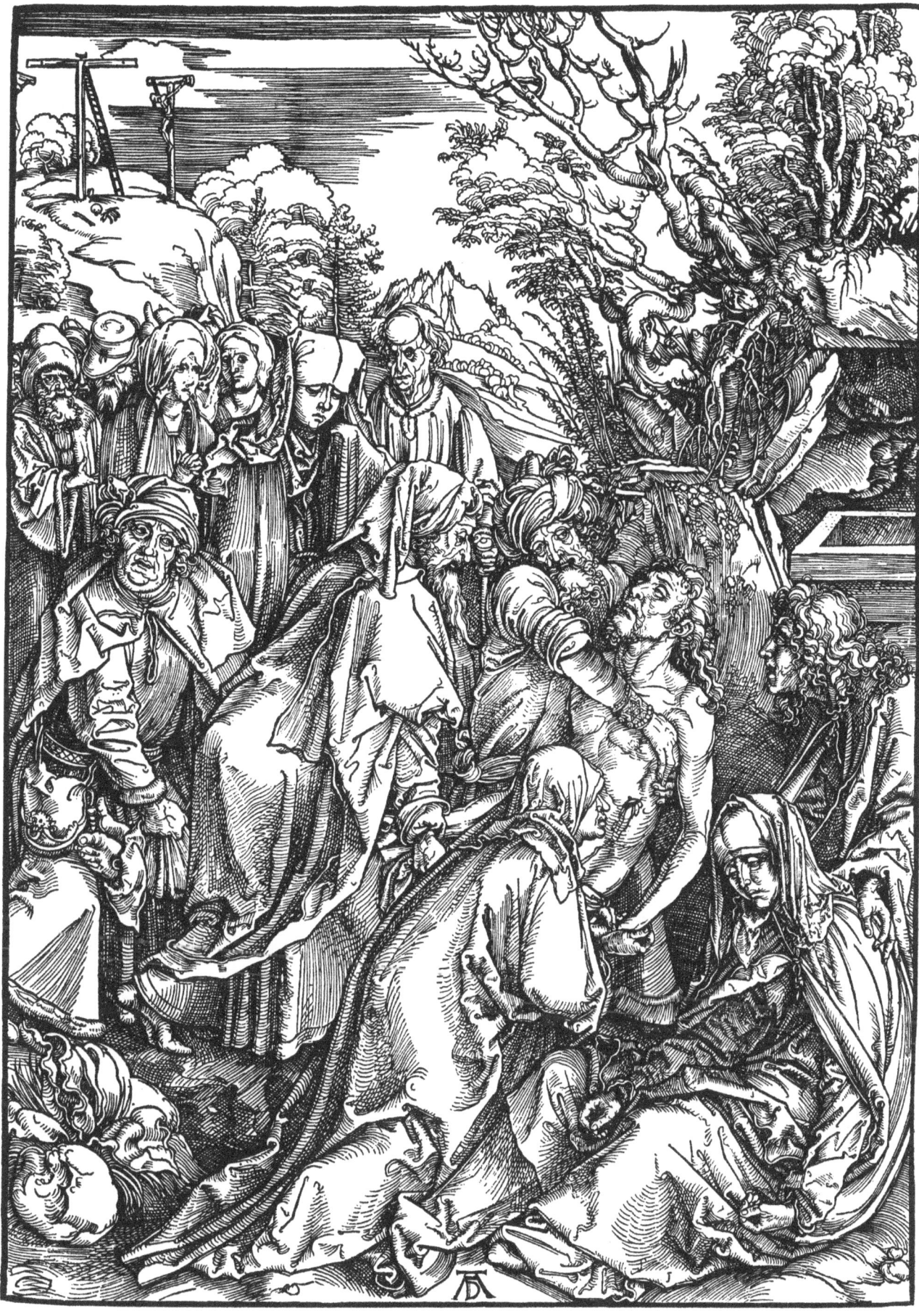

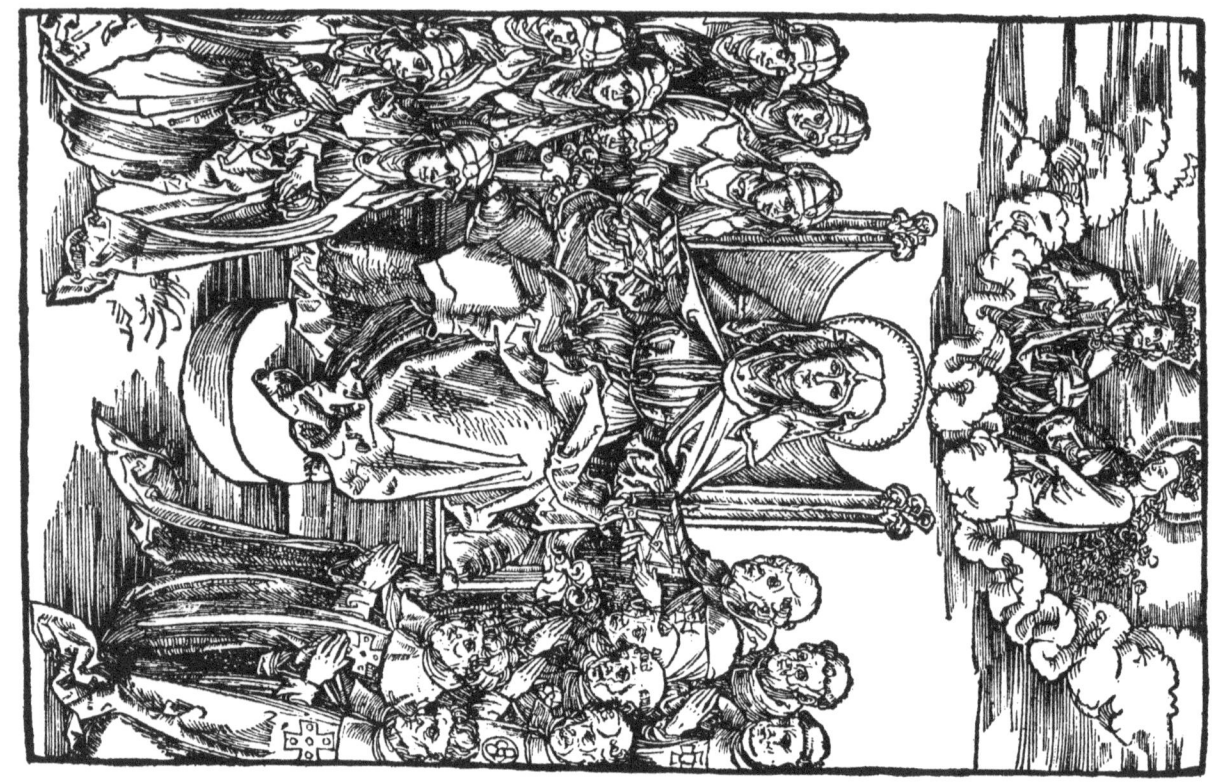

128

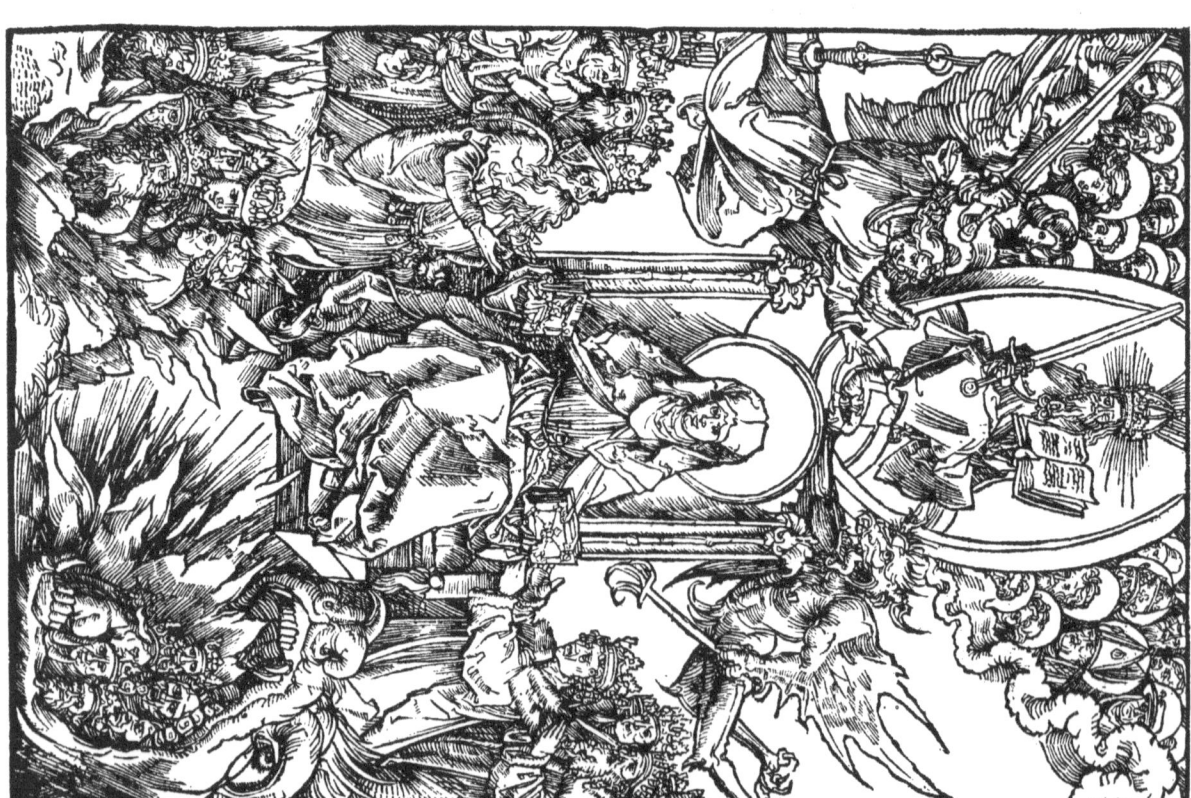

141

{ PAGE 109 }

Ich bin dein gott d mit
dir reden wil du solt dir
nit fürchten/wann ich
byn der schöpffer aller
ding vnd nit ein betrie
ger. Ich red nit alleyn
von dainē wegē sonder
vmb des hals willen al
ler cristen menschē. Du
wirdest sein mein gema
hel vnd mein redor/du
wirdest sehen vnd hörē
geystliche vñ heymliche
himlische ding vñ mein
geyst wirdt da bey dir
beleiben bis zū tod/wañ
ich wil dir als einē newē
werckzeūg zeigen vnnd
weysen newe vnnd alte
ding das die hoffertigē
gediemütigt vnd die die
mütigē glorificert vnd
erhöcht werdenn/vñ dz
die bösen gepessert vnd
die gutē noch pesser wer
den.

Ich byn der schöpffer
des himels der erde des
mers vnd aller ding die
darinn sein welcher ich
yetz mit dyr rede. Ich
hab dich auserwelt vnd
ich hab dich mir aufge
nomen zu einer gespon
sen das ich dir zeige mer
ne heimliche ding/wañ
es mir also gefellt. Auch
bist du aus besun erm
rechten mein wordē/als
du im tod deines mans
hast deinē wille in mein
hend gebē vnd gewellt
alle ding vmb mich ver
lassen. Darüb must ich
dich vmb so grosse lieb
fürsehenn. Darüb so an
nym ich dich mir zu ei
ner gespōsen vñ in mein
aygne wollustung wie
gott zūmbt zehaben mit
einer keüschen sel.

Heilige Gespons Cristi
Birgitta

Bitt gott für vns

134

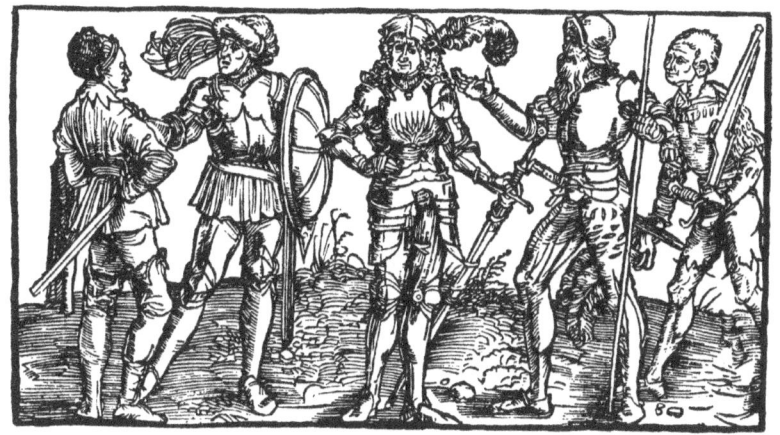

135

132 133

136

138

137

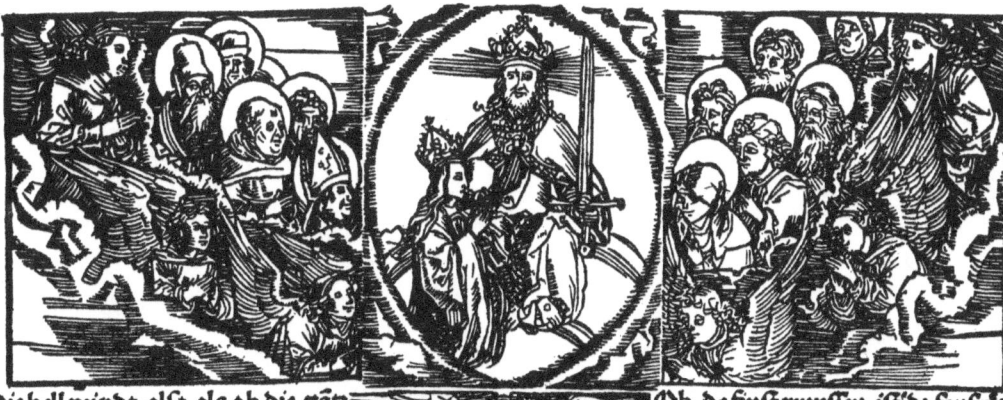

Die hell pundt also als ob die gātz welt pūm mit allen dingen so wer es ir nit gleich do vahen an all mit wee vñ ð gleich endē. In iren vmb kreyß sein vinsternussen vñ wirdt genant die vorhell vnnd sein doch ein hell, welher dohin kumbt wirt nymmer haben wonung bey gott.

Ob de finsternussen ist dz fegfeir do ist die berūrung der teufel da er scheynen durch gleichnuss gifftig würm wilde greuliche tier hitz kelt rc. hergeend vō ð pein ð hell. Ausser halb ð ist ein andre stat do kein andre pein ist dañ gepuch der sterck noch auffhōrender kranckheit.

Die drit stat ist, do kein andre pein ist dann nur begird zu komē zu got vñ seier seligē anschawūg vñ darūb all sel in den dreyen steten wonend nemē tal vō den gutē werckē der heiligē kirchē vñ in sund heit vō irē freundē.

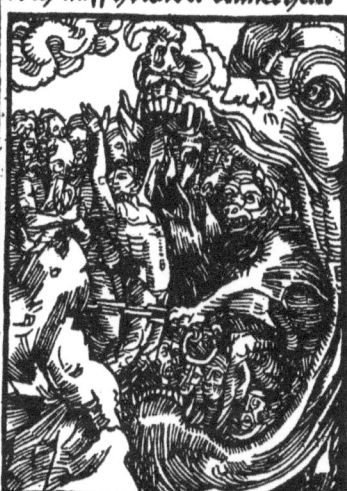

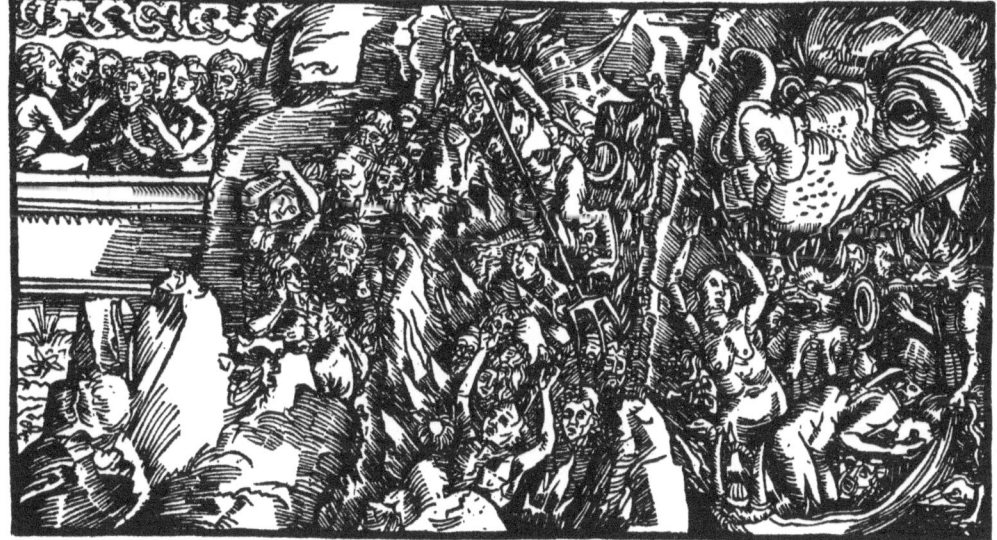

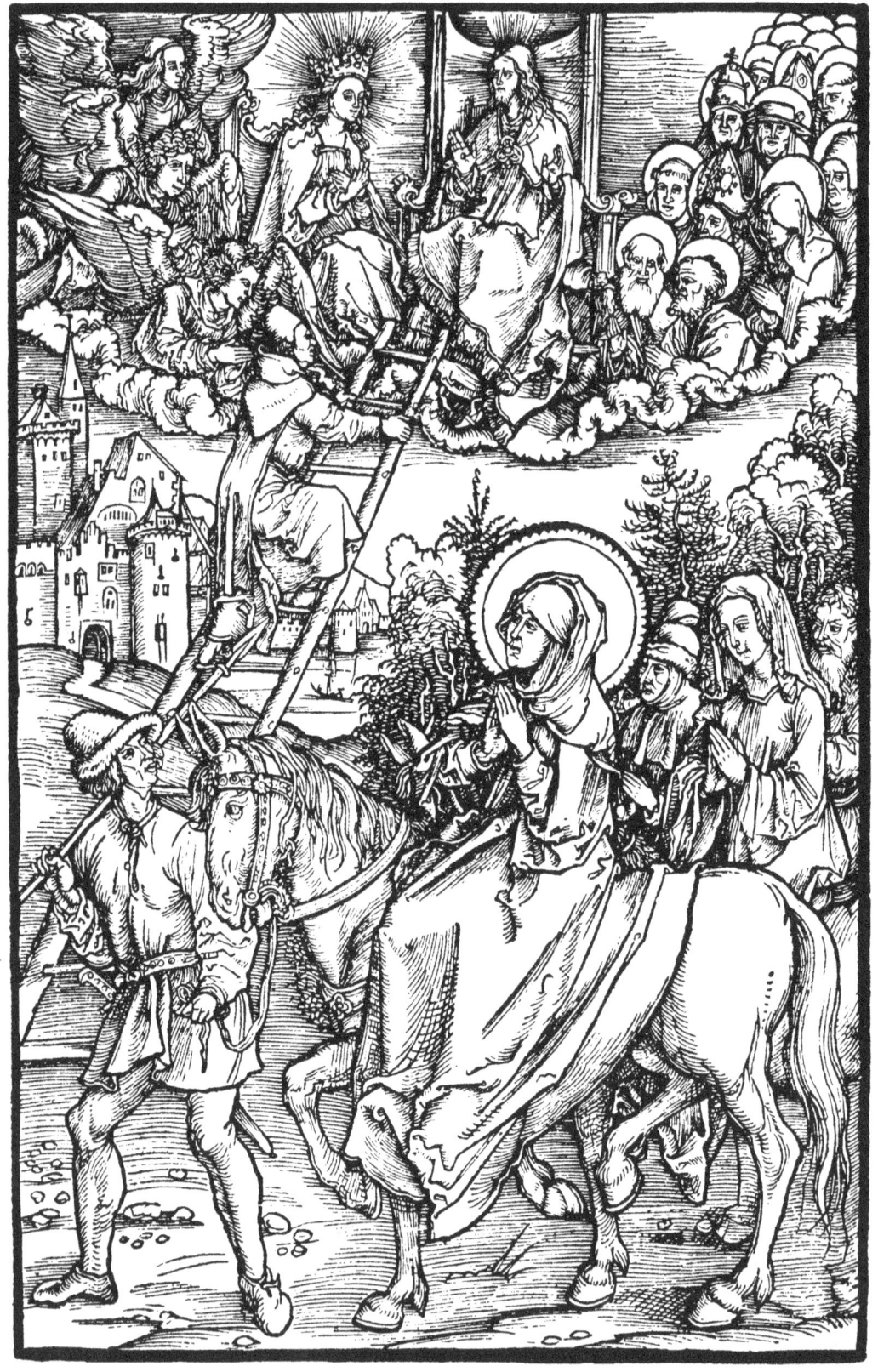

{ PAGE 114 }

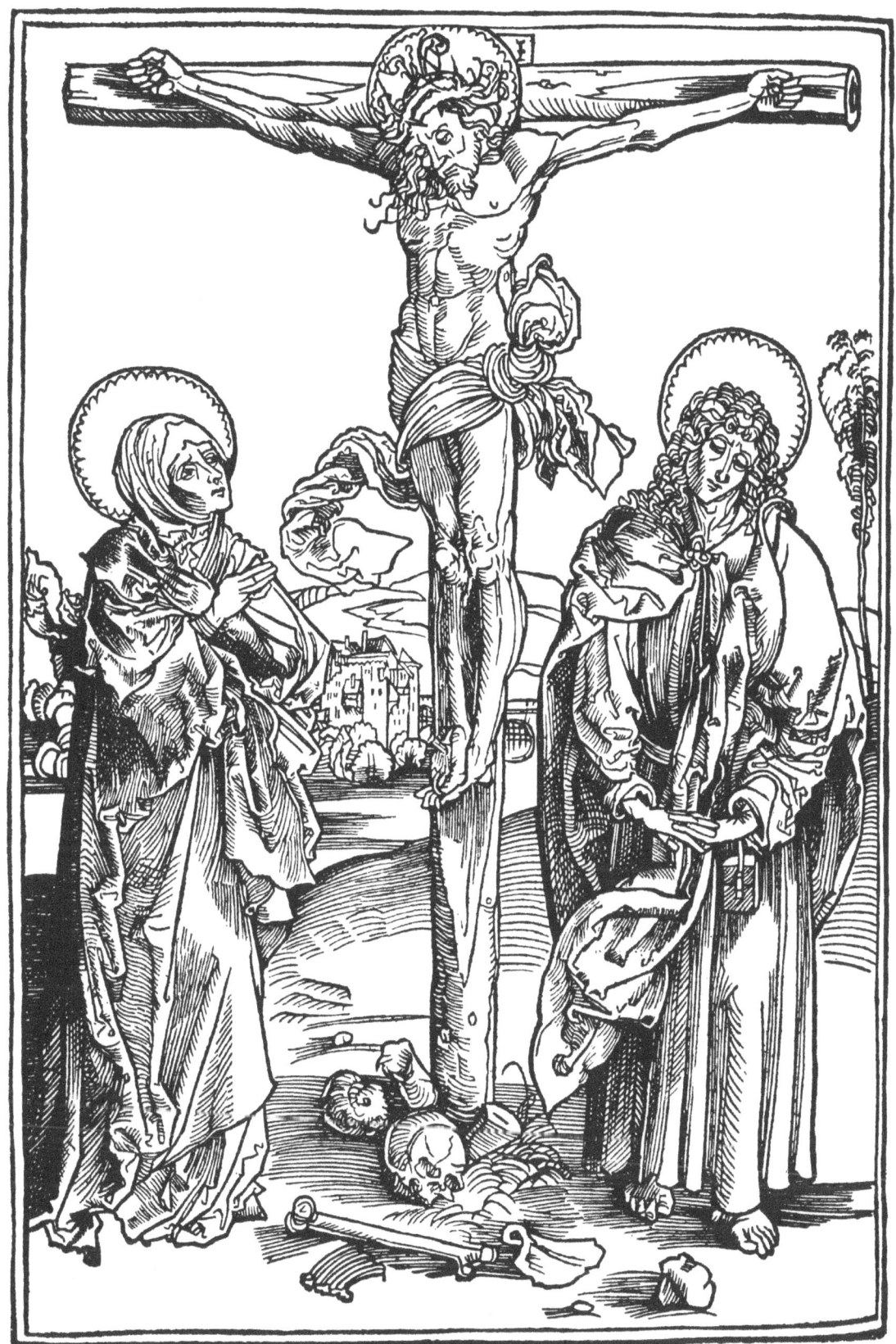

Plate 141 is printed together with Plate 128

{ PAGE 115 }

143

144

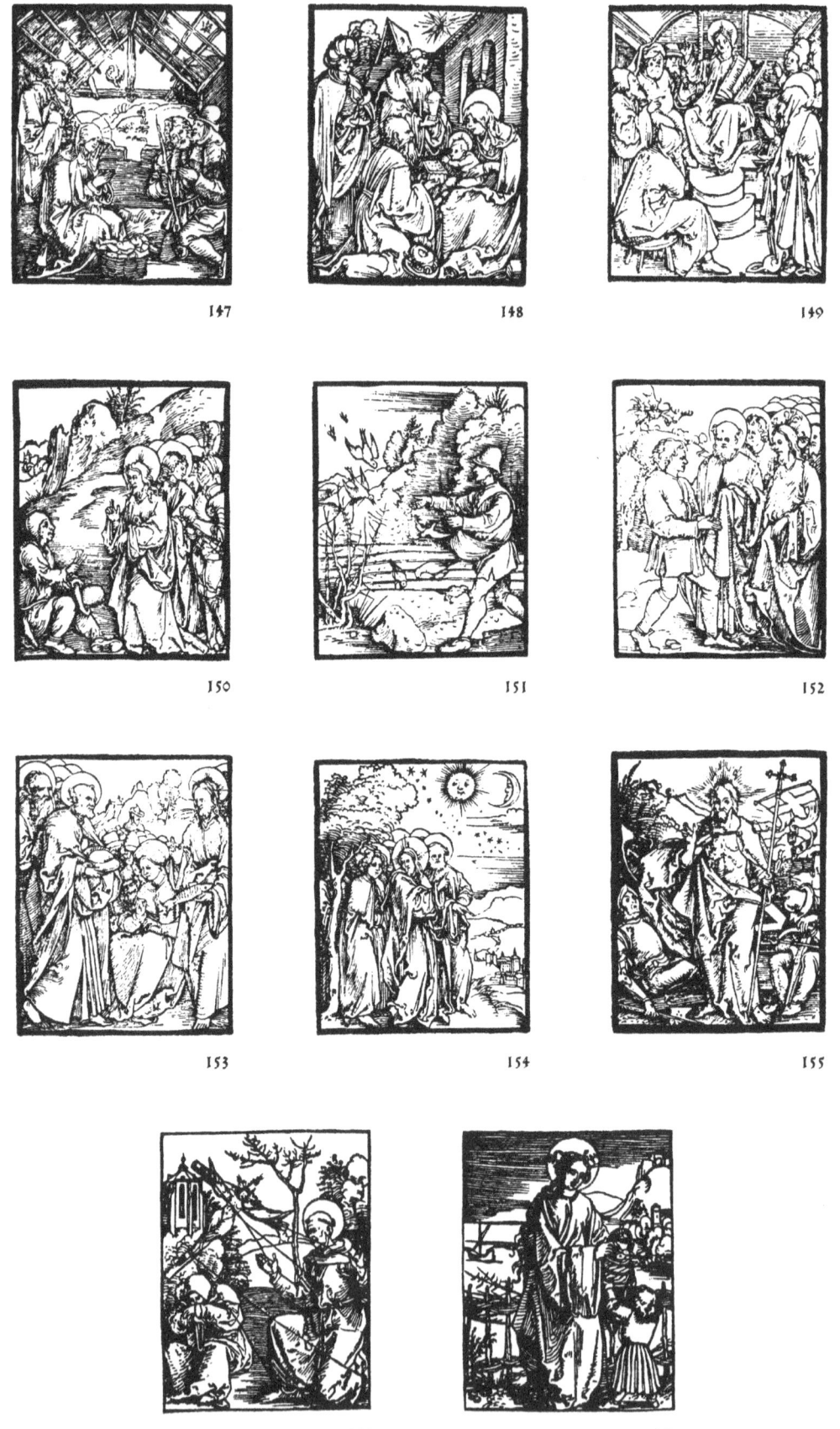

158

159

160

161

162

163

164

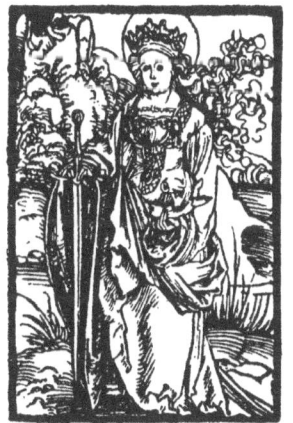
165

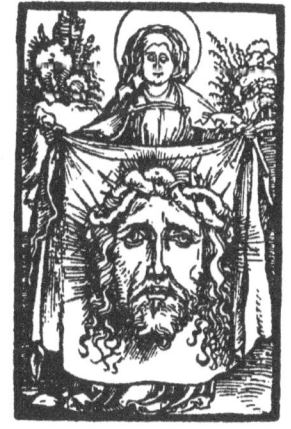
166

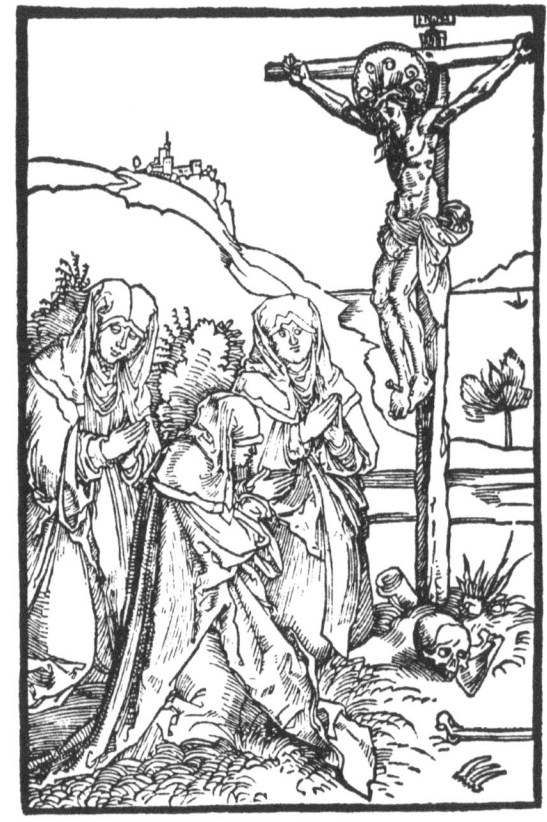

167

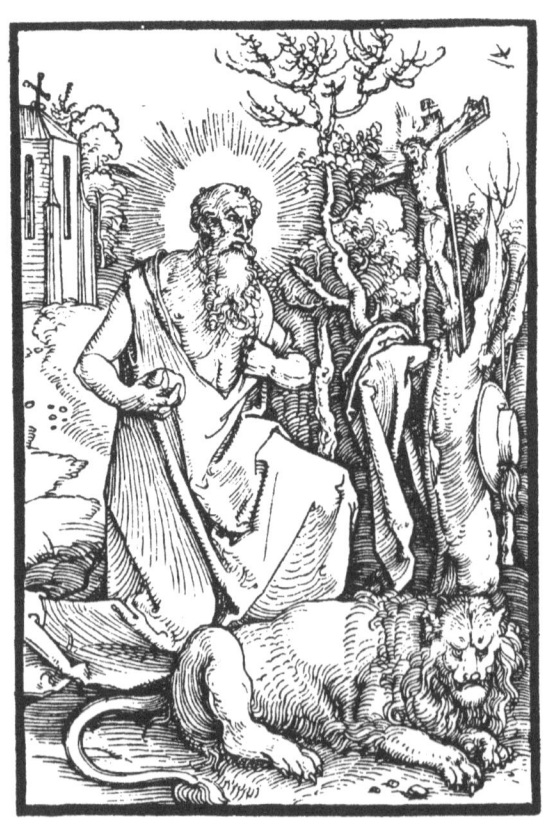

168

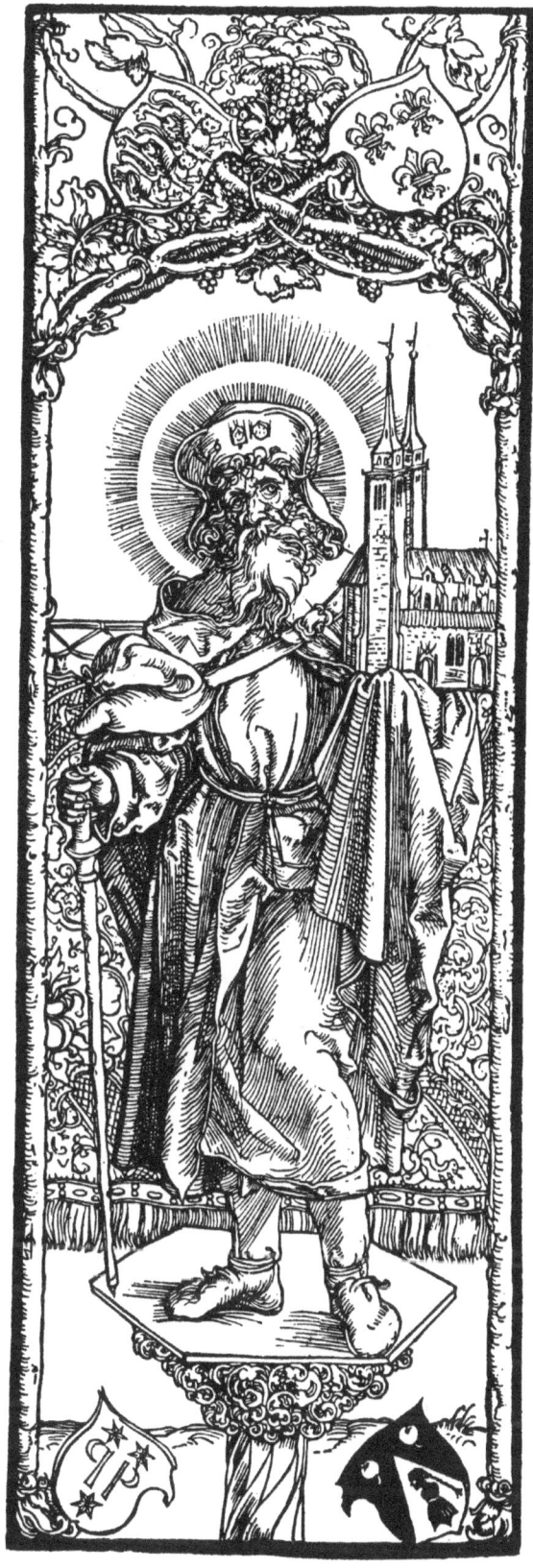

169

172

171

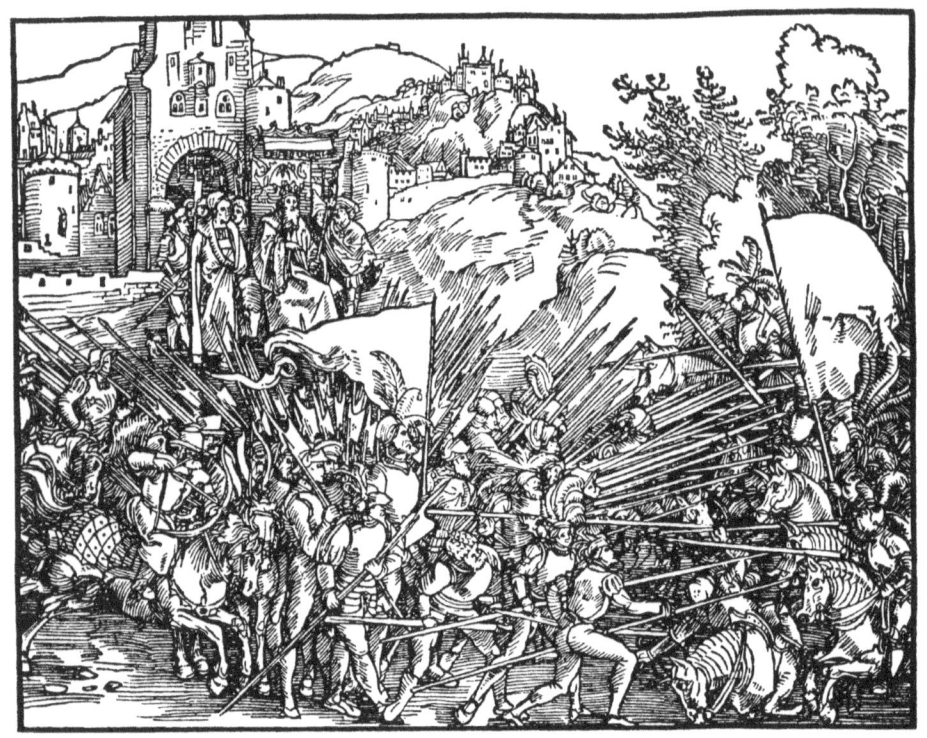

173

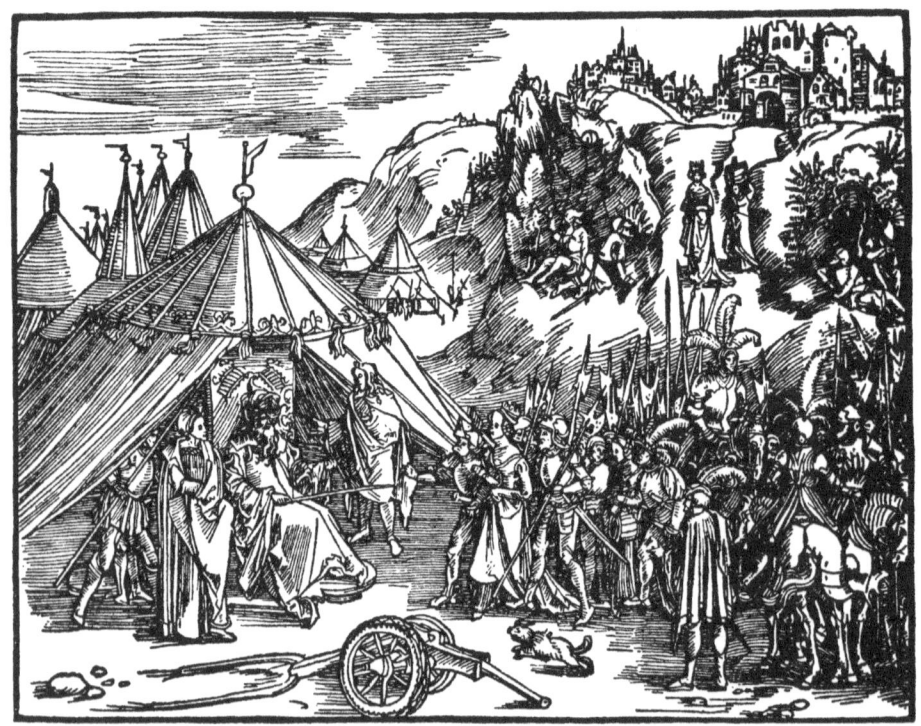

174

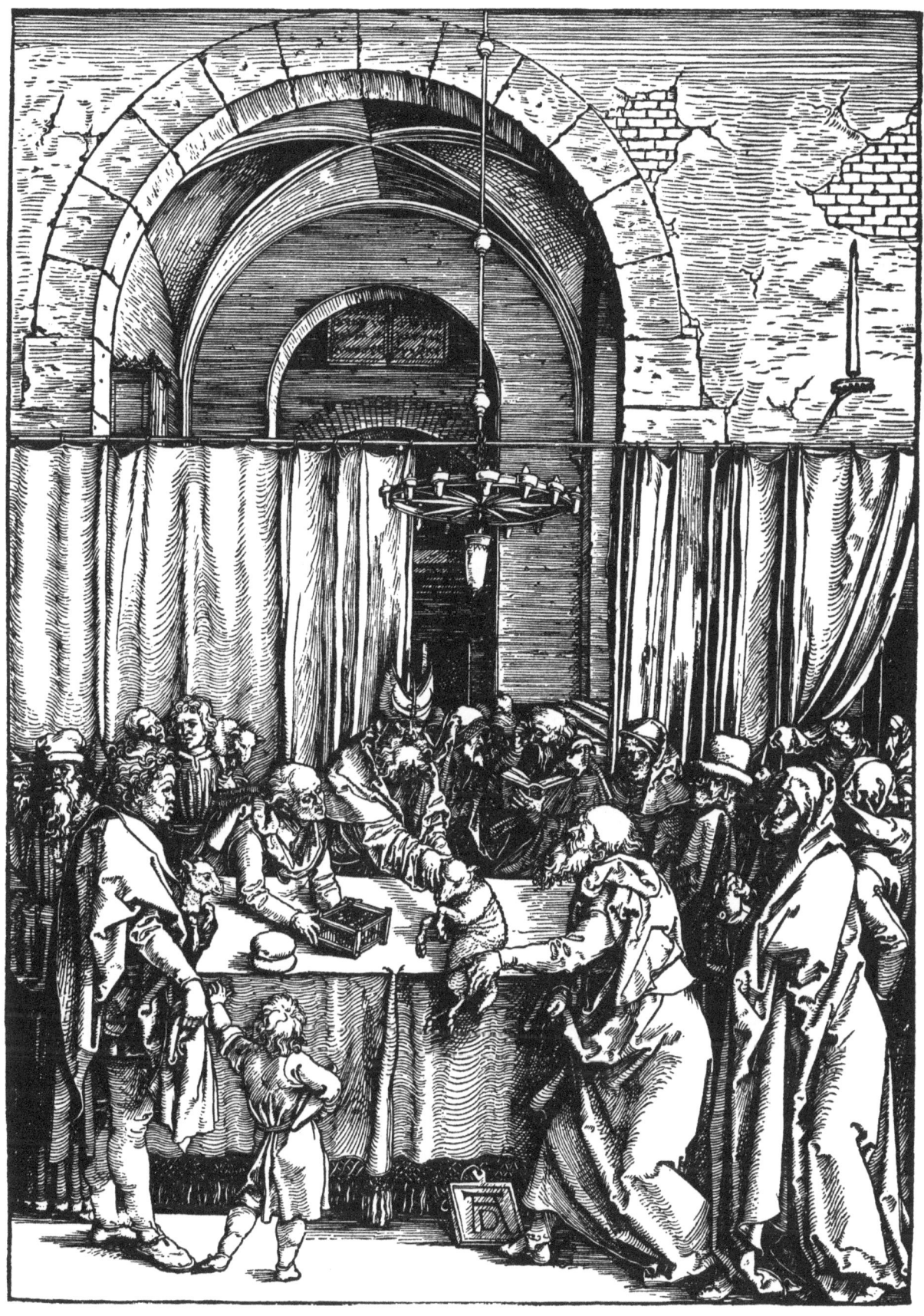

{ PAGE 125 }

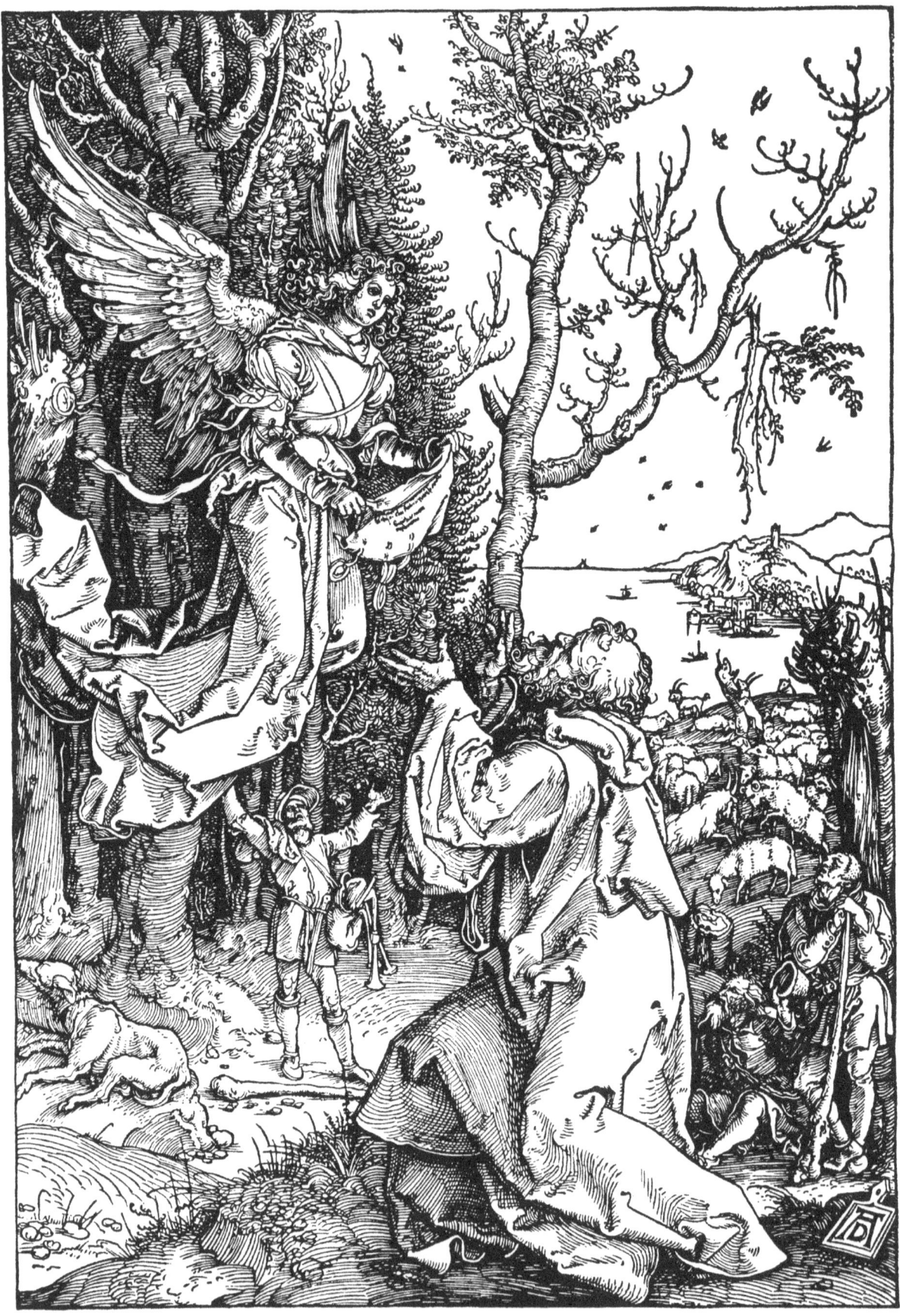

{ PAGE 126 }

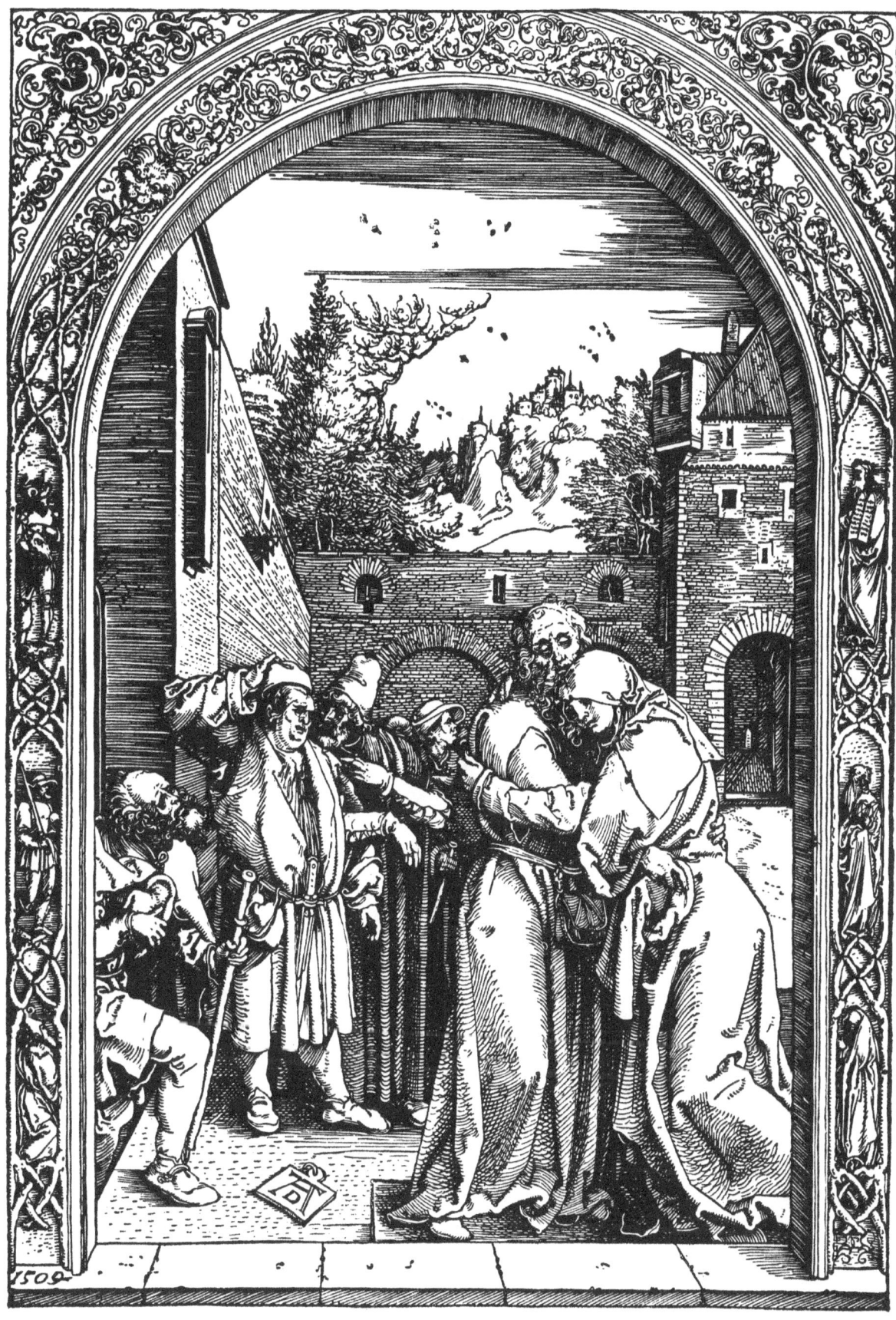

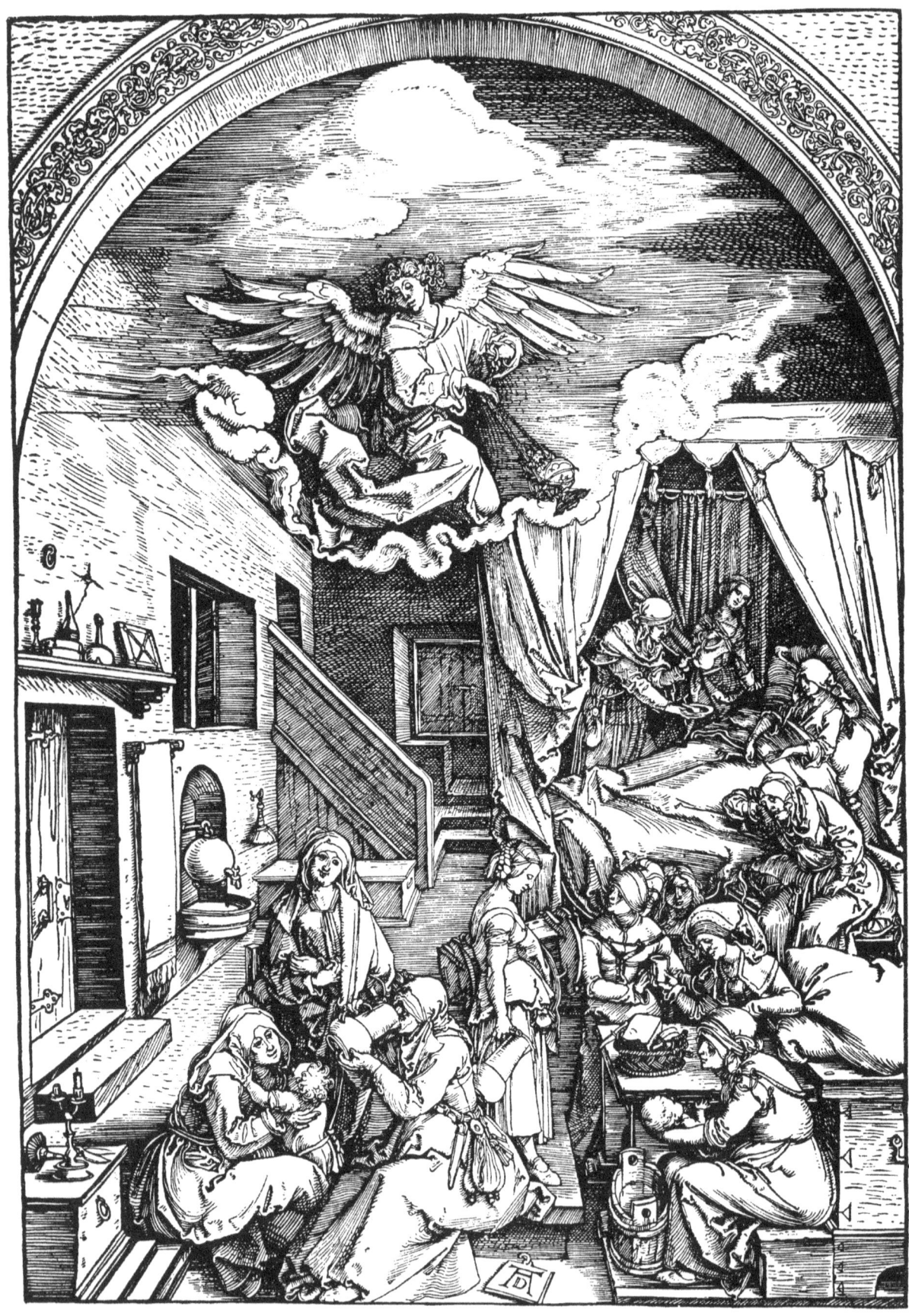

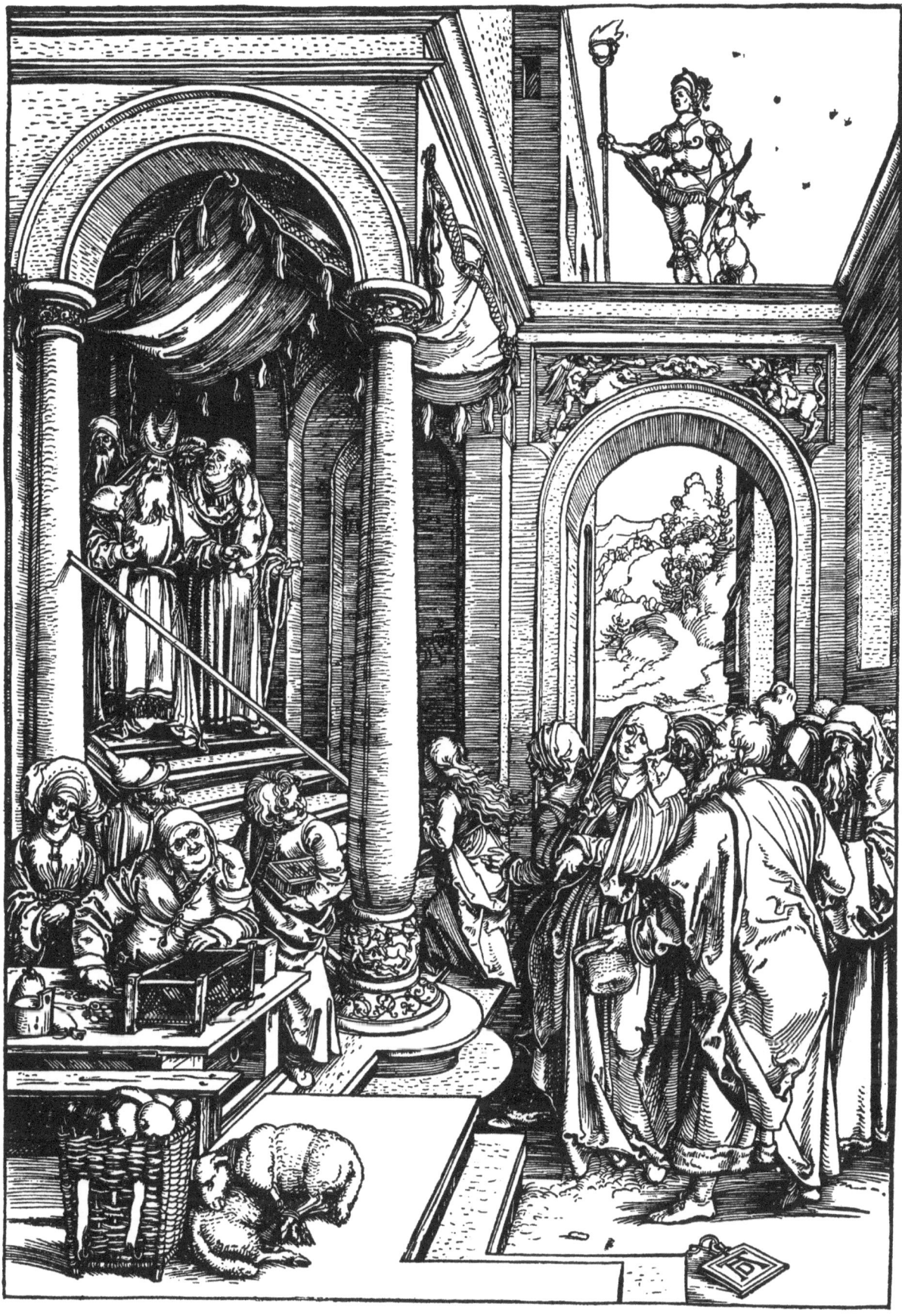

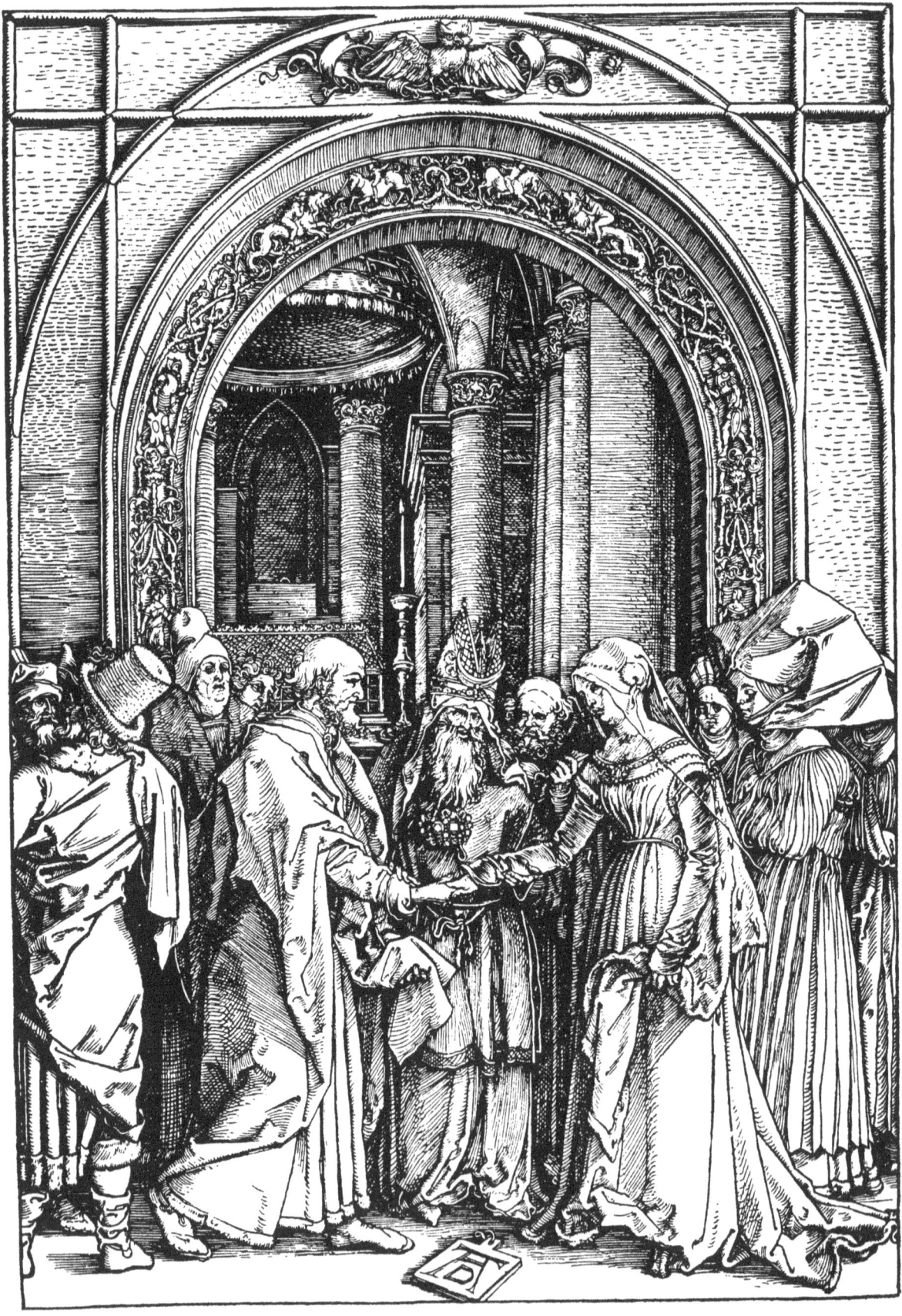

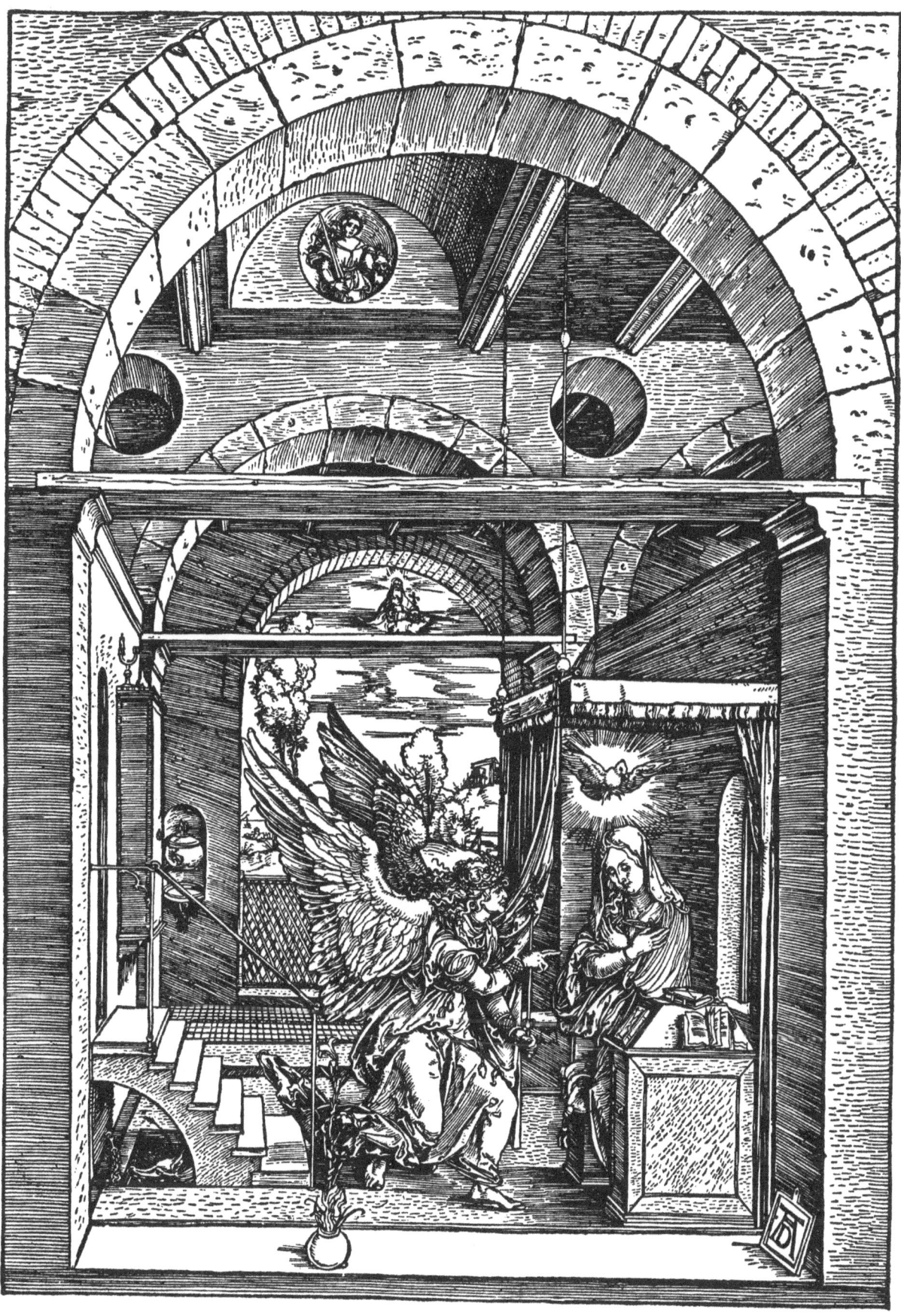

{ PAGE 131 }

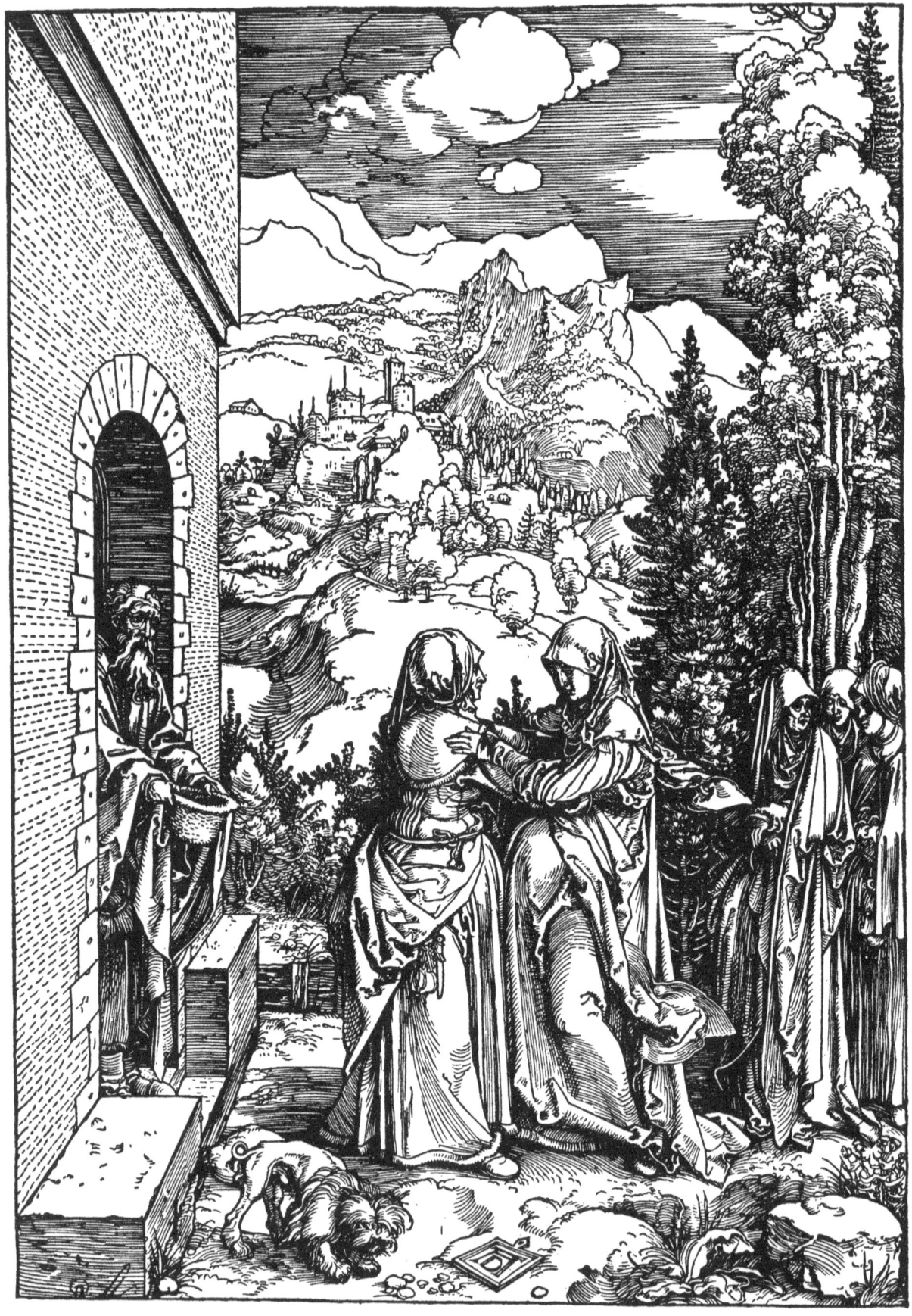

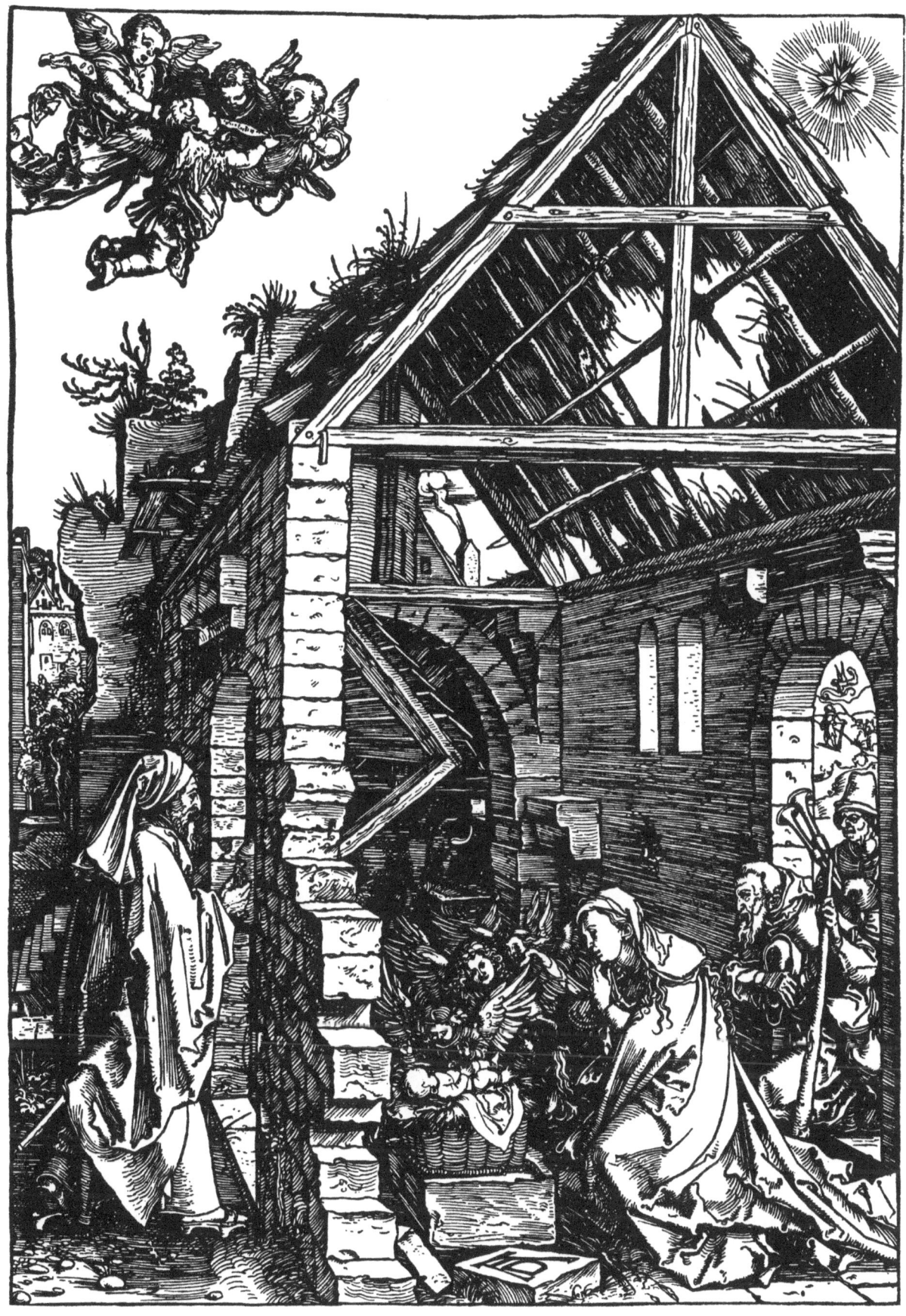

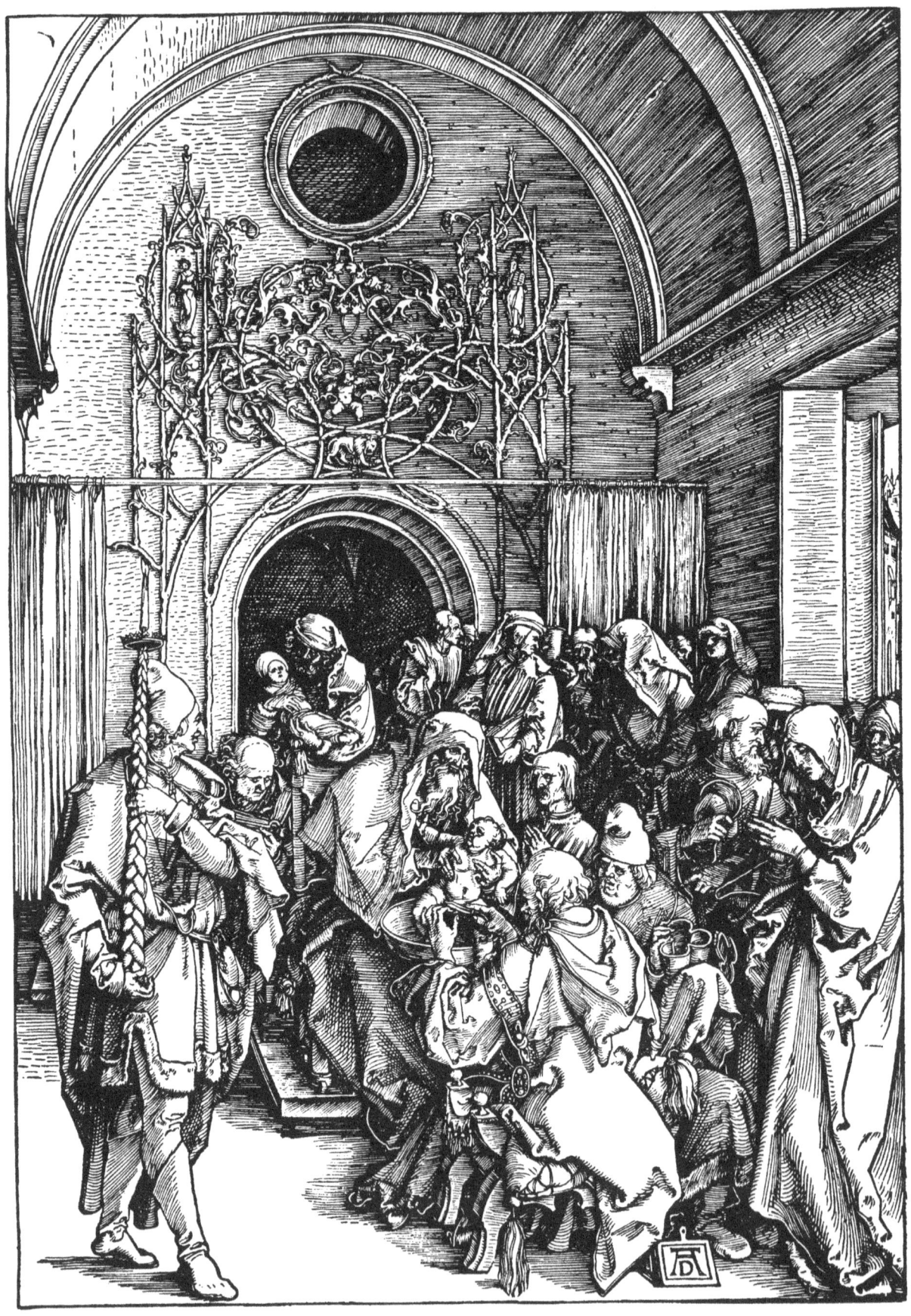

{ PAGE 134 }

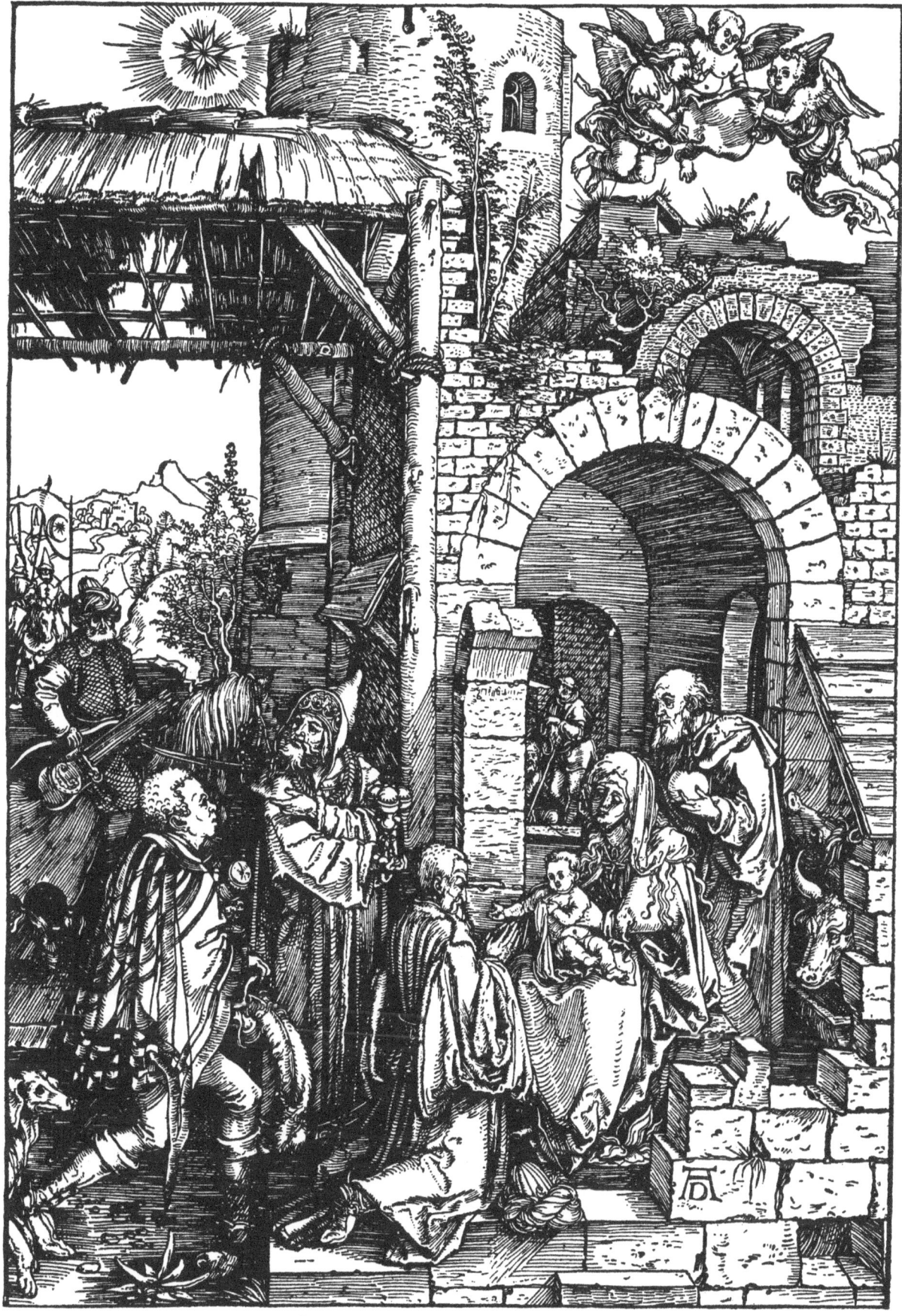

{ PAGE 135 }

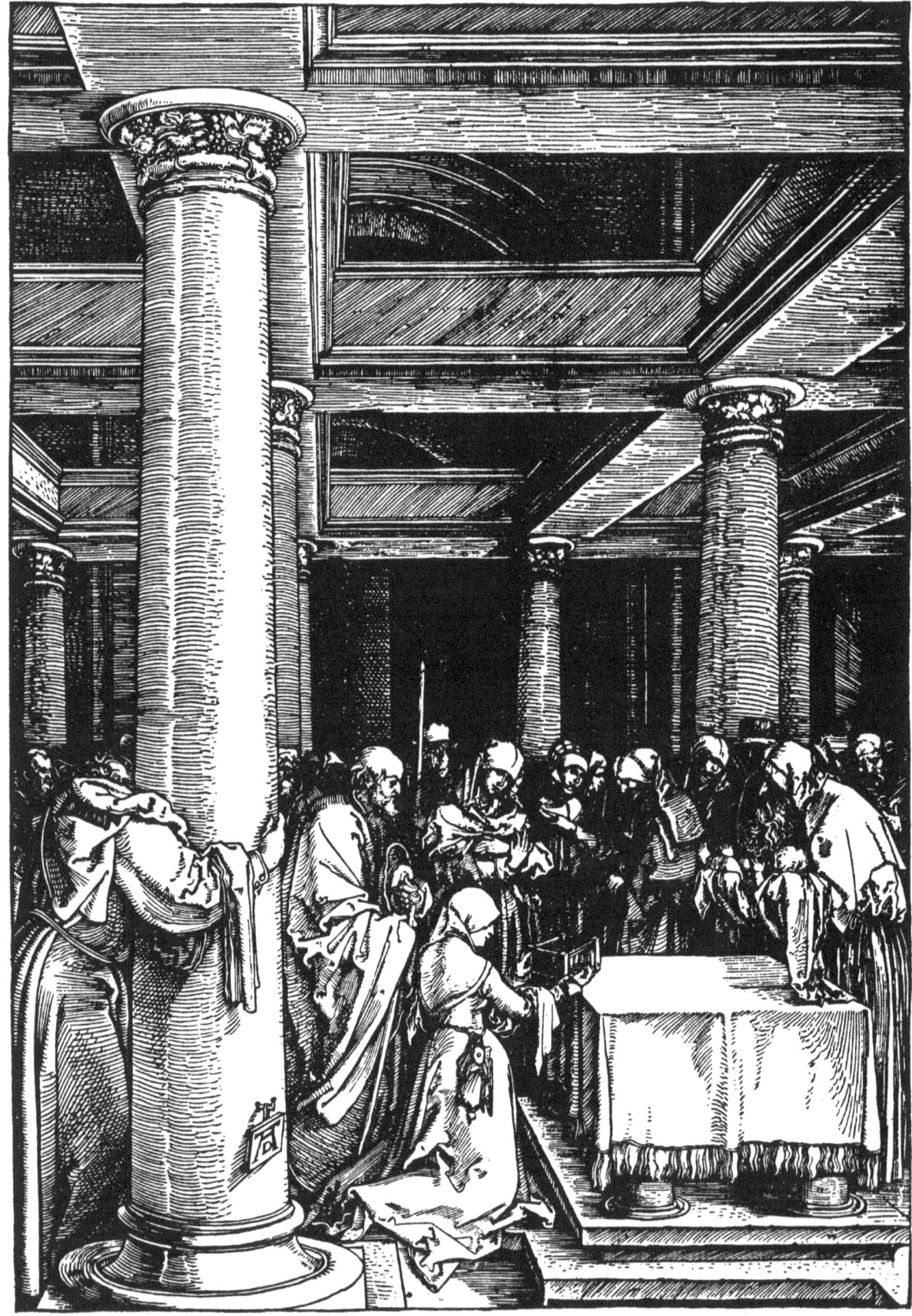

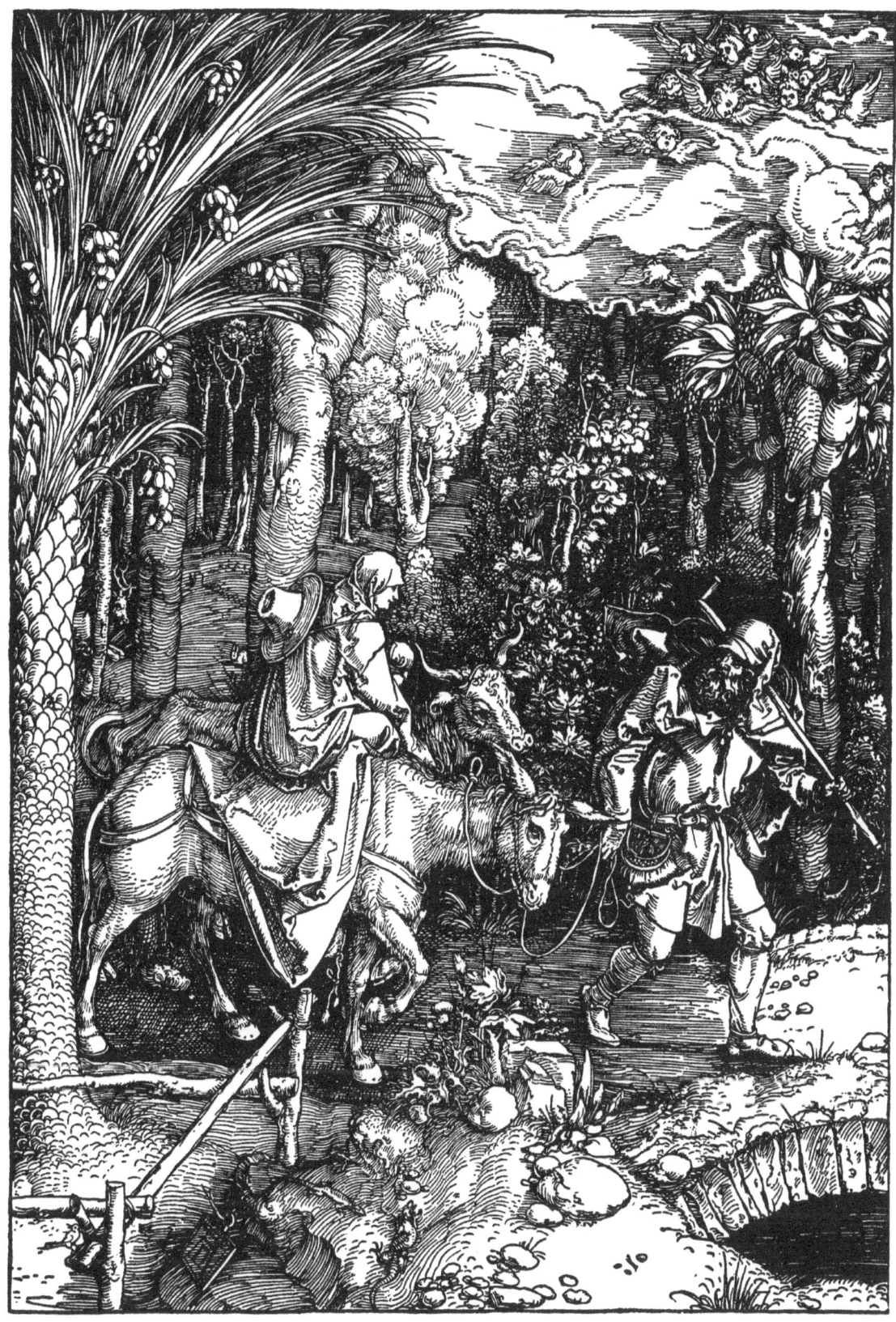

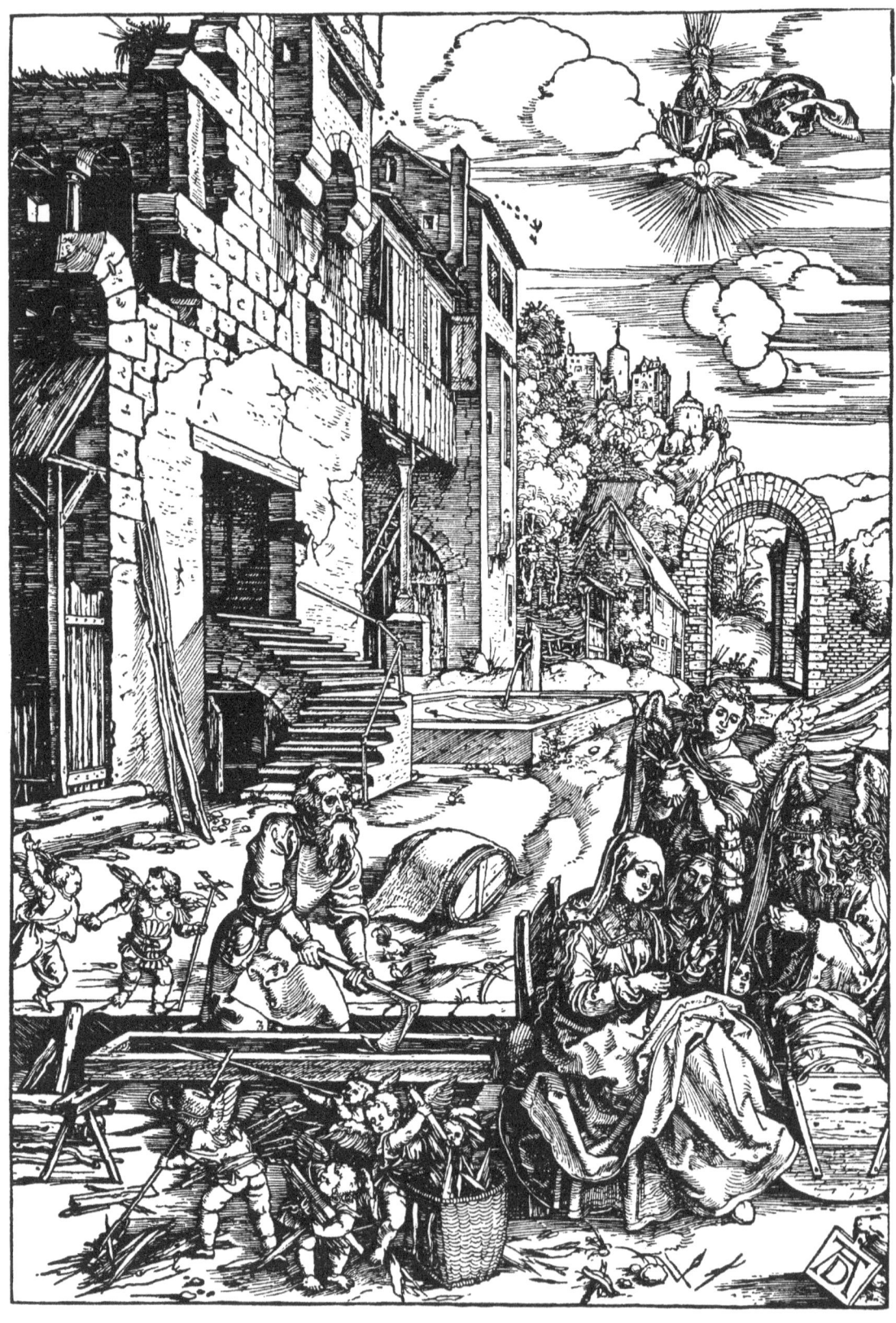

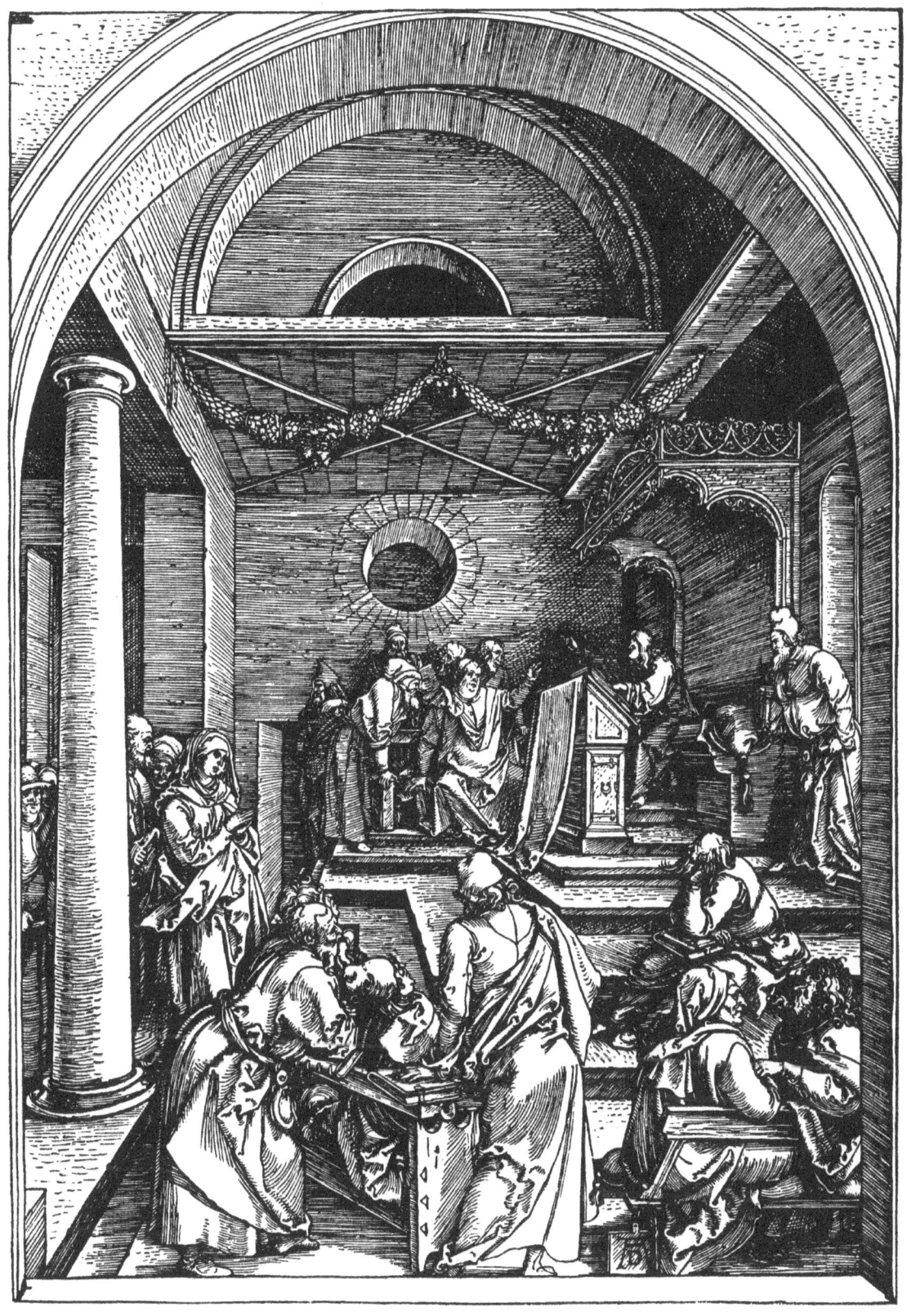

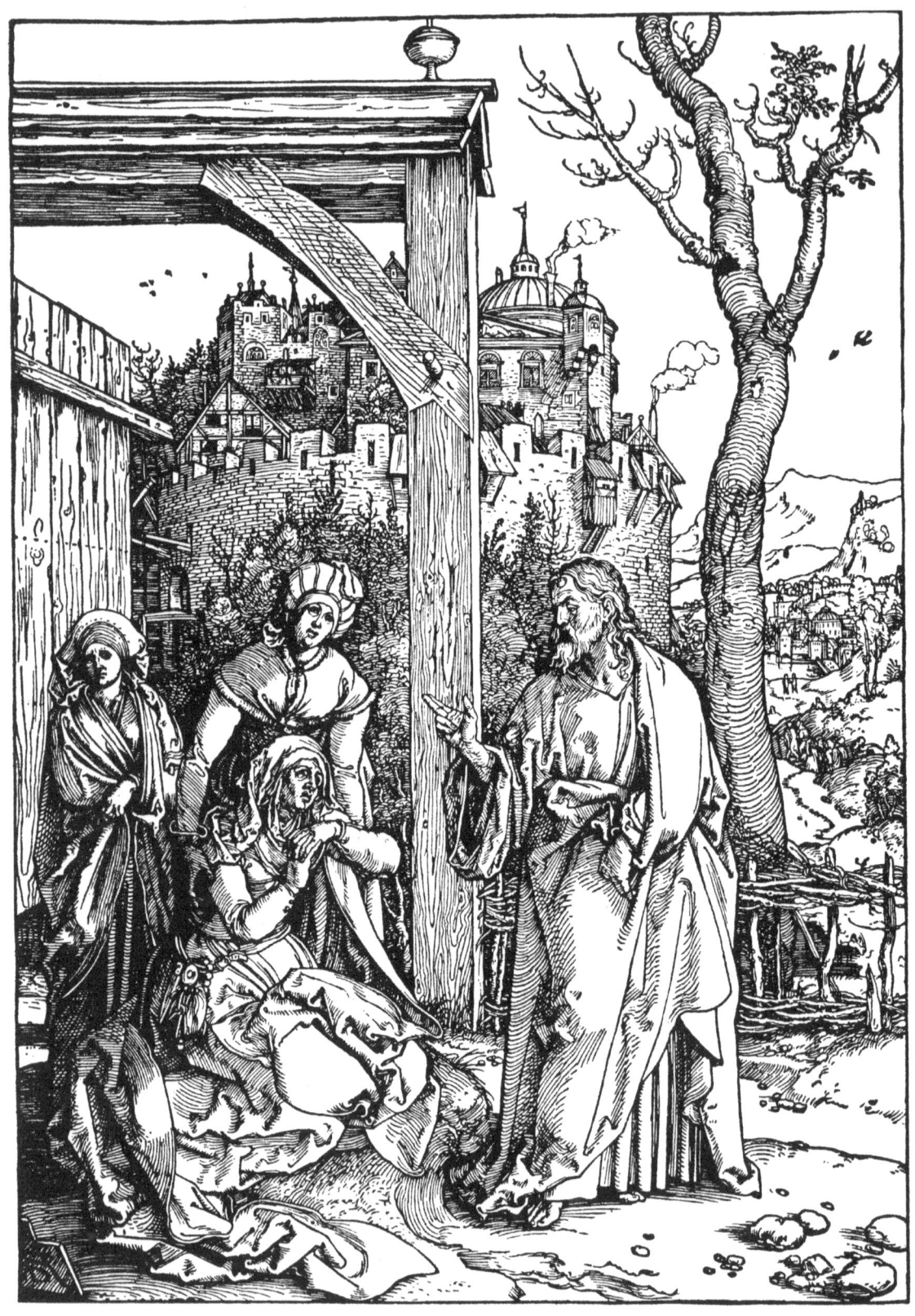

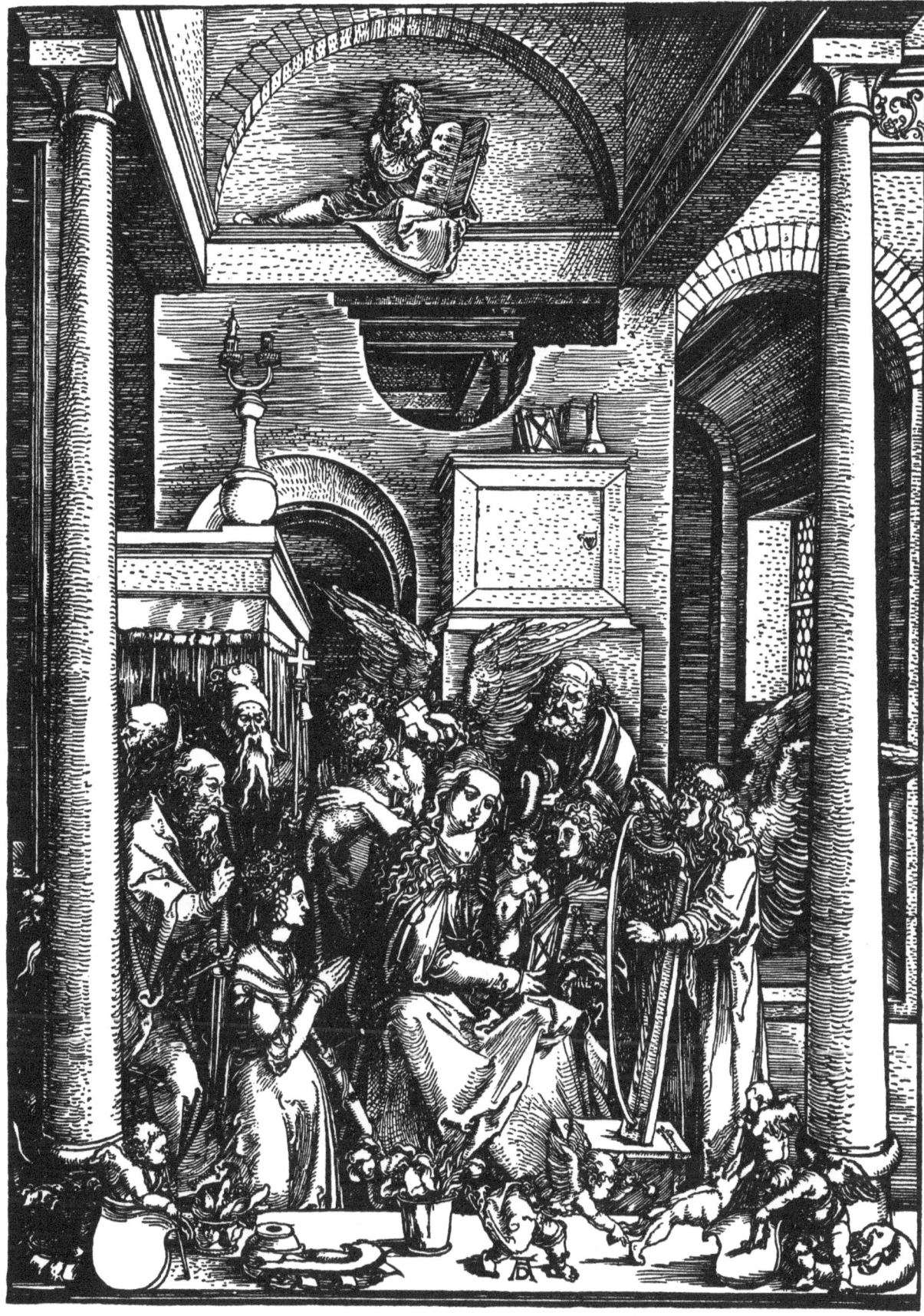

{ PAGE 141 }

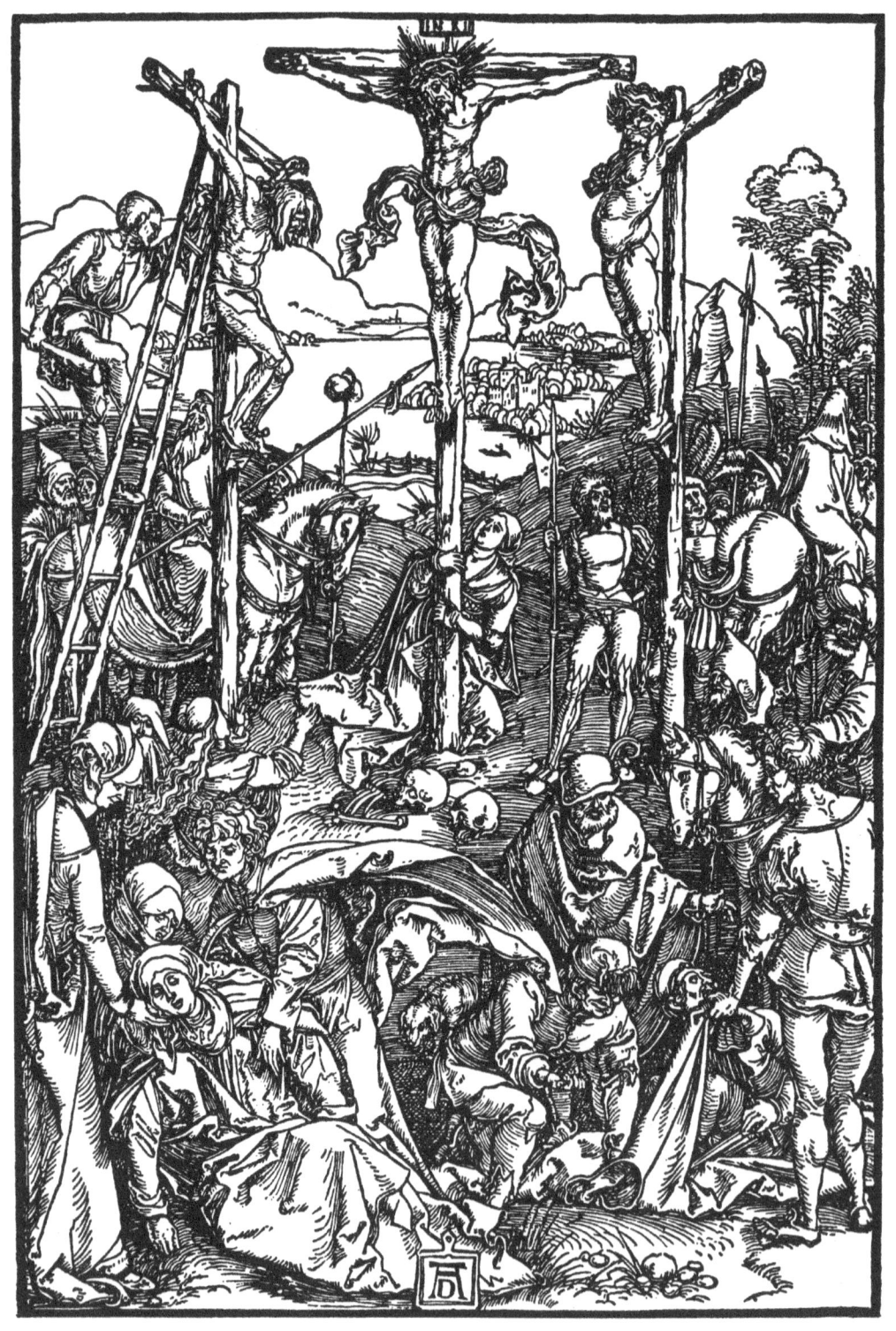

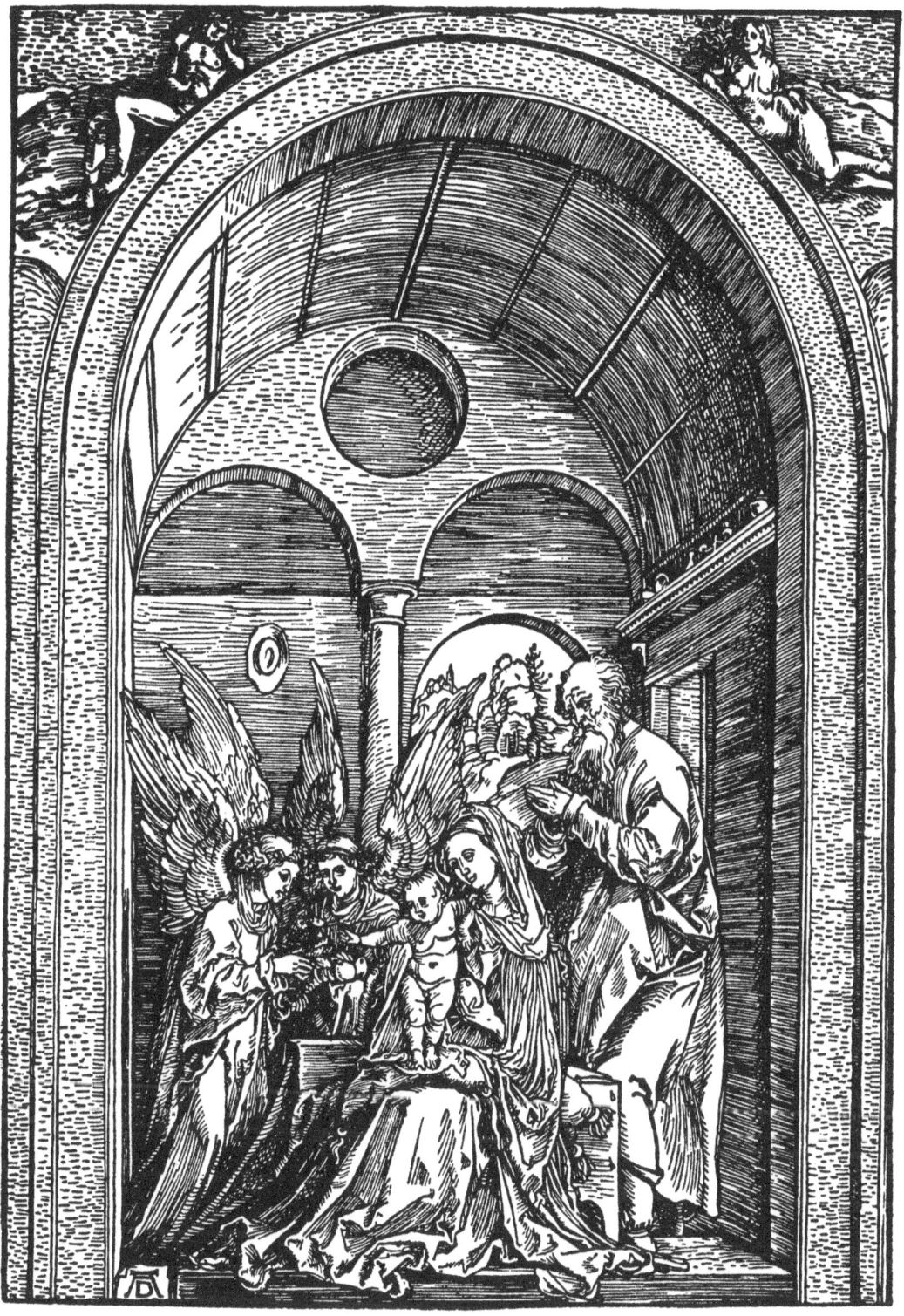

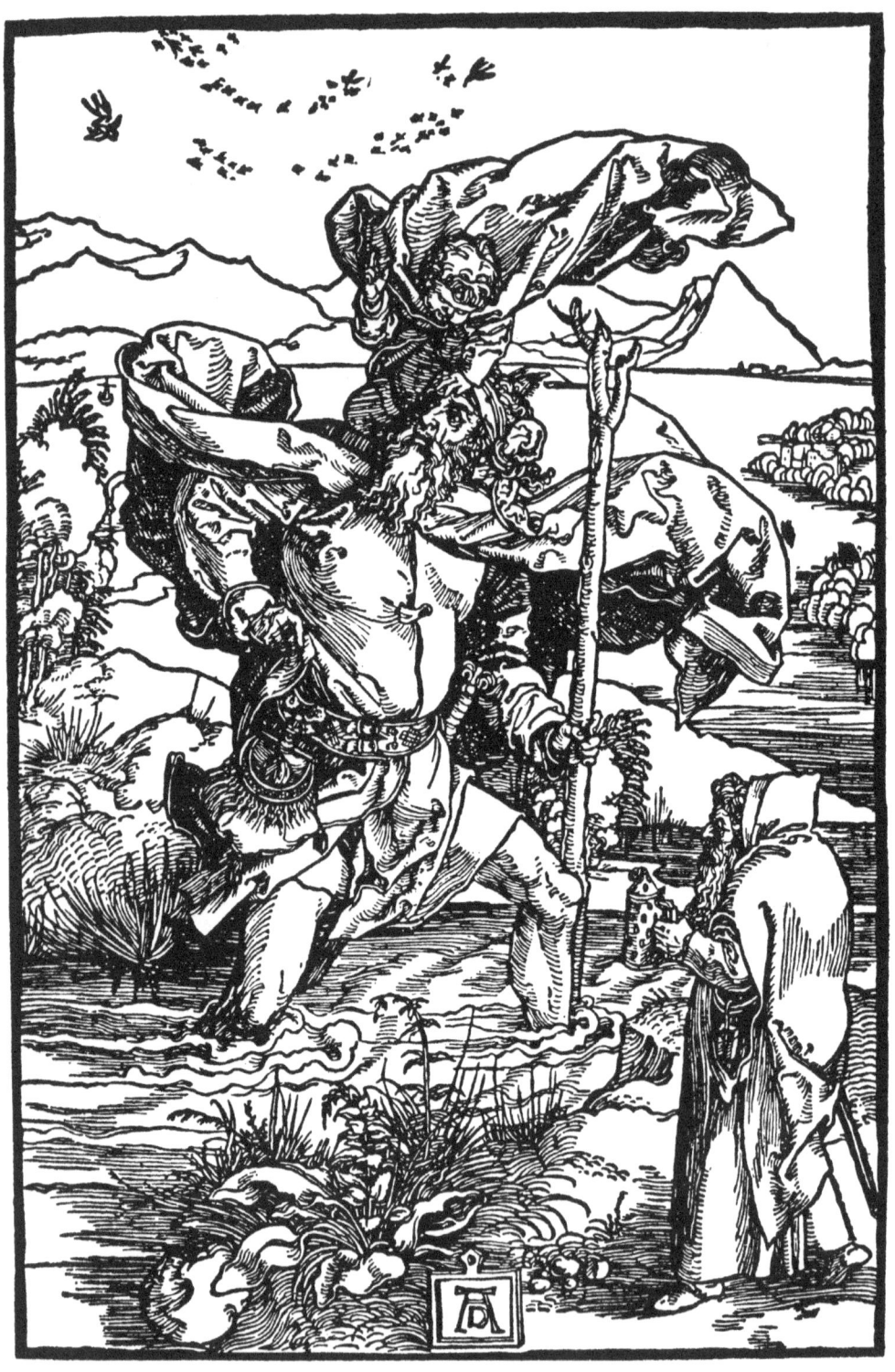

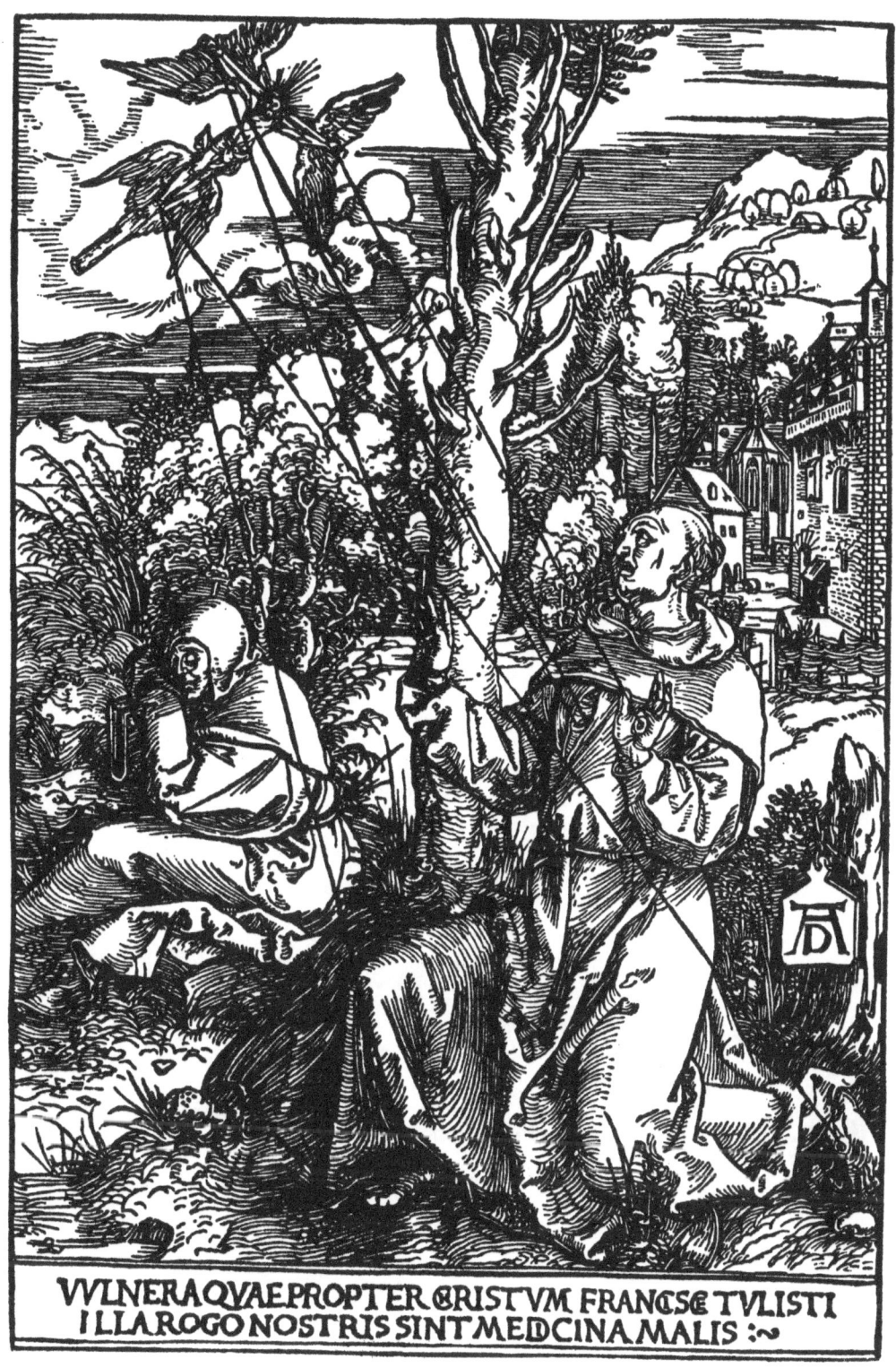

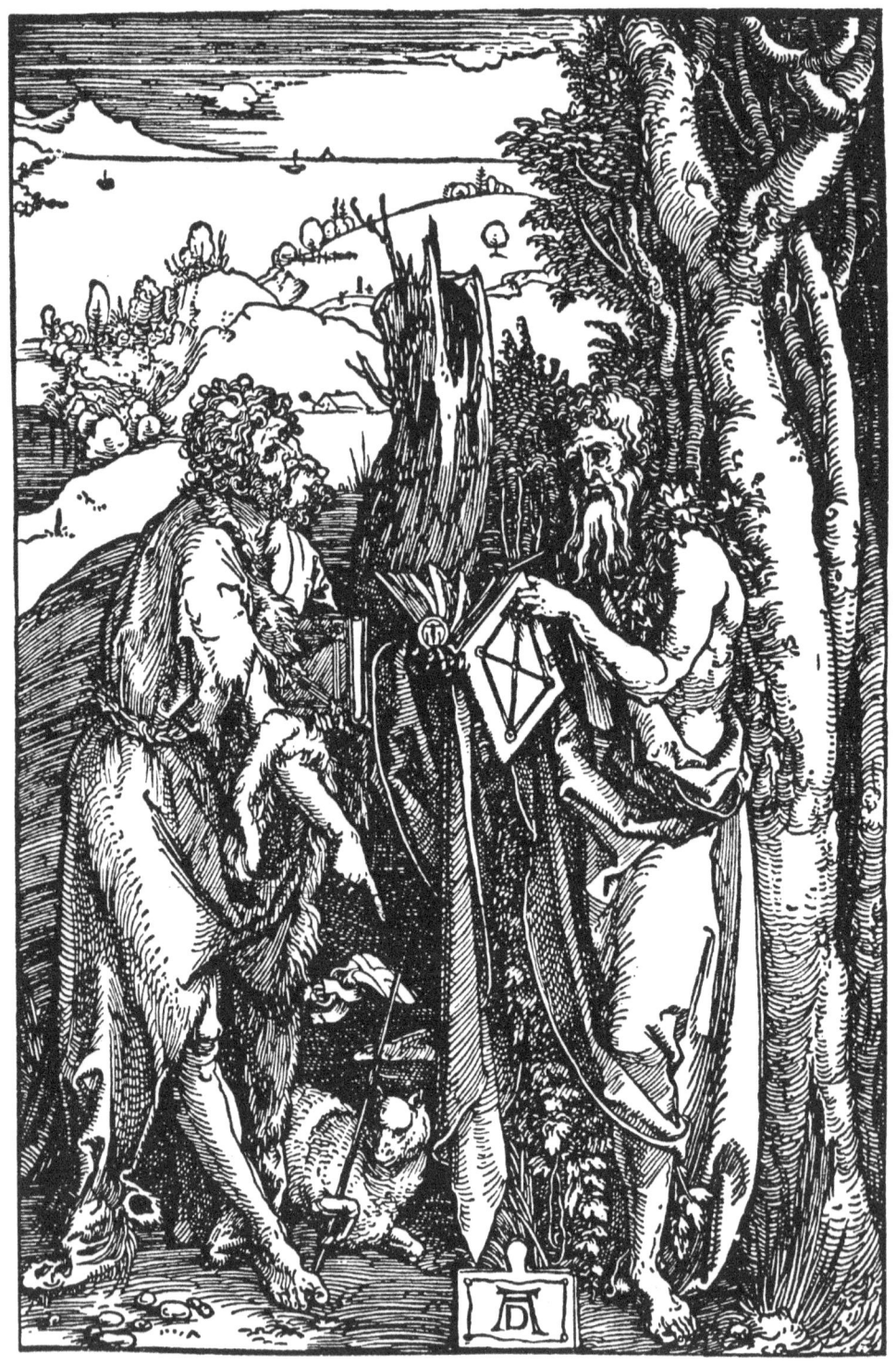

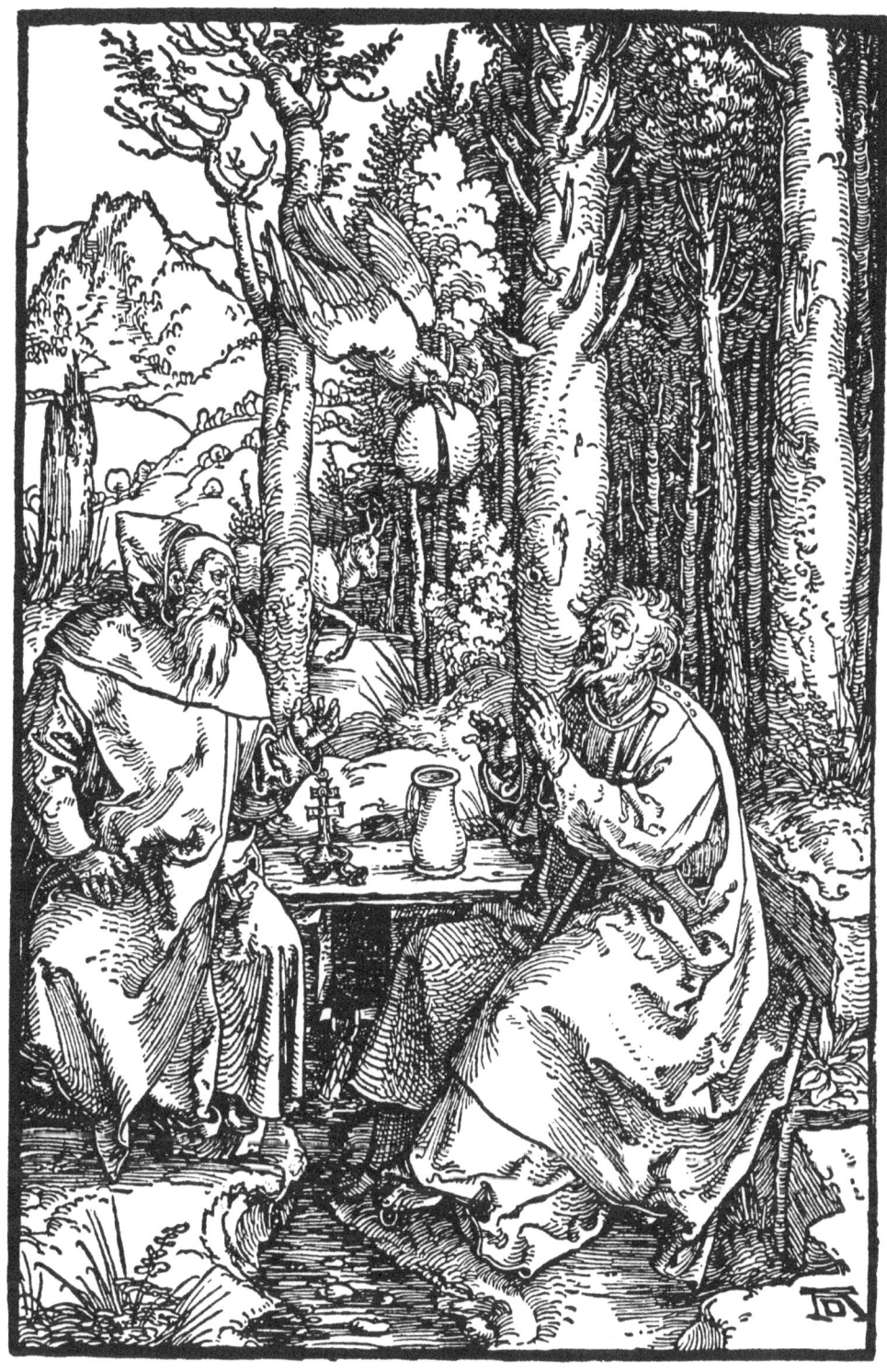

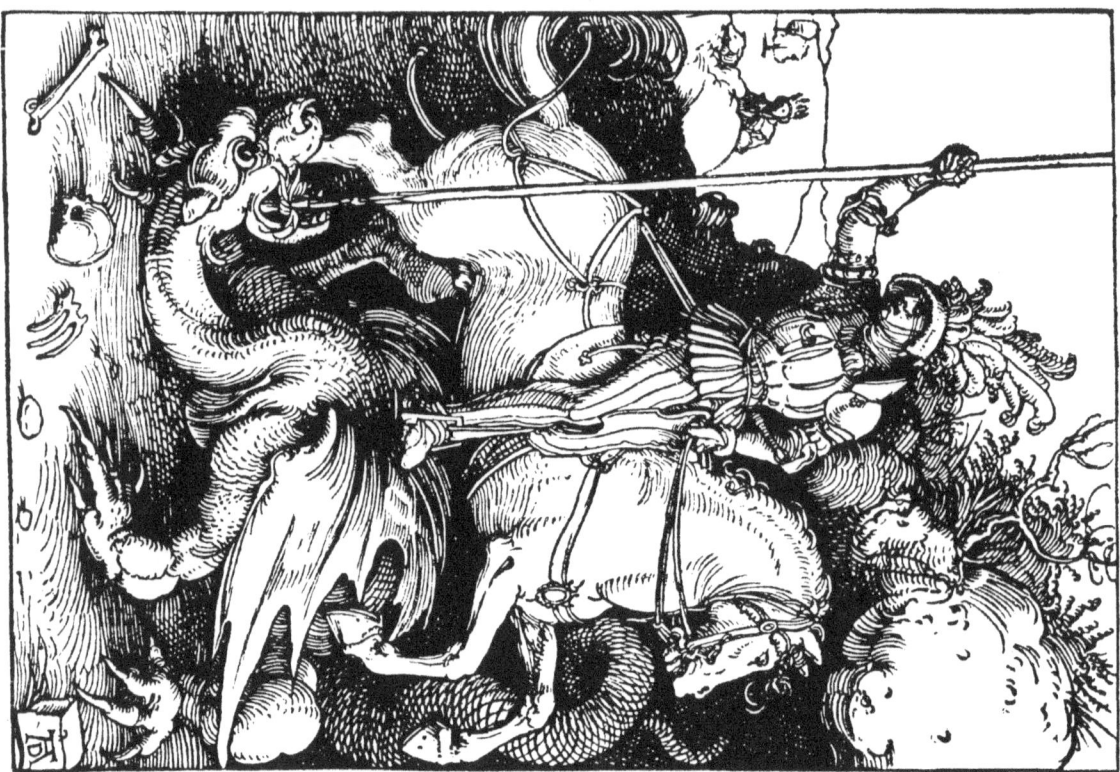

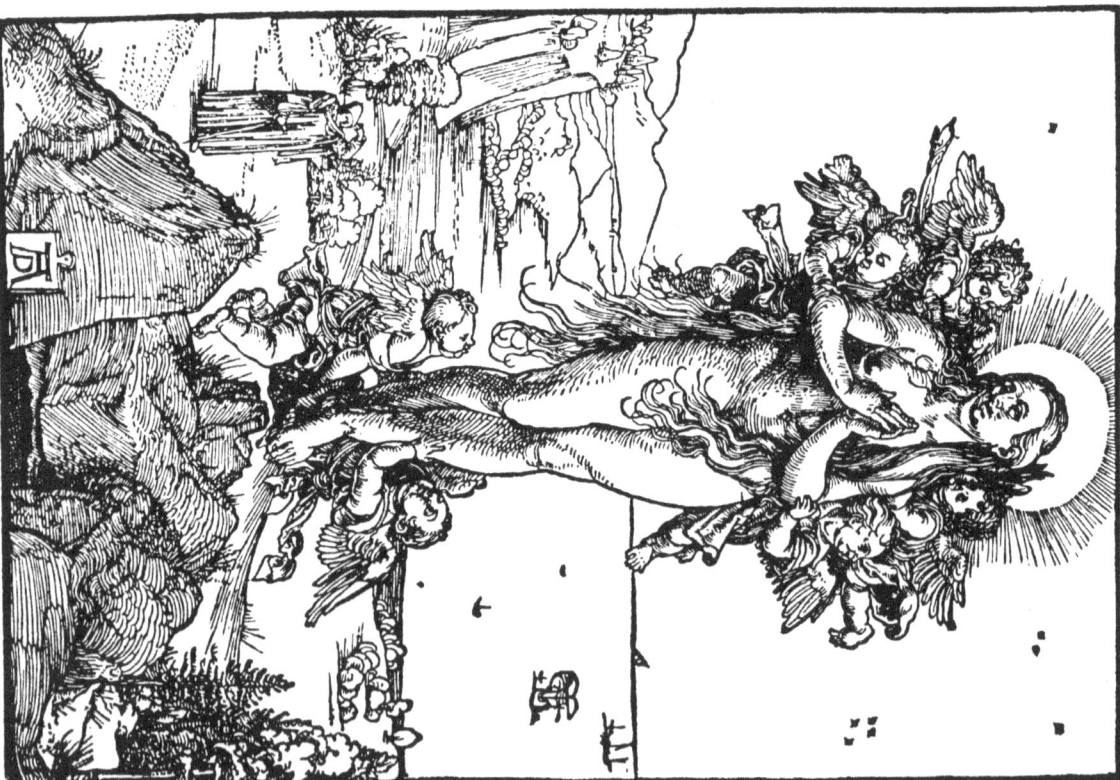

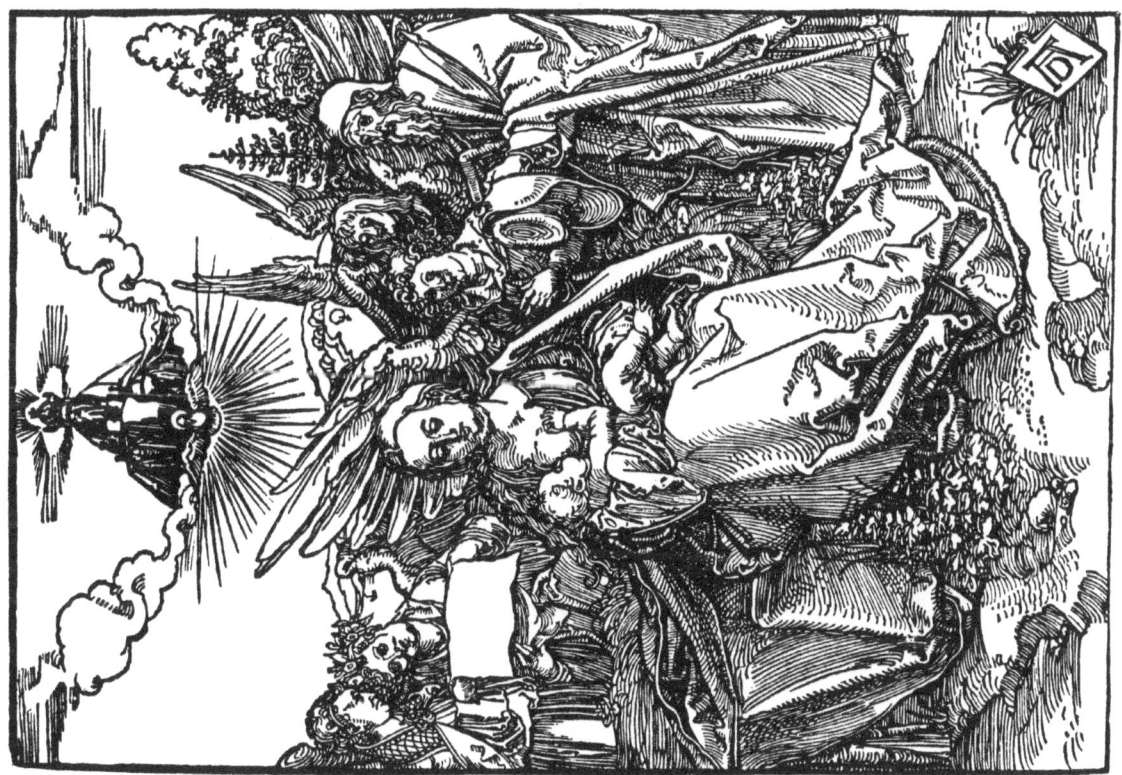

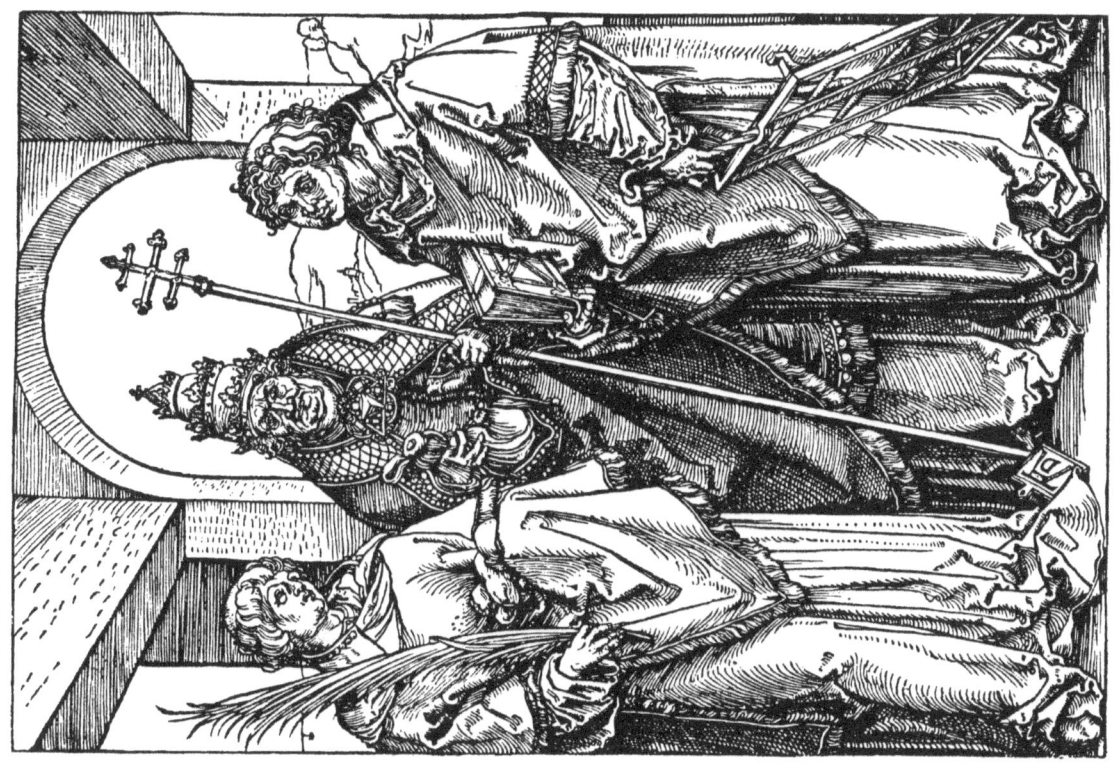

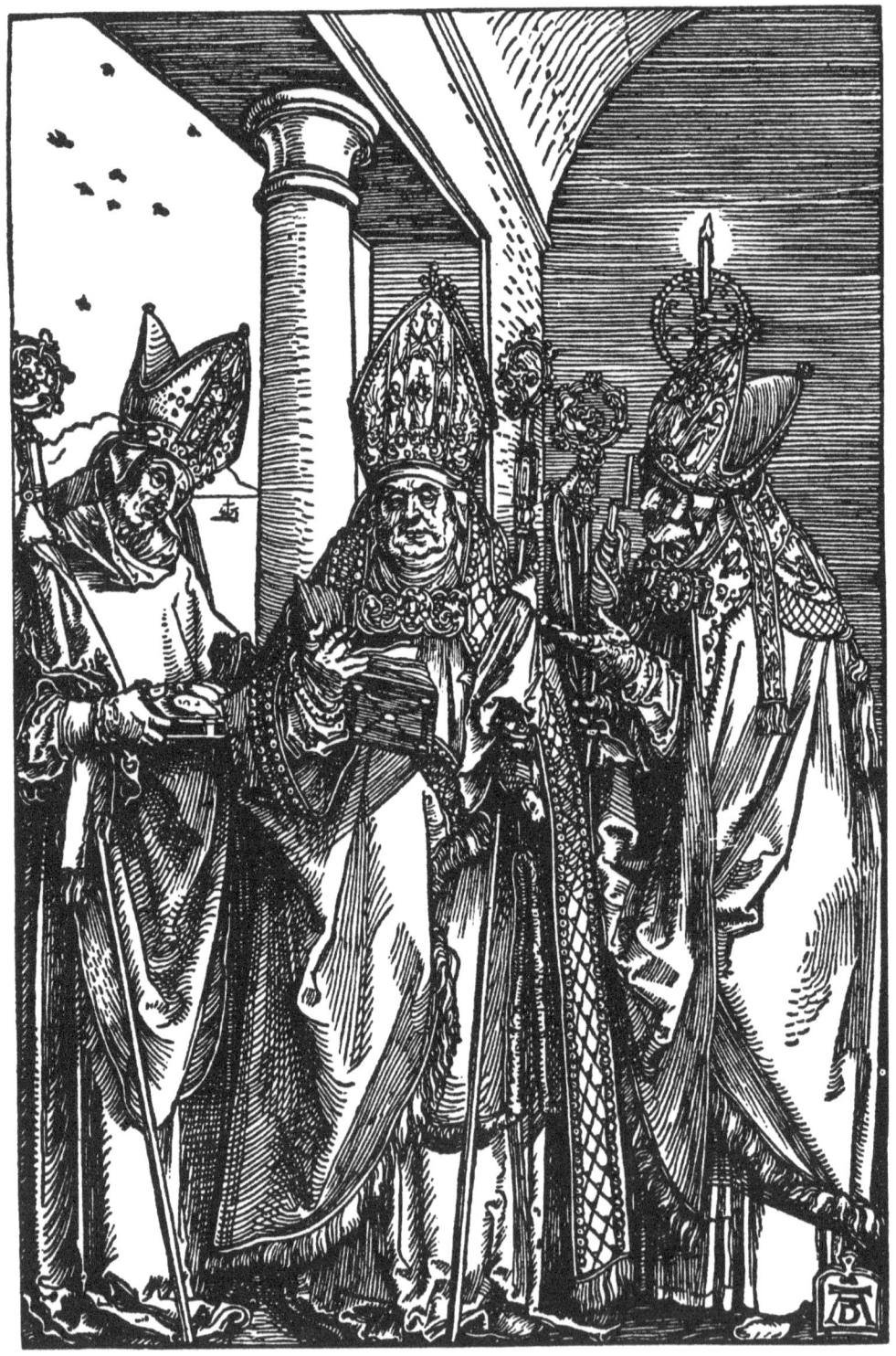

{ PAGE 151 }

{ PAGE 152 }

{ PAGE 153 }

{ PAGE 154 }

Wer recht bescheyden wol werden
Der pit got trum hye auff erden

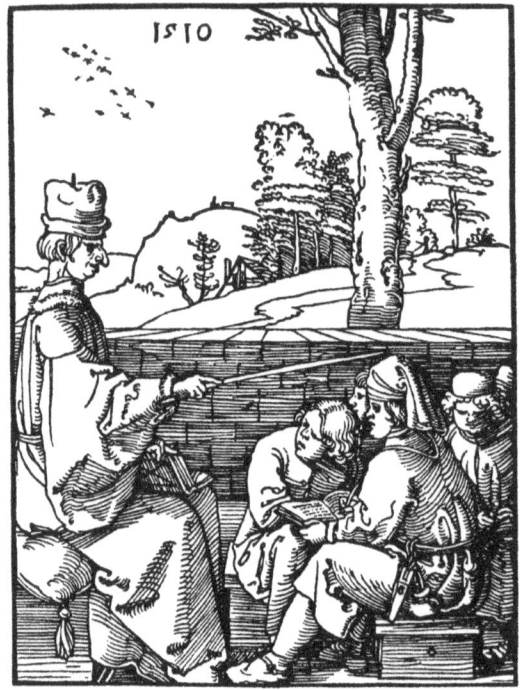

209

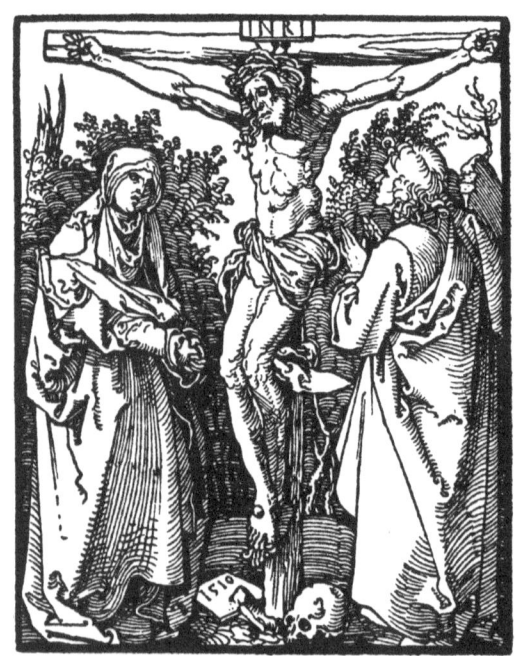

208

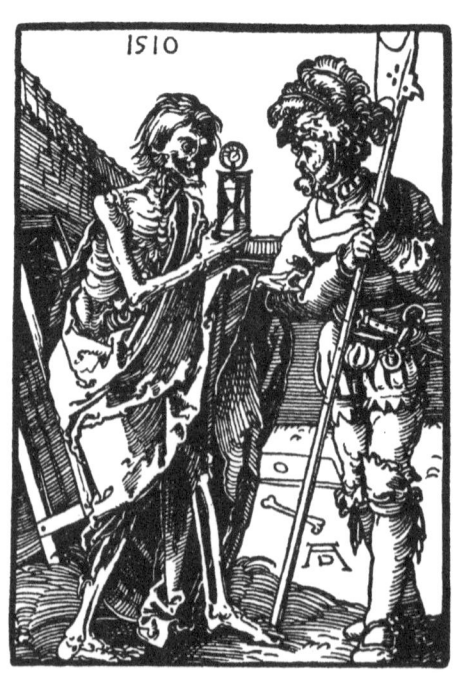

210

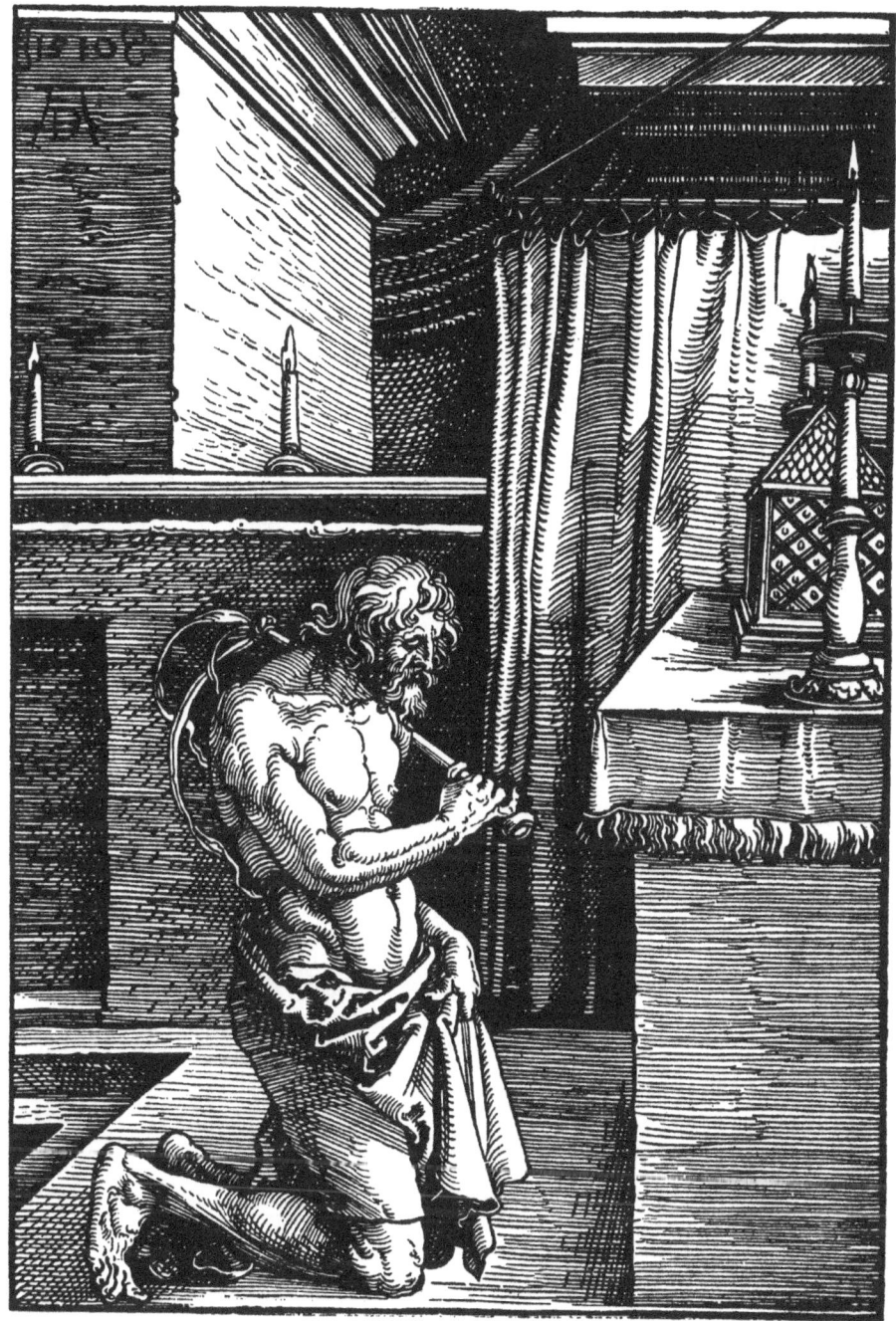

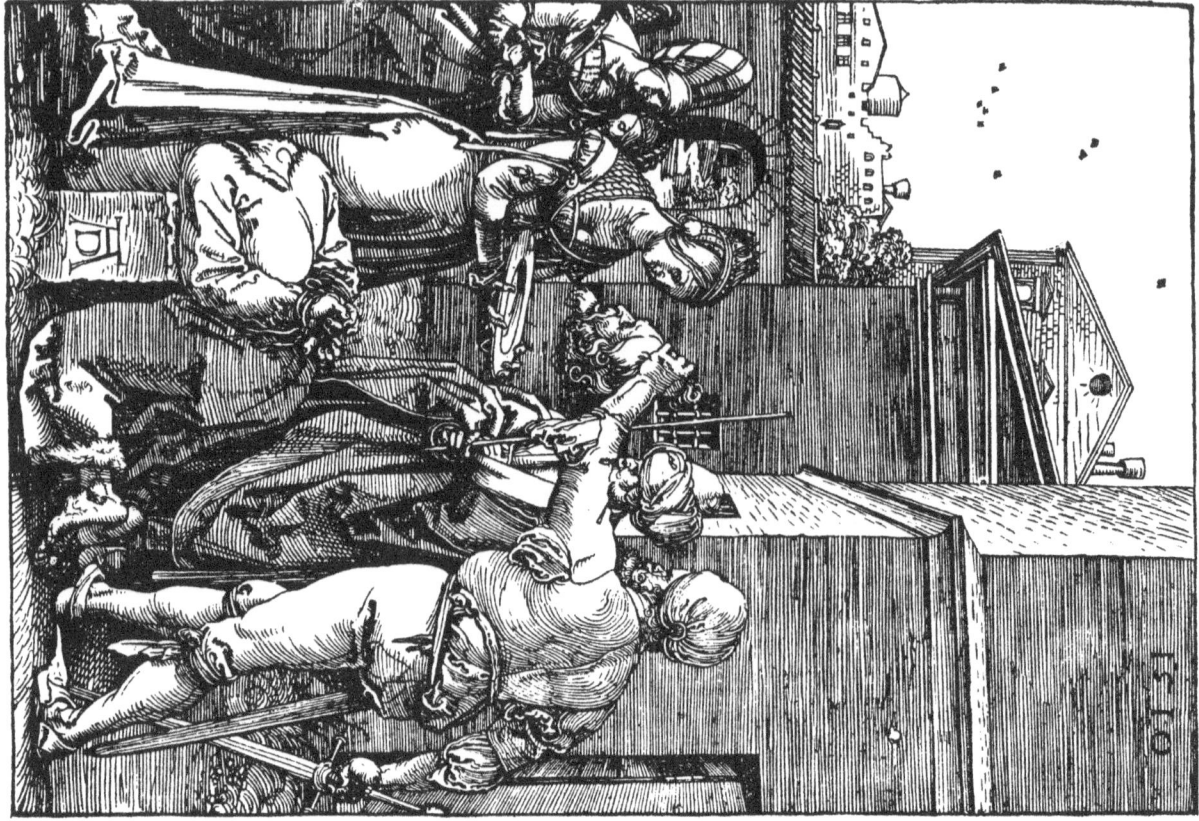

{ PAGE 158 }

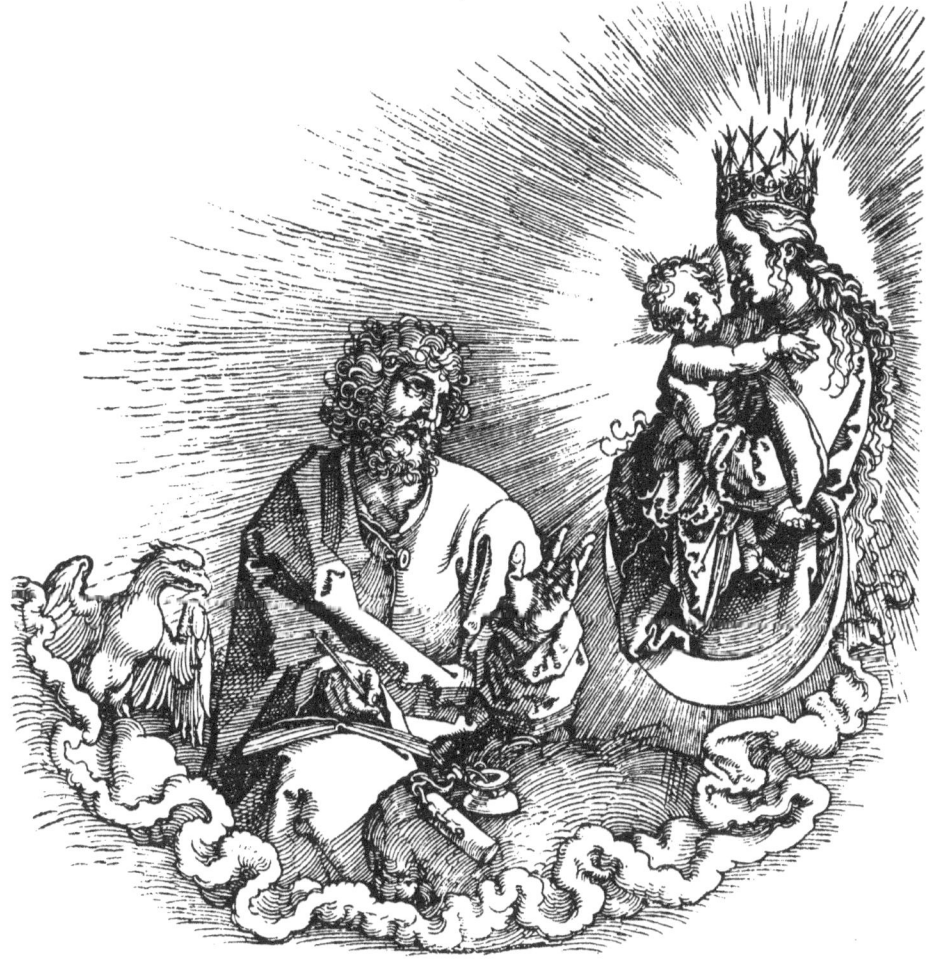

Passio domini nostri Jesu.ex hieronymo Paduano.Dominico Mancino.Sedulio.et Baptista Mantuano.per fratrem Chelidonium collecta.cum figuris Alberti Dureri Norici Pictoris.

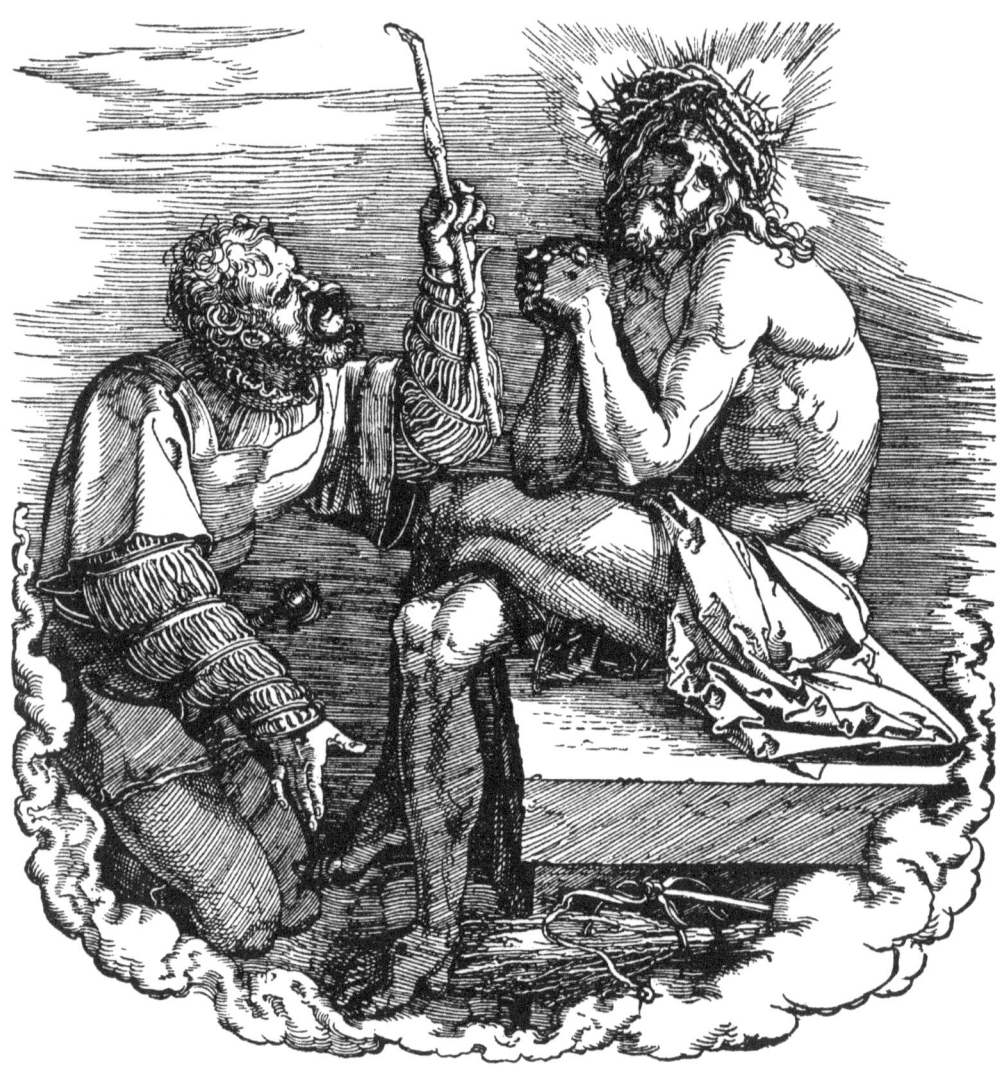

Has ego crudeles homo pro te perfero plagas
Atq; meo morbos sanguine curo tuos.
Vulneribusq; meis tua vulnera.morteq; mortem
Tollo deus:pro te plasmate factus homo.
Tuq; ingrate mihi:pungis mea stigmata culpis
Sæpe tuis.noxa vapulo sæpe tua.
Sat fuerit.me tanta olim tormenta sub hoste
Iudæo passum:nunc sit amice quies.

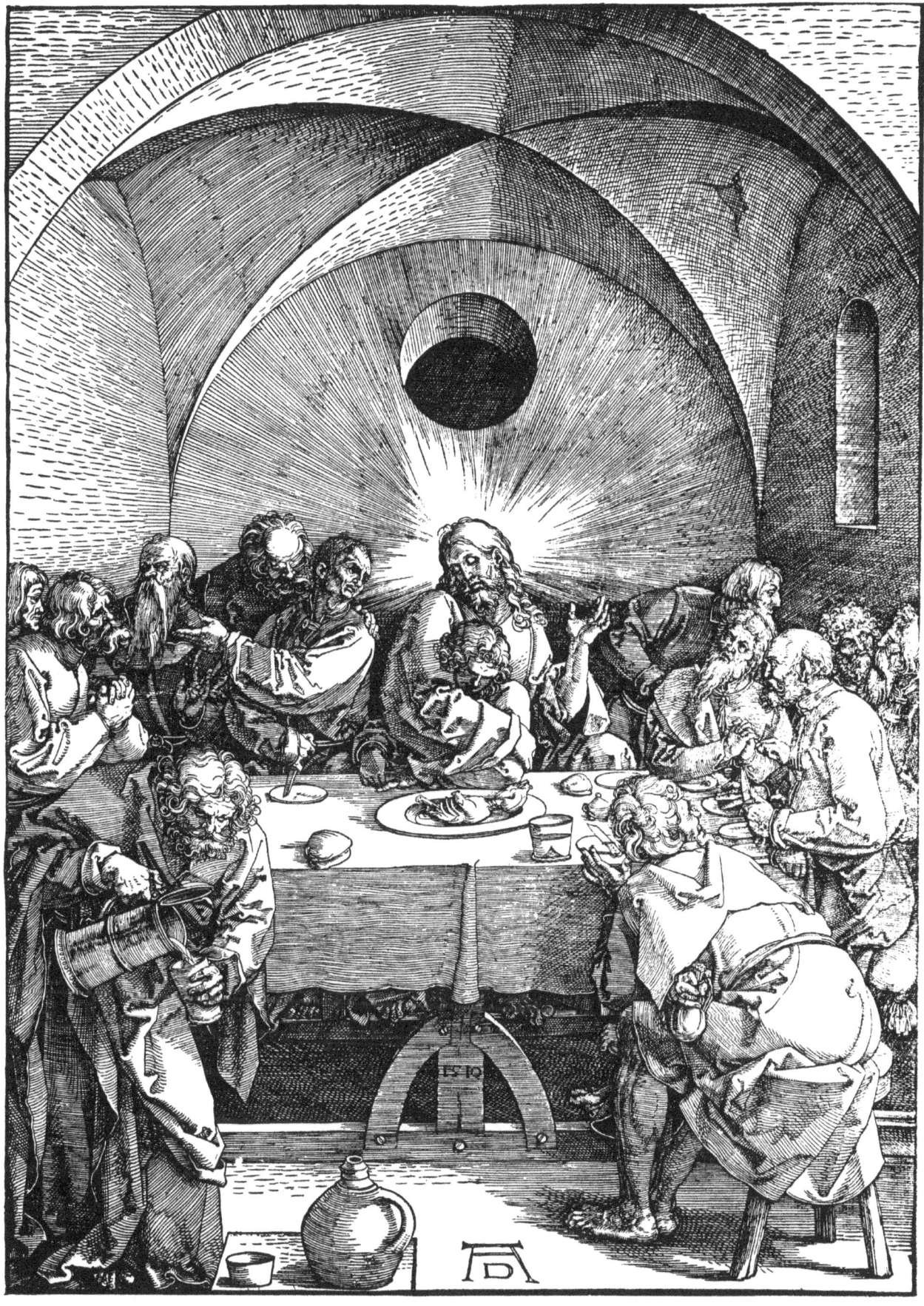

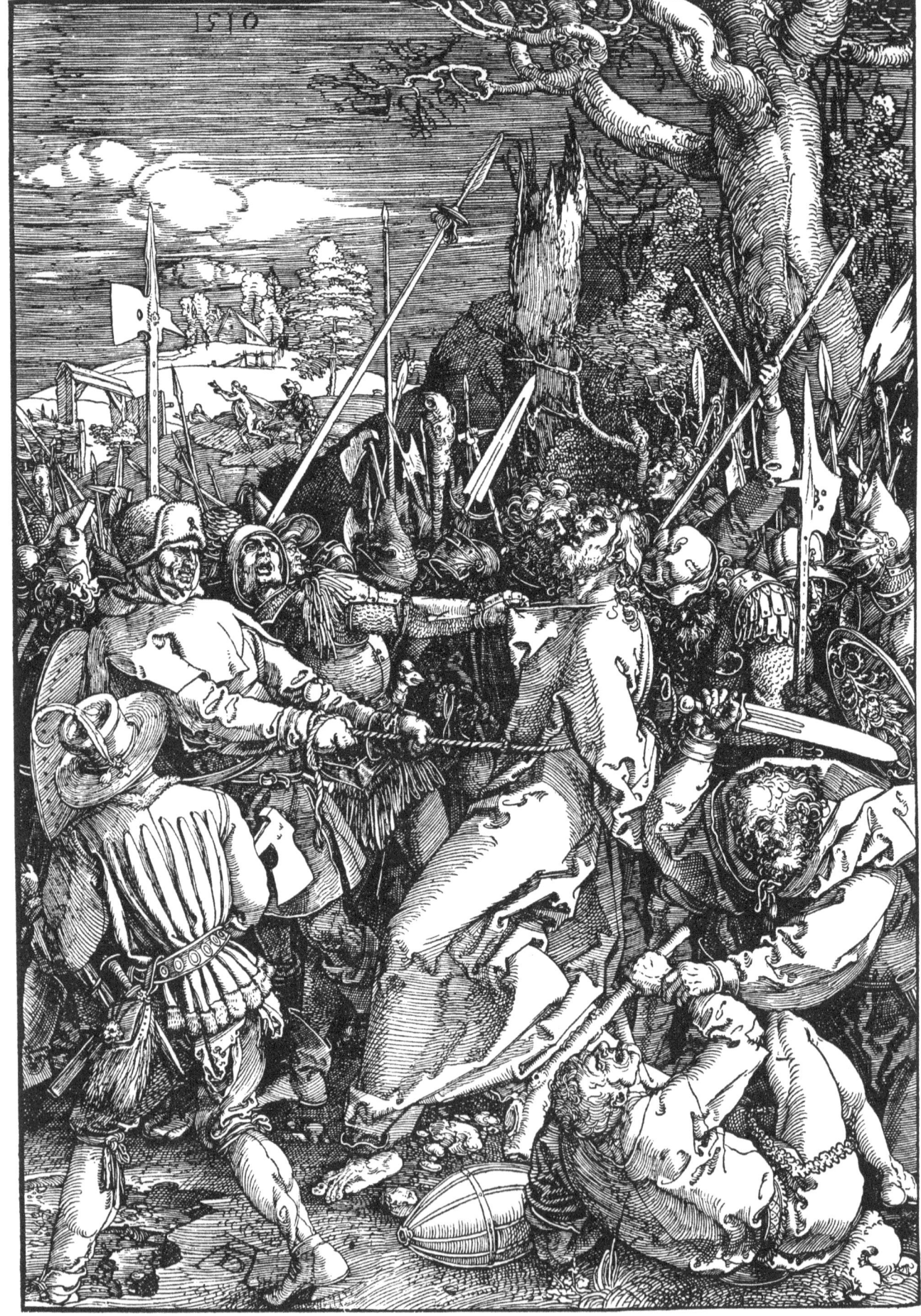

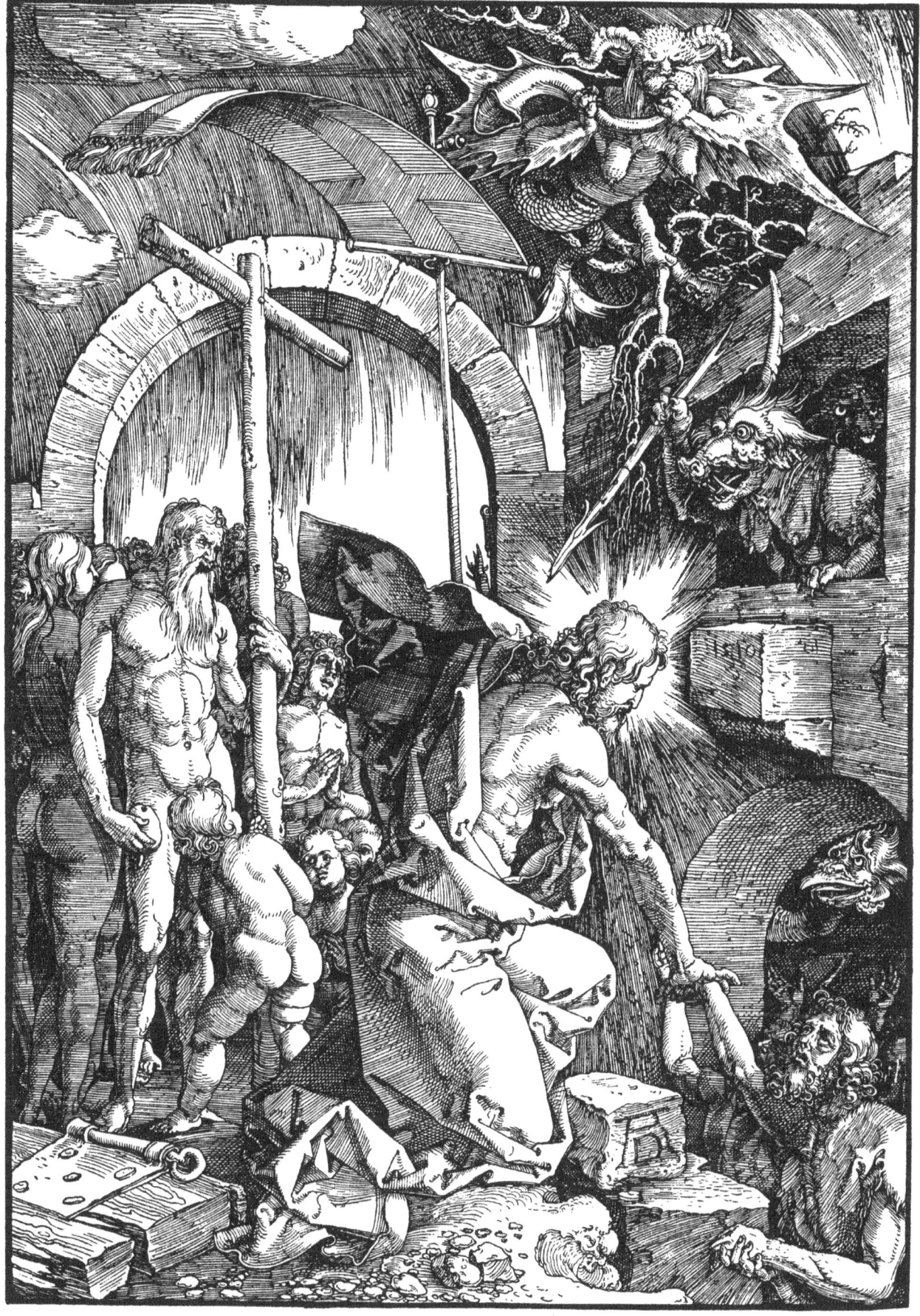

{ PAGE 163 }

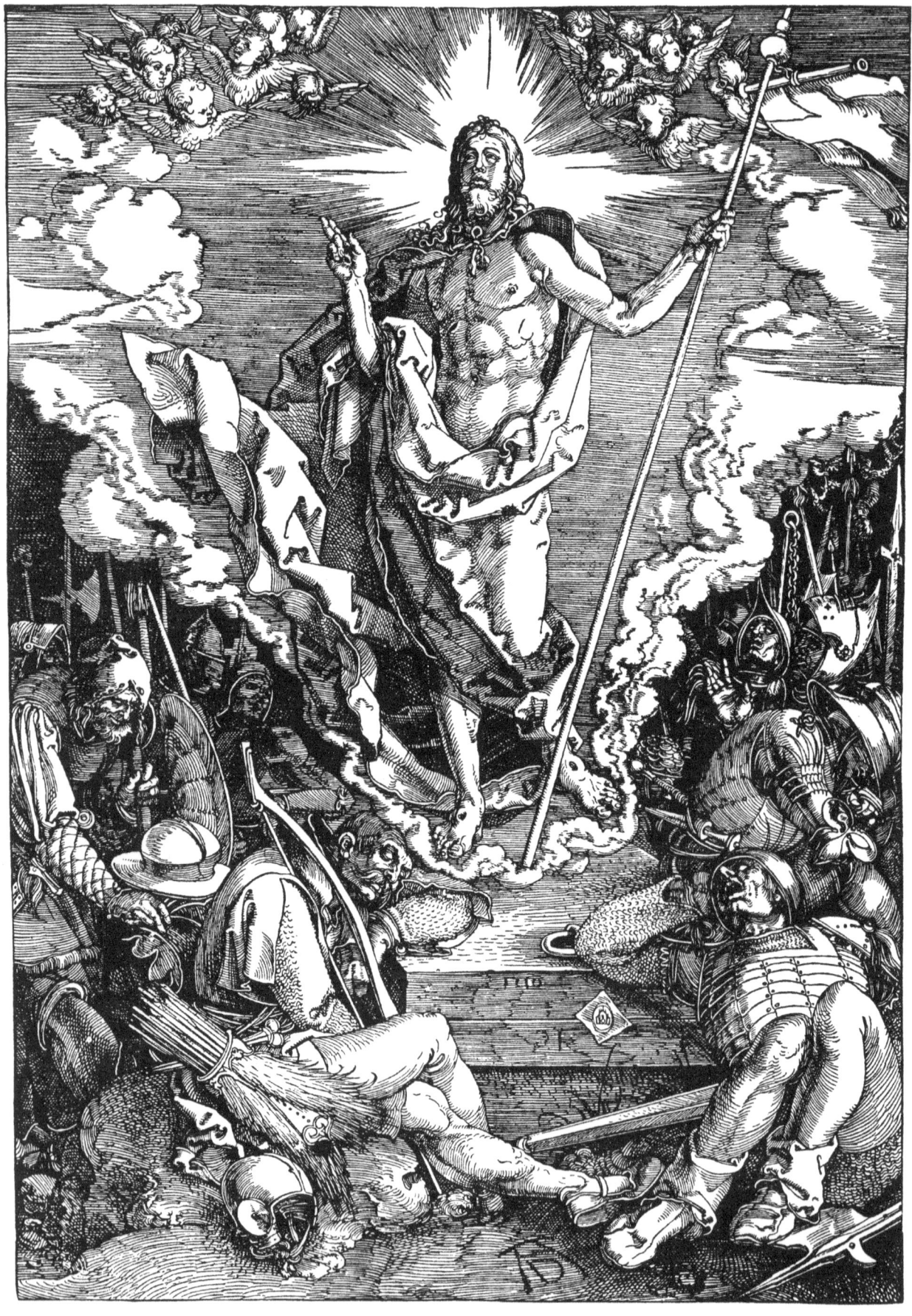

Epitome in divae Parthenices Mariae historiam ab Alberto Dürero Norico per figuras digestam cum versibus annexis Chelidonii

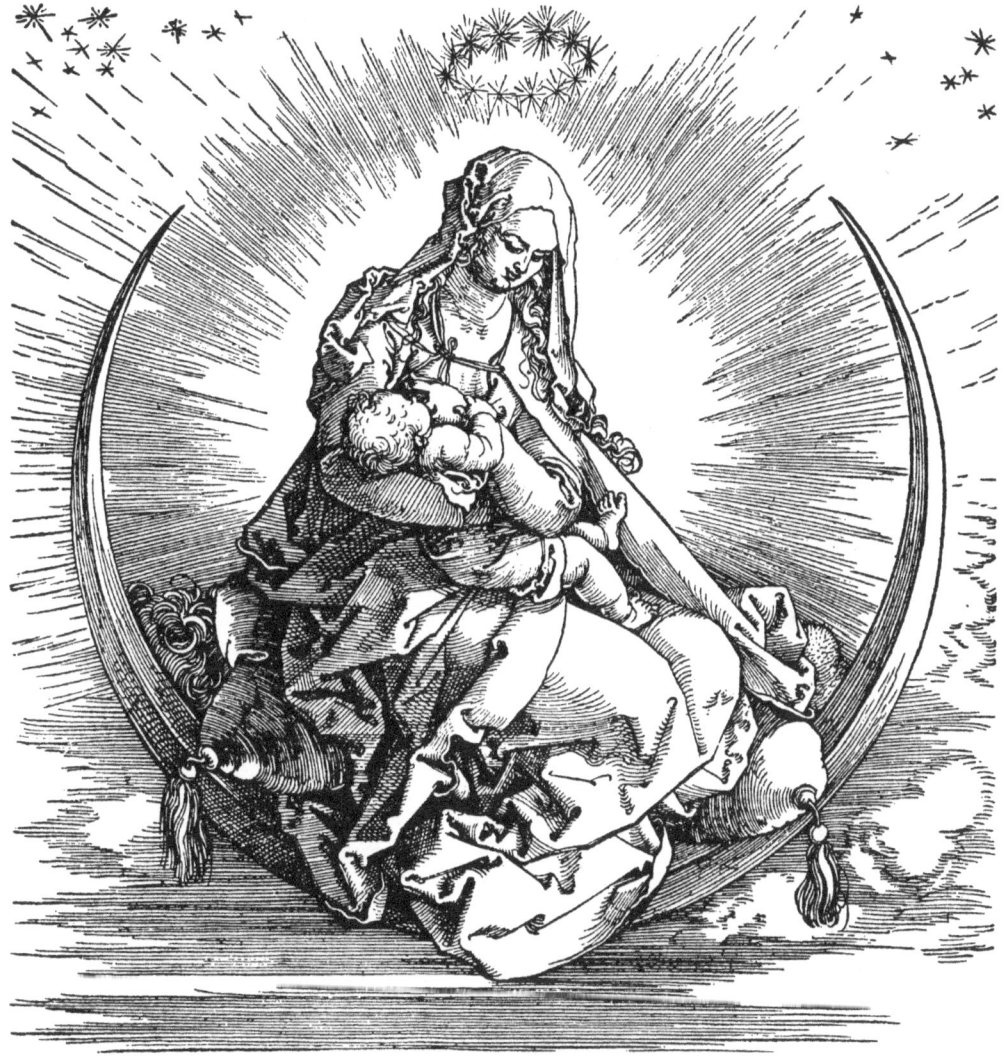

Quisquis fortunæ correptus turbine, perfers
Quam tibi iacturam fata sinistra ferunt.
Aut animæ delicta gemis, Phlegethontis & ignes
Anxius æternos corde tremente paues.
Quisquis & vrgeris iam iam decedere vita
Alterius: migrans: nescius hospitij.
Huc ades: auxilium: pete: continuoq; rogabo
Pro te: quem paui lacte: tuliq; sinu.
Ille deus rerum mihi subdidit astra: deosq;.
Flectitur ille meis O homo supplicijs.

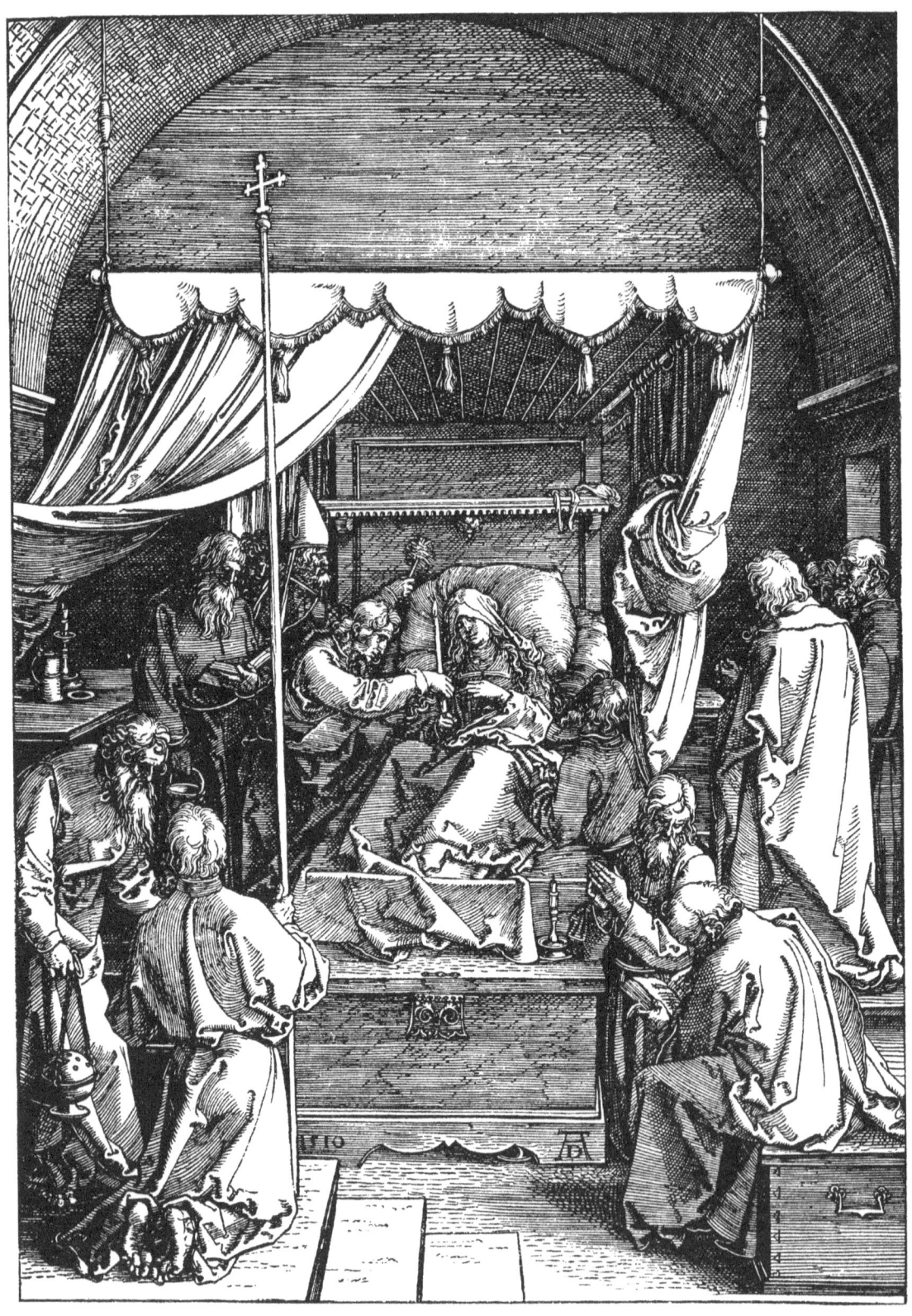

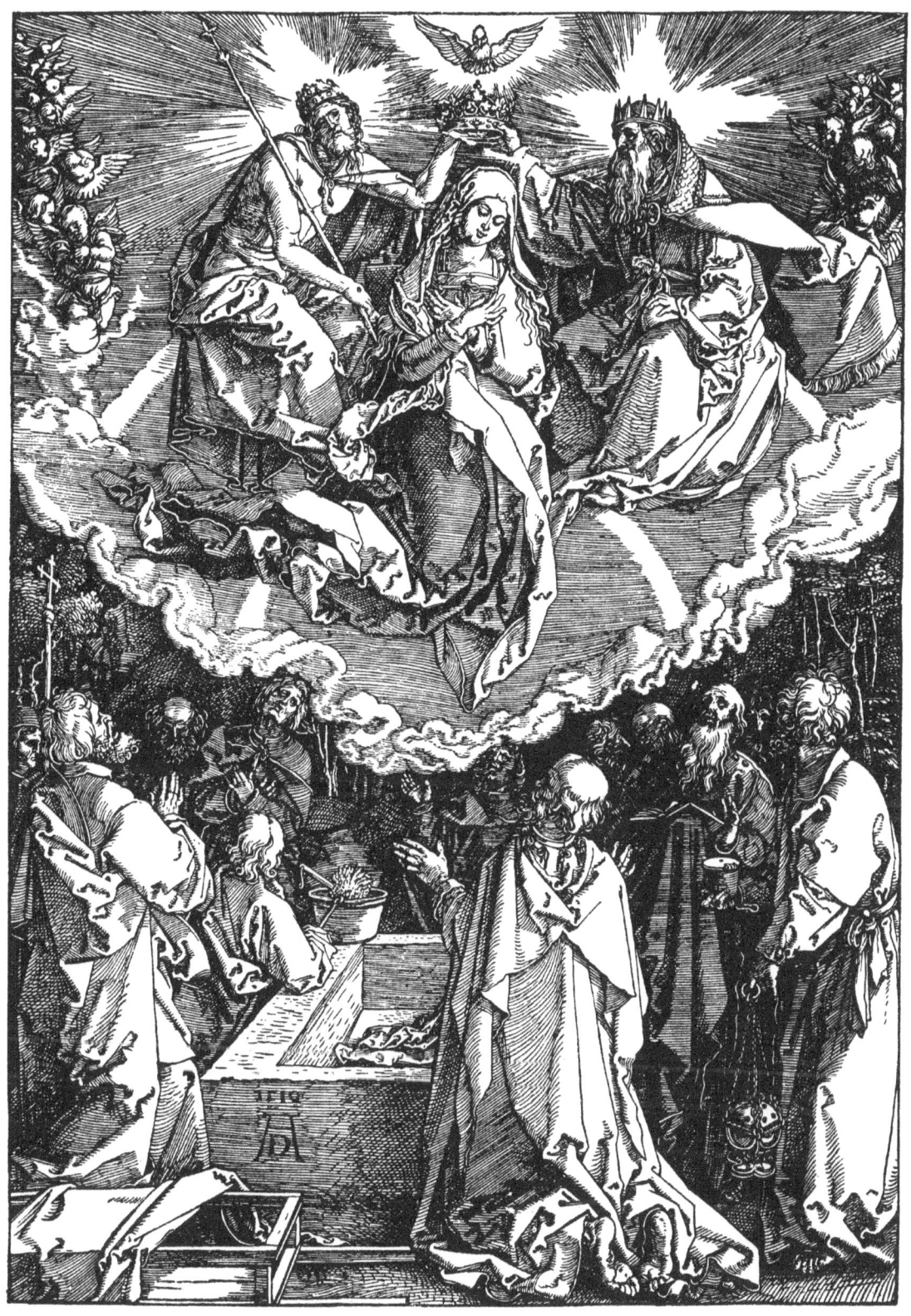

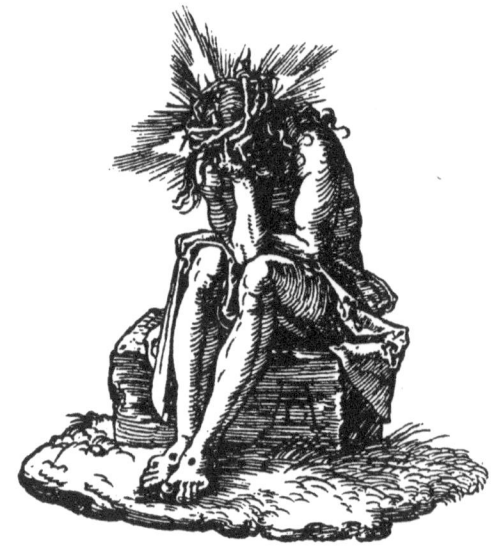

222

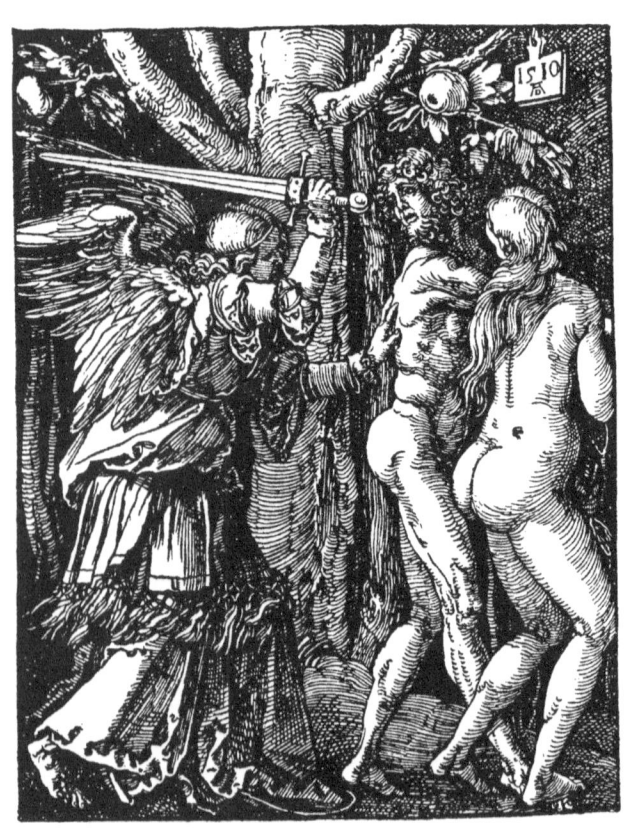

223

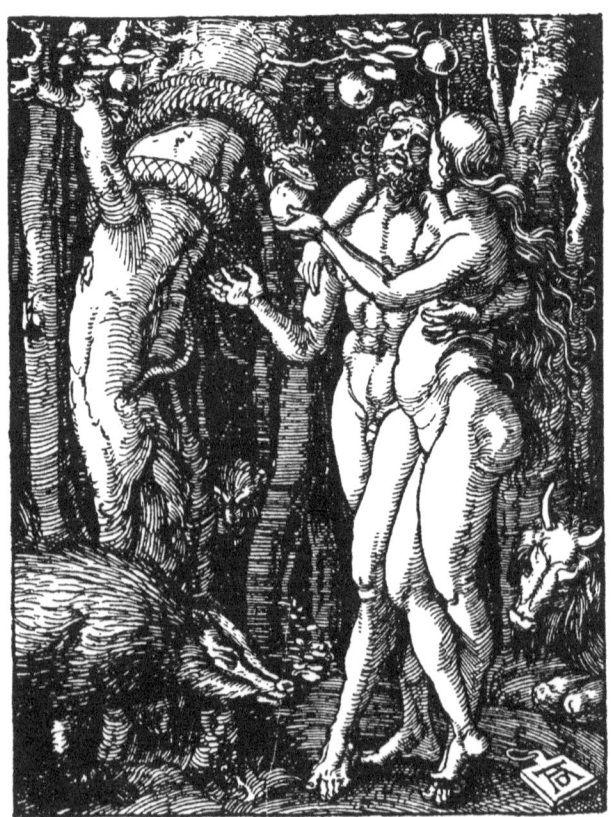

224

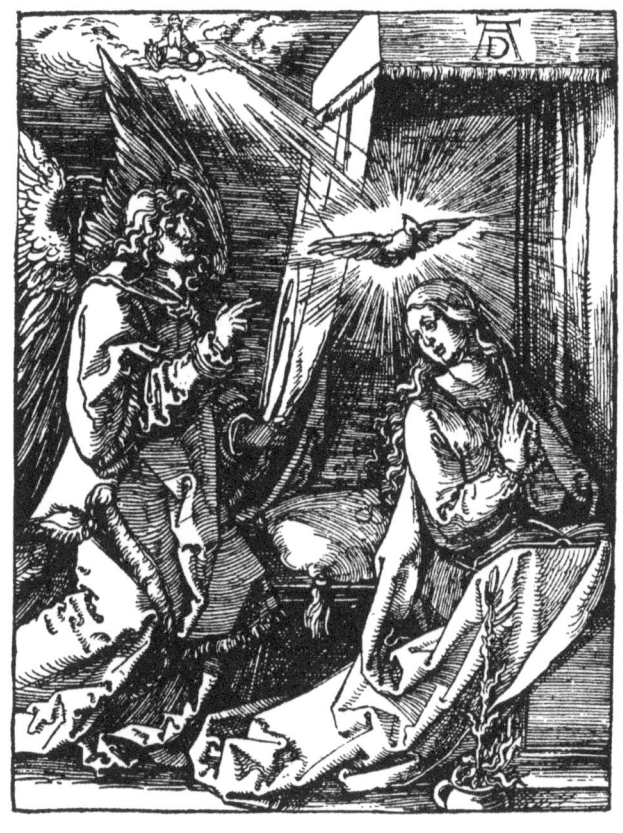

225

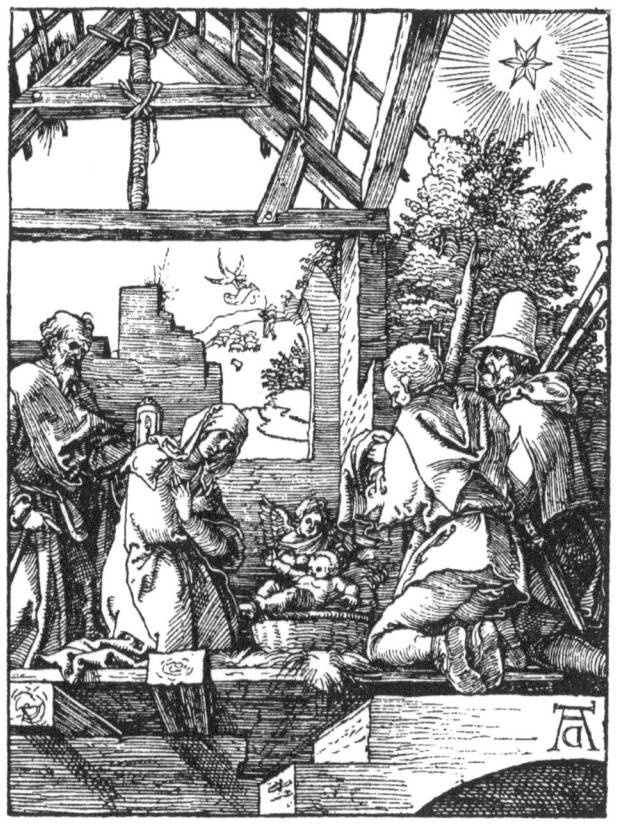

226

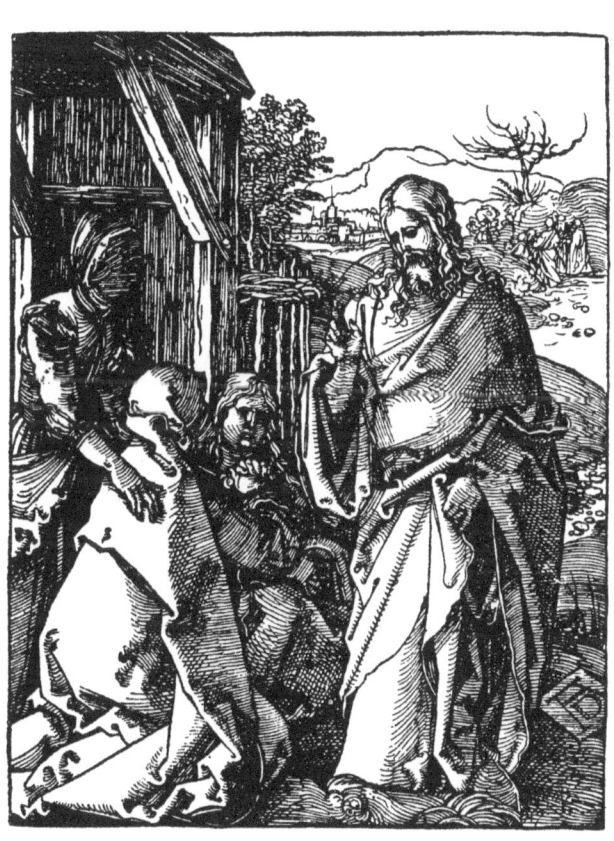

227

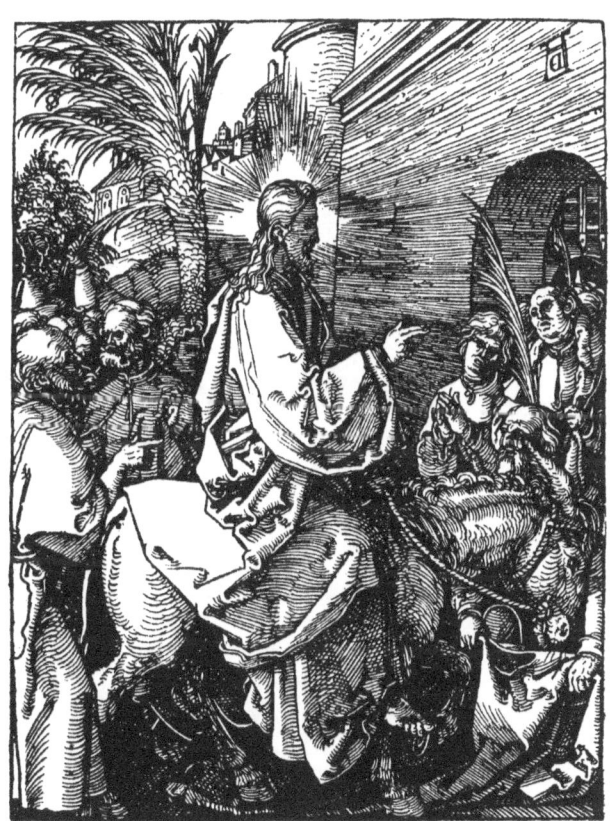

228

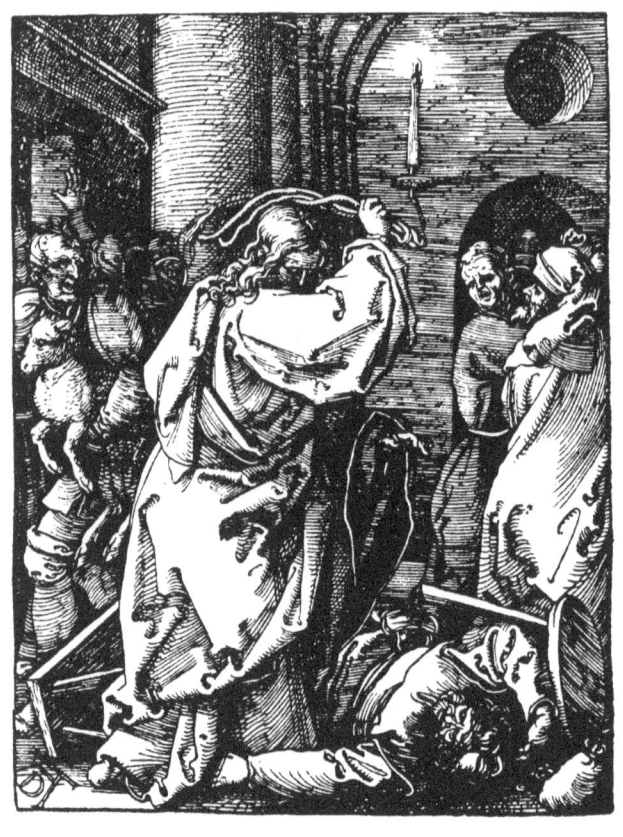

229

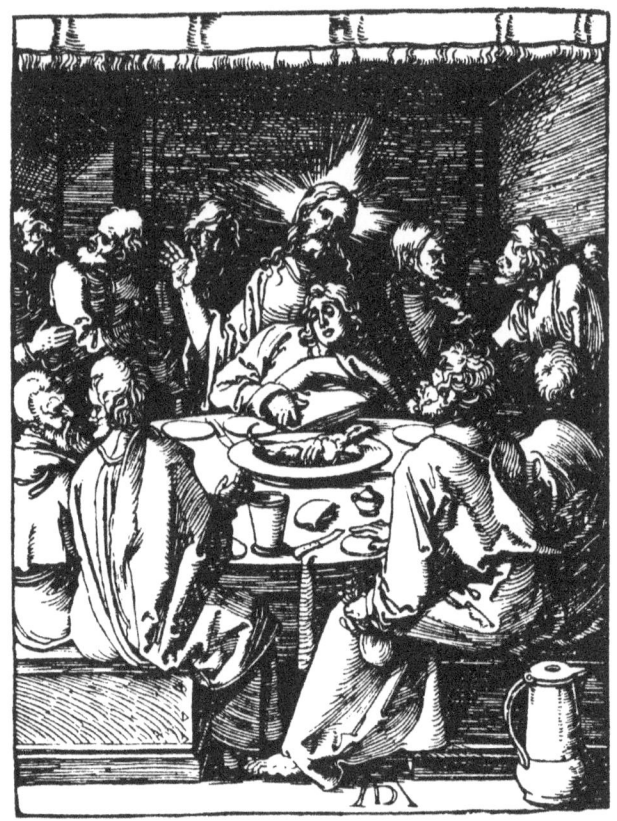

230

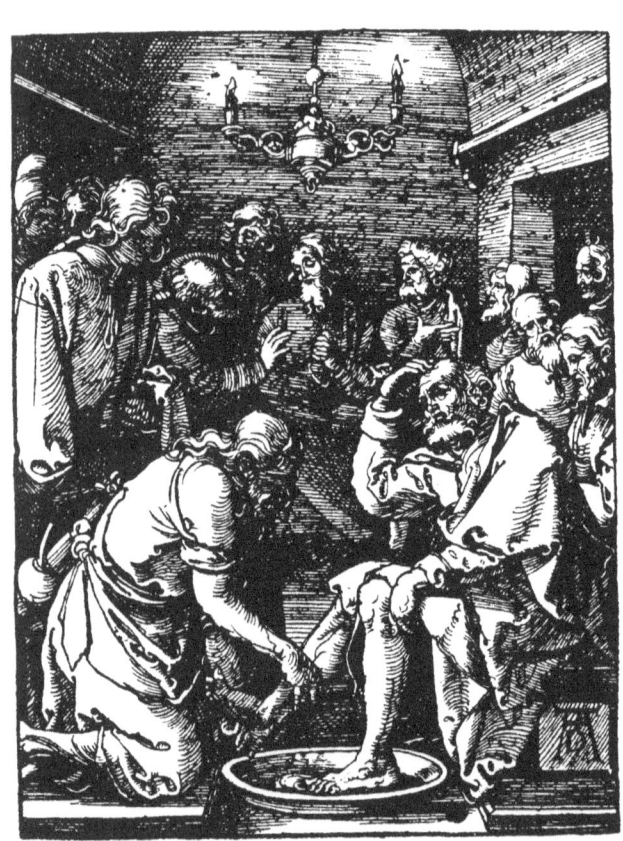

231

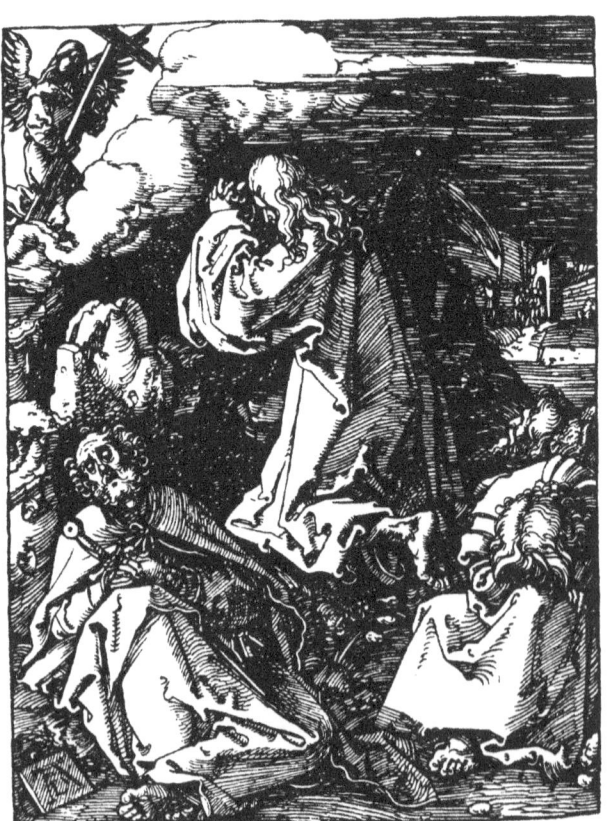

232

{ PAGE 170 }

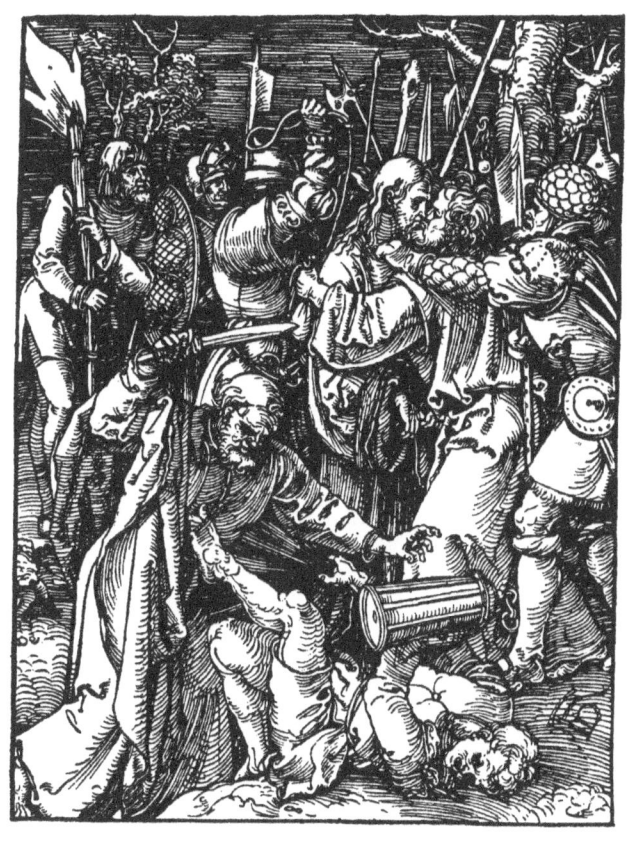

233

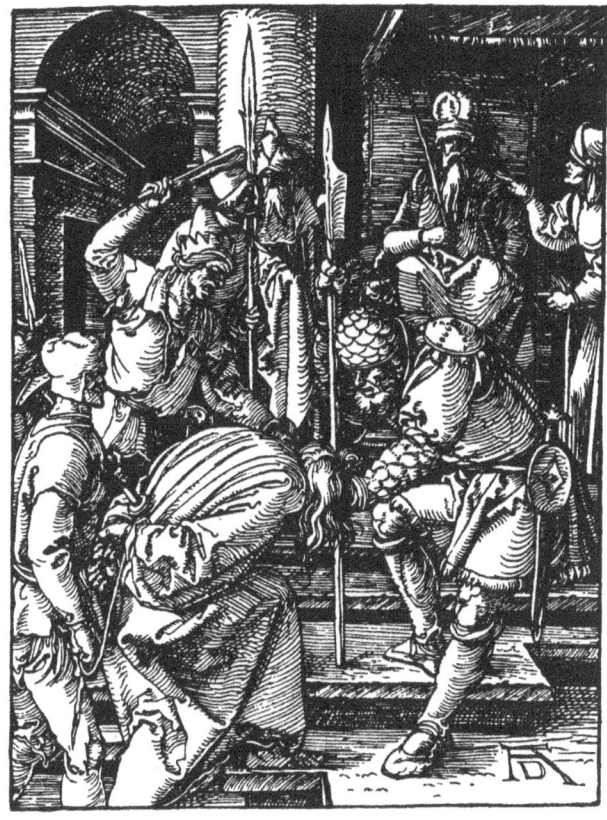

234

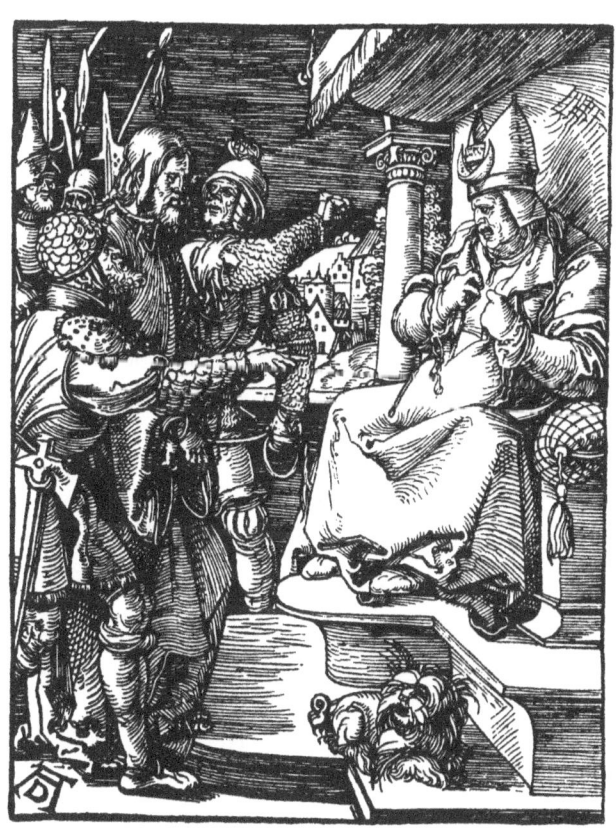

235

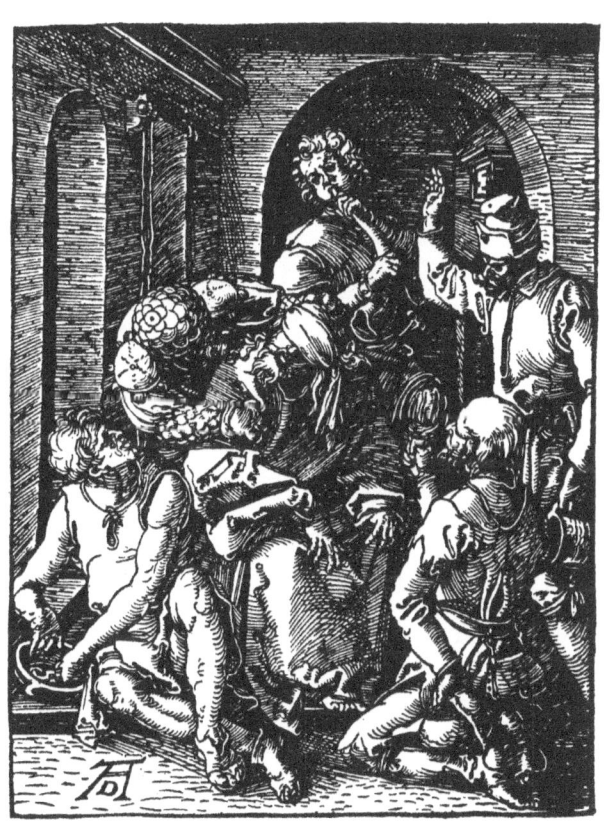

236

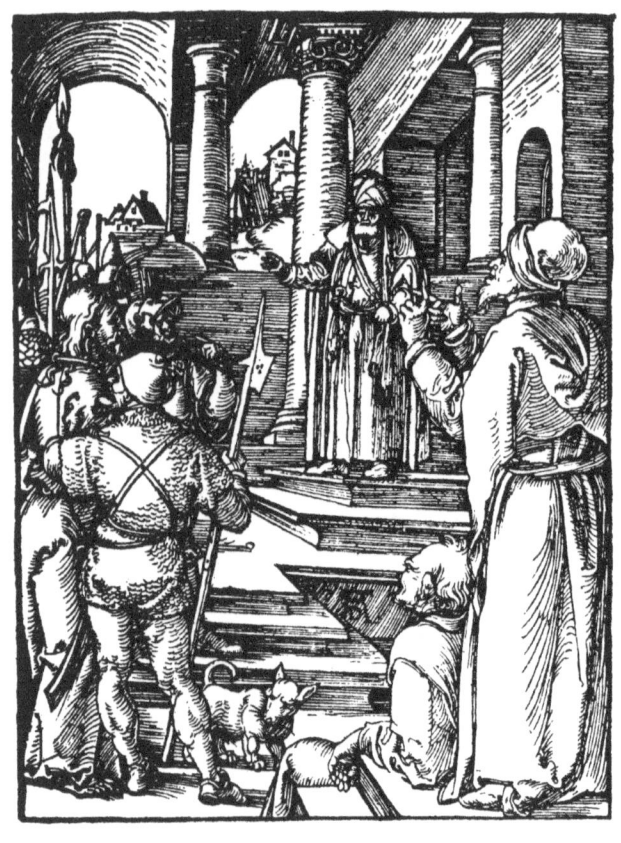

237

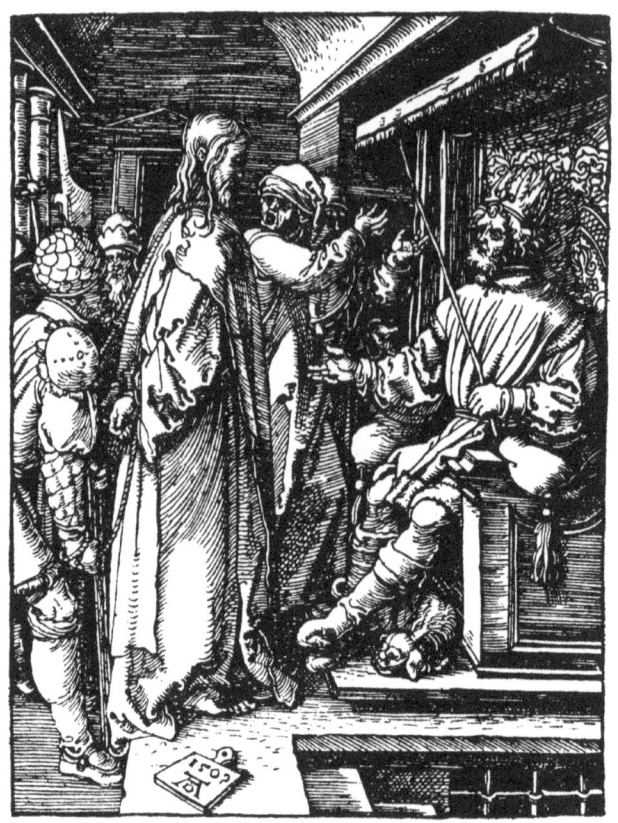

238

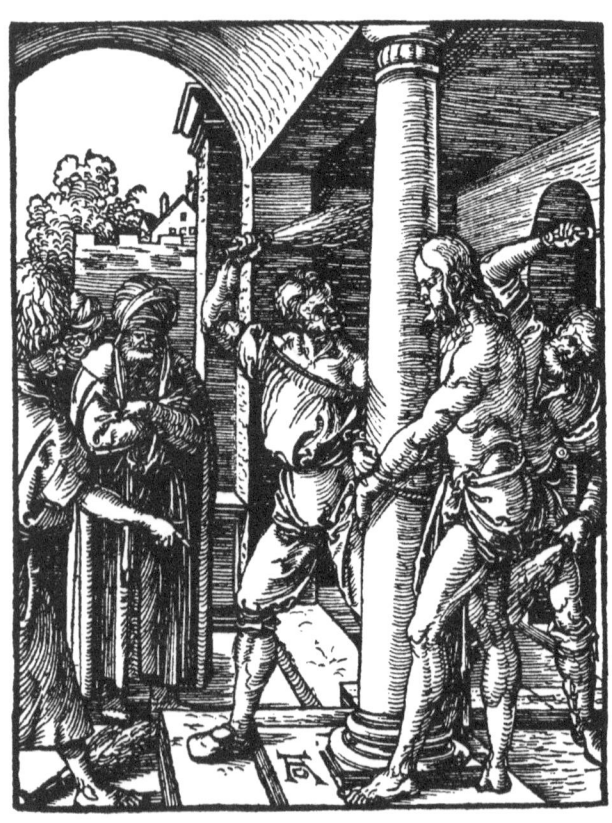

239

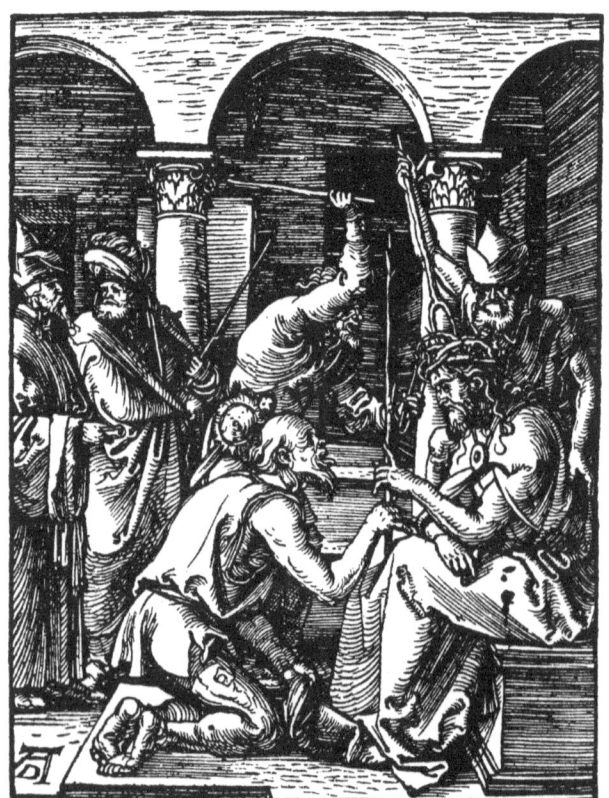

240

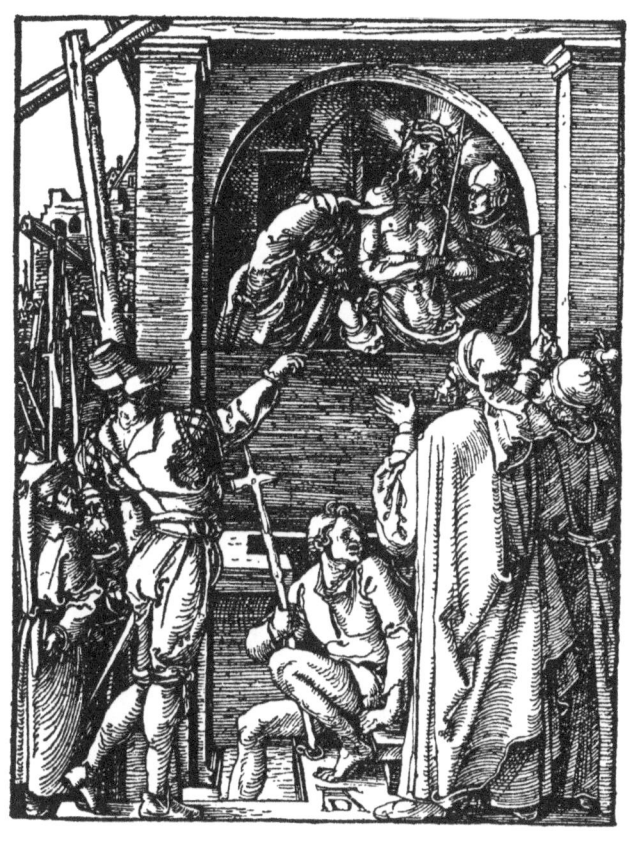

241

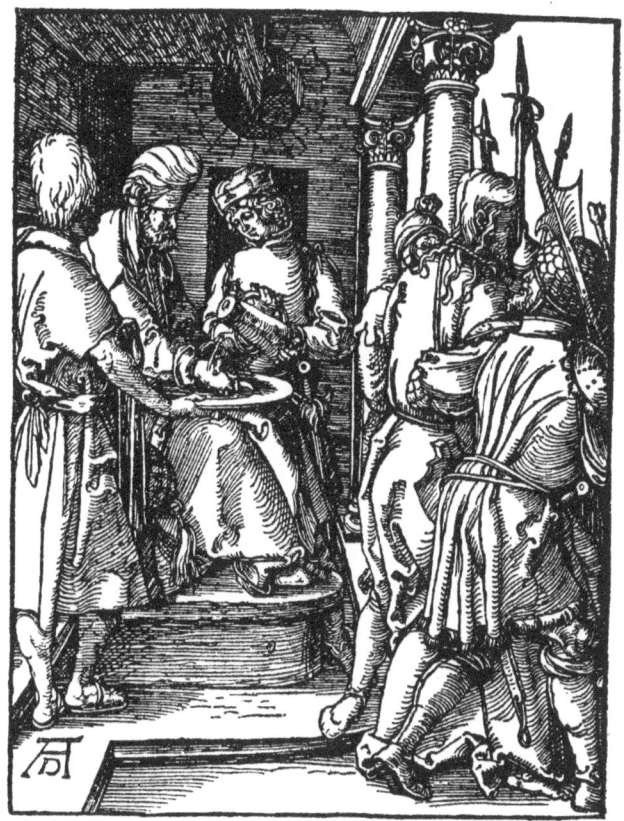

242

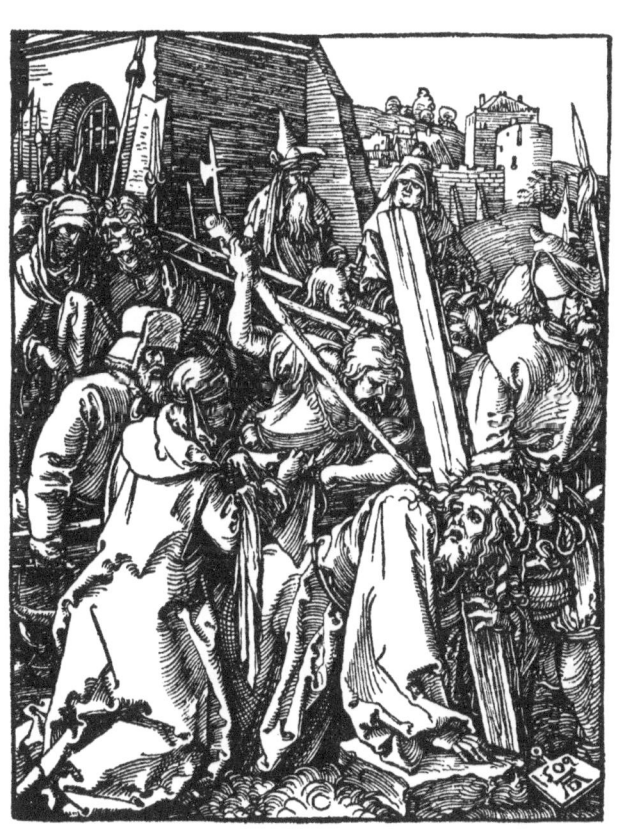

243

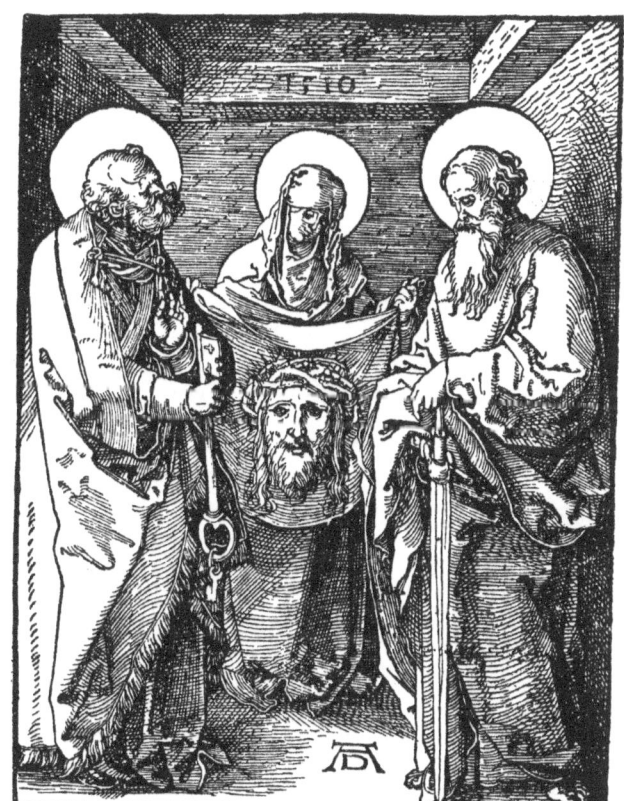

244

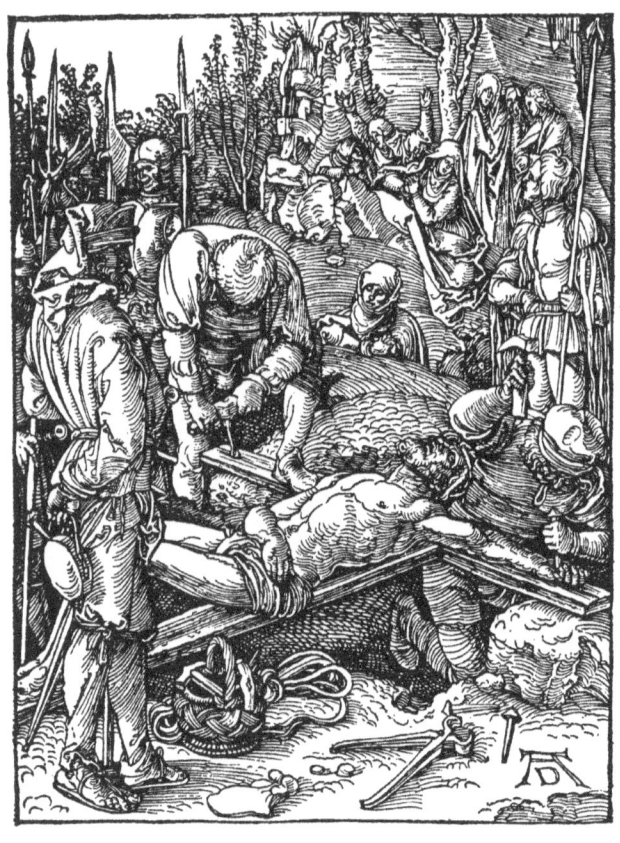

245

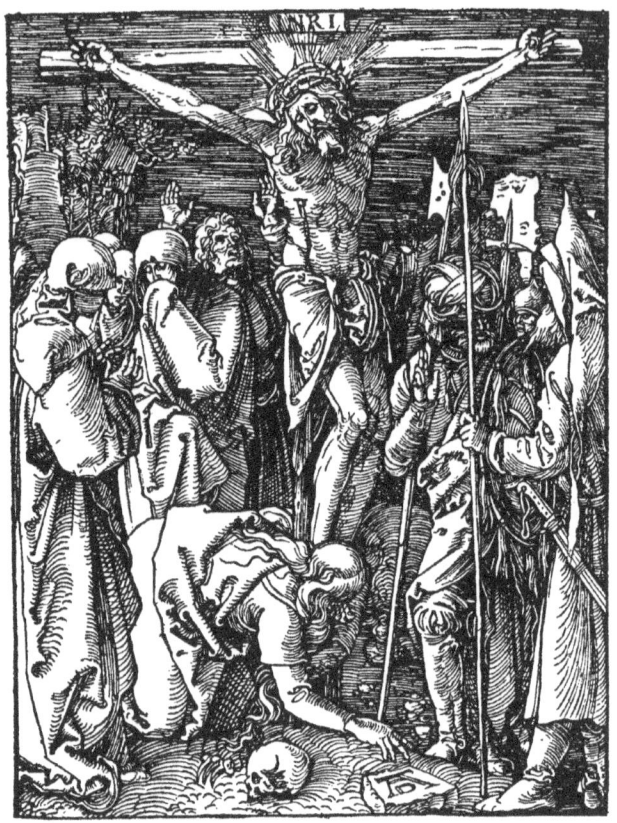

246

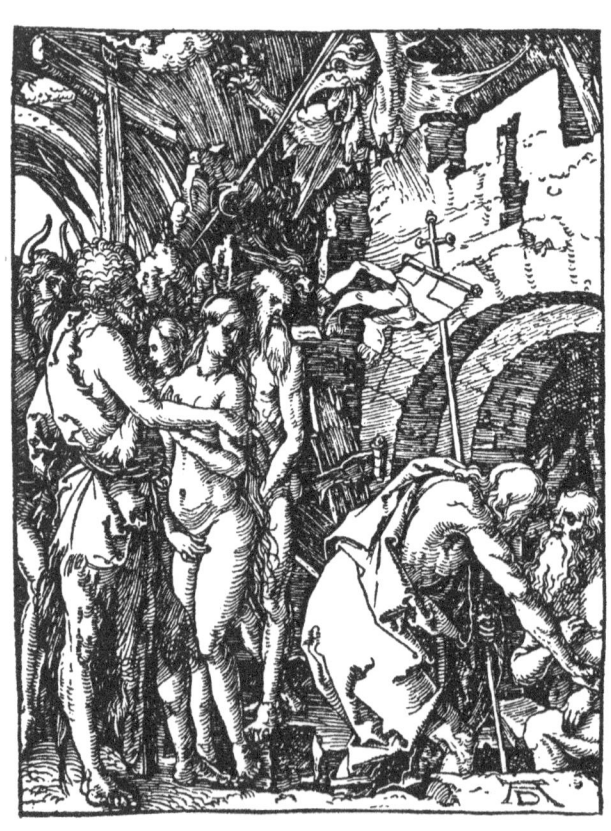

247

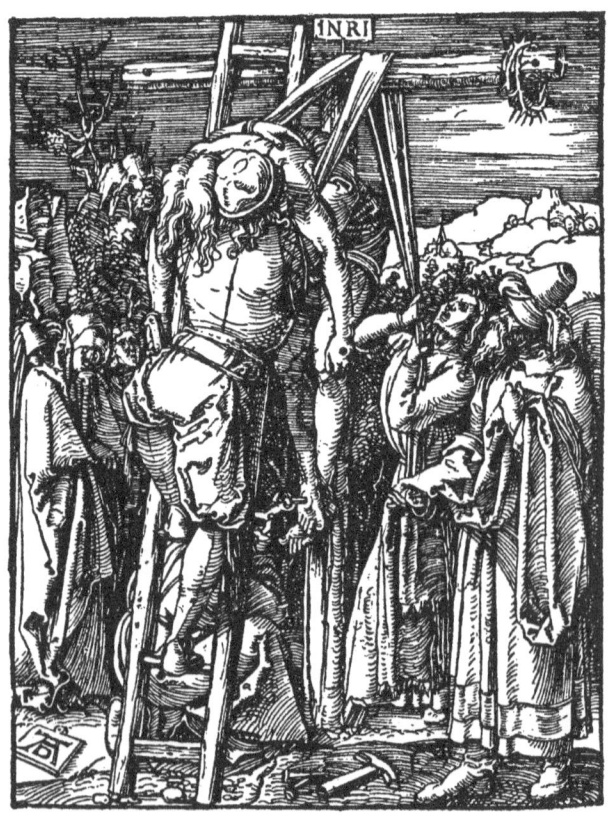

248

{ PAGE 174 }

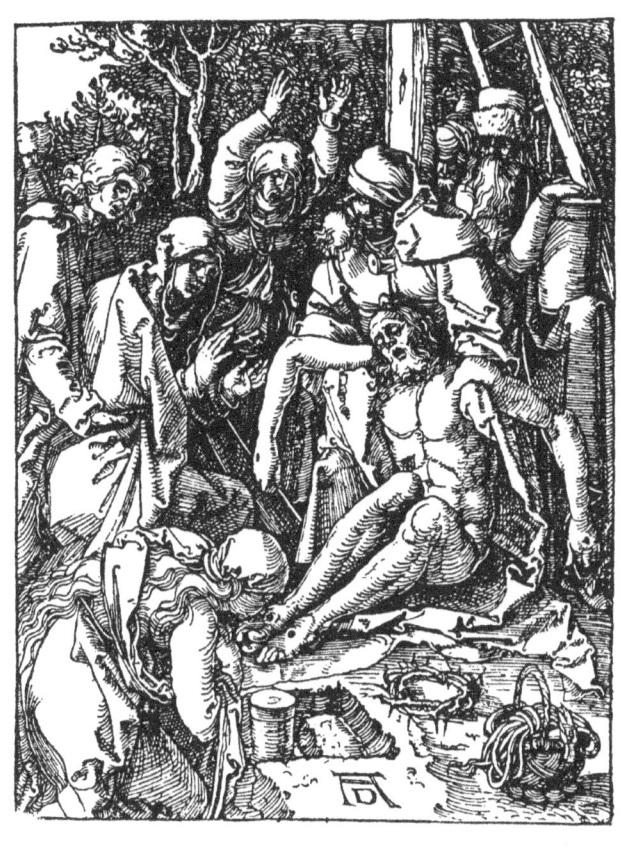

249

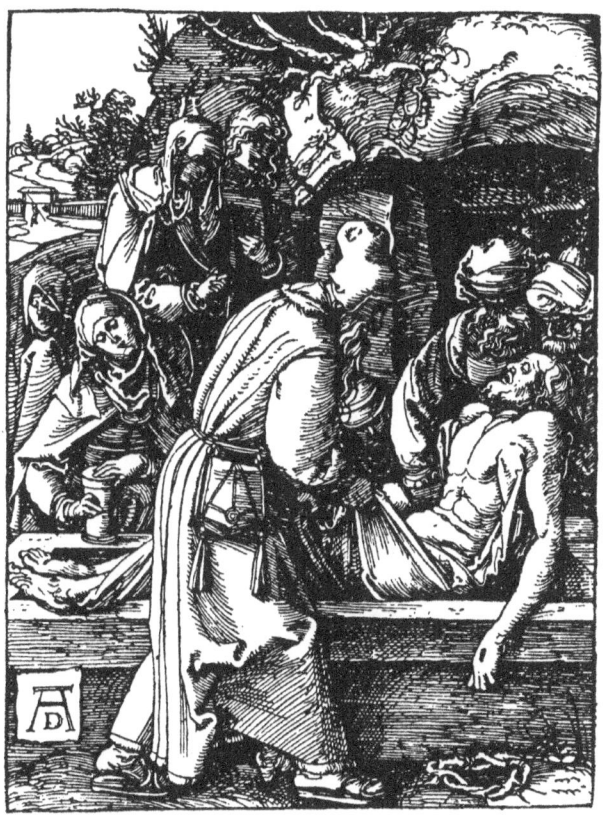

250

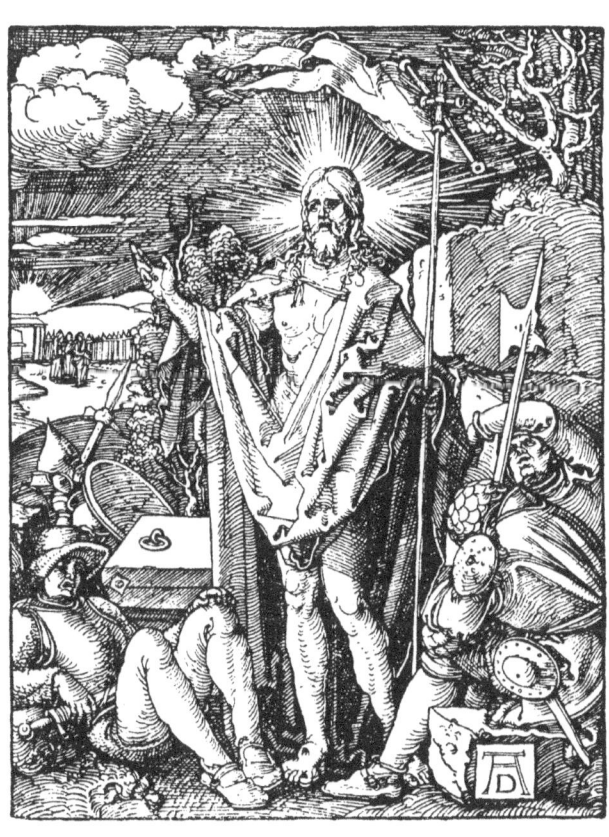

251

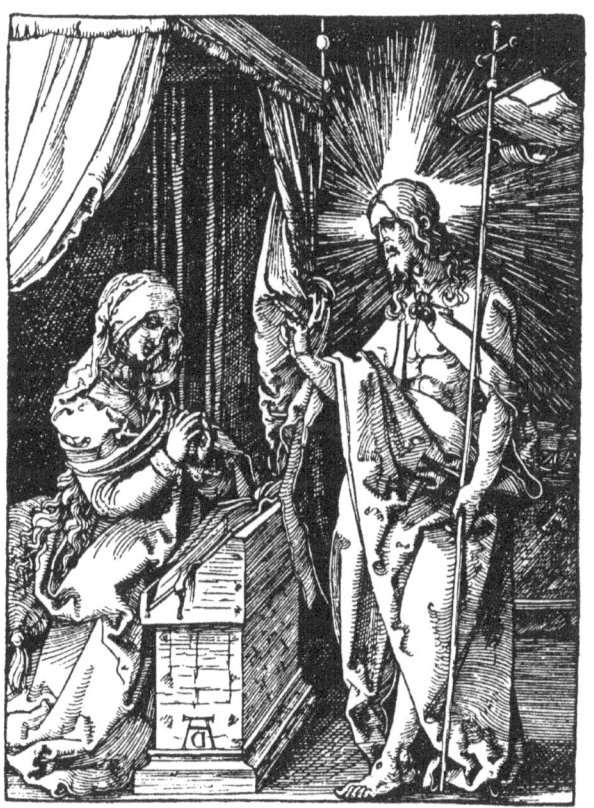

252

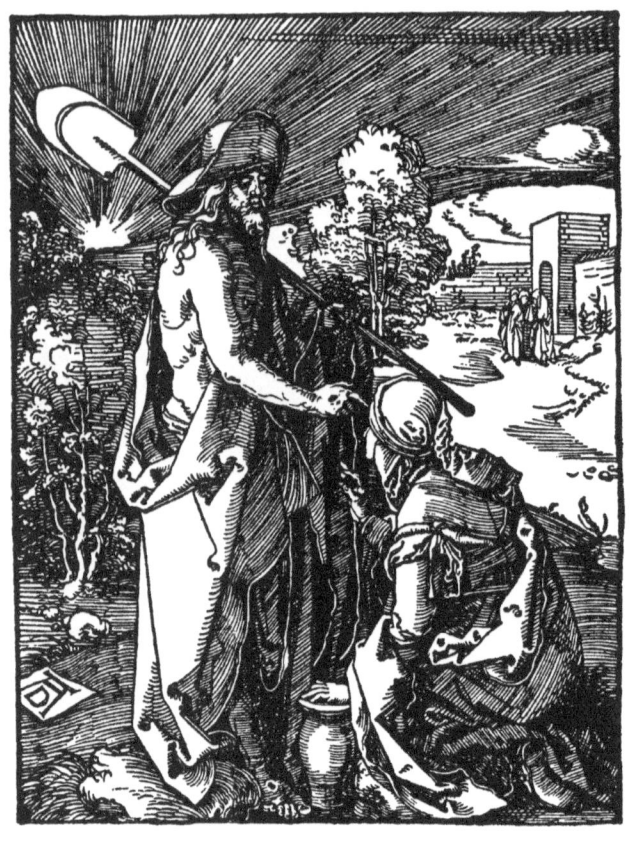

253

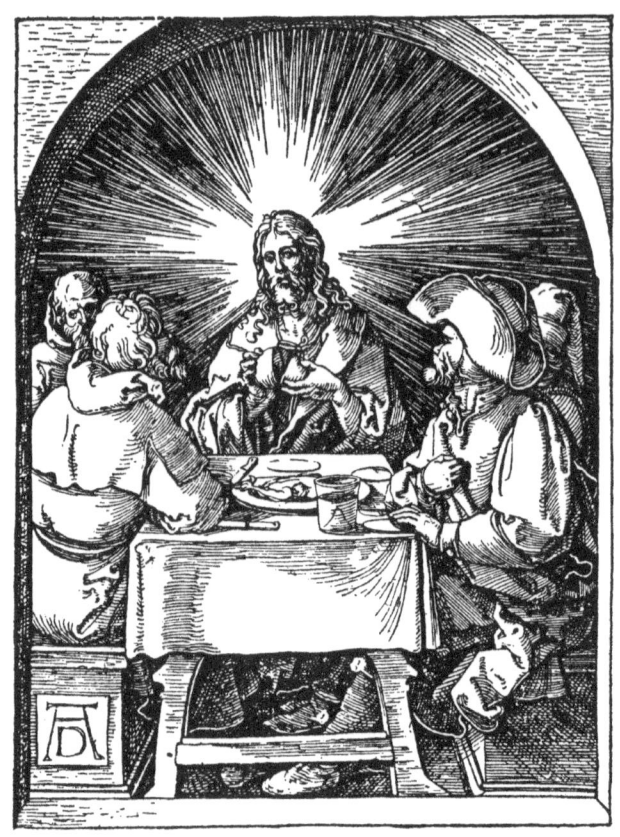

254

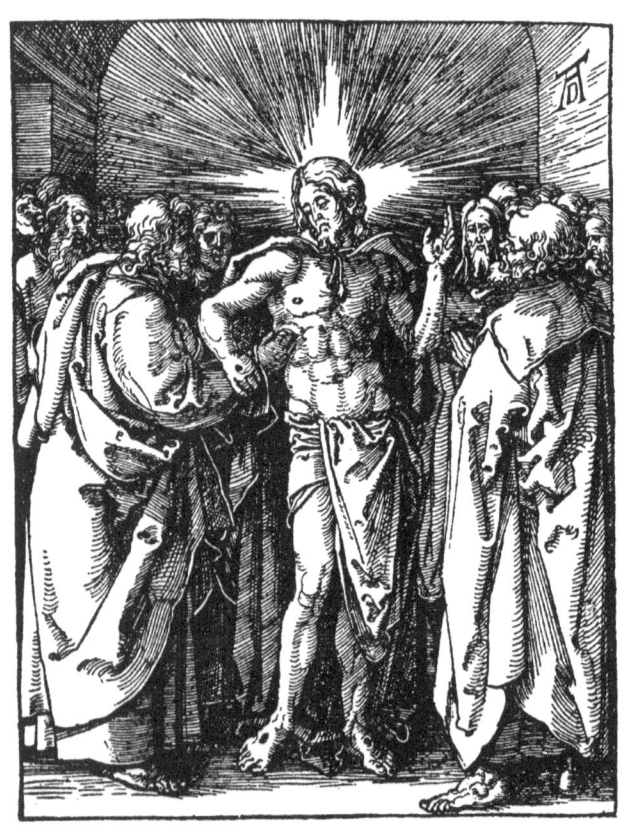

255

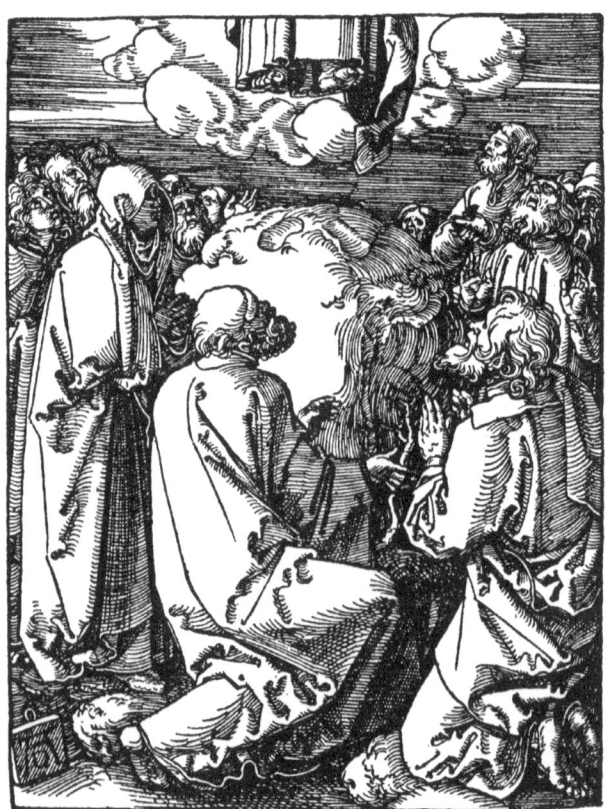

256

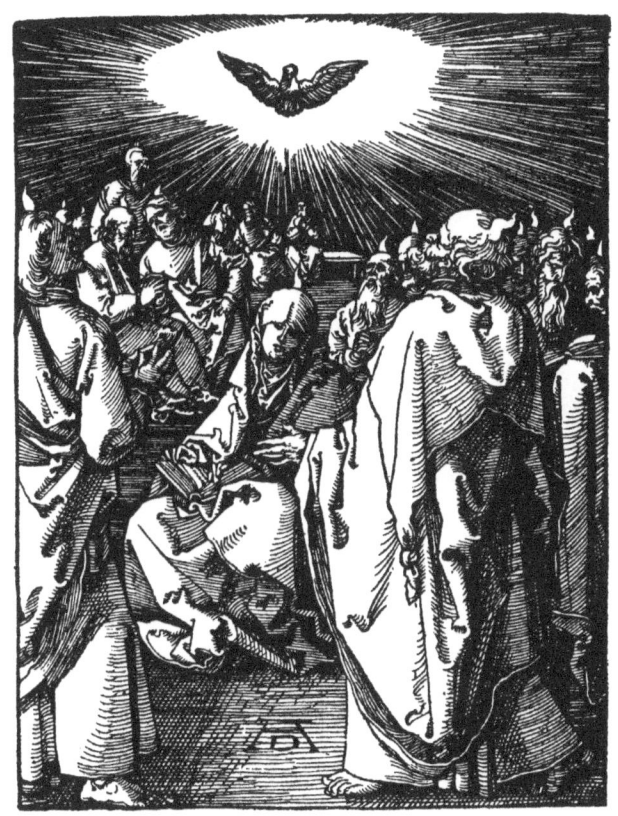

257

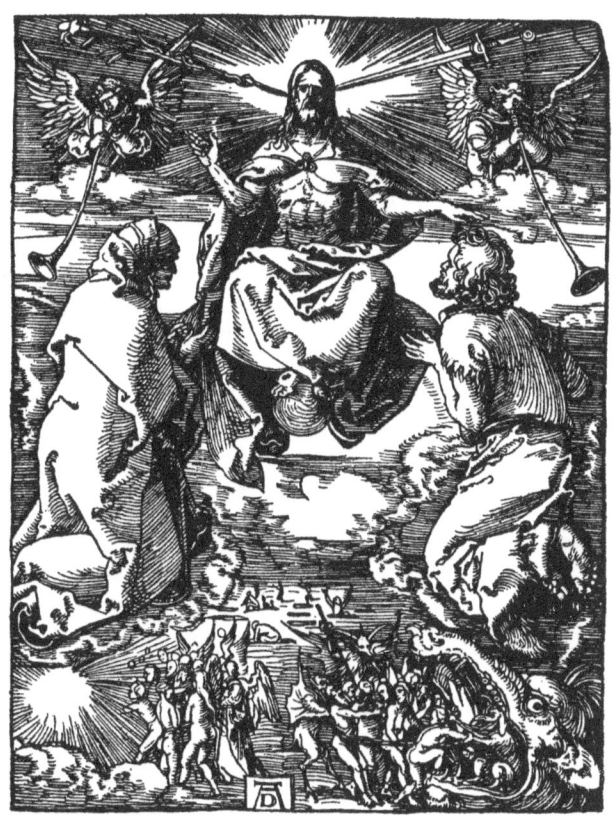

258

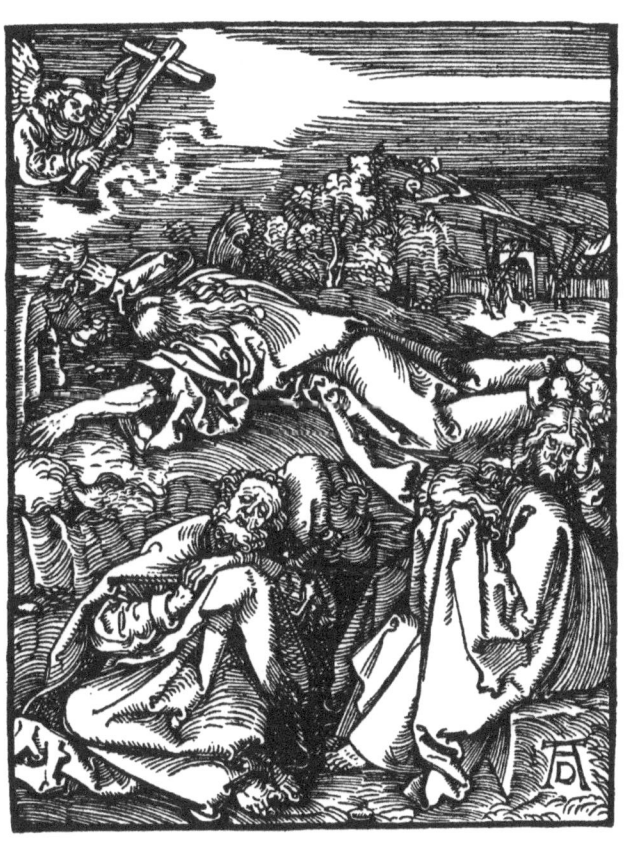

259

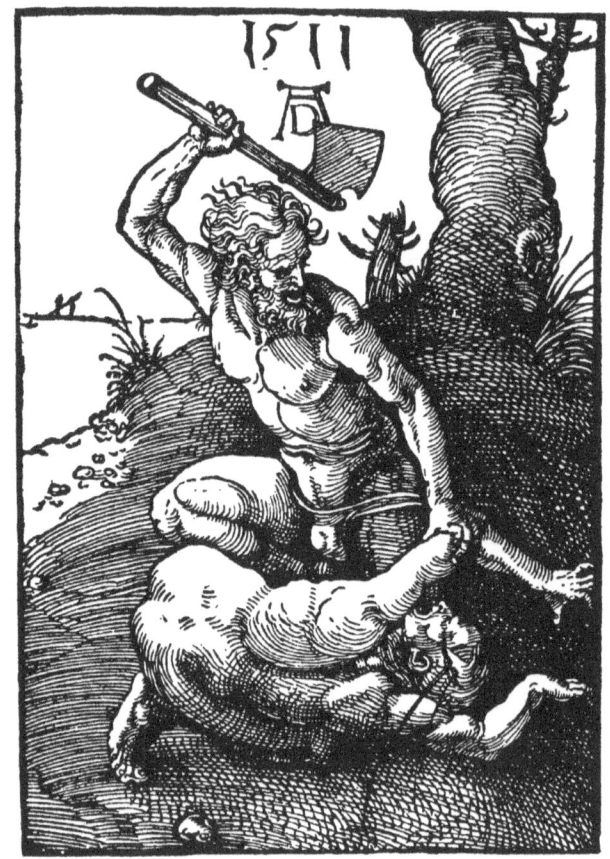

261

Plate 260 is printed together with Plate 212

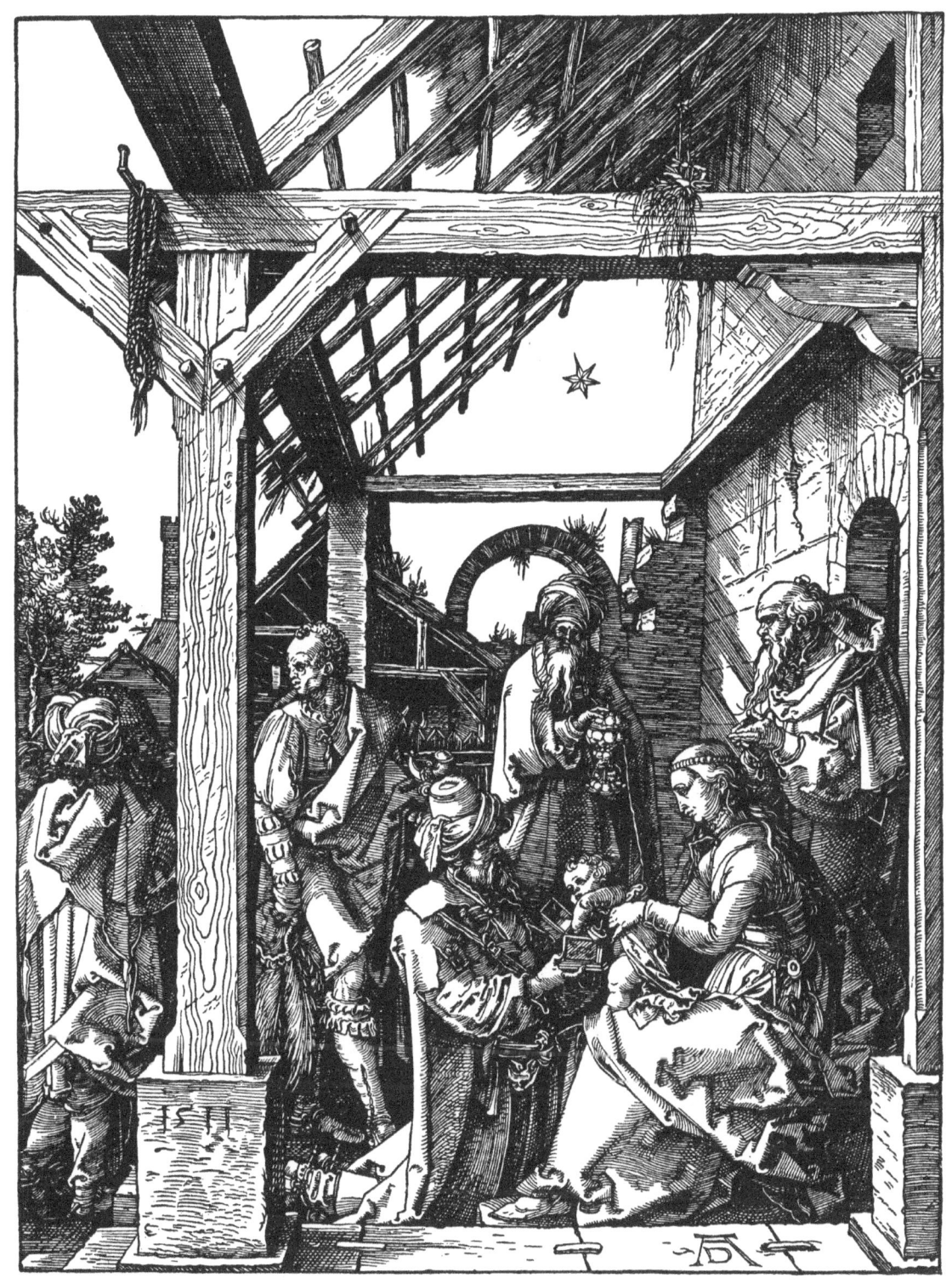

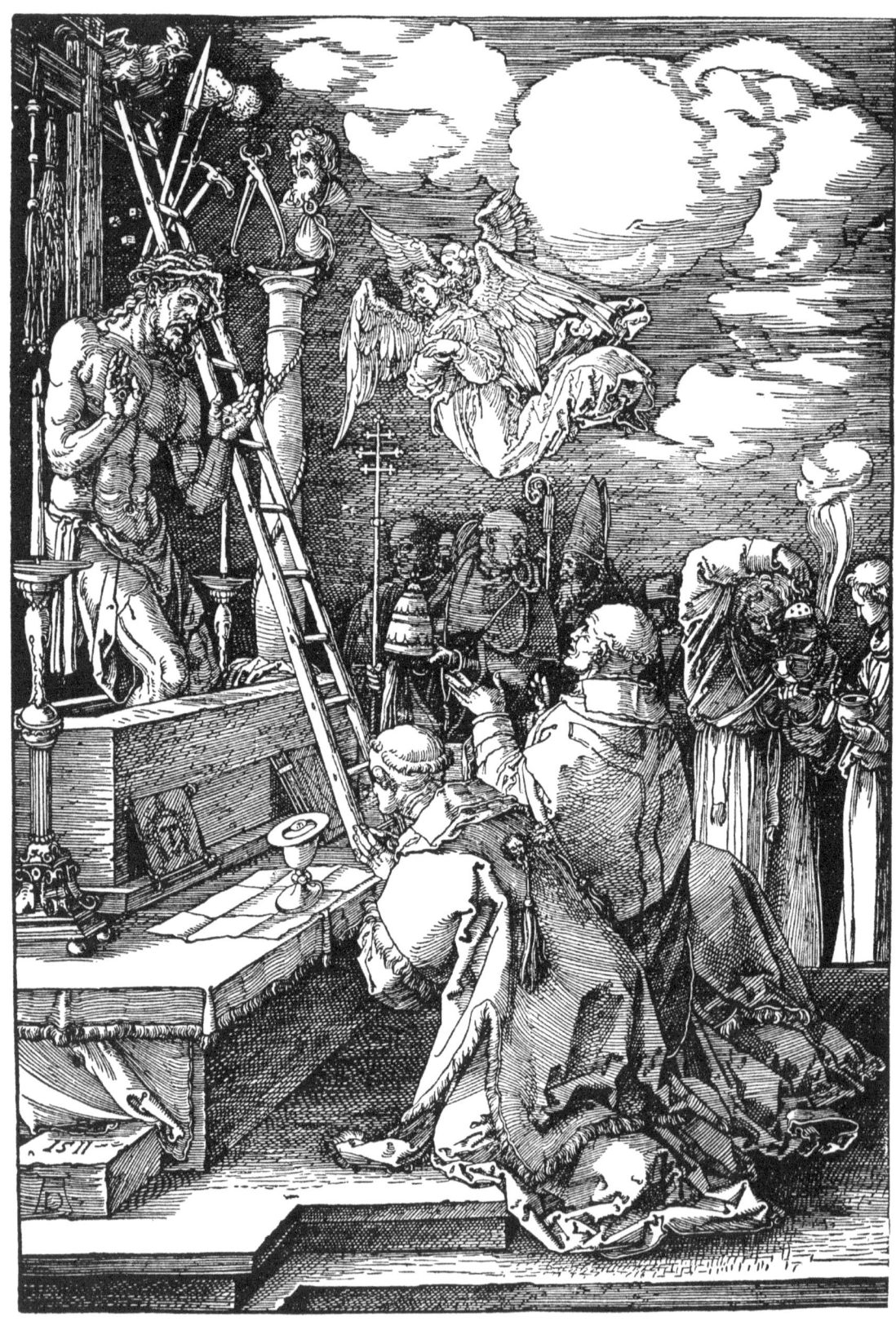

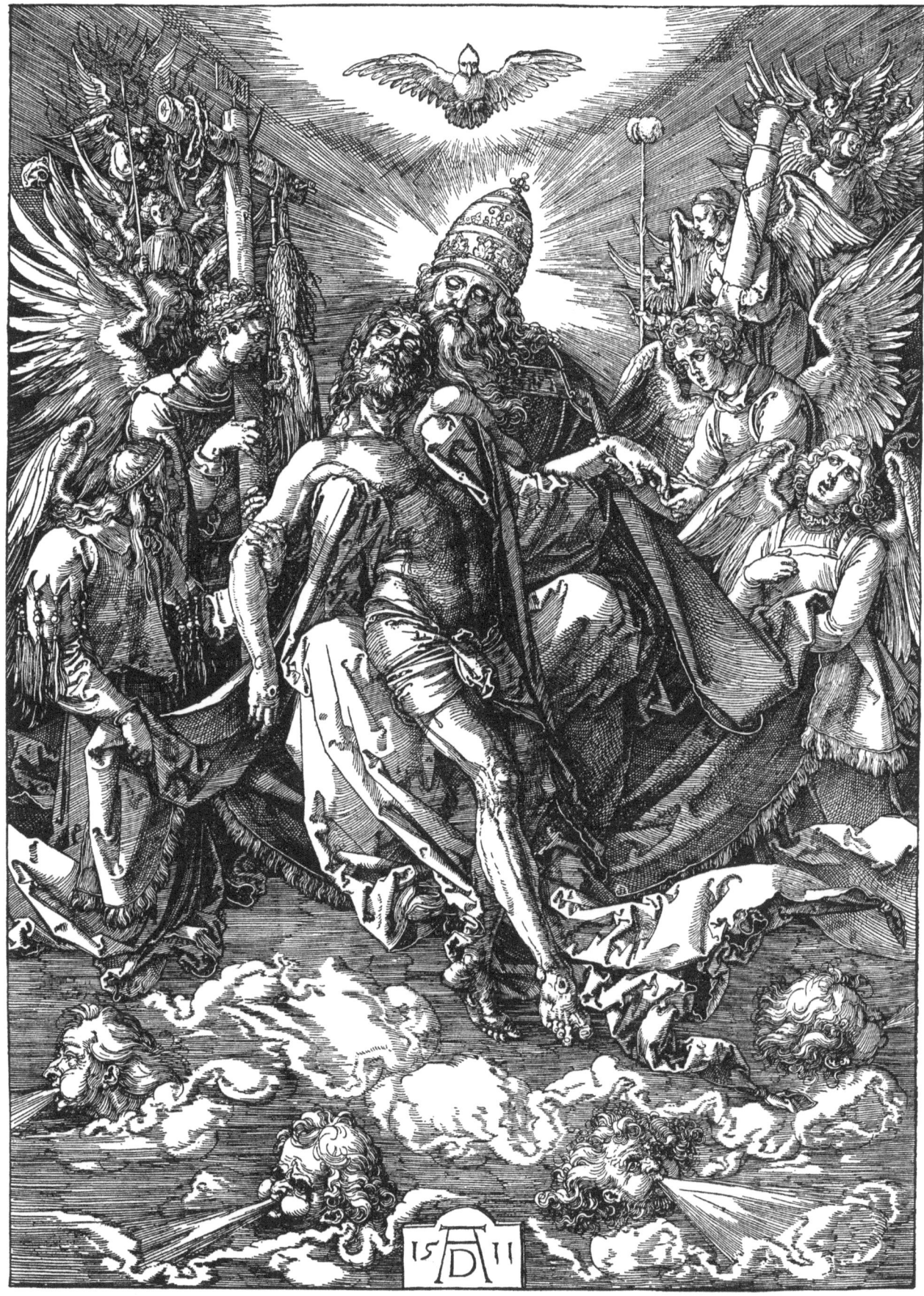

{ PAGE 181 }

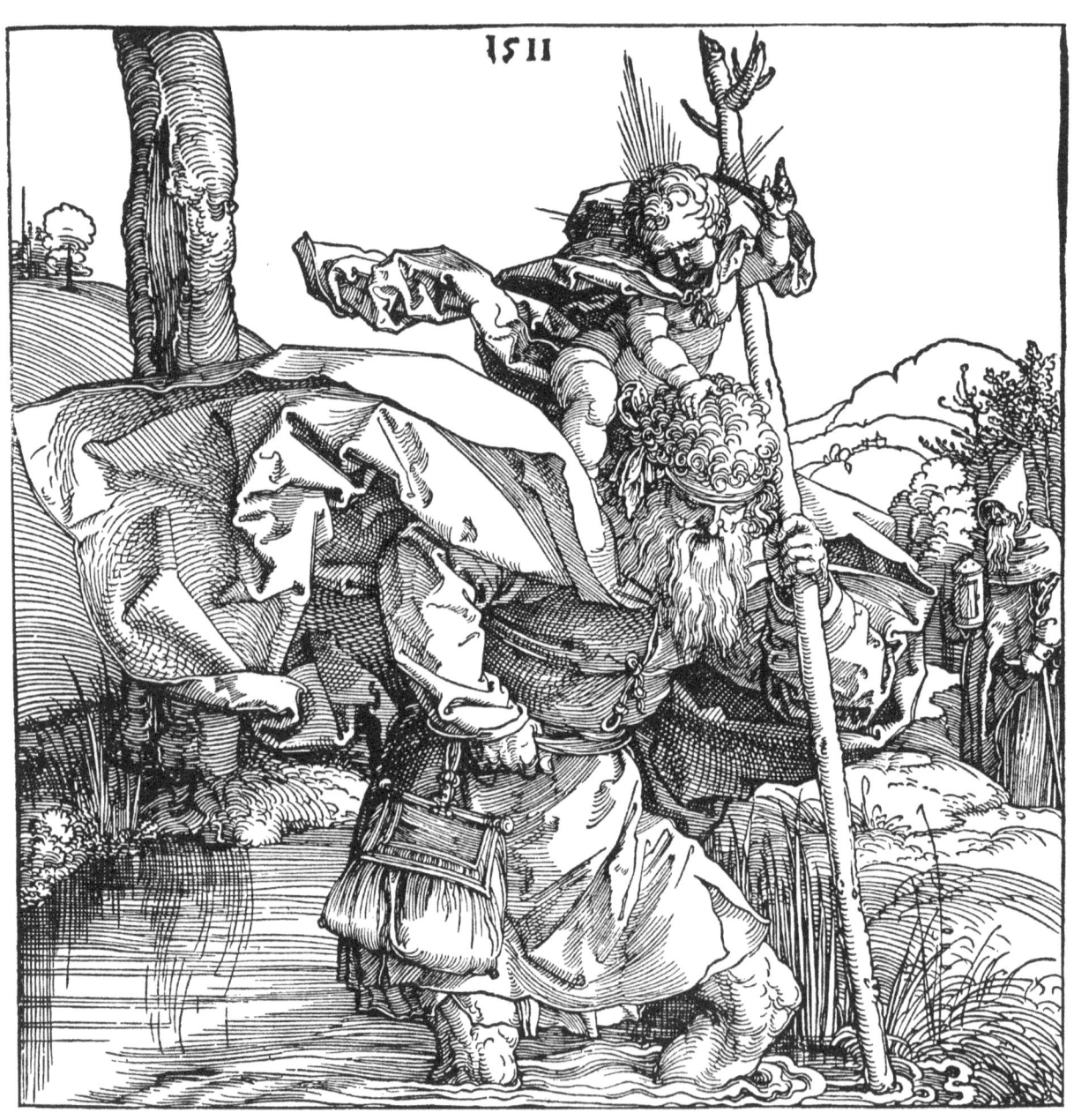

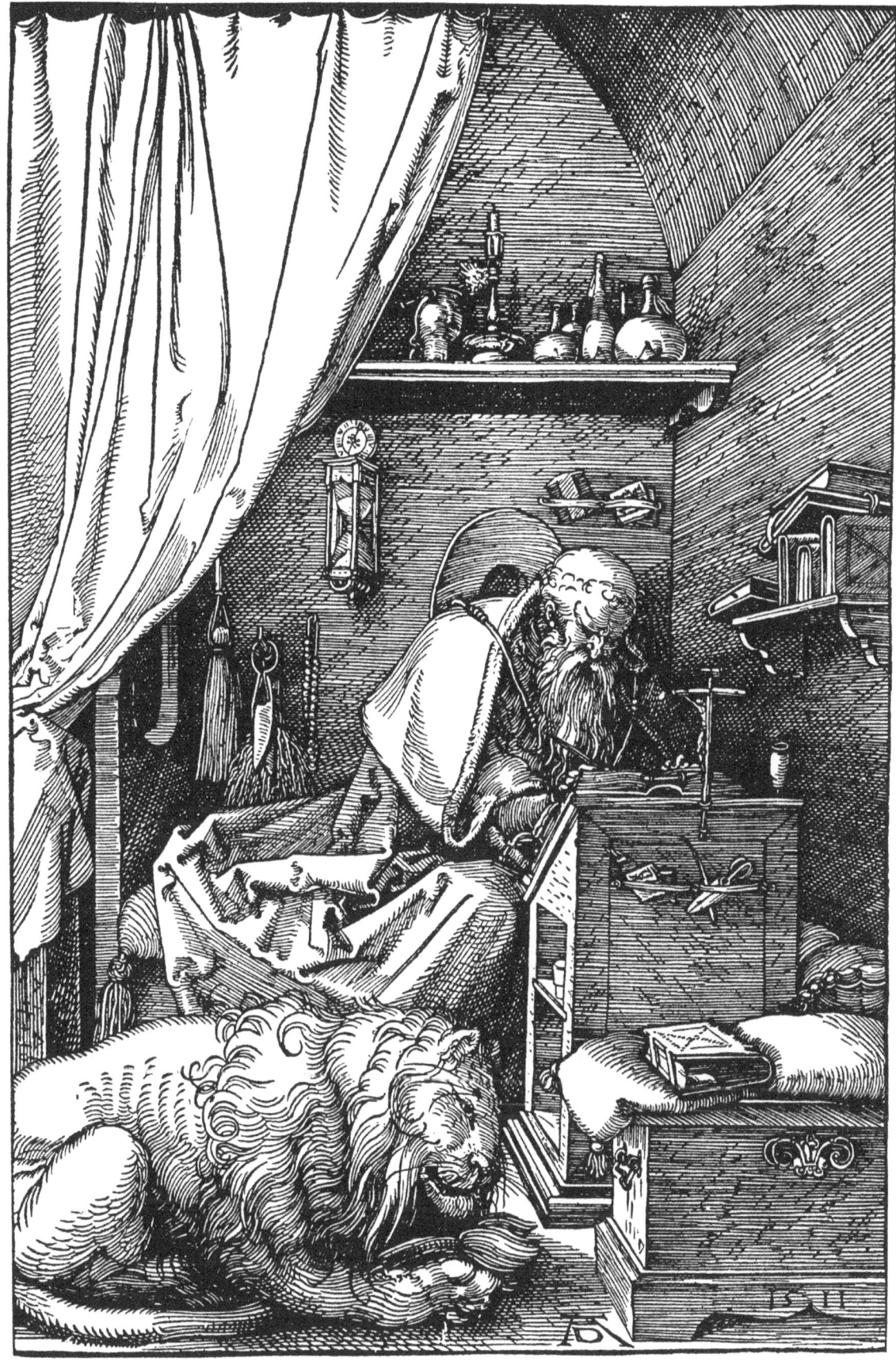

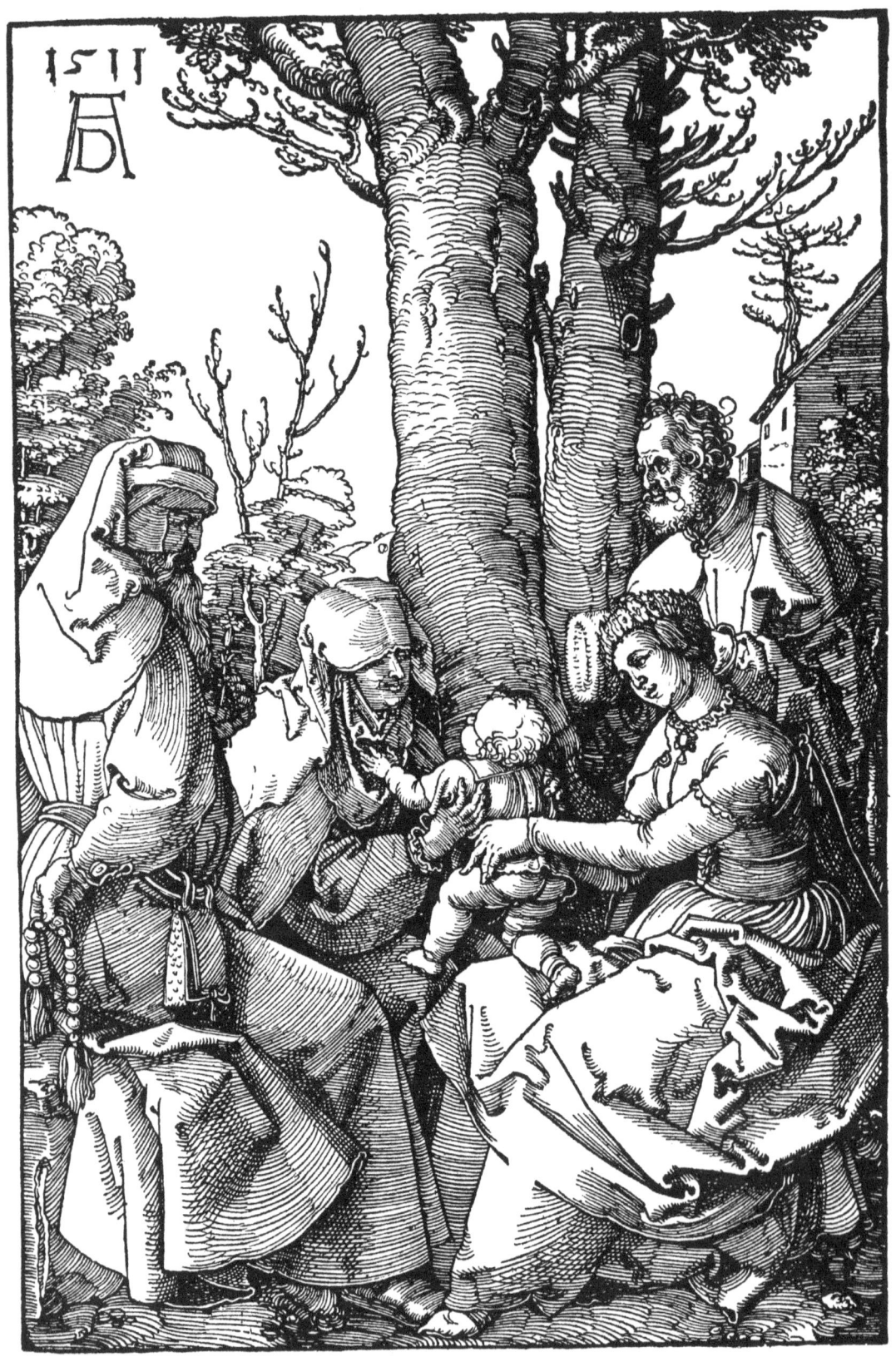

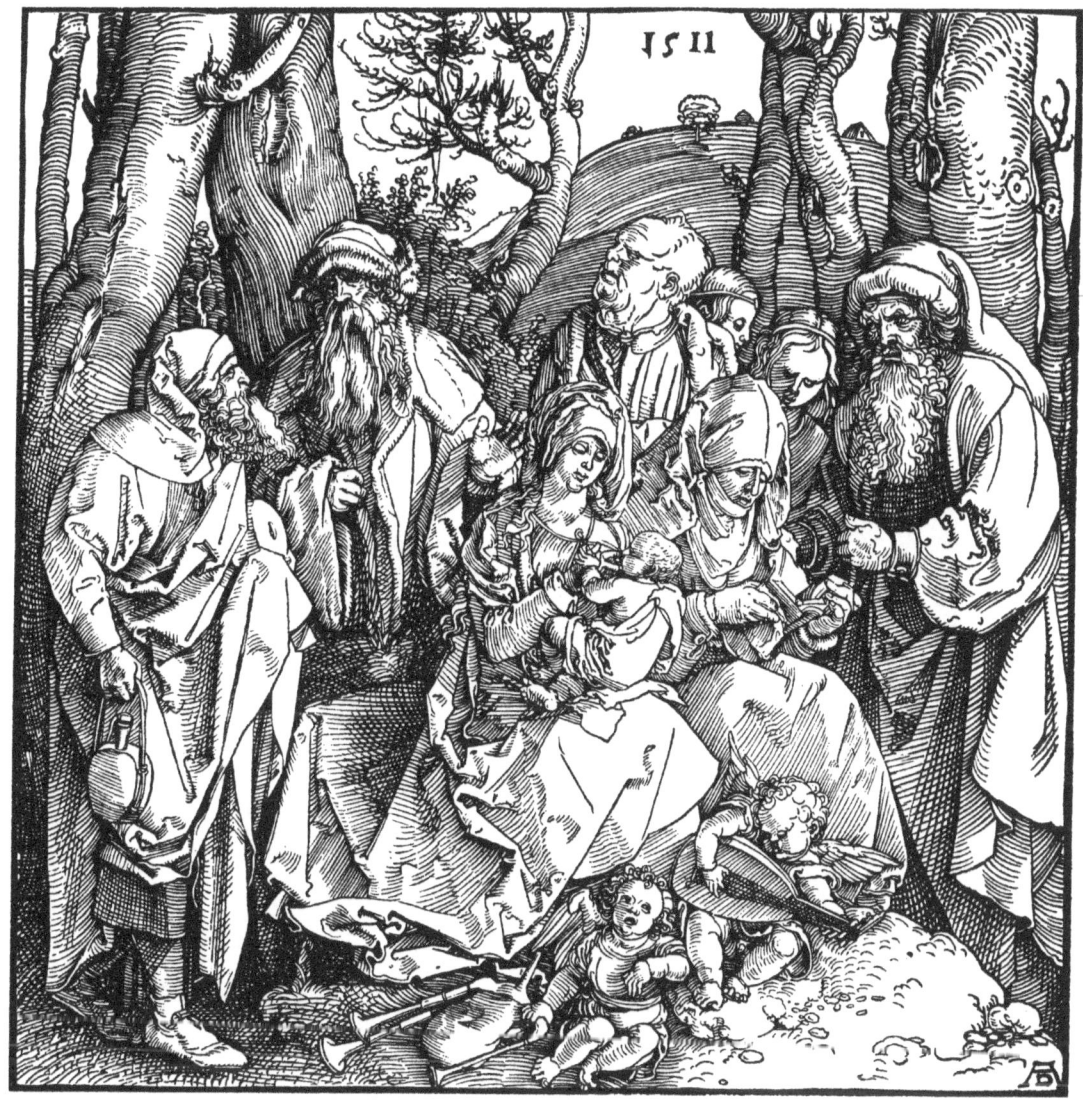

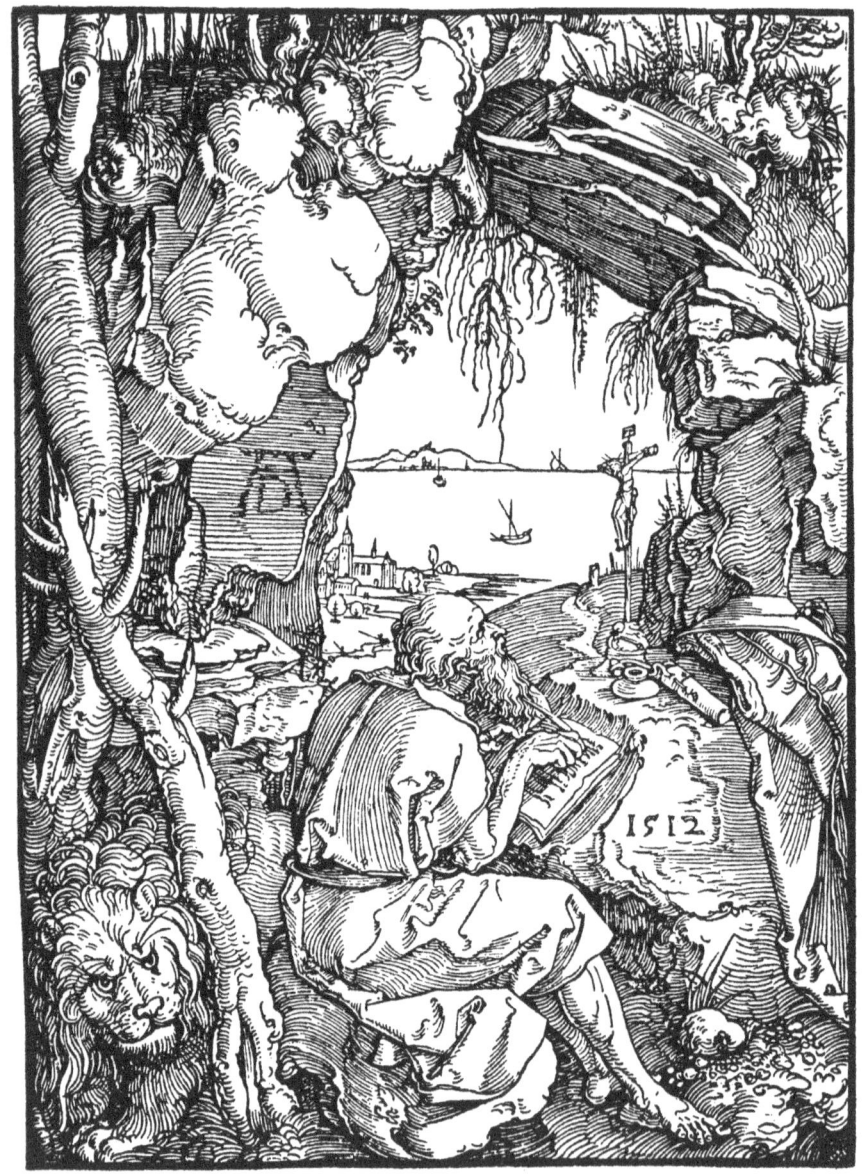

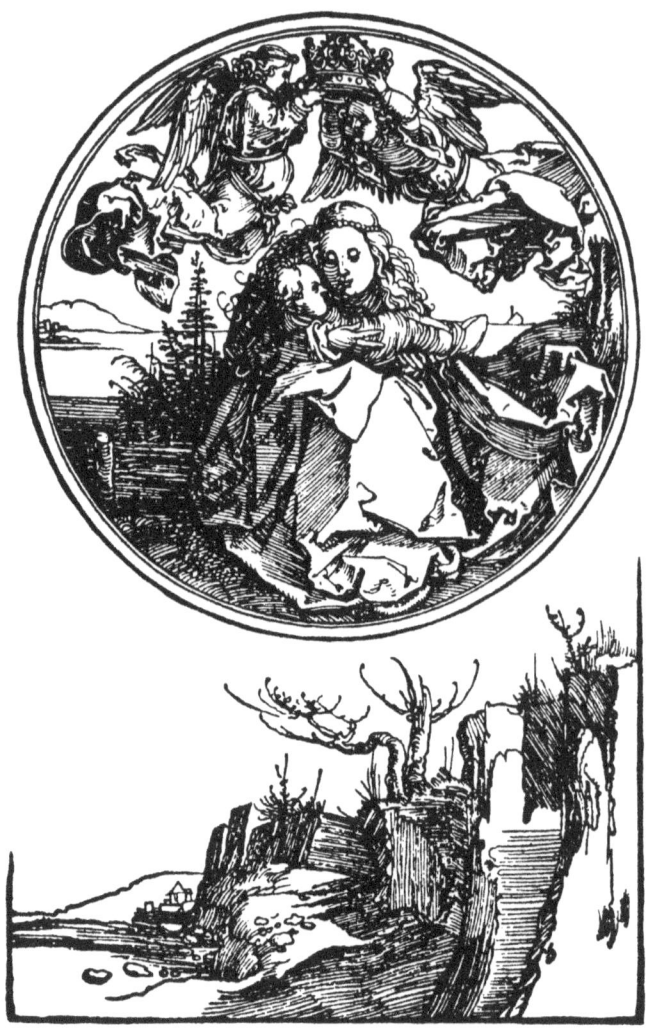

271

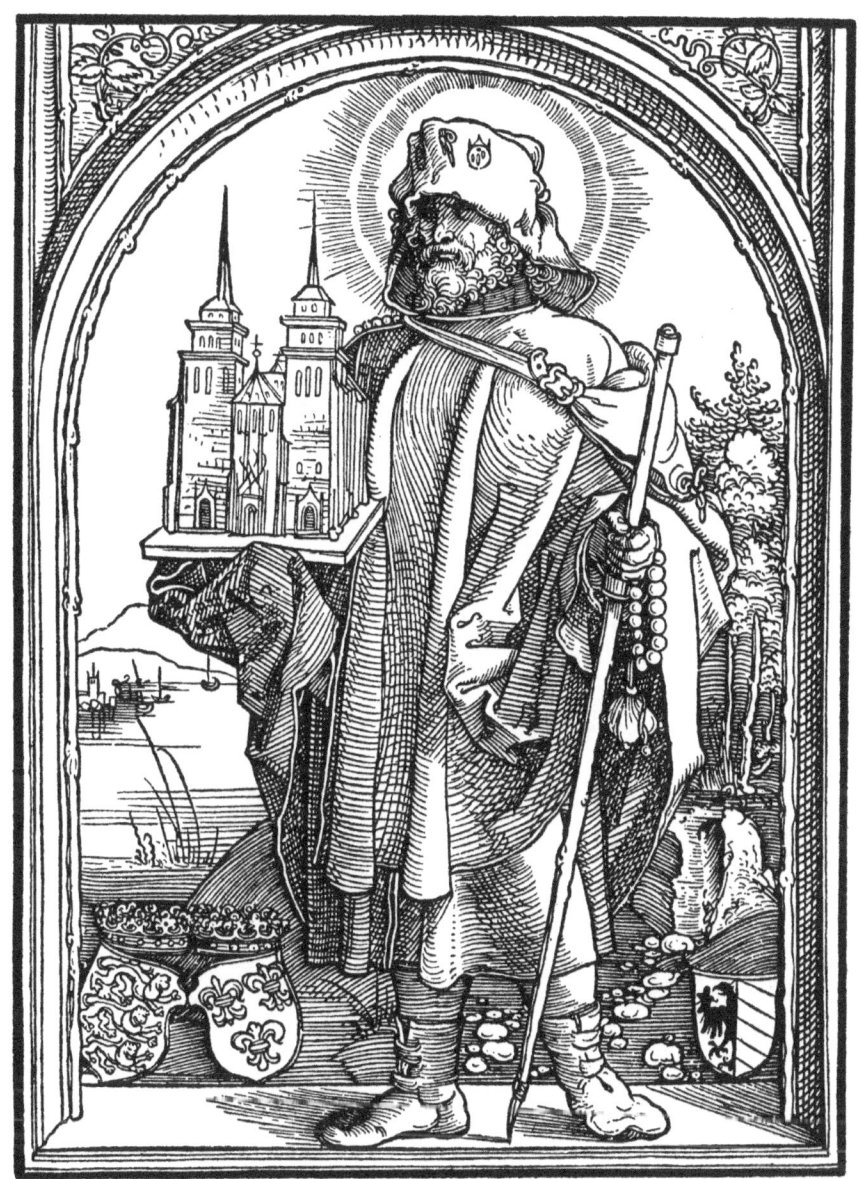

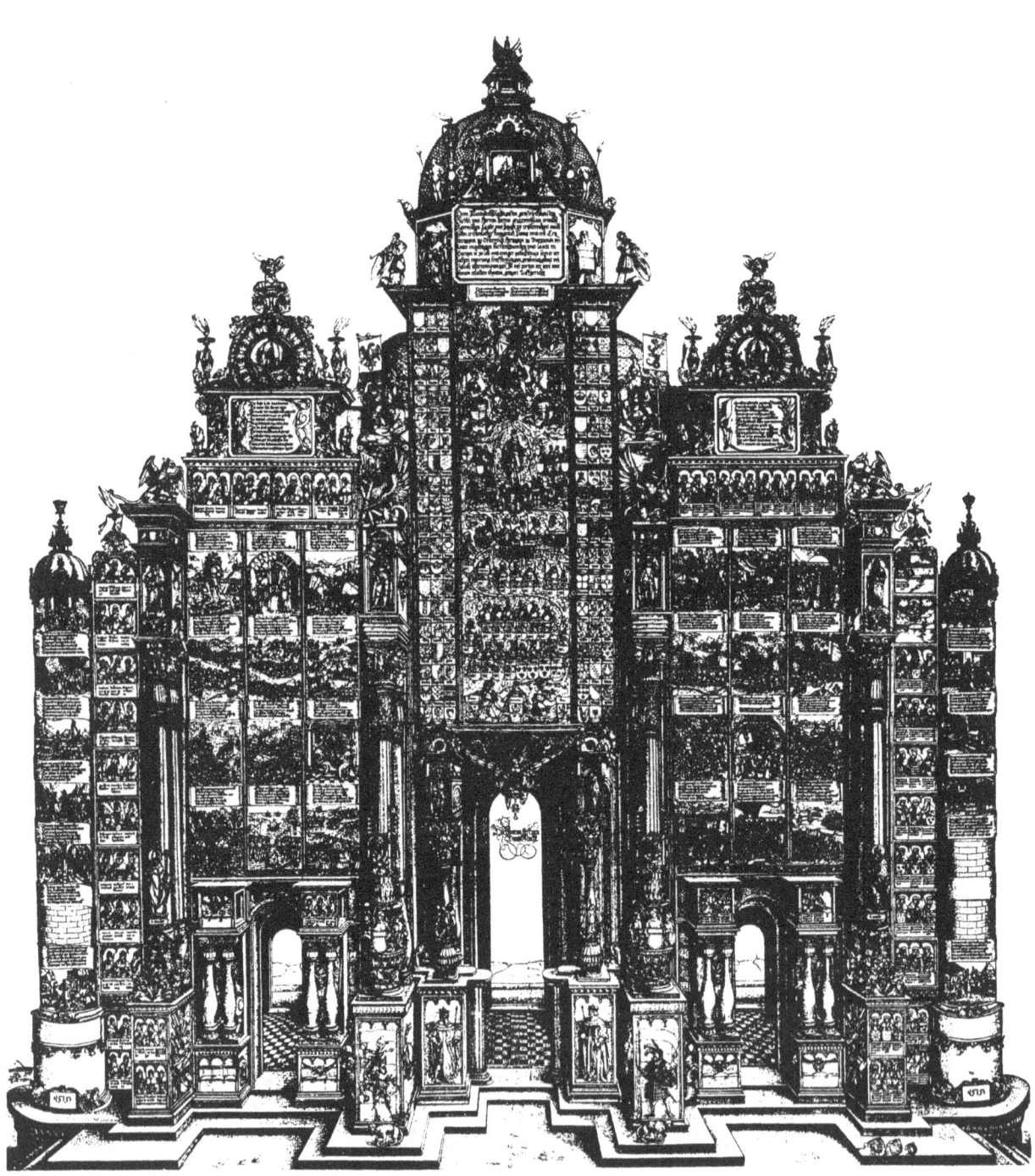

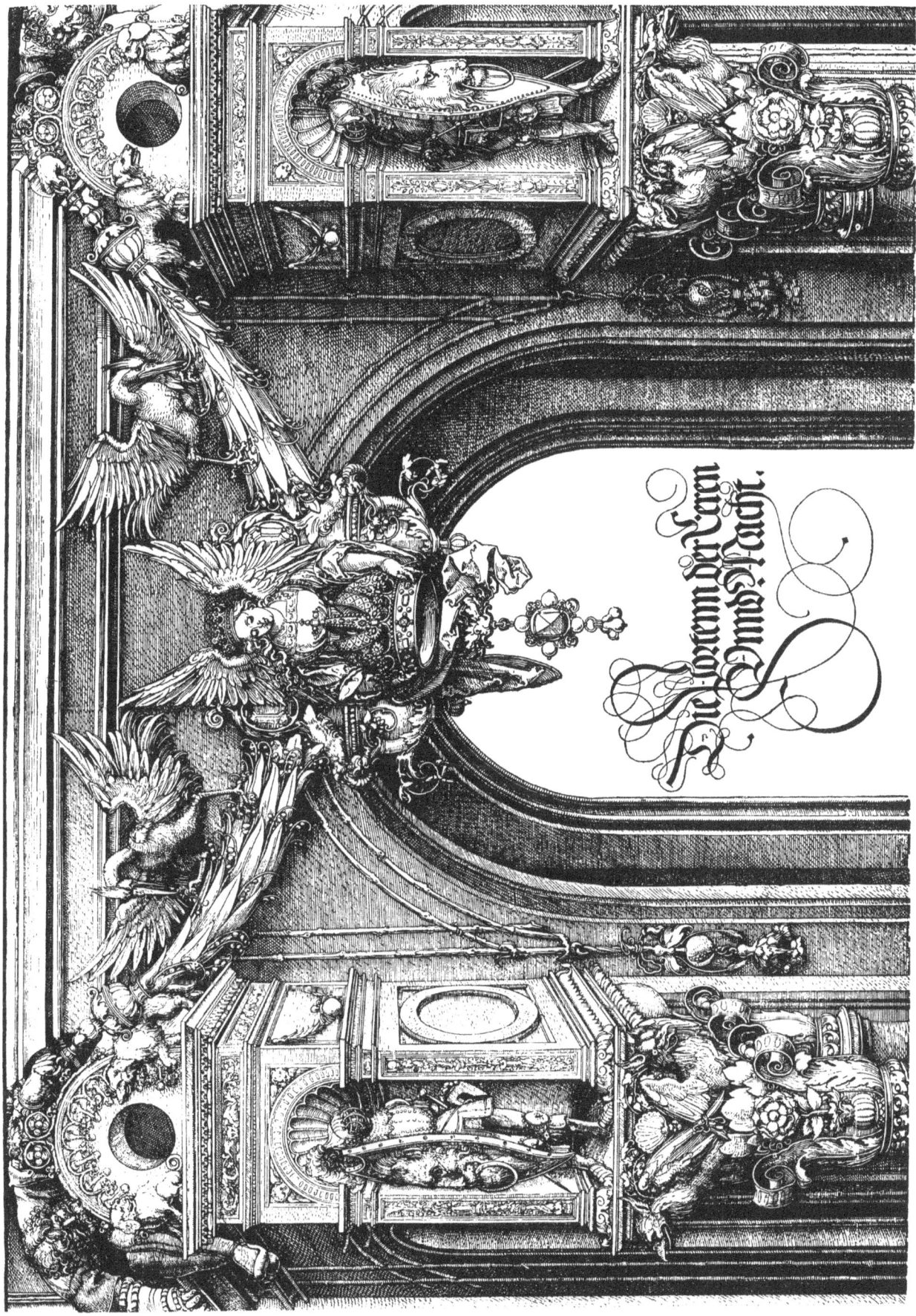

{ PAGE 191 }

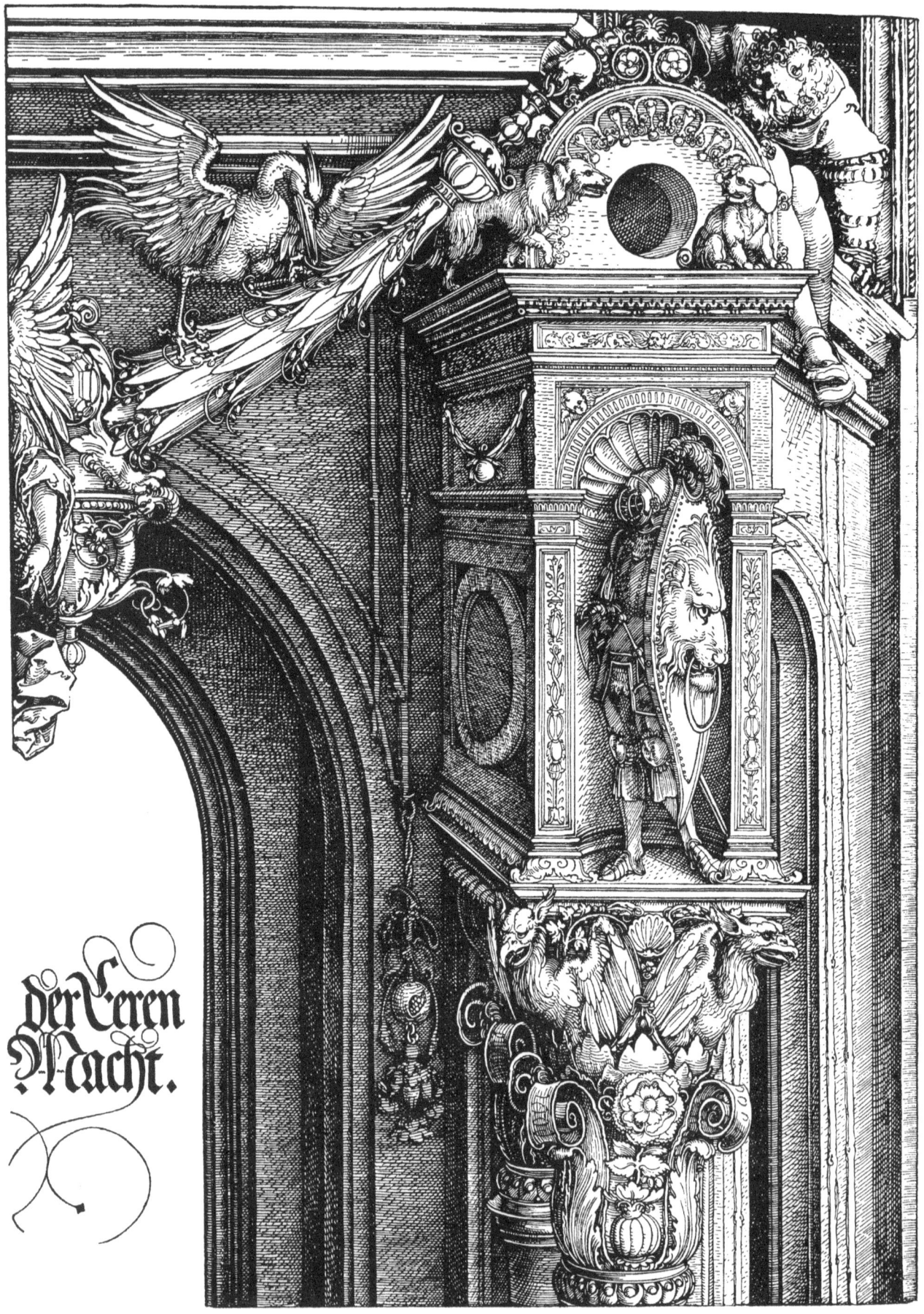

der Eeren
Nacht.

{ PAGE 192 }

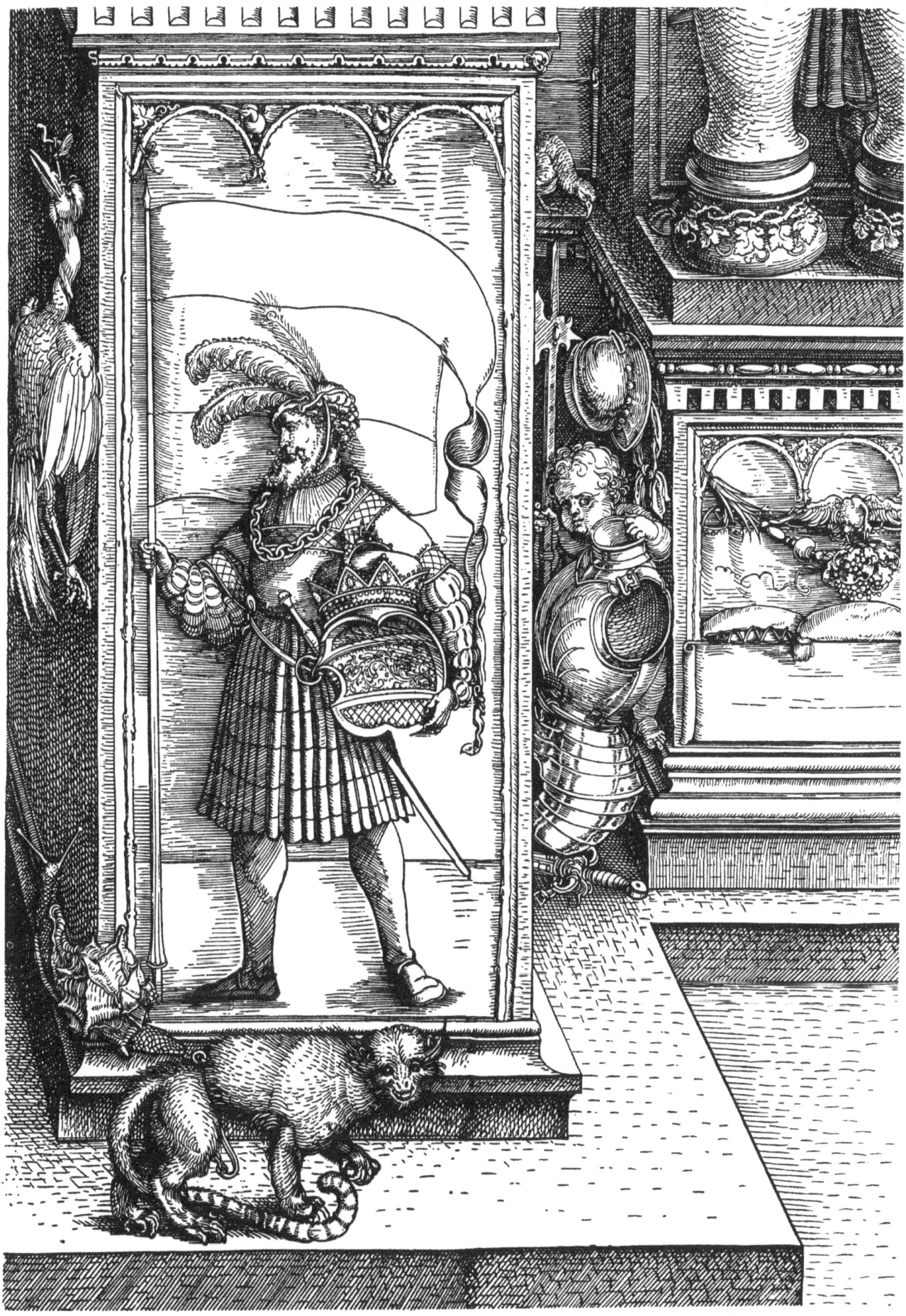

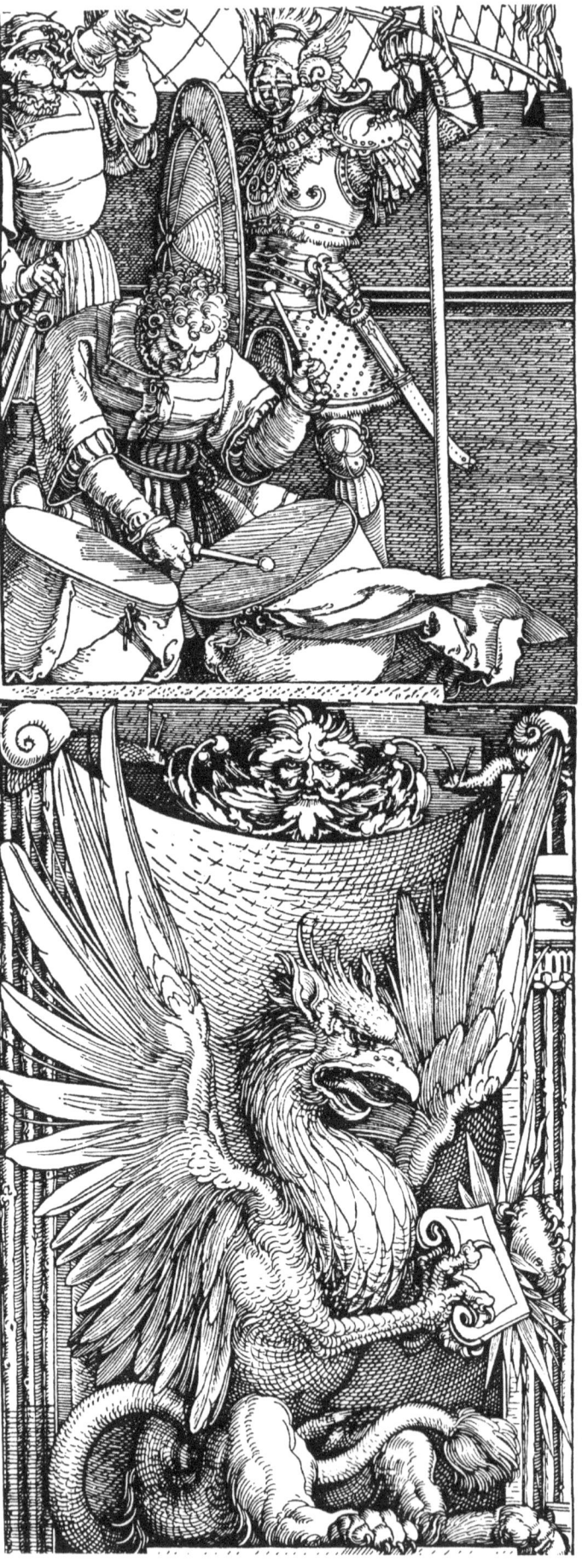

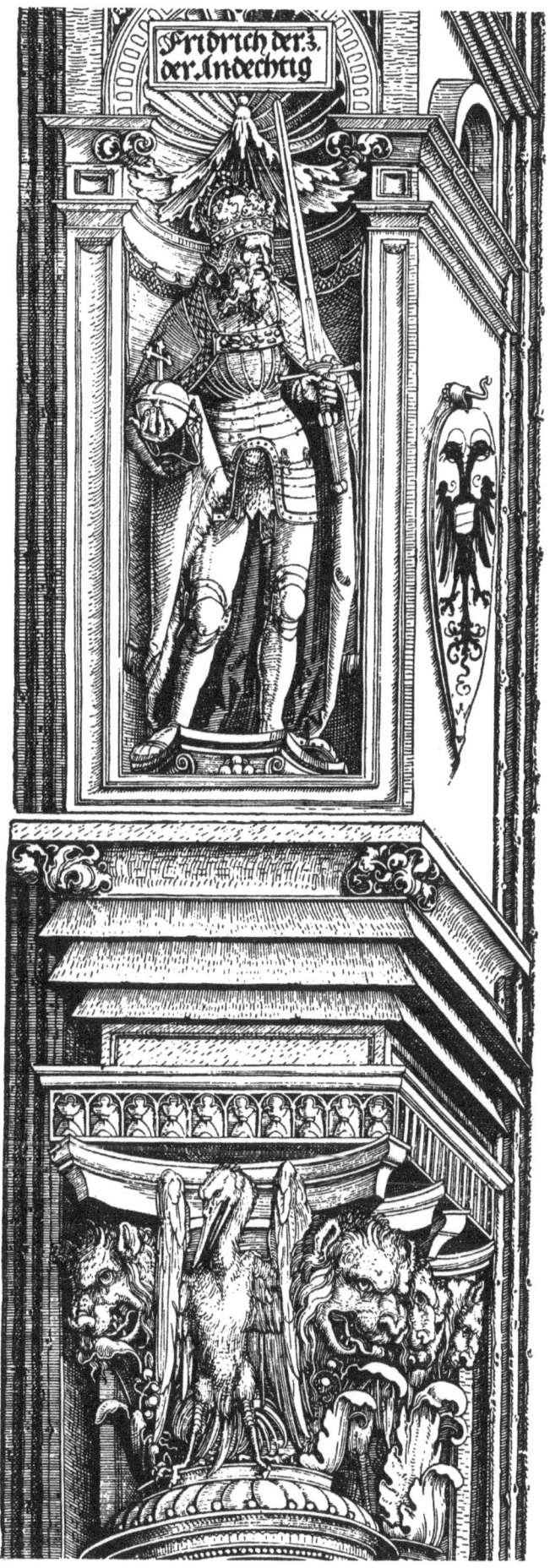

{ PAGE 197 }

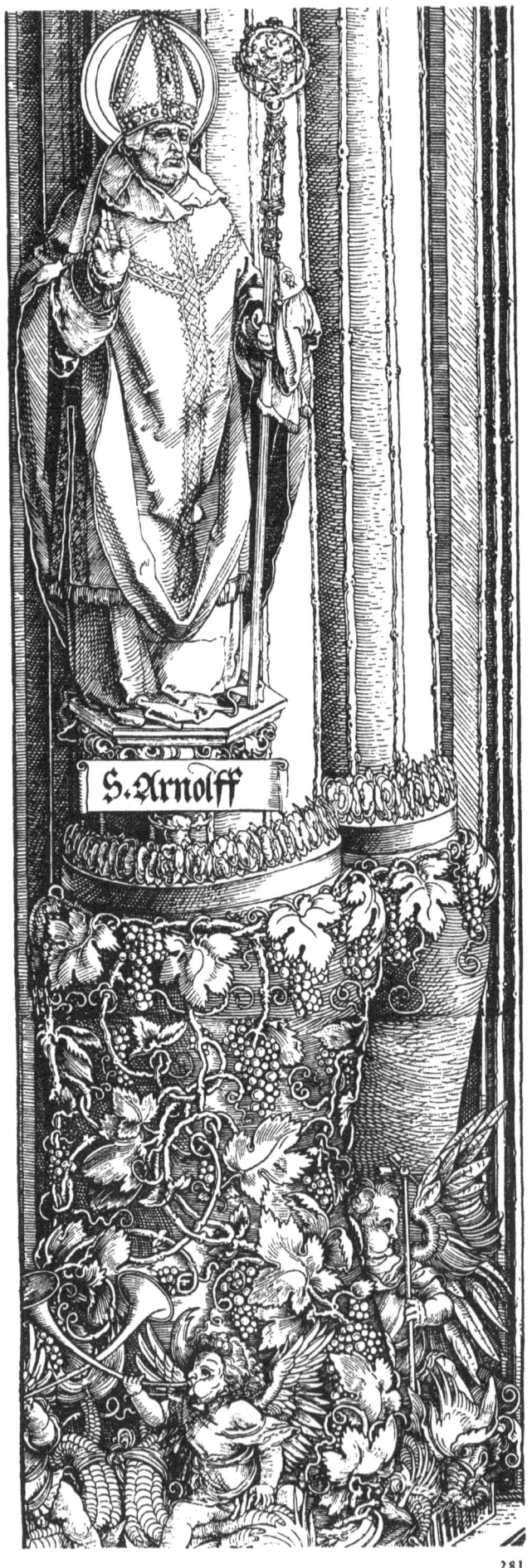

{ PAGE 198 }

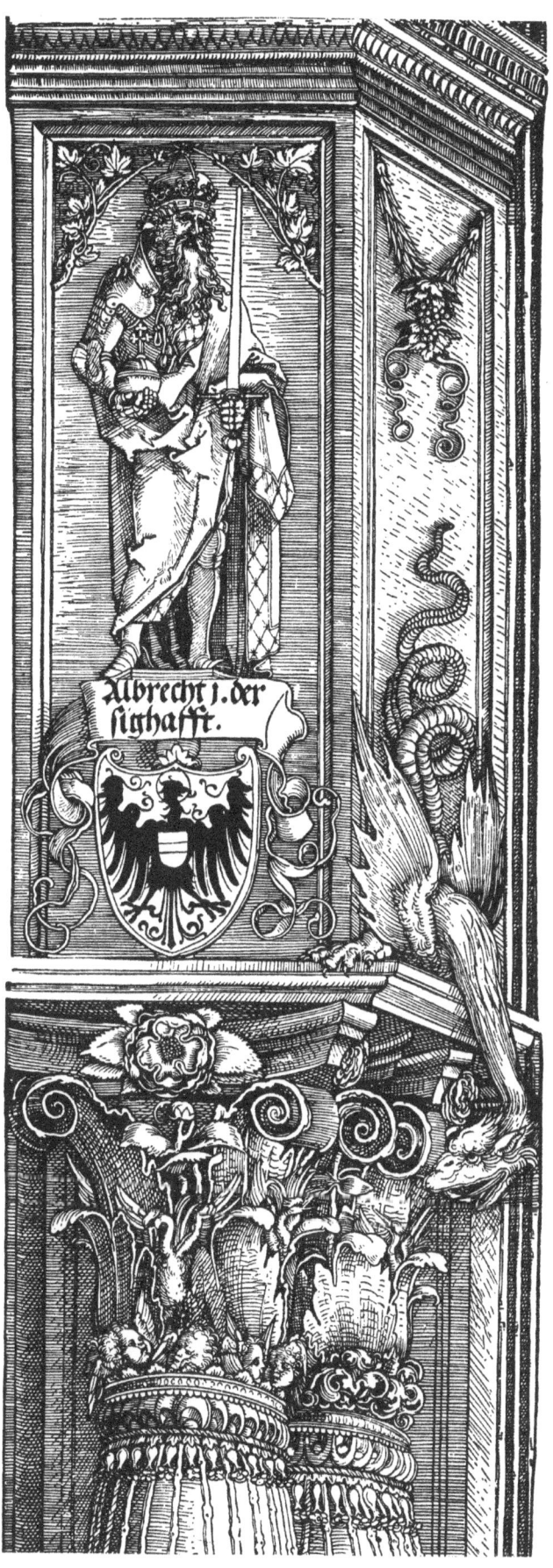

286

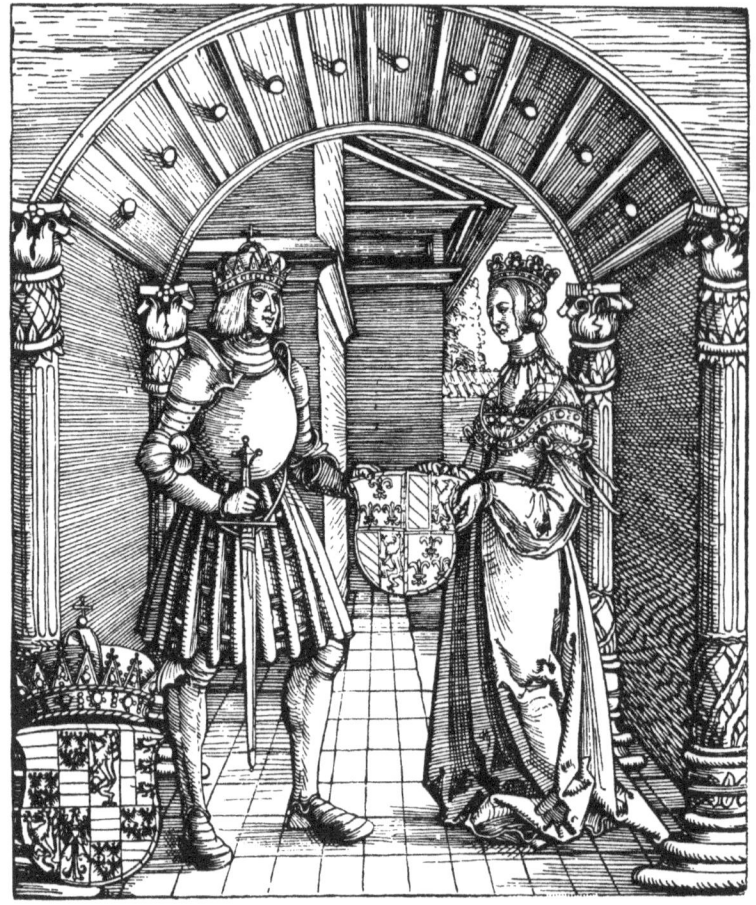
287

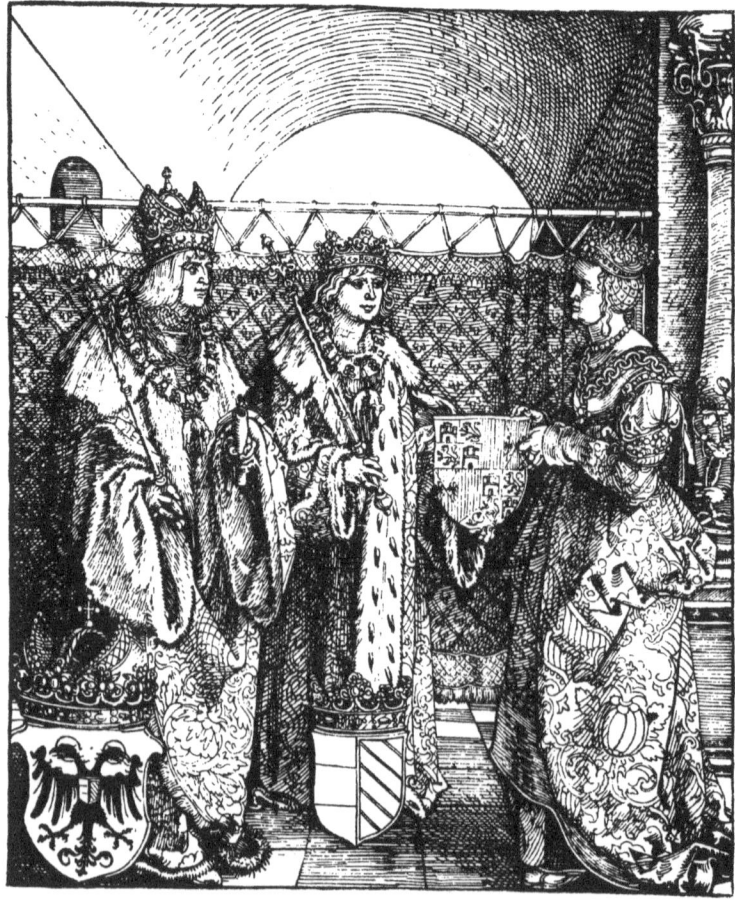
288

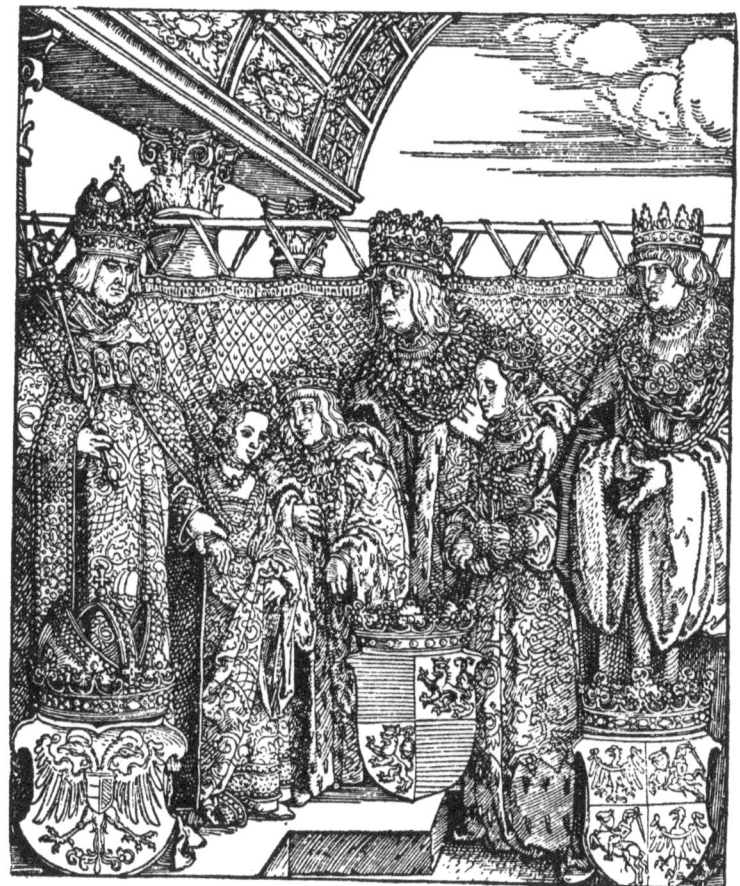

289

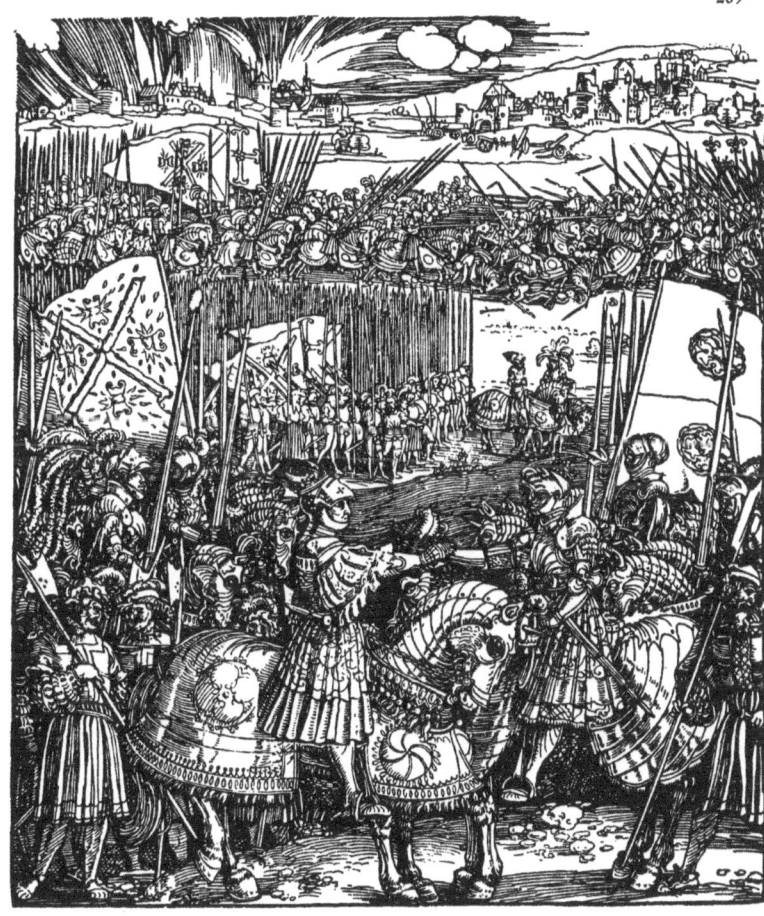

290

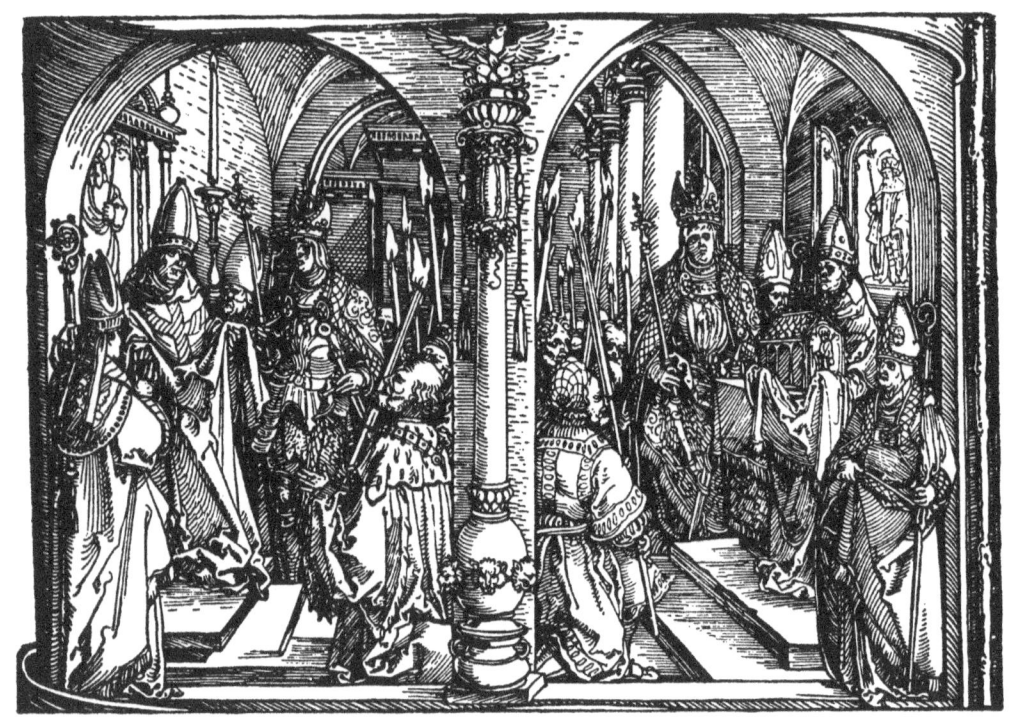

291

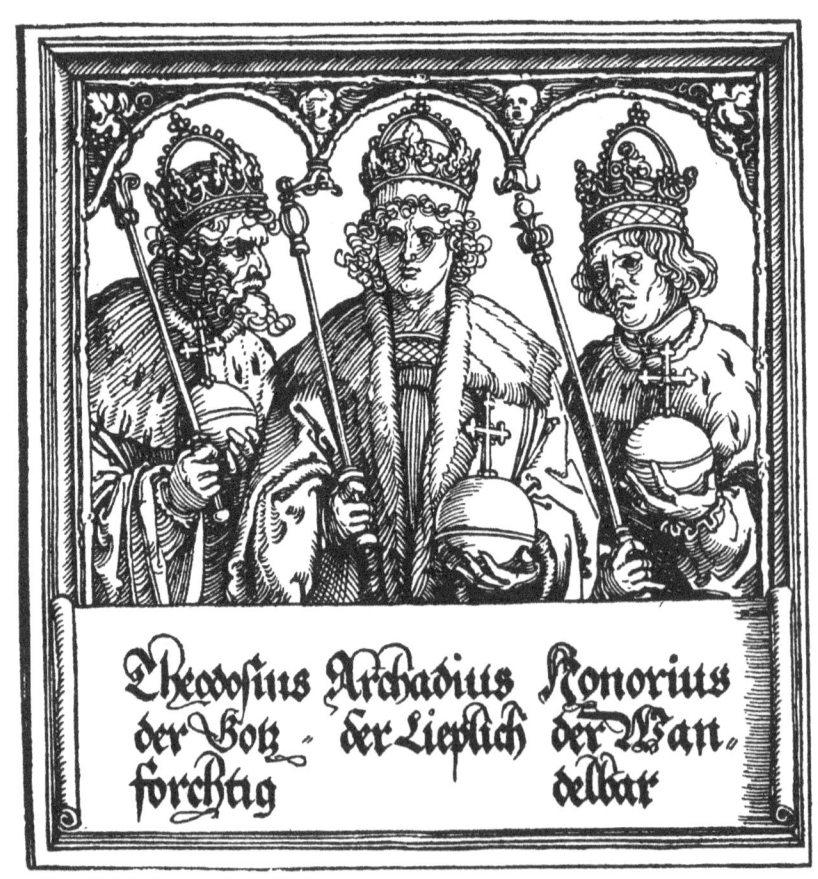

292

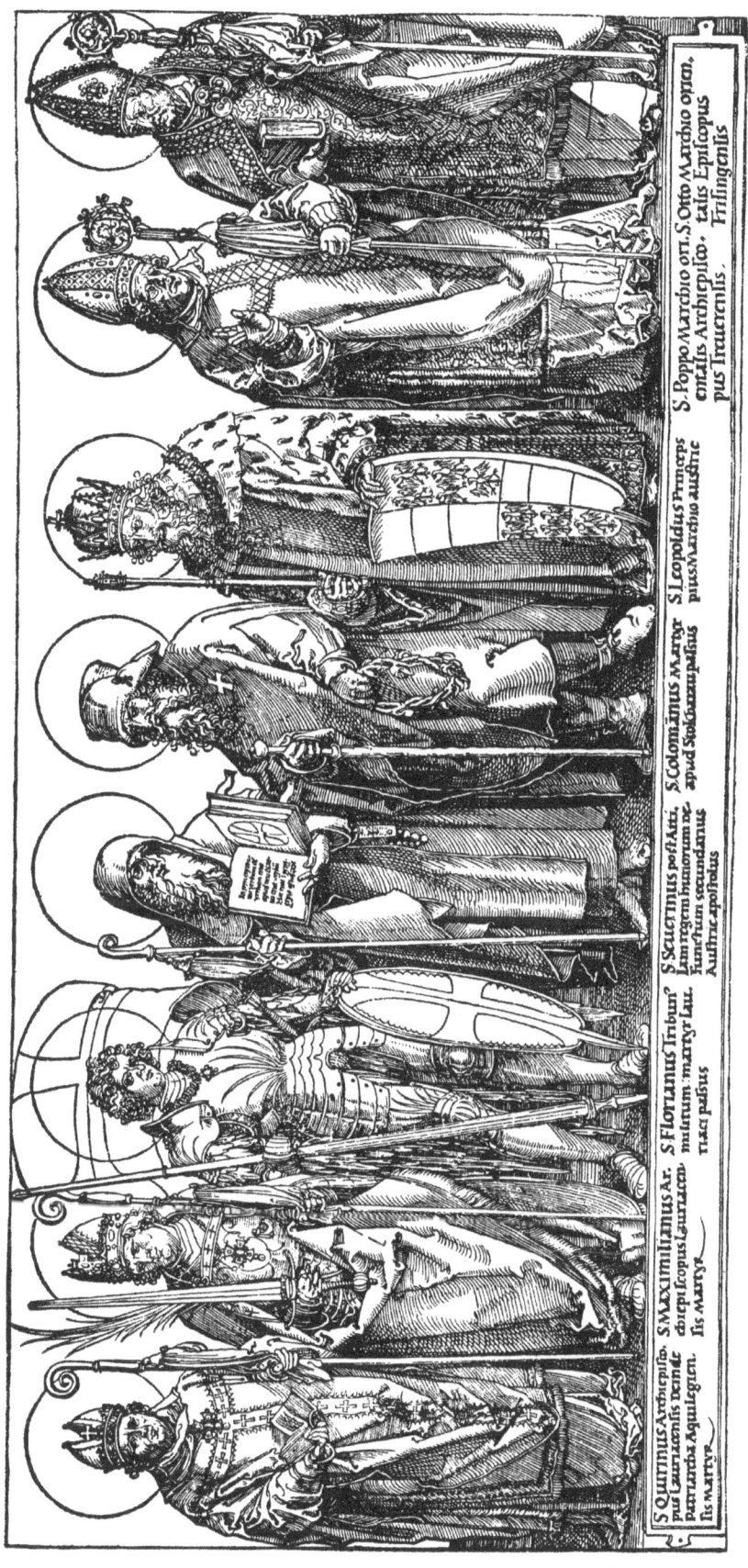

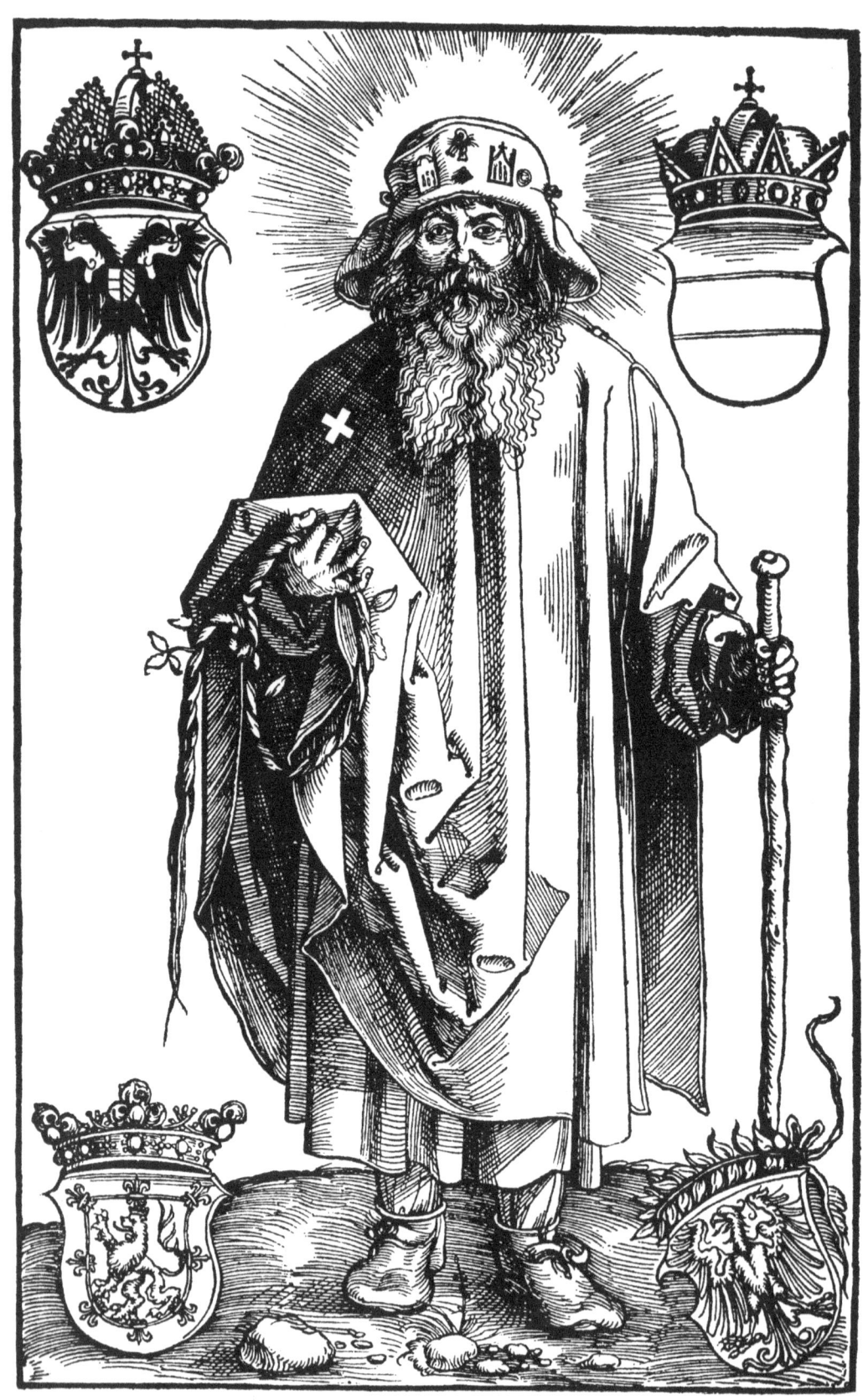

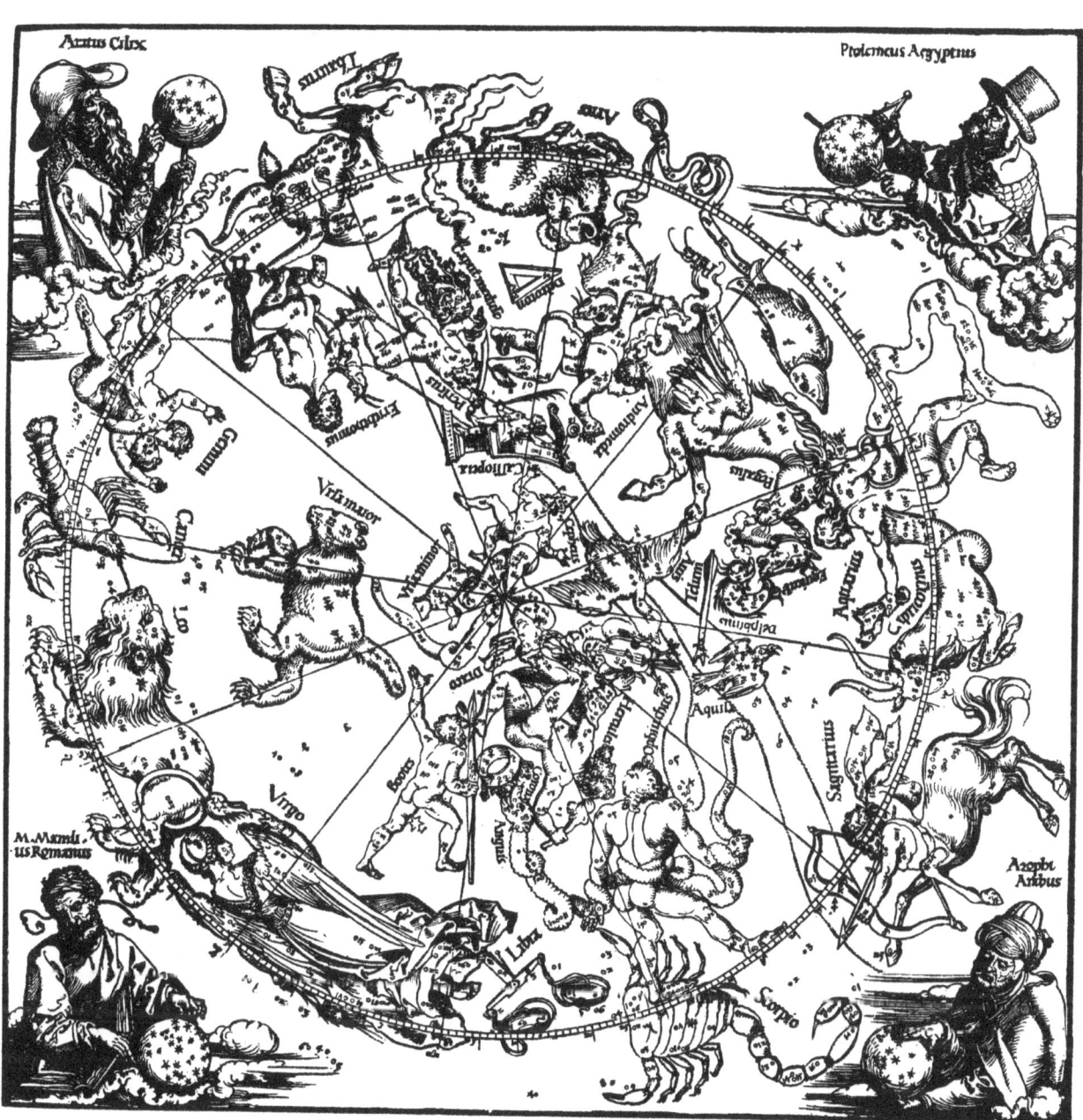

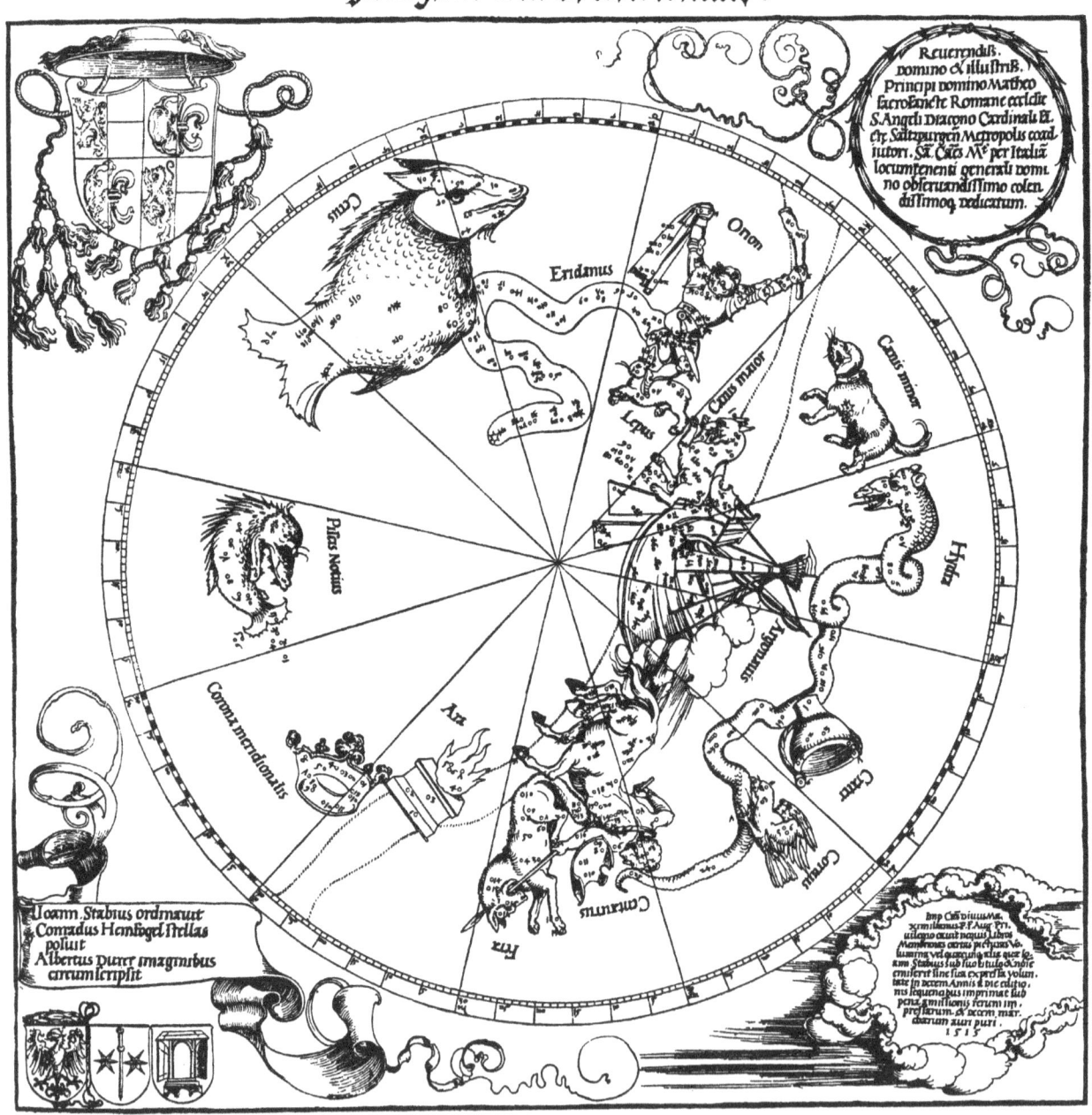

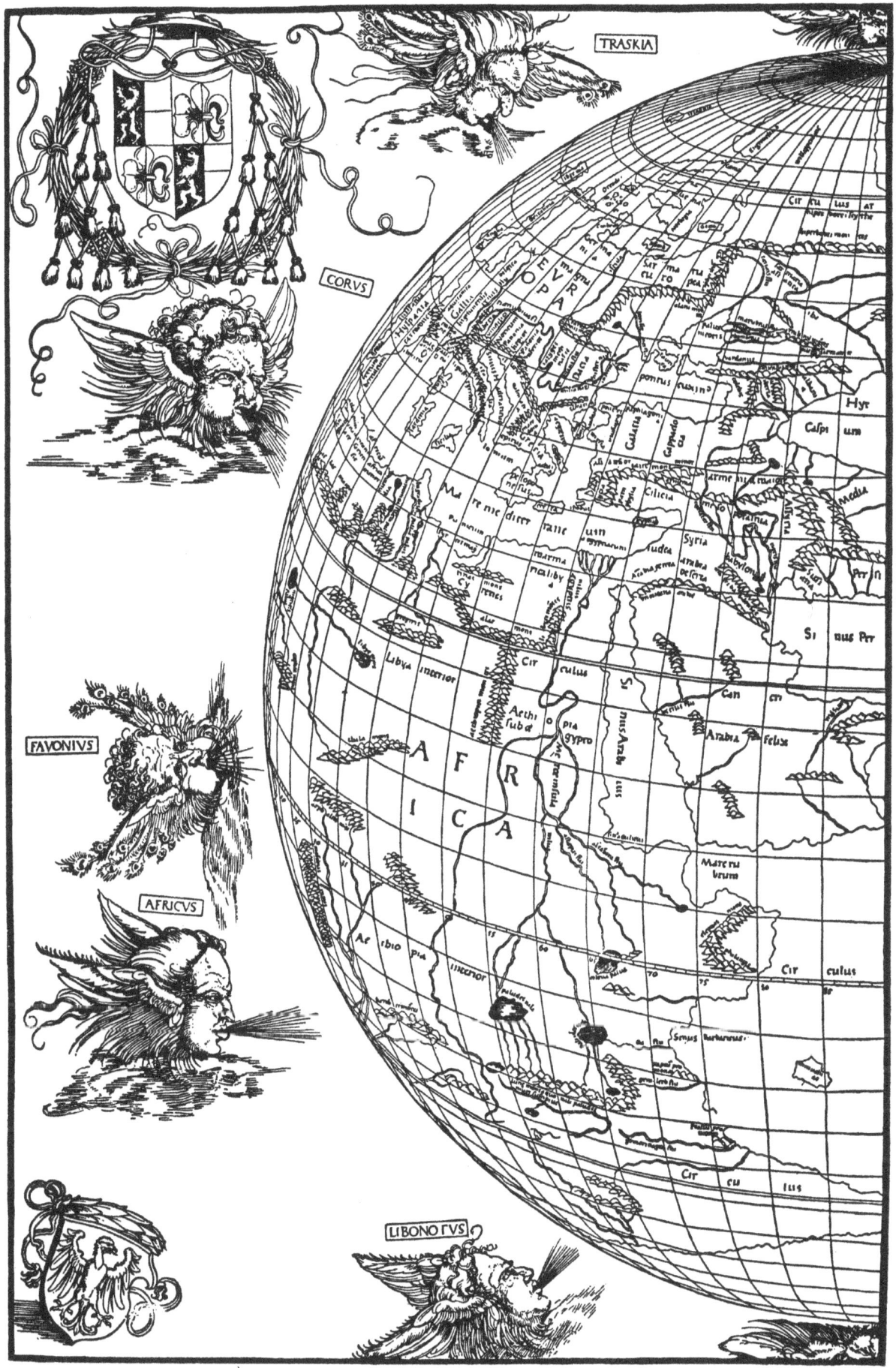

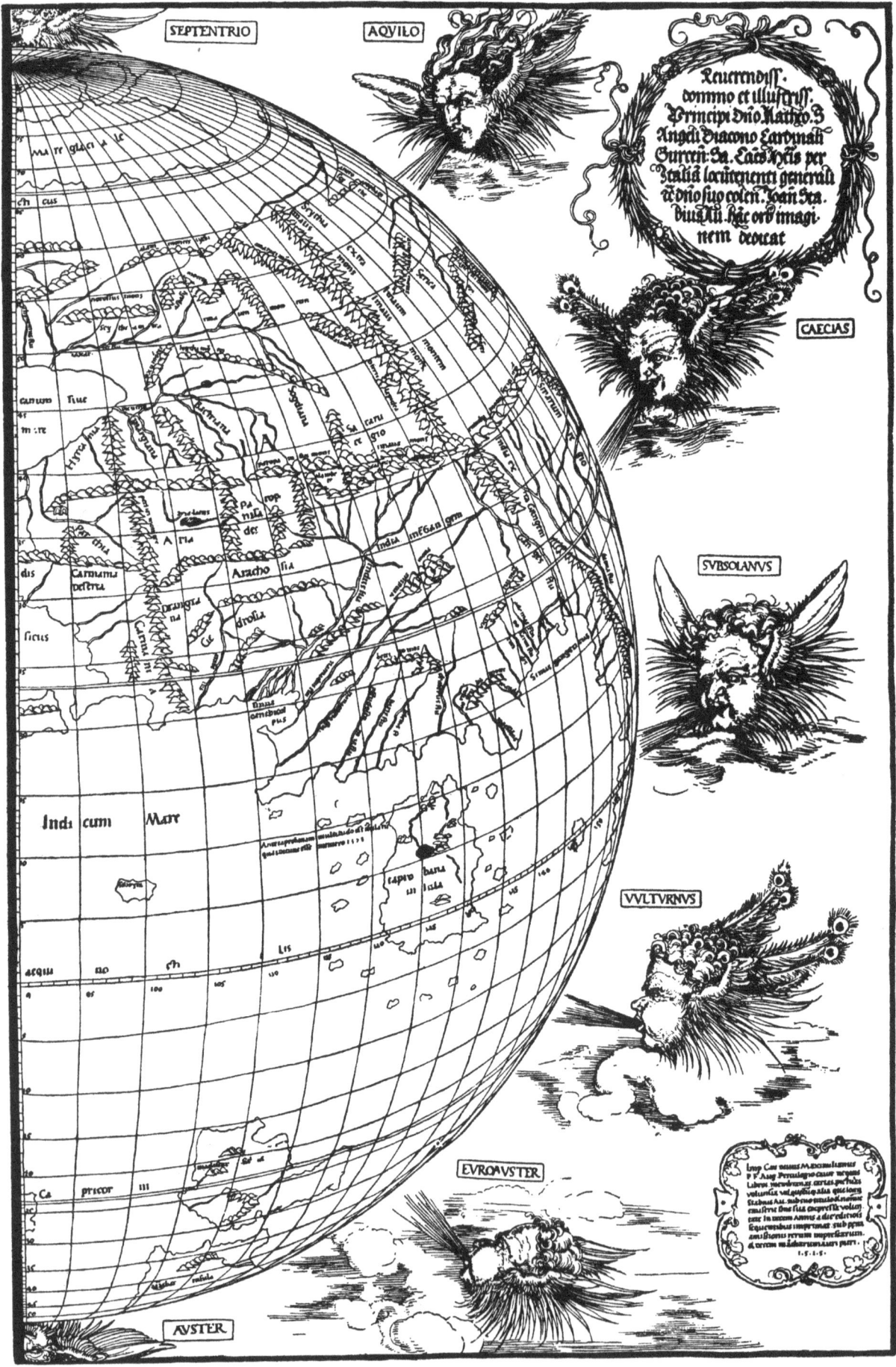

{ PAGE 212 }

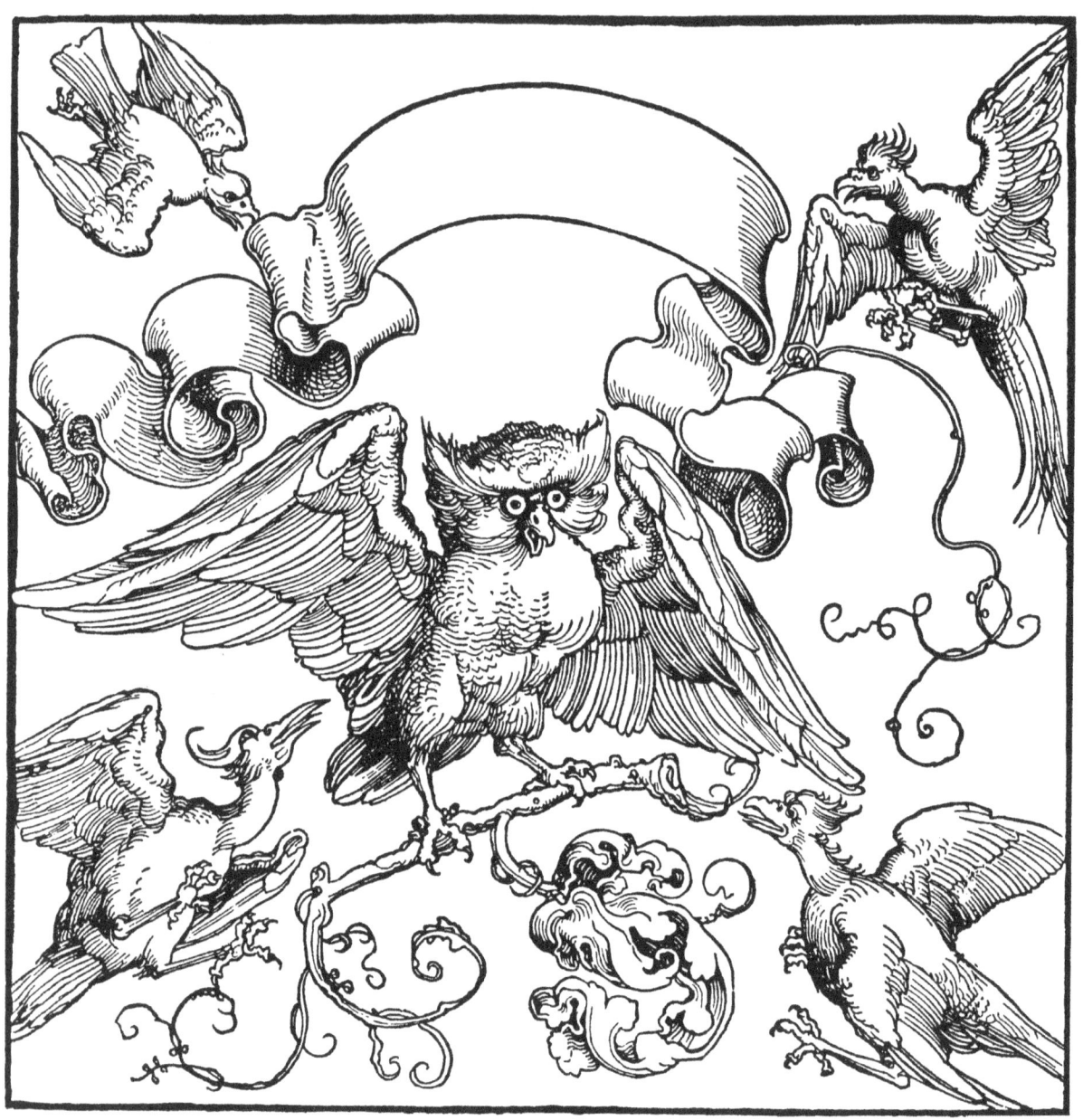

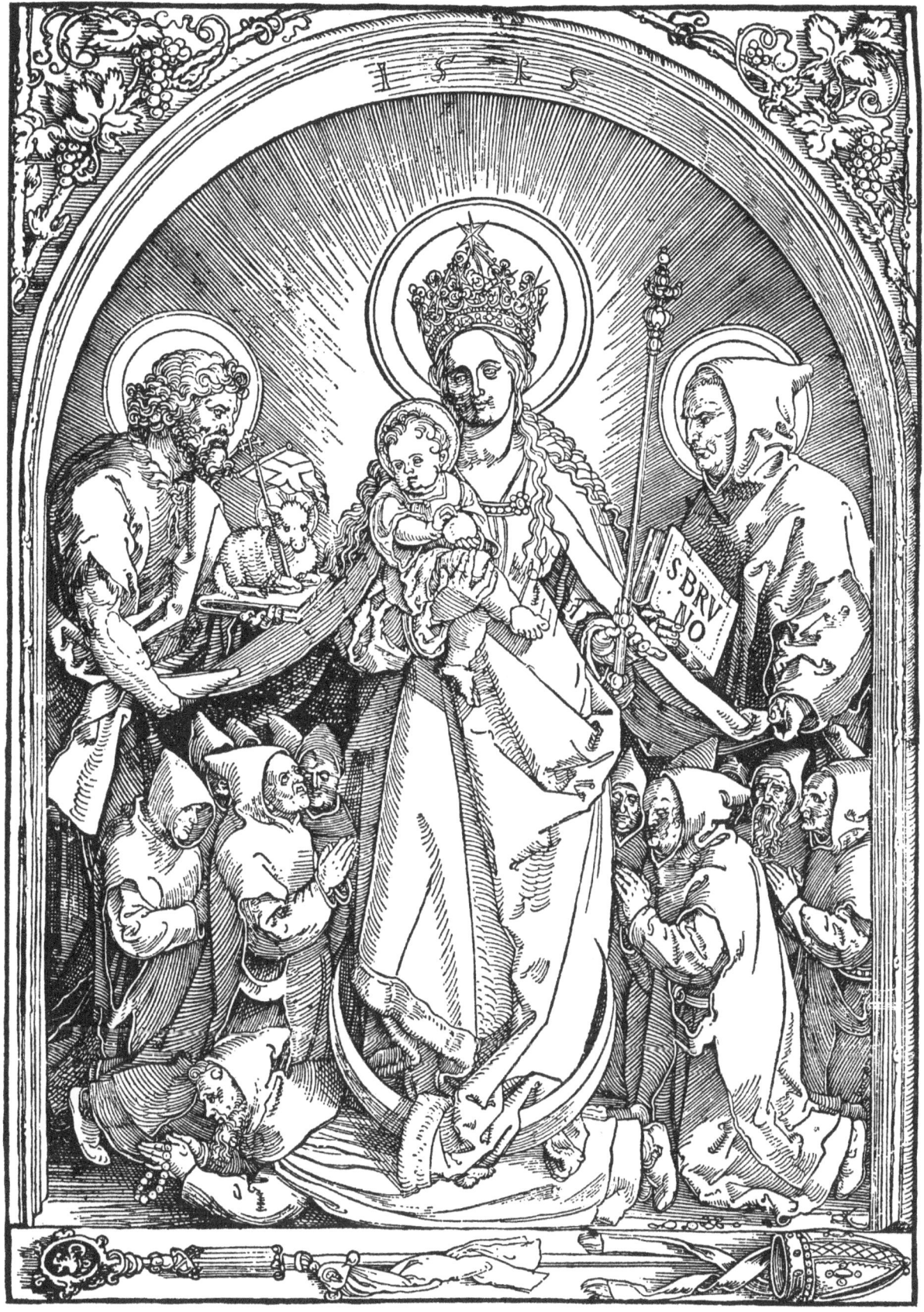

{ PAGE 215 }

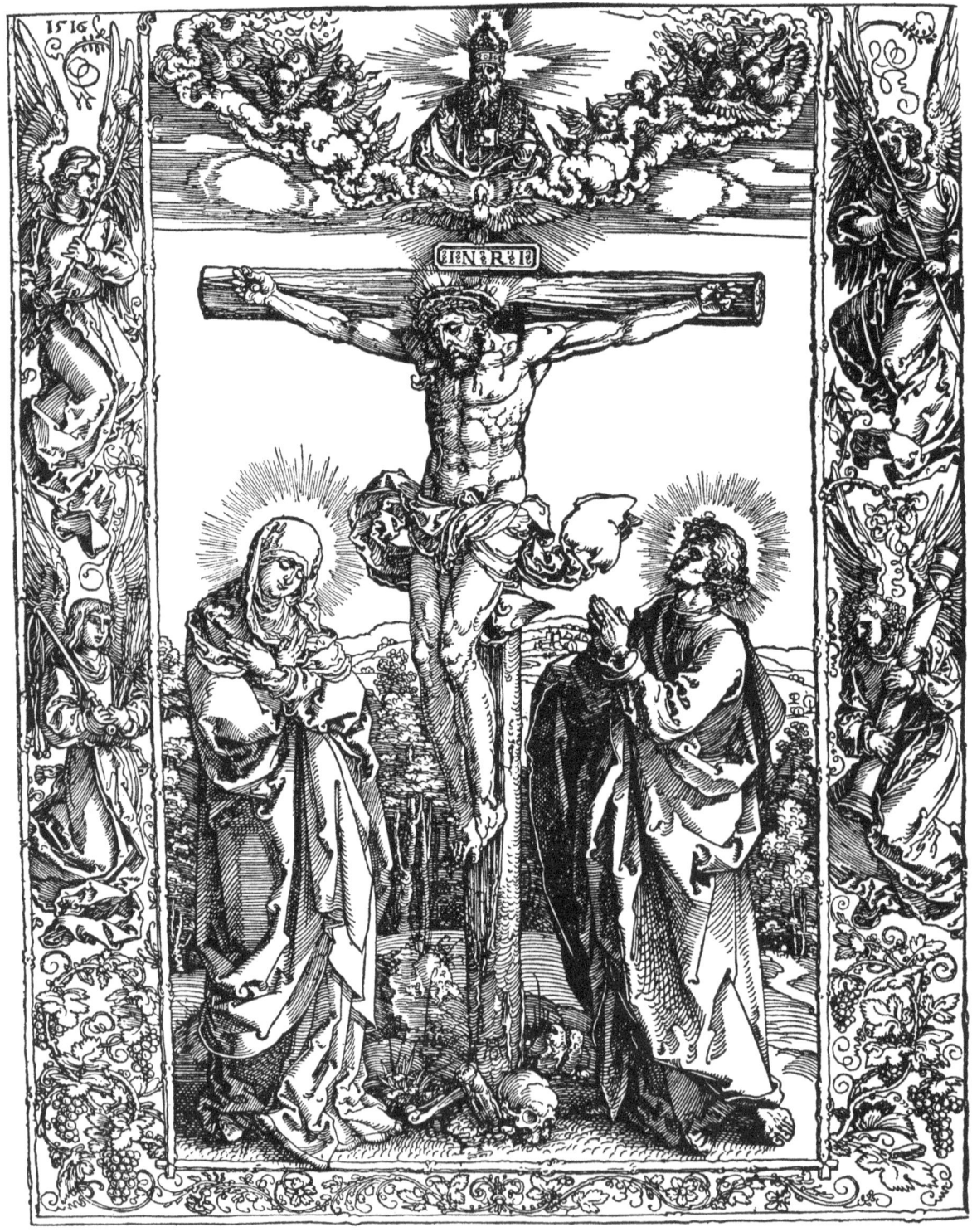

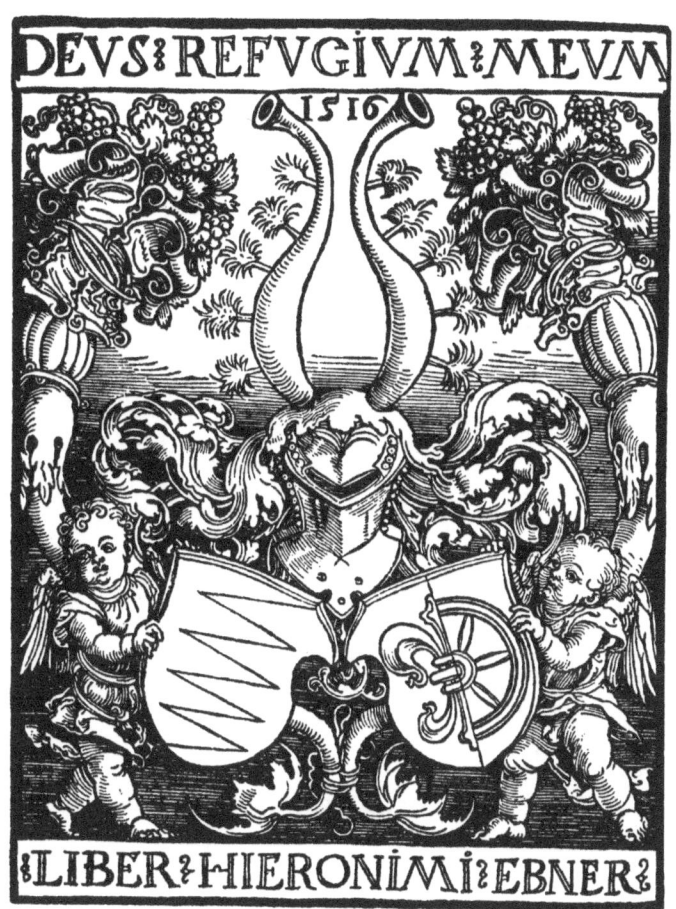

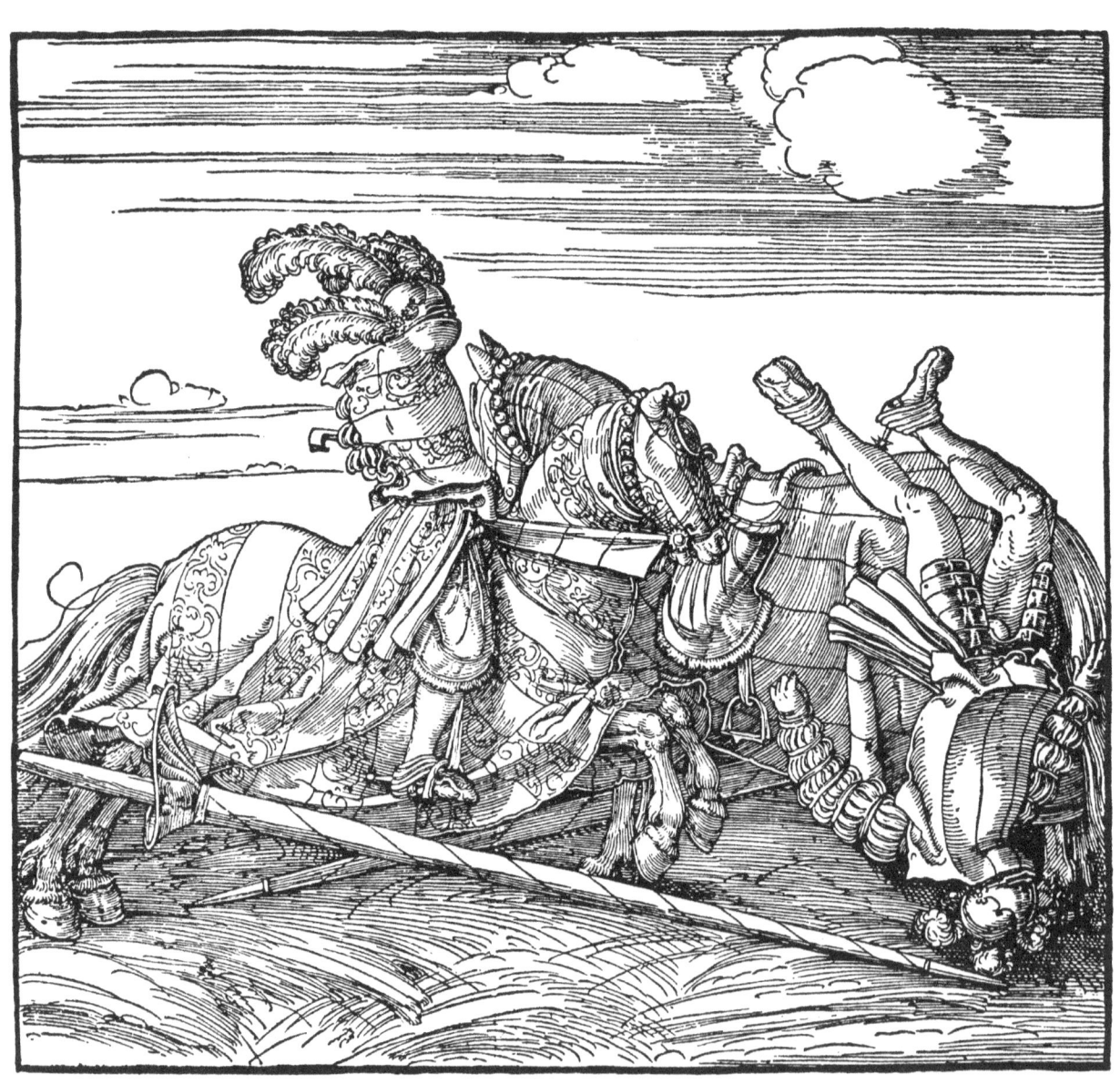

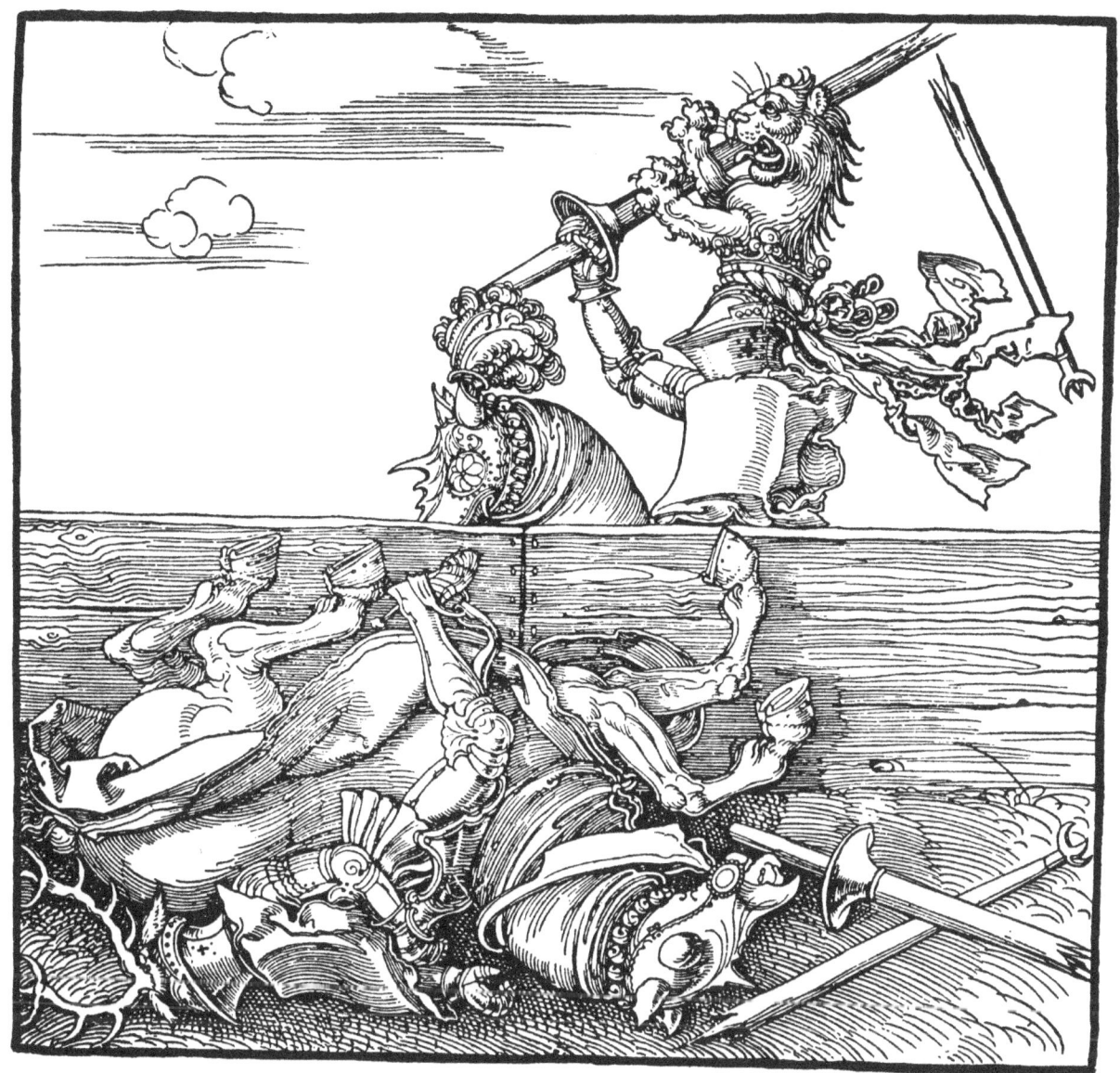

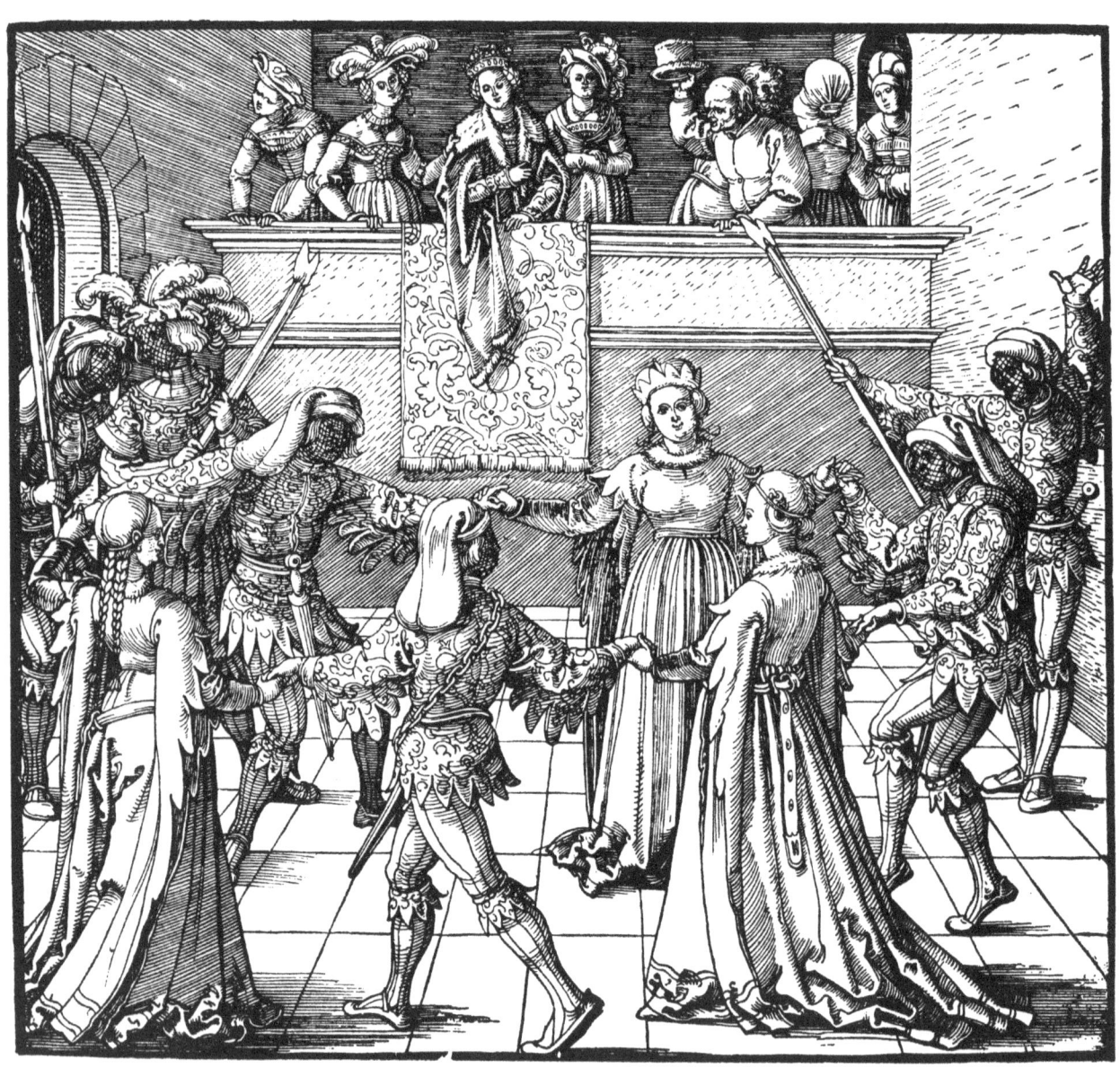

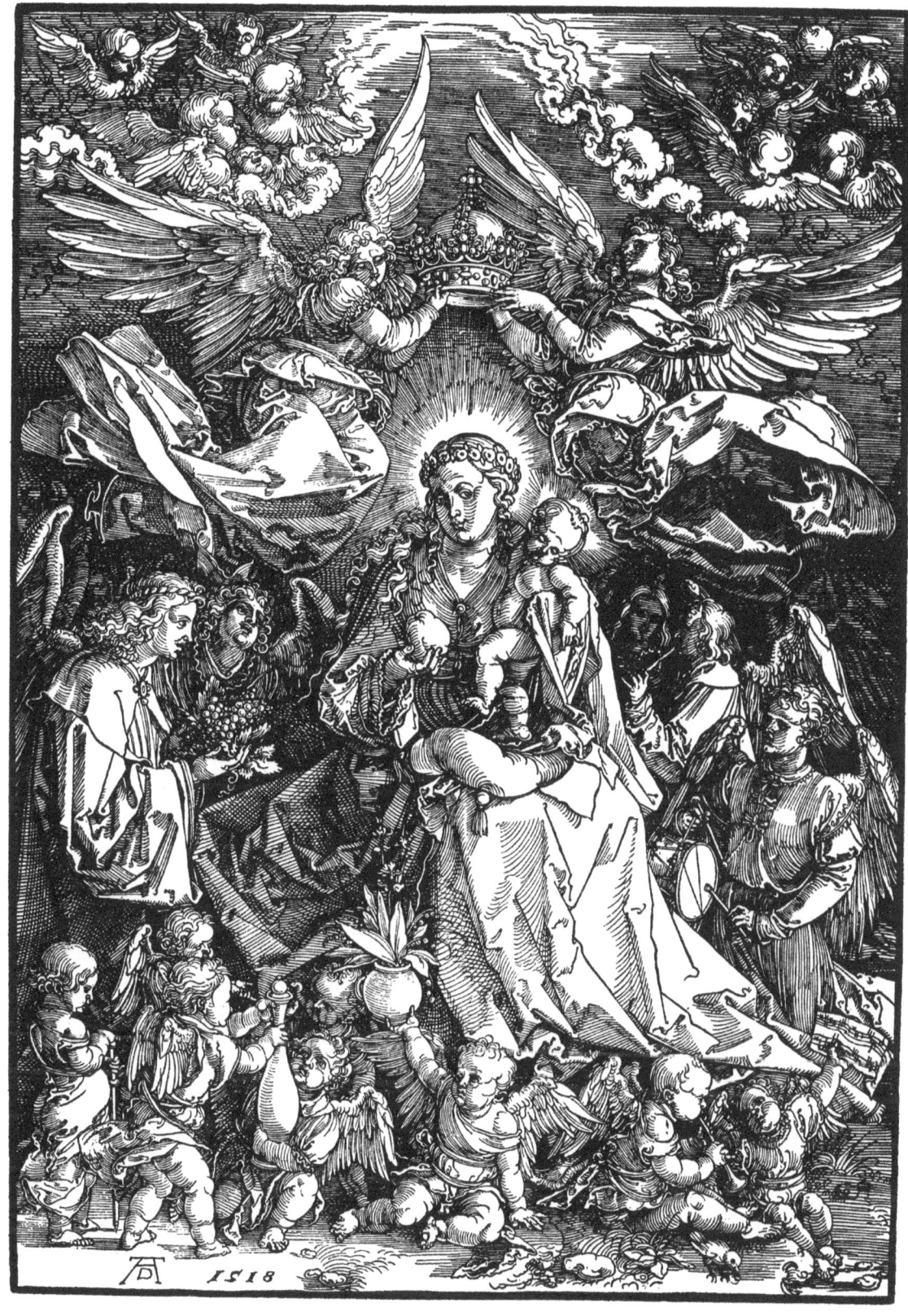

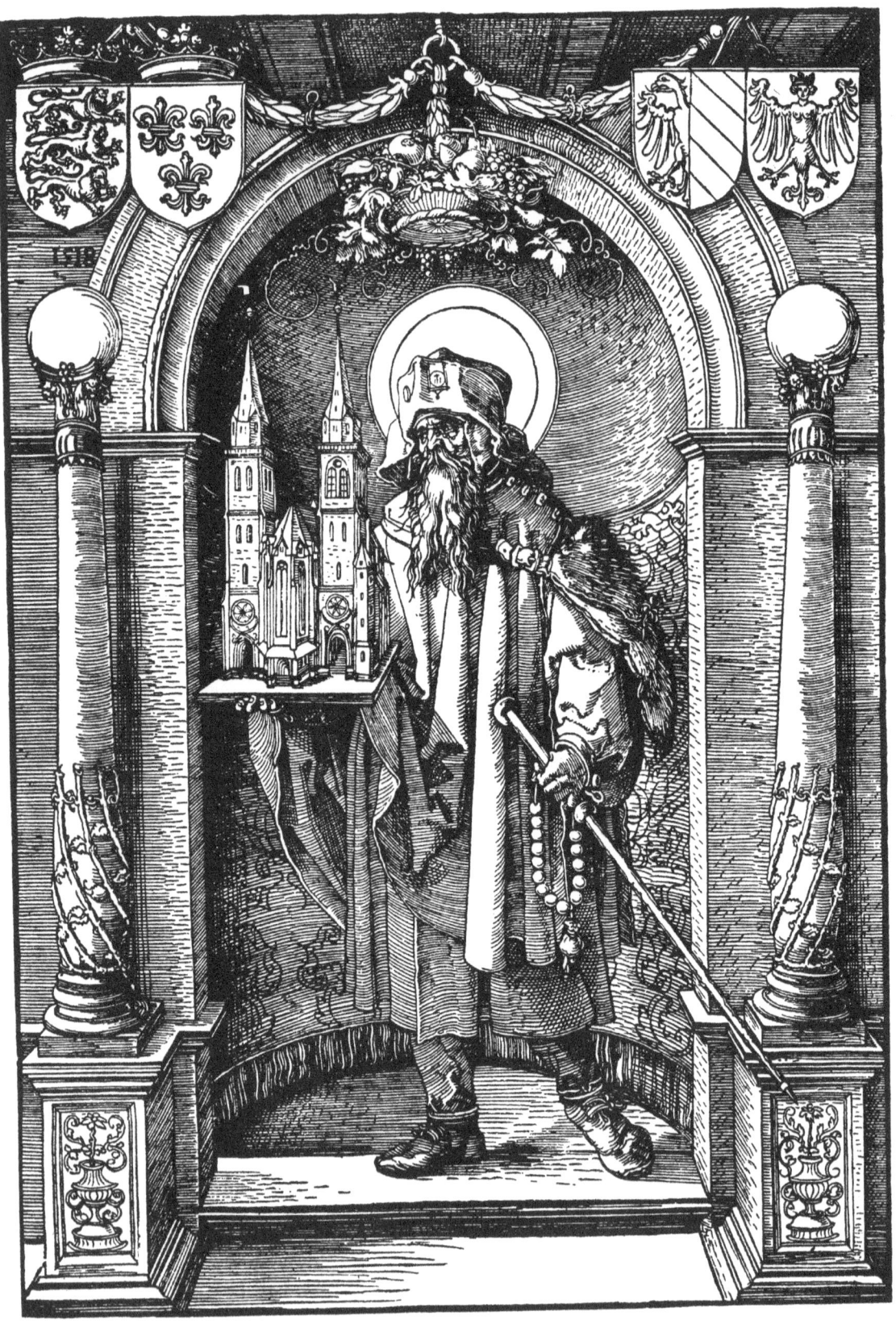

{ PAGE 222 }

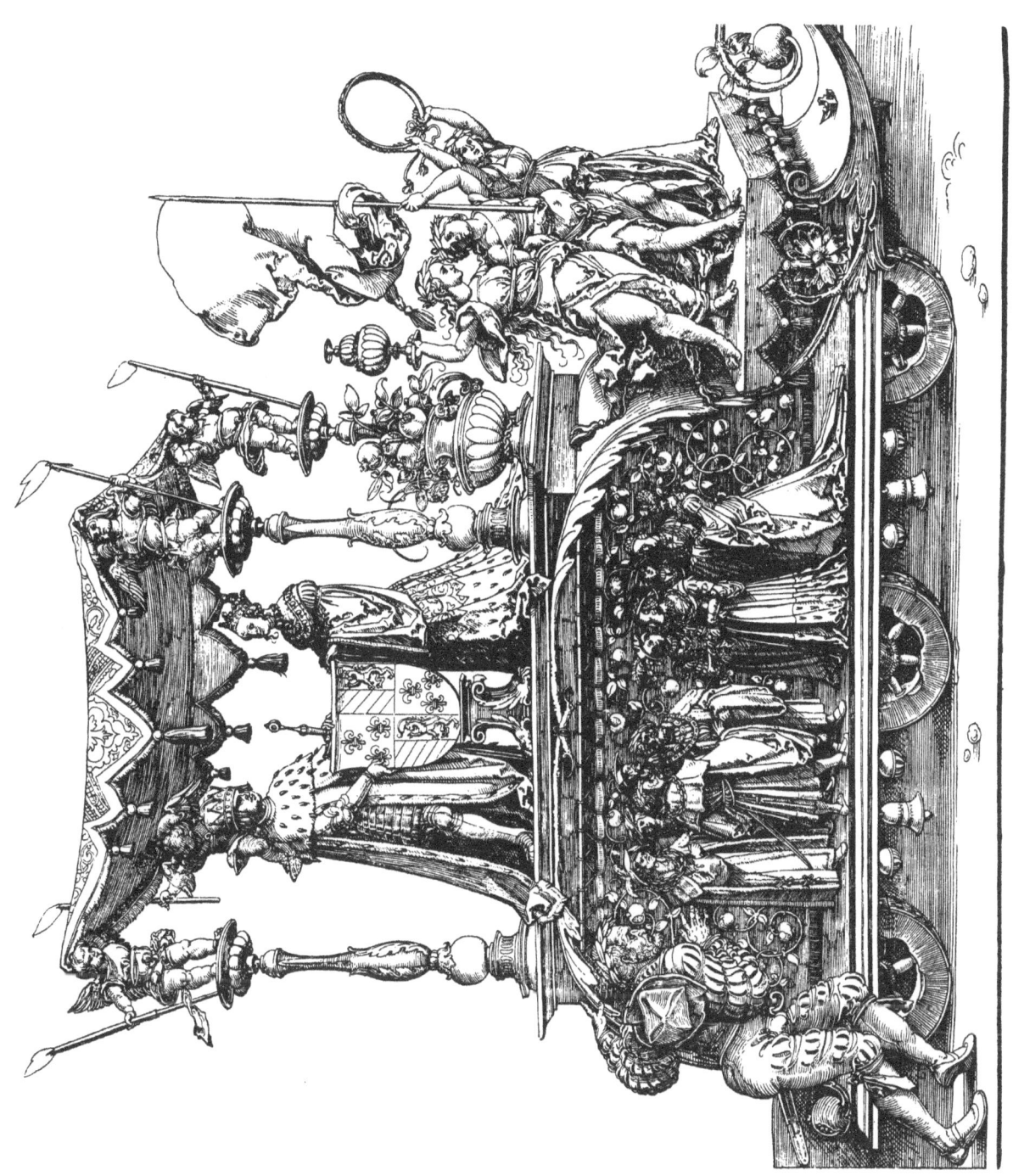

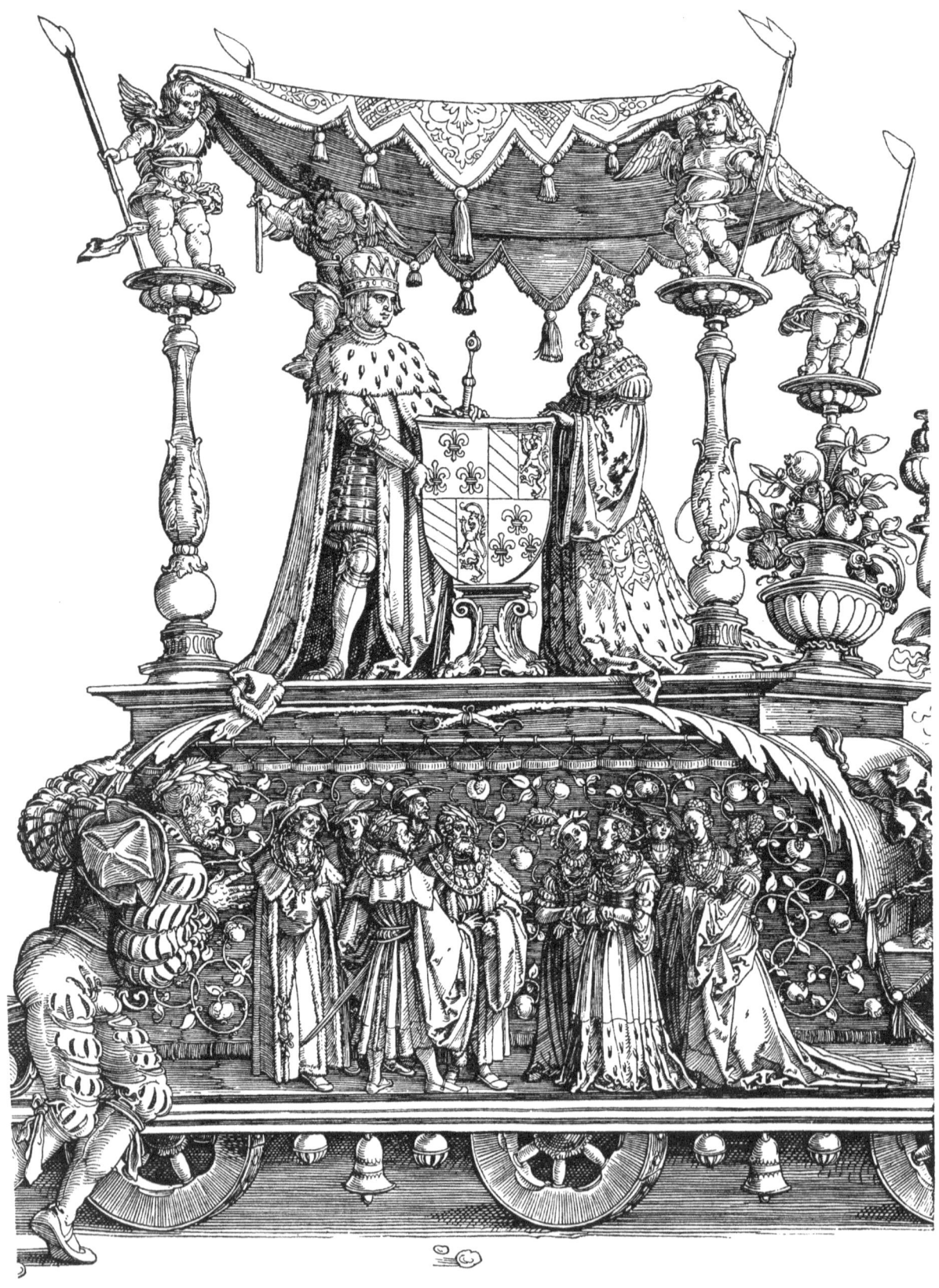

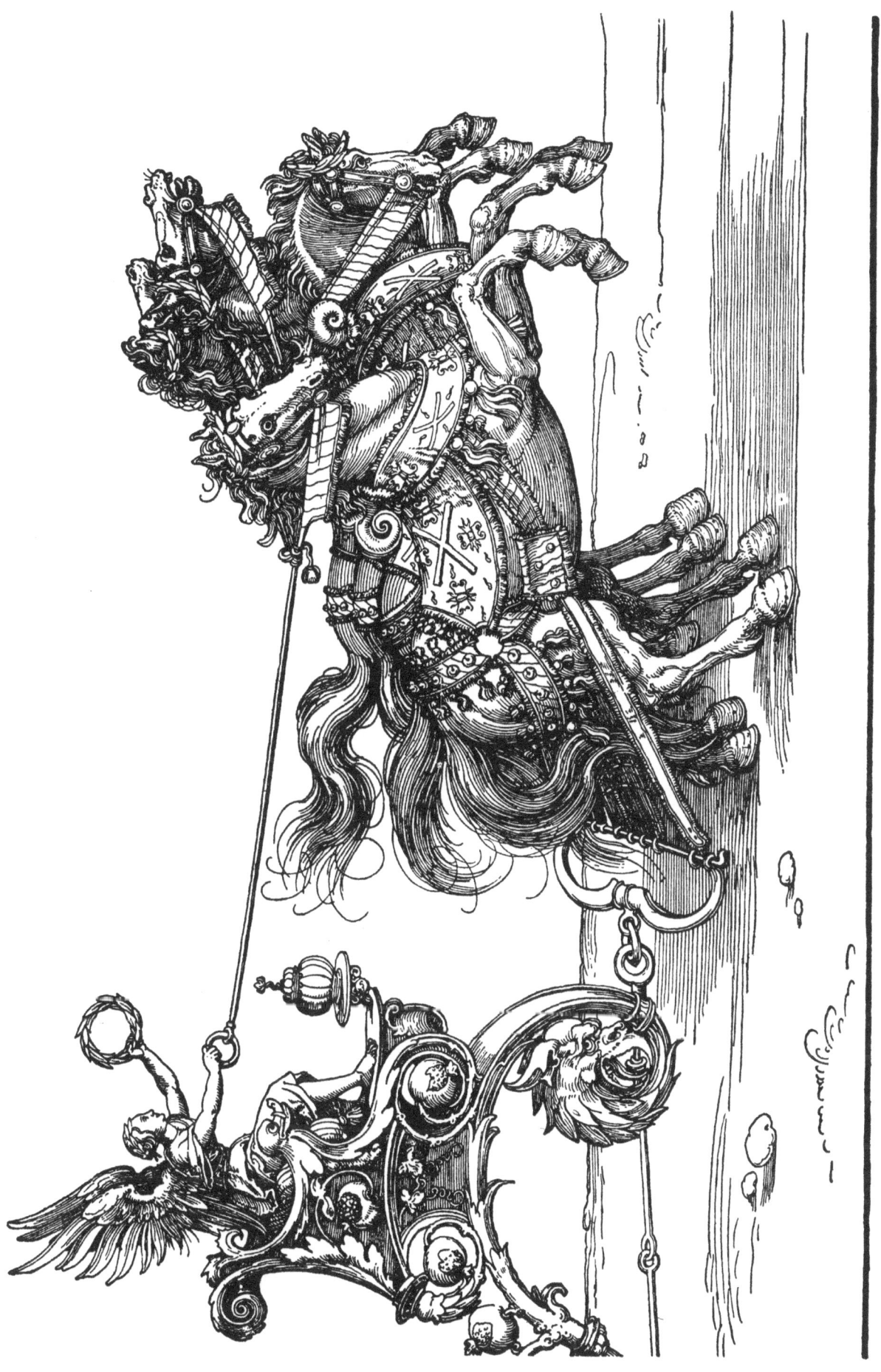

{ PAGE 225 }

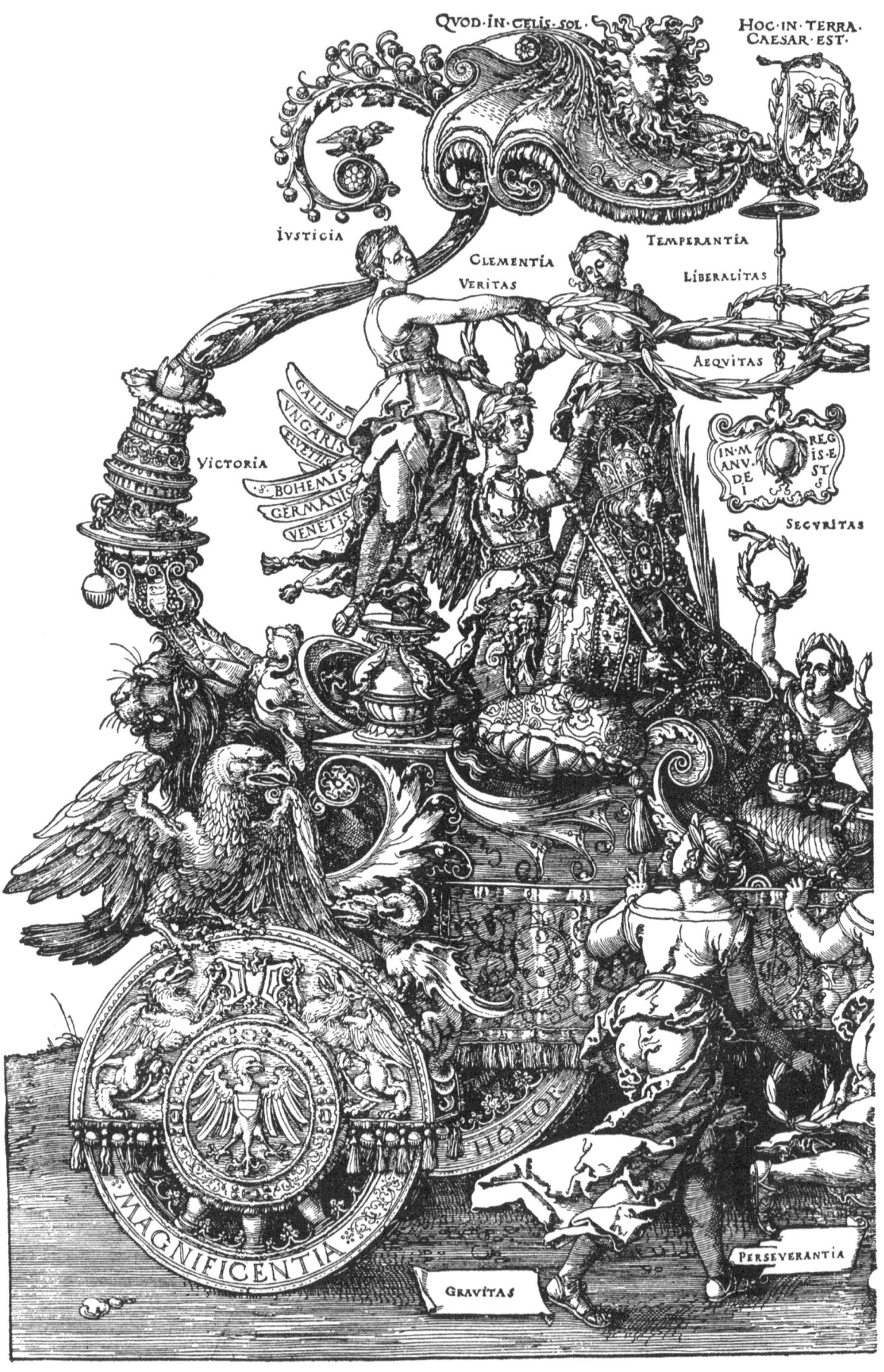

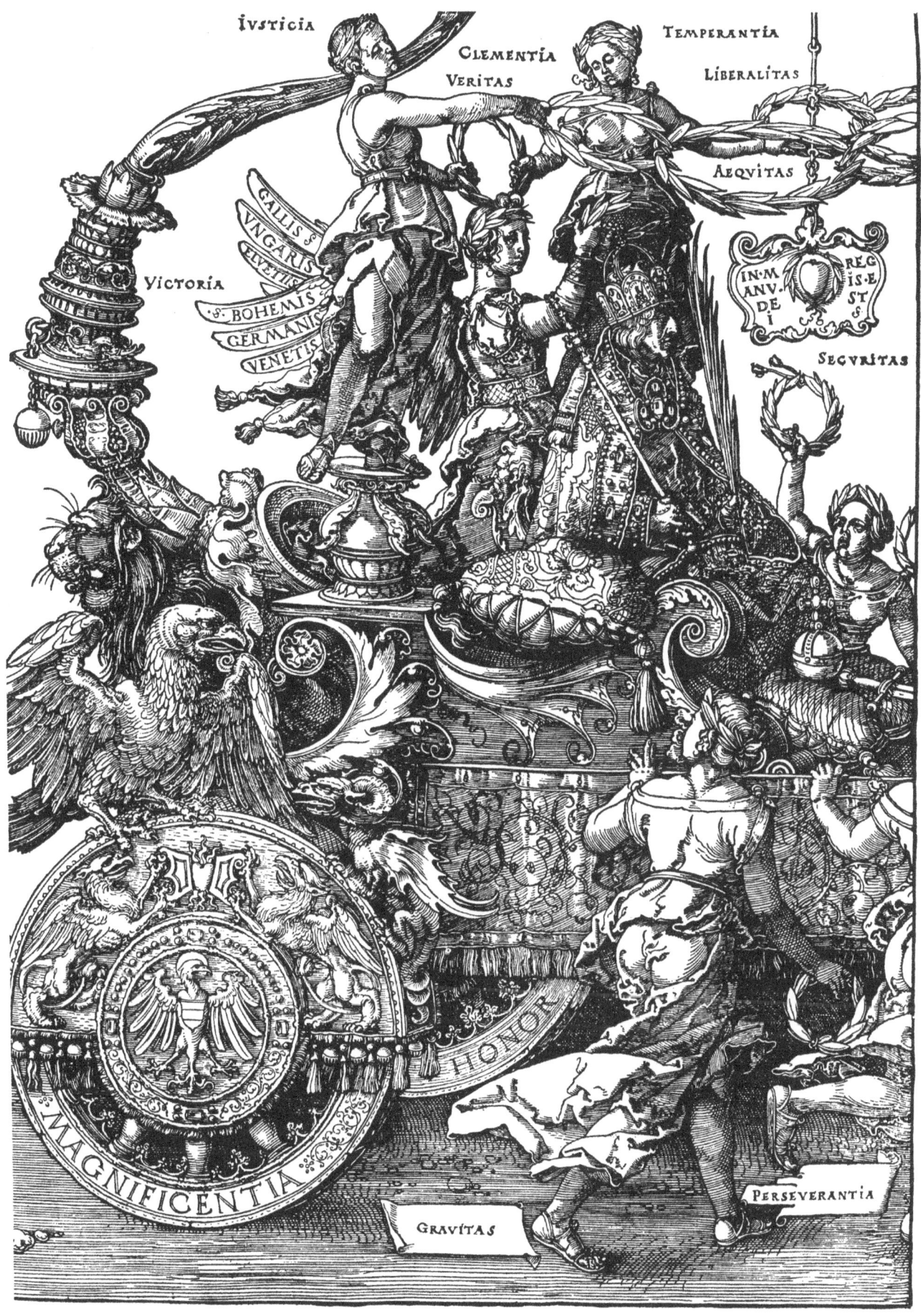

{ PAGE 227 }

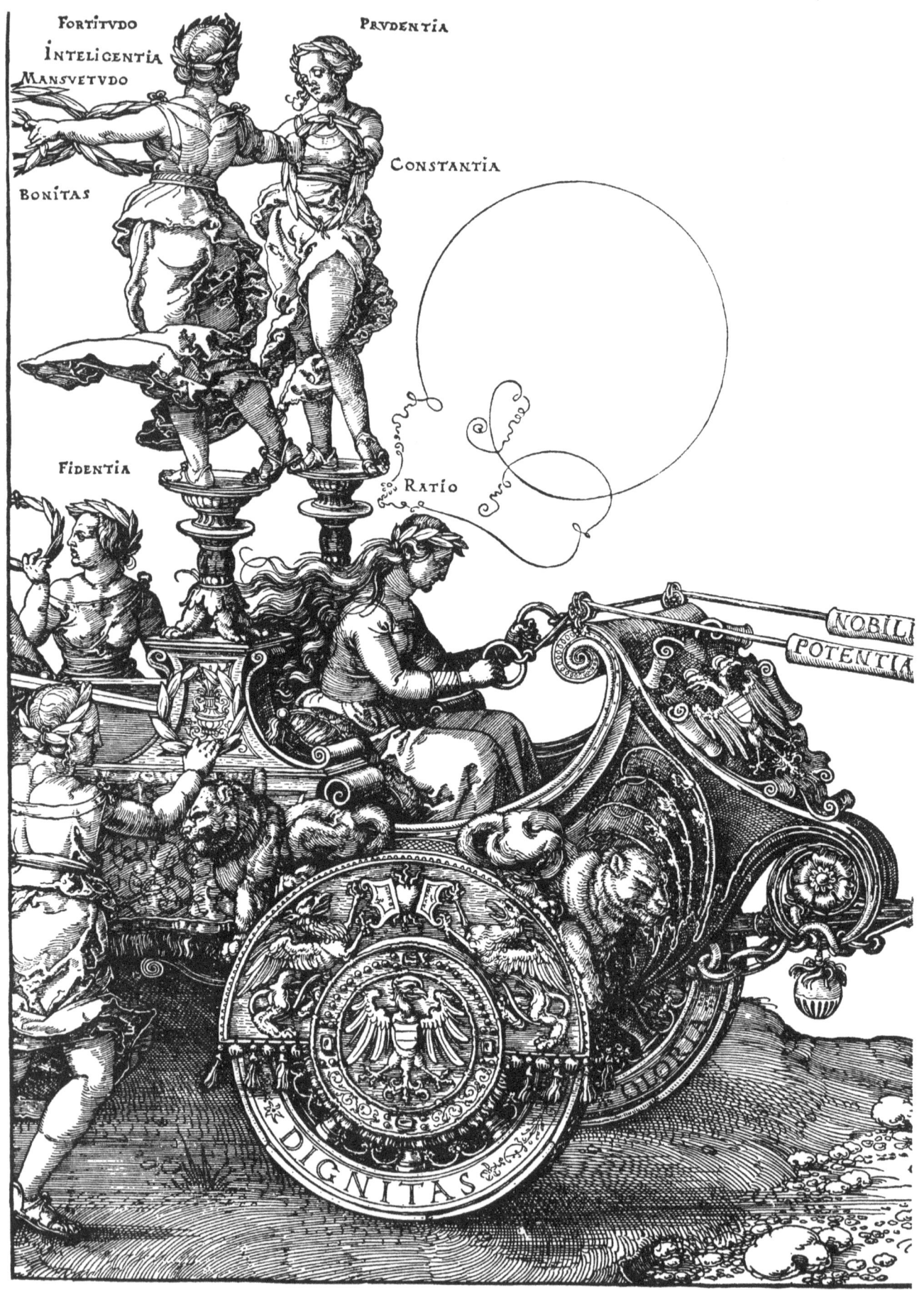
{ PAGE 228 }

Diser nachuerzeychenter Eren/ oder Triumph wagen/ ist dem allerdurchleuchtigisten Großmechtigisten herrn zwey-
lund Keyser Maximilian/ hochlöblicher gedechtnuß vnserem allergnedigisten herrn zů sonderen eren erfunden vnnd
verordnet/ vnnd zů vntertheinigem gefallen dem großmechtigisten yetz Regierenten Keyser Karolo ꝛc. durch Albrecht
Dürer daselbst in das werck gepracht.

Erstlich/ dieweyl jhr Keyserlich May. alle König vnnd herren mit glori/ magnificent/ eer/ vnd wirdigkeyt vbertrifft/
so ist der selb wagen auff vier eren reder/ darauff jhr Keyserlich May. solcher vbertreflichkeyt halben billich empore
gefürt werden soll gestelt. Nemlich auff Gloriam/ Magnificentiam/ Dignitatem/ vnnd Honorem.

Nachuolgent seindt an den vier orten des wagens die vier angeltugent/ an stat vier seulen gesetzt. Nemlich Justicia
Fortitudo/ Prudentia/ Temperantia. Auß welchen all ander tugent jrn anfang vnnd vrsprung haben/ an die auch
keyn khönig odder herr volkumen seyn kan/ oder mag. Dann wo die Gerechtigkeyt/ Manlich sterck des gemůts/ die
Vernufft/ vnnd Bescheidenheyt mangelt/ kan keyn Reych bestendig seyn.

Nach dem Moderatio/ vnnd Prouidentia der vernunfft am nachsten sind/ fůren die selben zwo
tugent die zwey nachsten pferd vor der vernufft/ damit der wag mit rechtermaß vnnd fürsichtig-
keyt seinen gang haben mag.

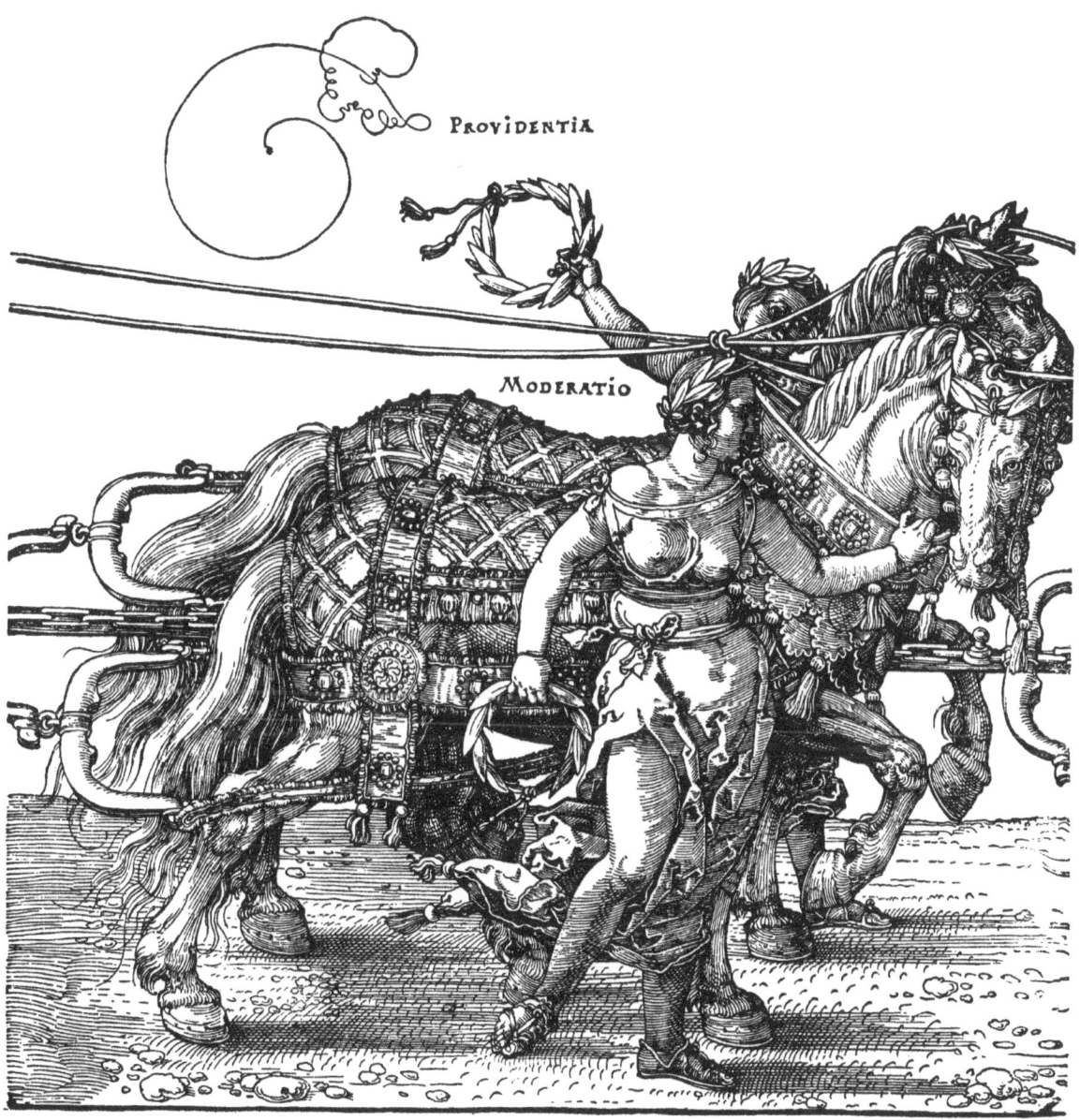

Vnd damit diser wagen recht vnd wol gefürt werd/ist Ratio zuvorderst an/für ainen fūrman vnd weglayter gesetzt/ darumb das alle besteudige ding mit vernufft geschehen sollen. Die selbige Ratio helt auch zwaylextsayteyns Nobilitatis/das ander Potentie/angesehen daß die Keyser. May. alle König vñ herrn mit adel vñ macht übertroffen hat.

Vnd auff daß die pferd so an den wagen gespant sind/ nit als vnuernūfftige thier auß dem wege der Verstendigkeyt lauffen/sonder dester statlicher durch Vernunfft regiert werden mögen/ so hat ein yetzlich pferdt seine layter vñ halter/ damit es nit anders geen/noch lauffen möge/ dañ wie sich nach eygenschafft der selben tugendt gepürt.

Vnd wiewol alle menschen nach dem willen gottes regiert werden/ noch dañ sagen die weysen/daß in sonderheyt das hertz des Königs in der handt gotes stee/ der das auch nach seinem götlichen wolgefallen wendt vnd khert/ darumb so stecht vor der Keyserlichen May. dise geschrifft. In manu dei cor Regis est. Vnd für das wort Cor/ist zu merer zierligkeyt ain hertz mit ainer Laurea gemalet. Bedewt das edel hertz Keyserlicher May. so mit allen tugendten vnnd eren gekrönet vnnd geziert gewest ist.

Darnach geen zwey pferd die stetigs für sich begeren/ werden durch Magnanimitatem vnnd Audaciam regiert.

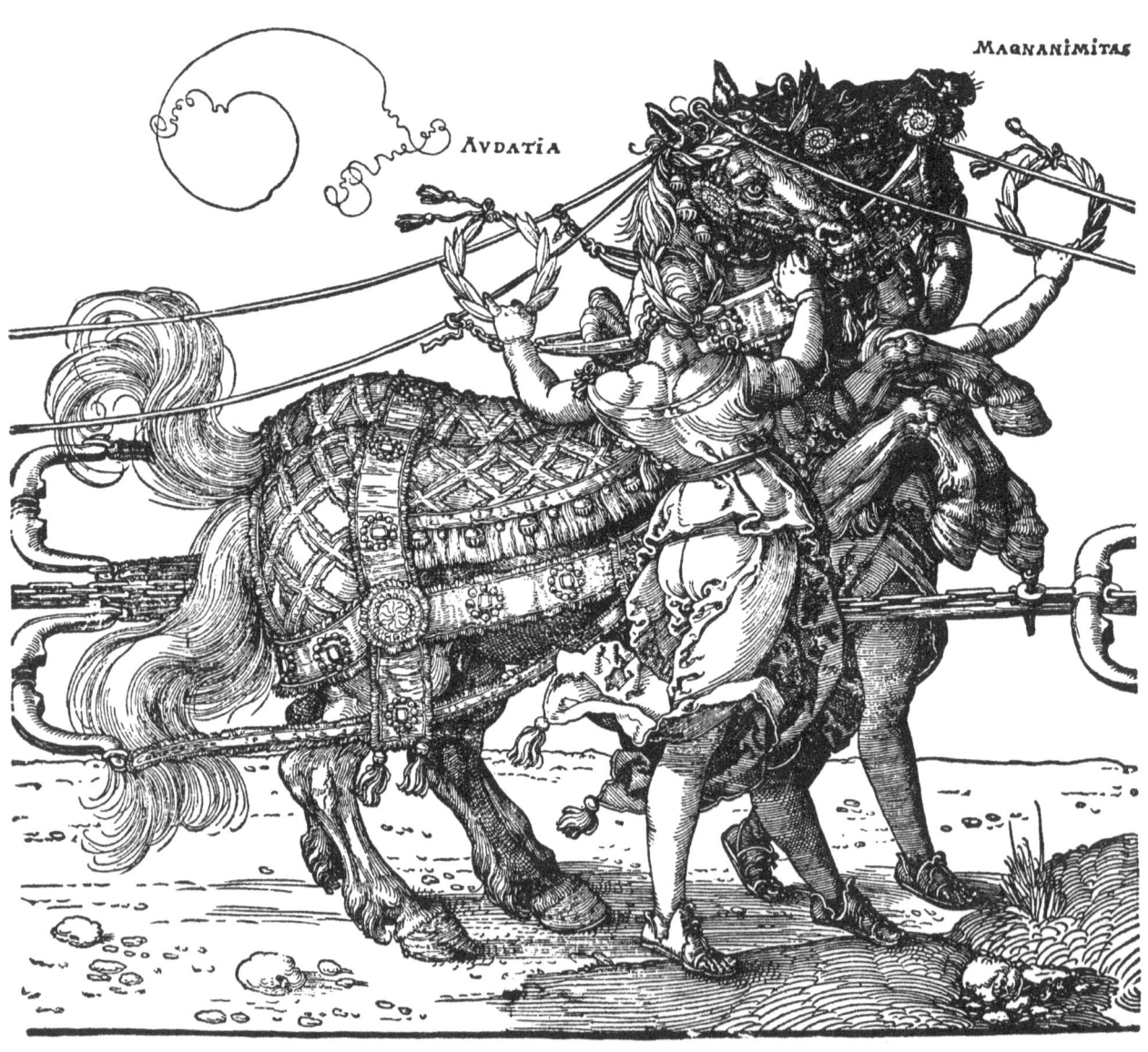

auch mit warheyt gesagt werden mag/daß weylund die Kayserliche May. mit jrer zierd vñ Clarheyt auff den daß das die scheynnend Sunn am hymel gewest ist/so wirt ob jrer May. dise schrifft gesetzt. Quod in celis in terra Cesar. Vnd ist für das wort Sol ein Sunn gemalet/vnd für das wort Cesar ain Adler.

 Marimilian von Gottes gnaden
 E. Römischer Kayser. ie

lieber getrewer/wir haben den Triumphwagen mitsampt der Exposition/den du vns zu vnderthenigem gefal vnsers Triumphs erdacht vnd gestelt. Auch durch Albrecht Thürer auffreyssen lassen/vnnd bey zeyger diß gesendt hast entpfangen/den auch notturfftigklich vbersehen/vñ tragen an sölichem deinem erfinden fleyß vñ anders gnedigs wolgefallen/sind geneygt/das in sondern gnaden gegen dir zu erkennen/wöllen wir dir gnedi/ ung nit verhalten. Geben in vnser Stat Jnßbruck am Neunvndzweynhigisten Marcij. Anno. ic. xviij. reychs am. xxxij. jaren.

 Per Regem per se.

 Ad Mandatum Cesaree
 Maiestatis proprium.
 Westner.

Dem Ersamen vnserm Rat/vnd des Reychs lieben getrewen Wilbolden Pirckhaymer. Diser wagen ist zu Nürmberg erfunde
 gerissen vnnd gedruckt durch Albrechten

Damit der die großmütigkeyt vnd keckheyt den wagen nit verfüren/so seind für die sell en zuvorderst iv.ij andere Roß gespandt/die werden durch Experientiam vnd Solertiam gemaystert. Dañ wo te erfarn.iß oñ fuerrechtigkeyt mit istnung die ic.Theyl vnd Großmütigke jt ley.ht schade bringen. Thürer/im jar. M.D.xxij.

 Cum Gratia et Priuilegio Cesaree Maiestatis.

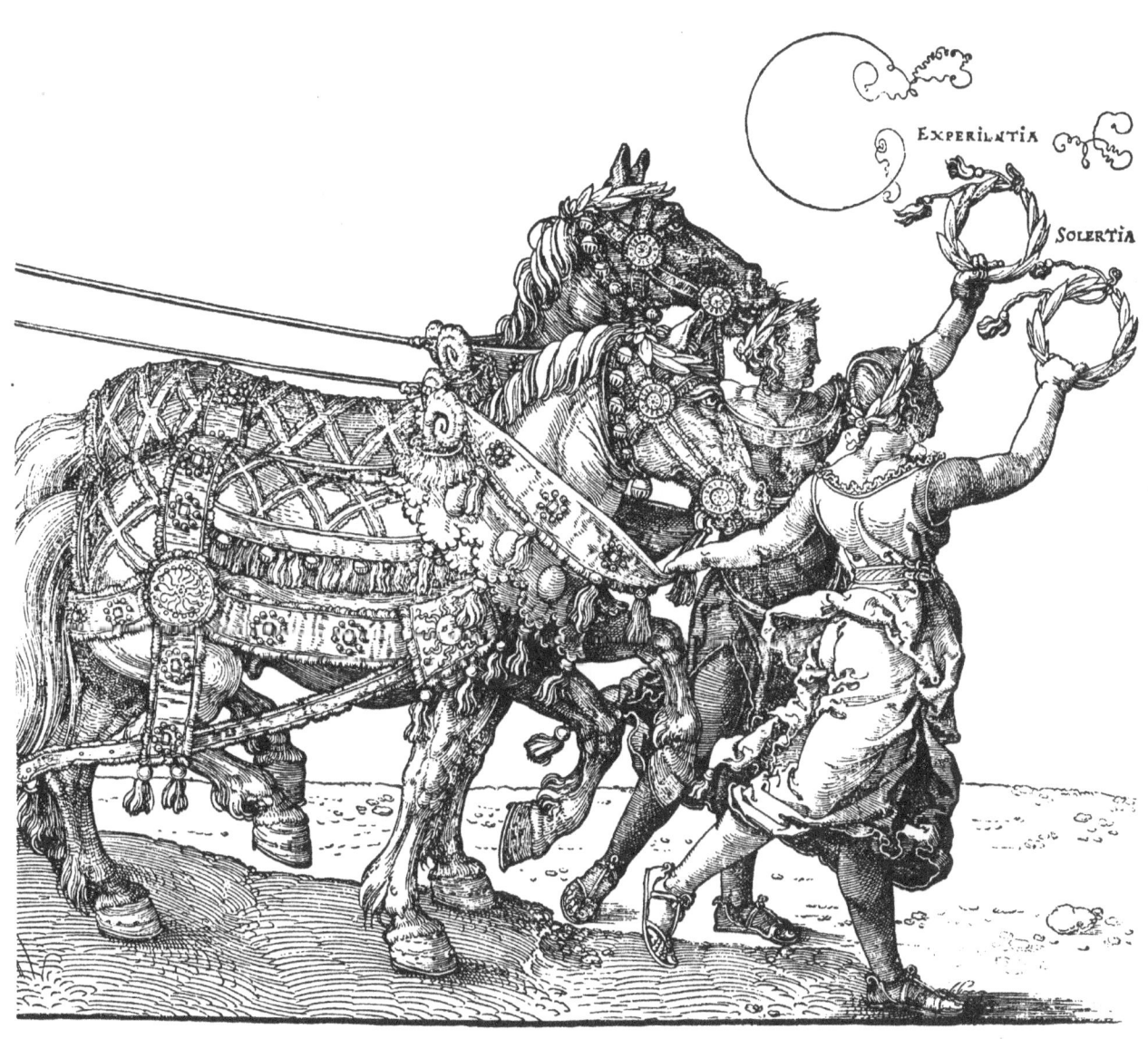

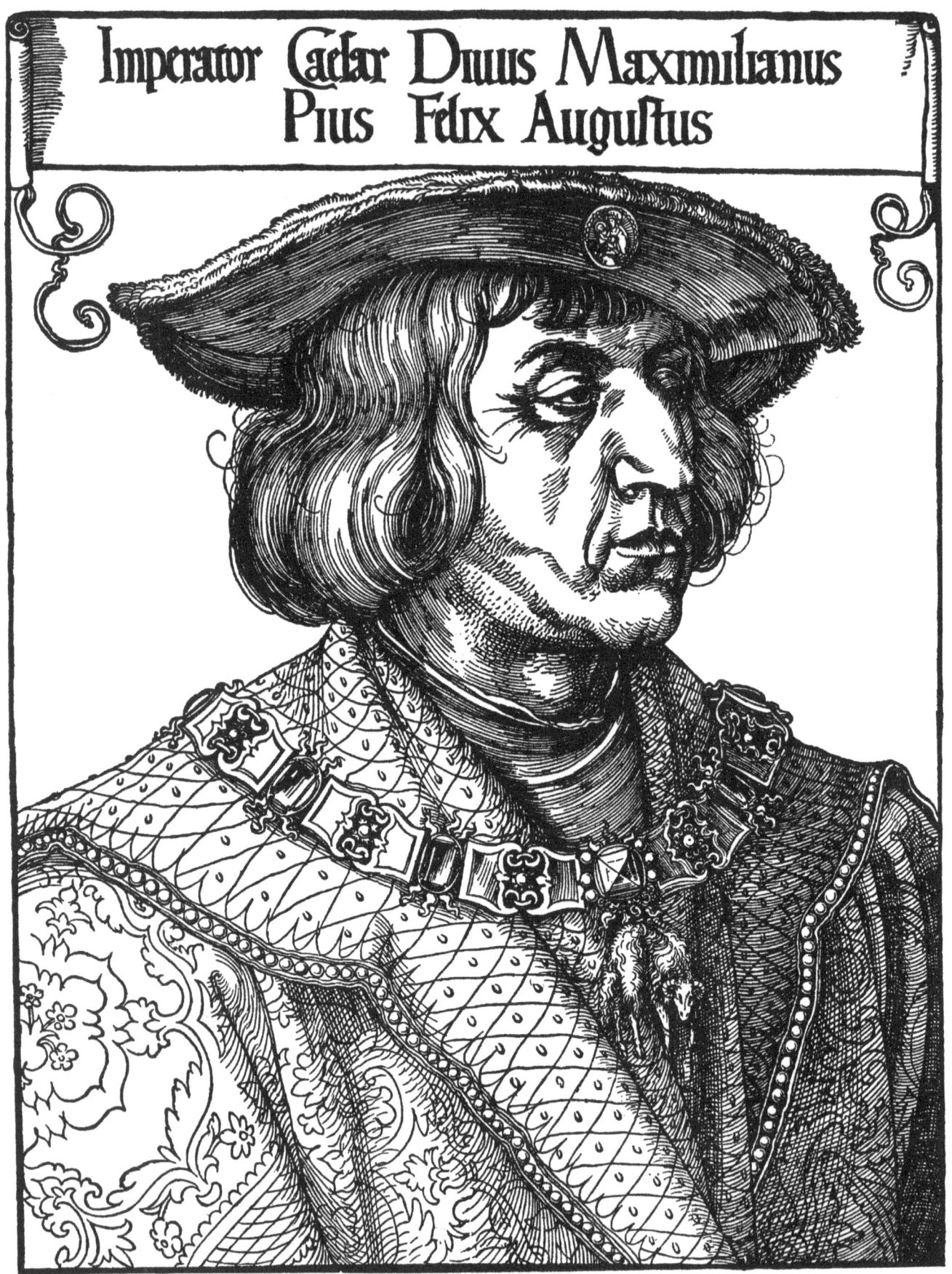

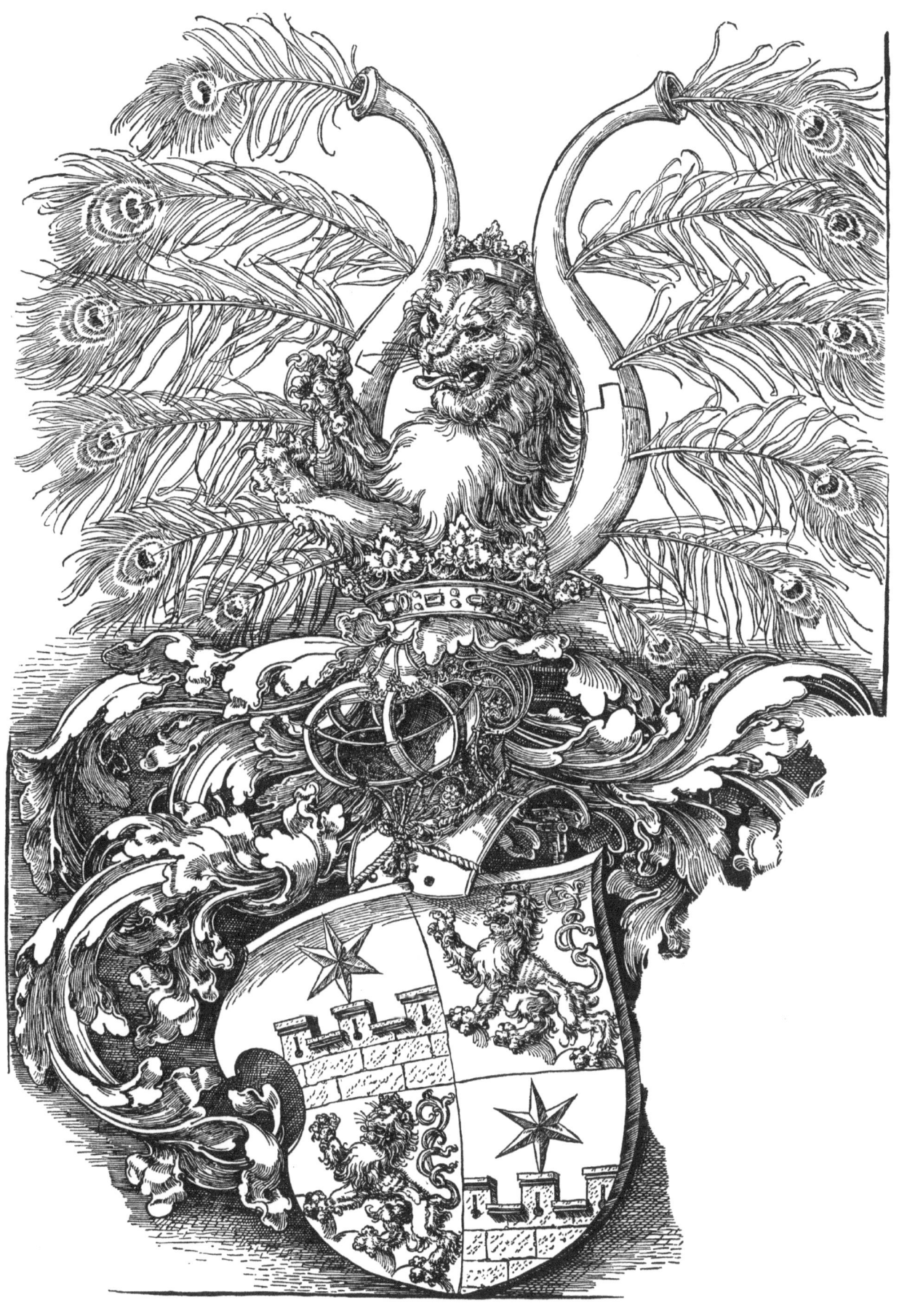

{ PAGE 233 }

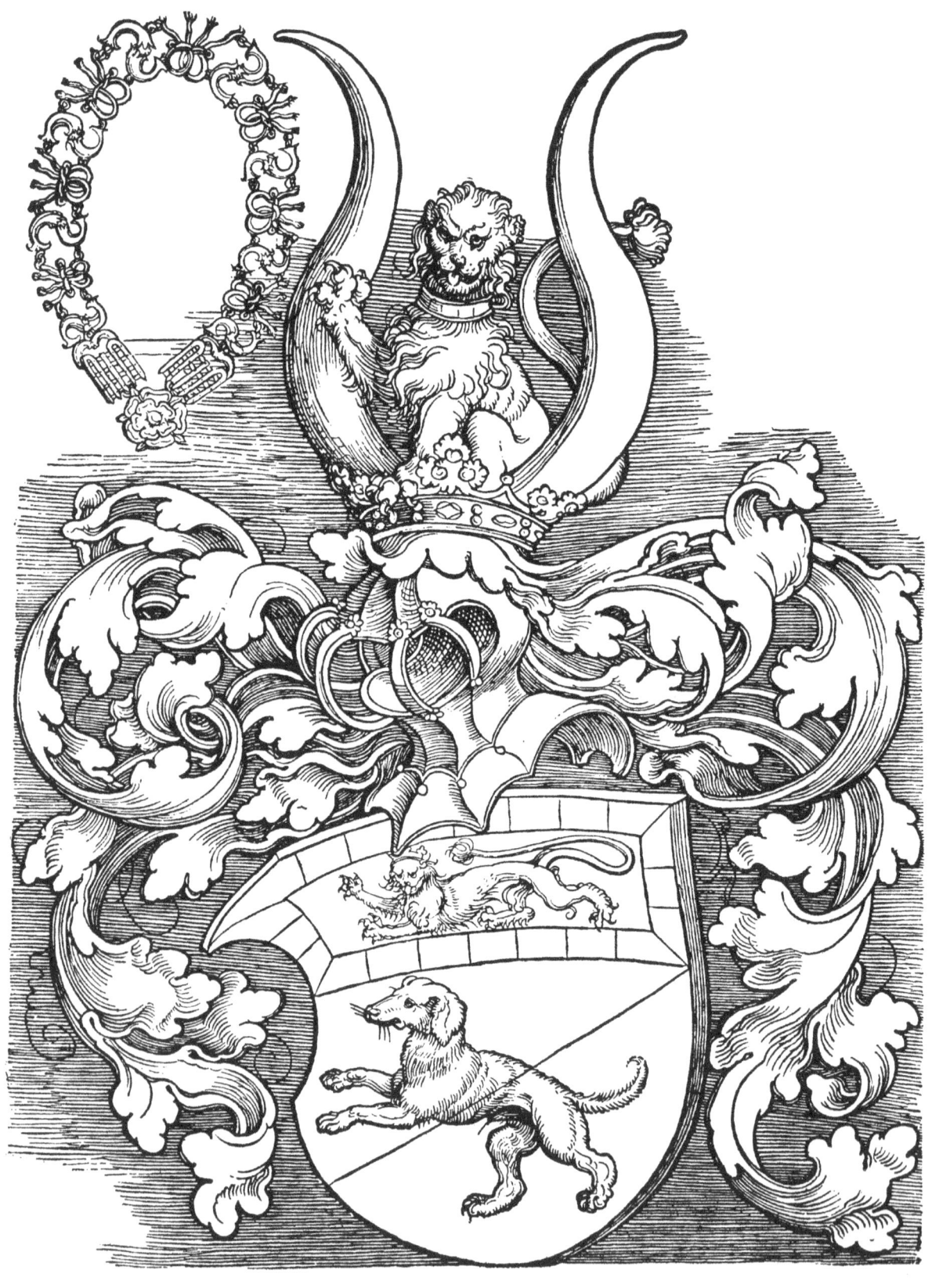

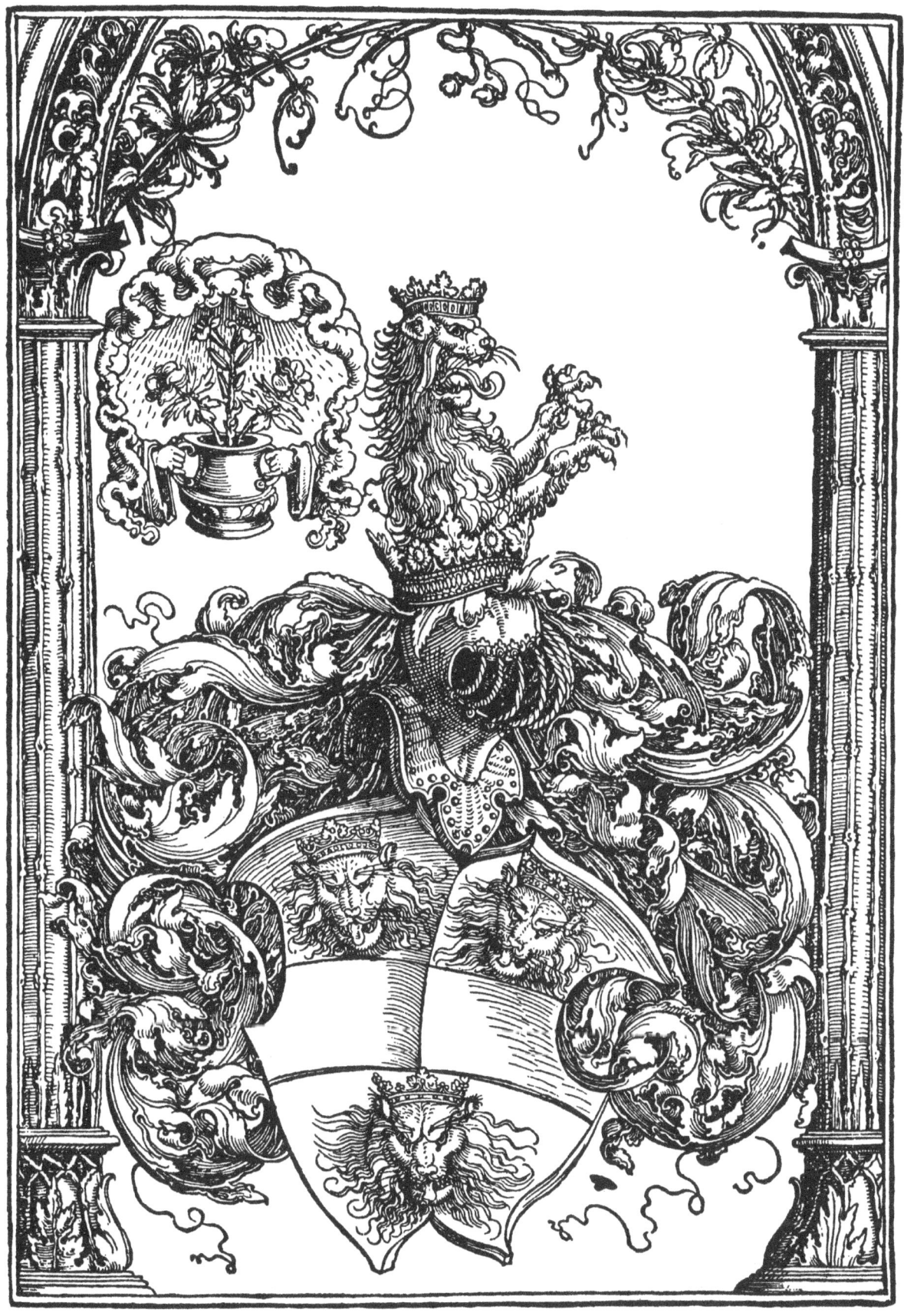

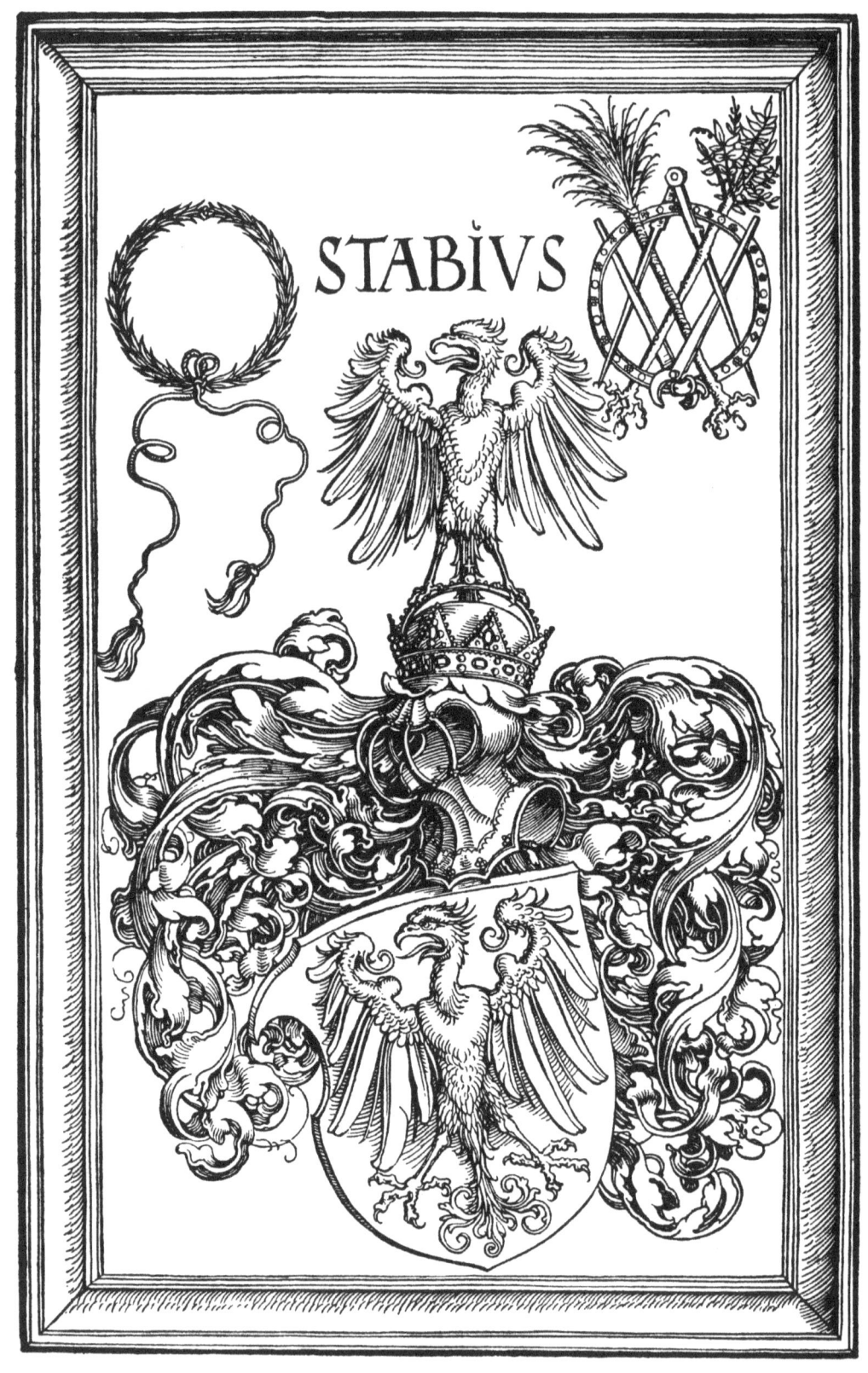

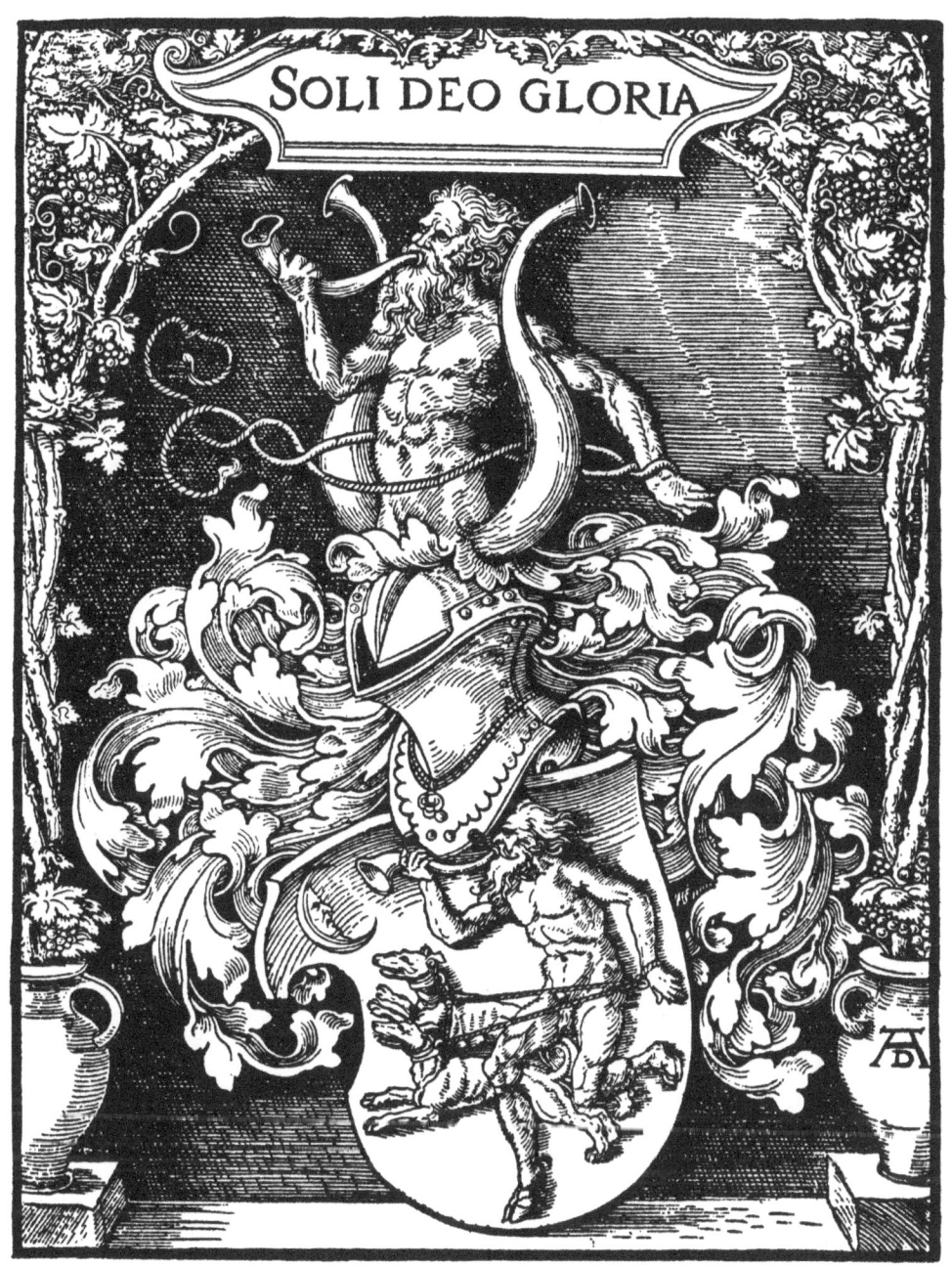

DON·PERO·LASSO· DE·CAS TILLA·

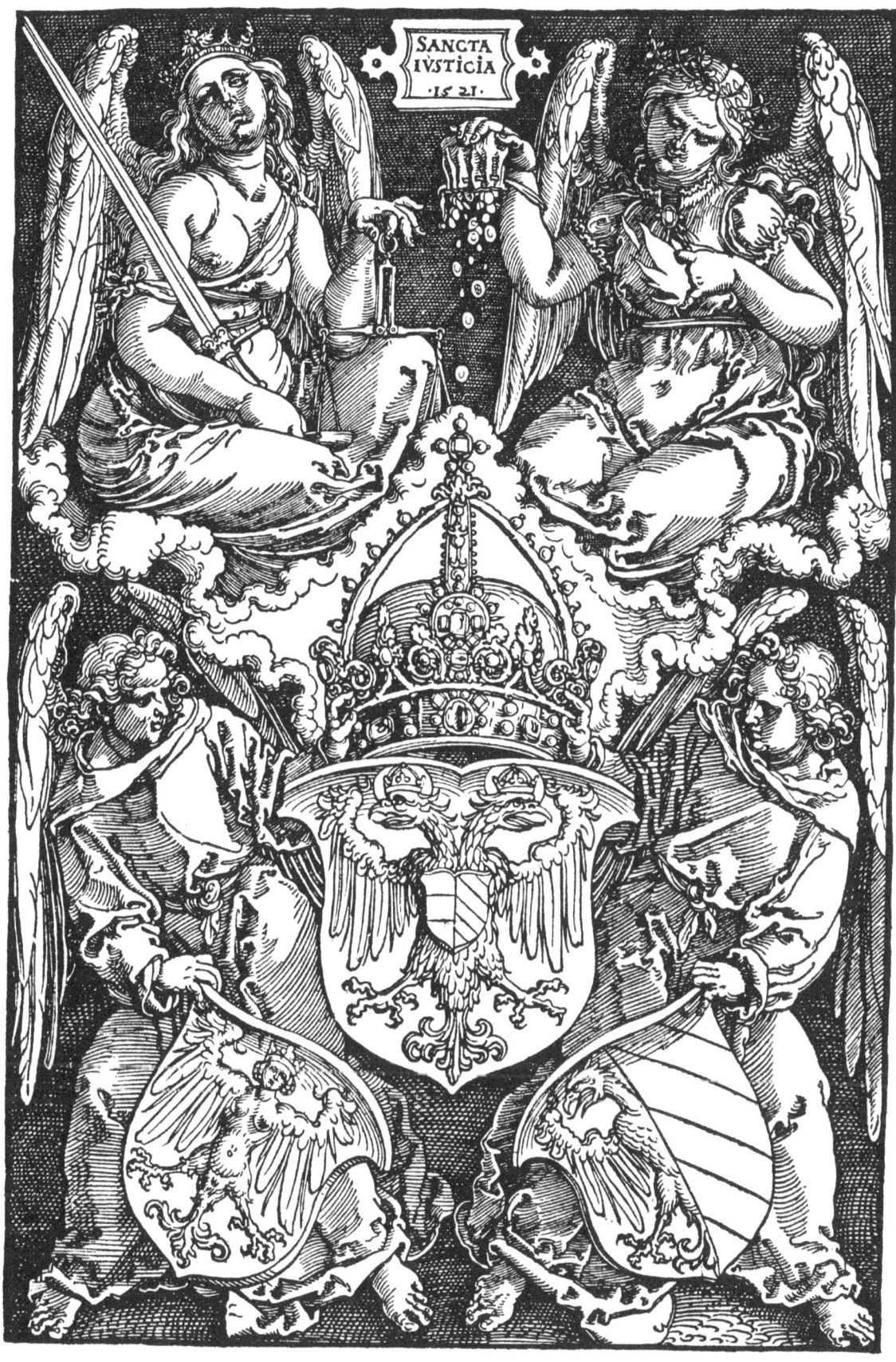

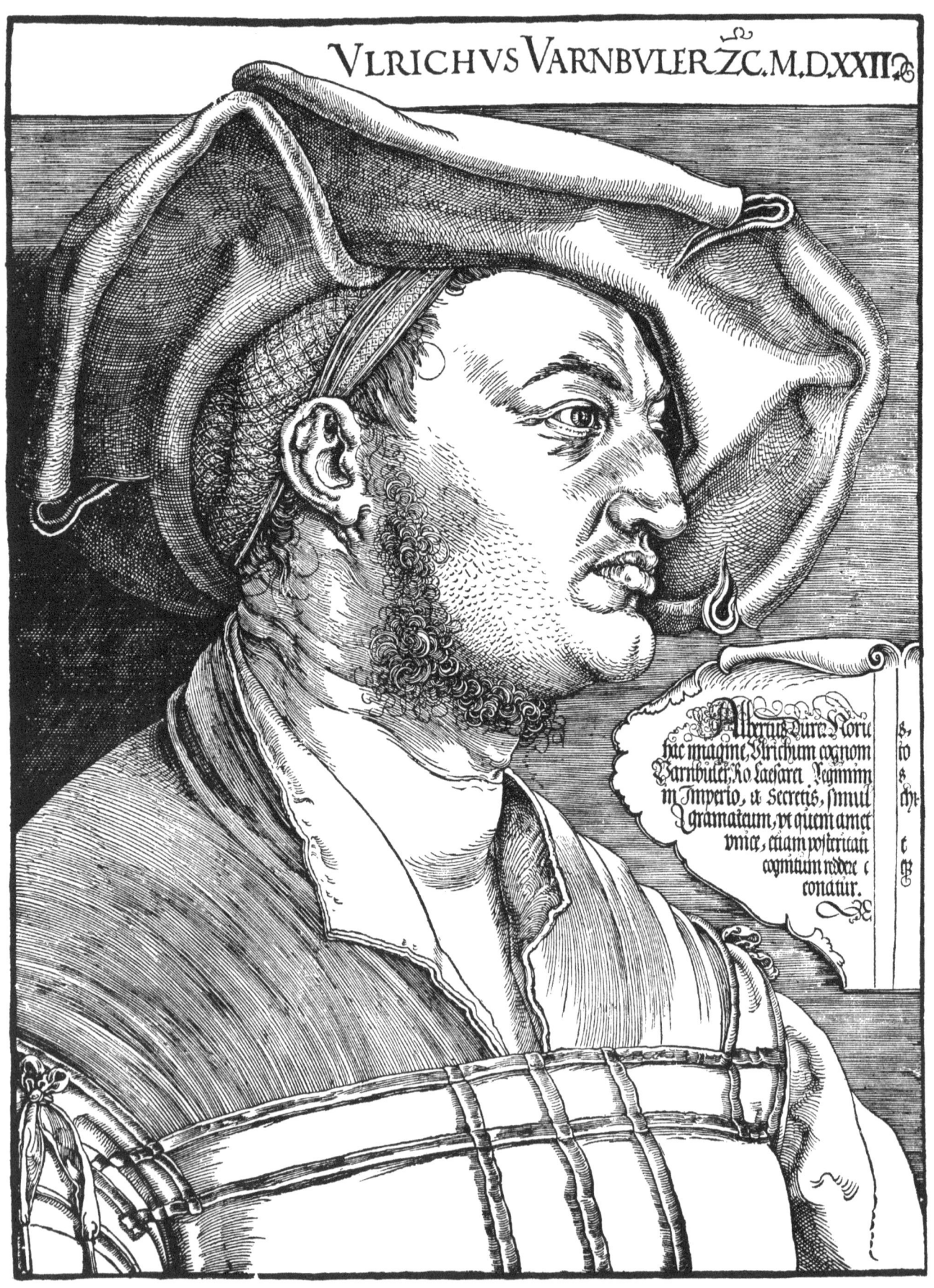

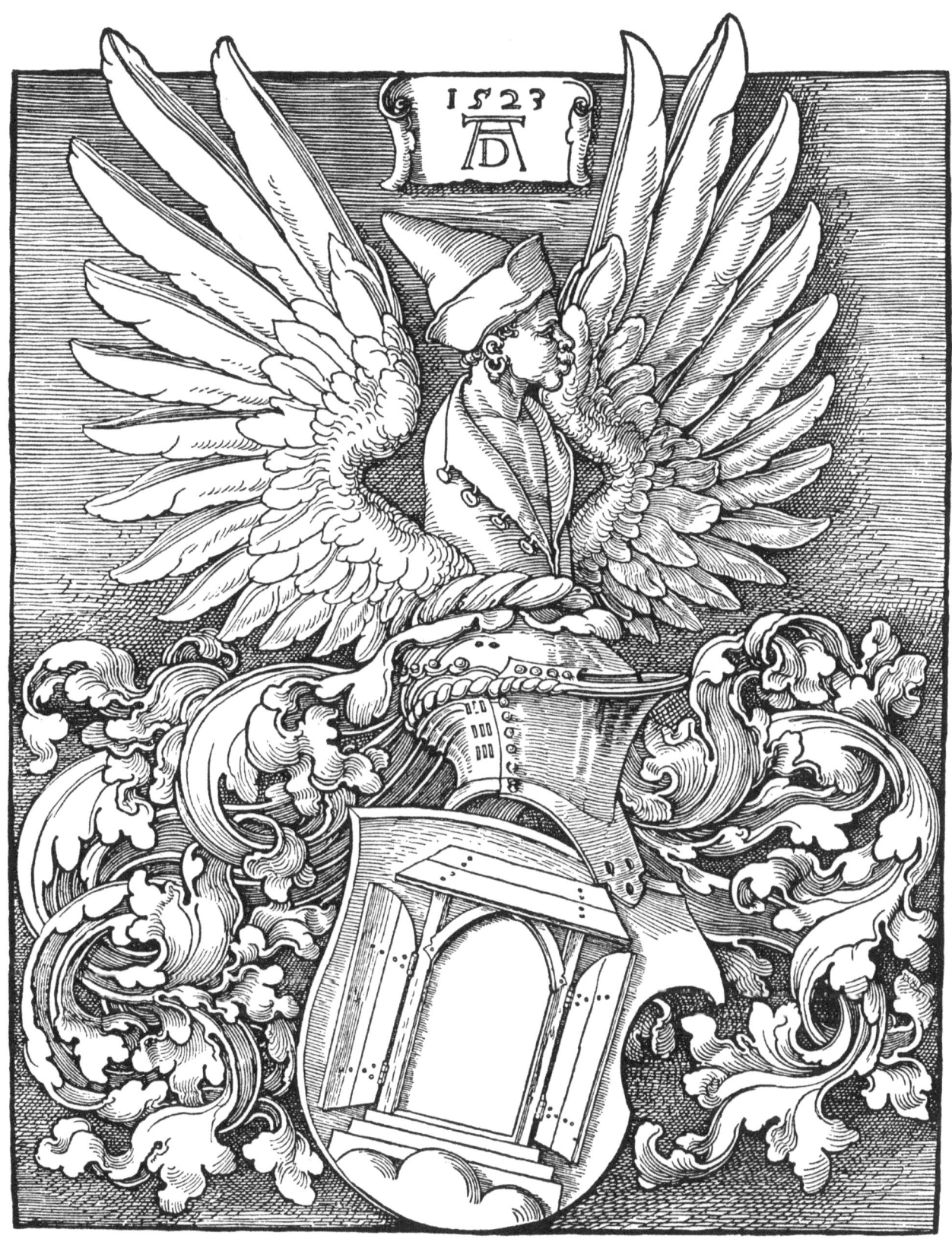

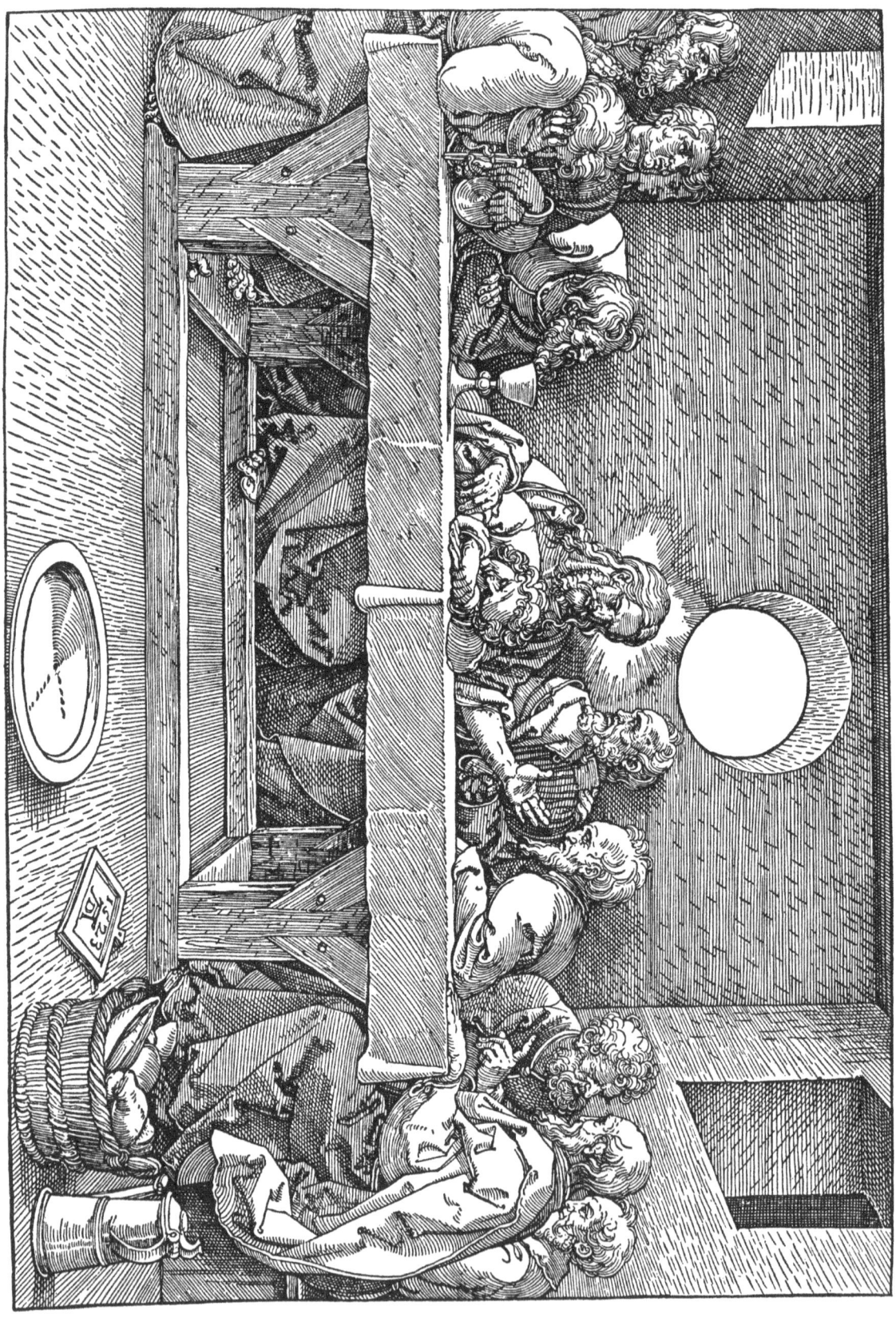

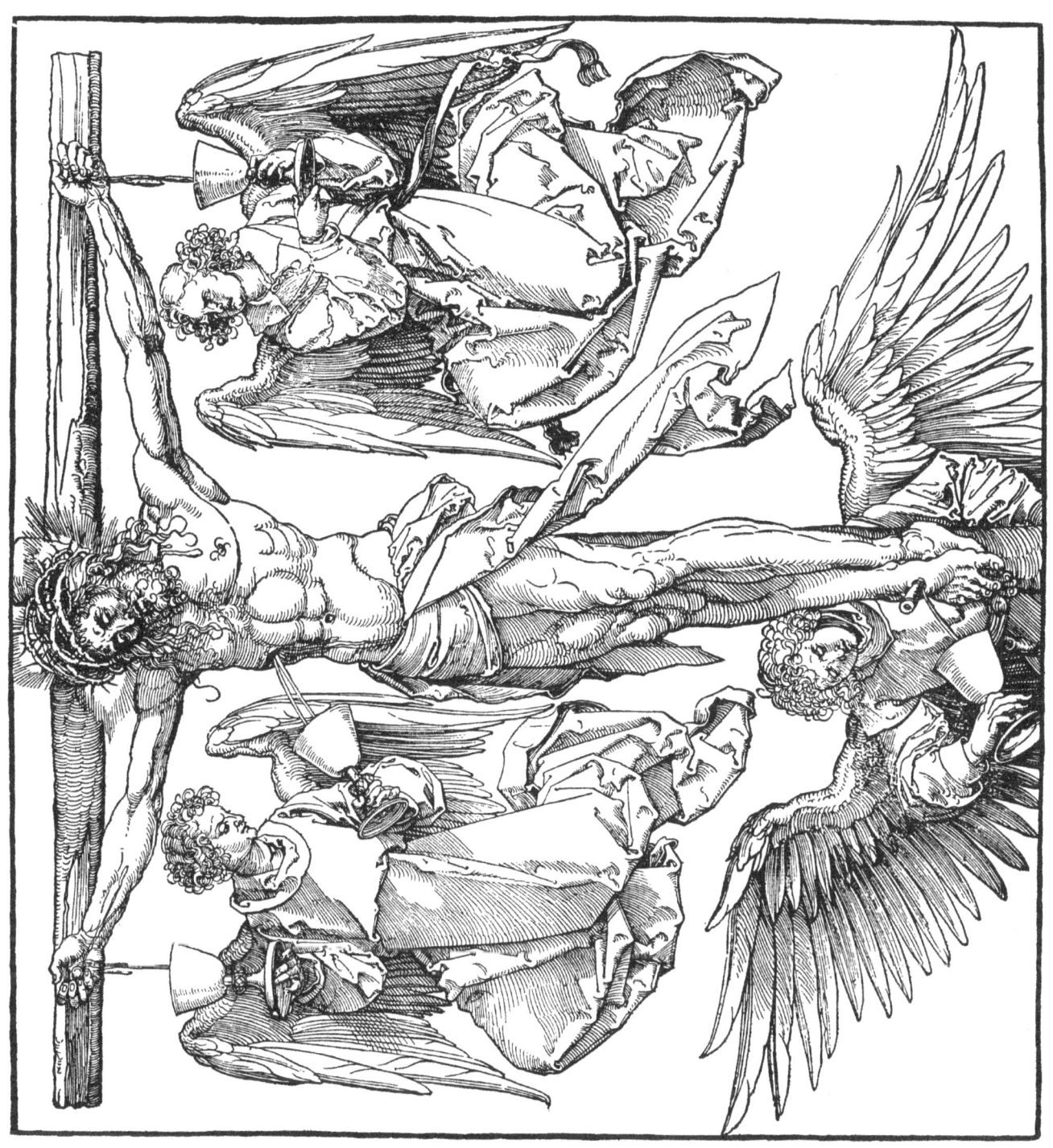

{ PAGE 243 }

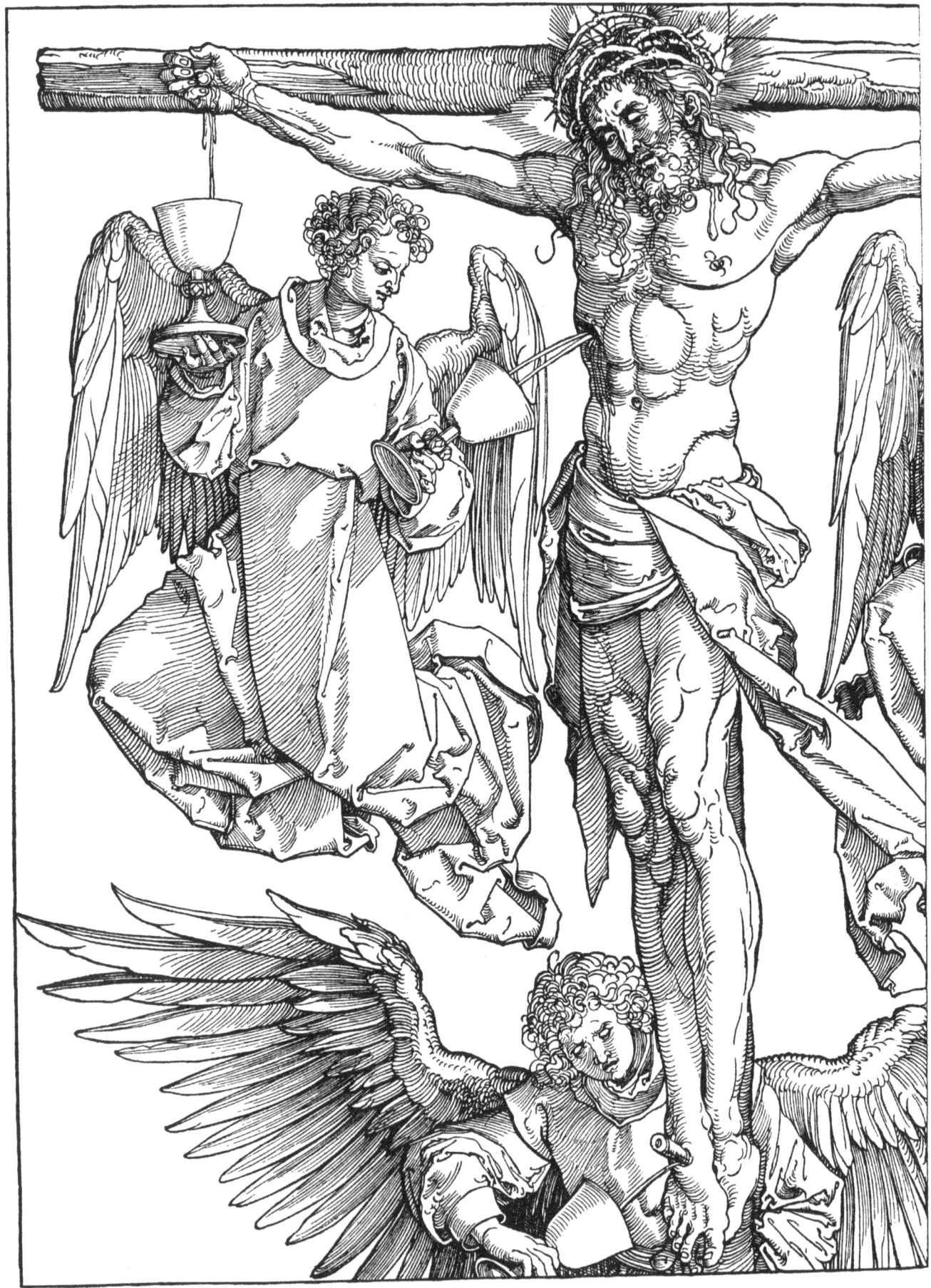

¶ Dyse Figuren/mit Irem darzü gehörigen Reymen/dye von eynem alten Tetsch/vor hundert Jaren vngeuerlich/gemürckt/vnd in dem Schloß Michelfelden am Rheyn zü mitfasten/Im Taufent Fünffhundert vnd Vier vnd zwaintzig Jar/gefunden abgemalet/vnd abgemacht sindt. Zaygen an/was dye alten/der yetzigen kunfftshalben/So sich täglich ereugen/Jn Irem verstandt gehabt/vnd heymlich bey sich behalten haben.

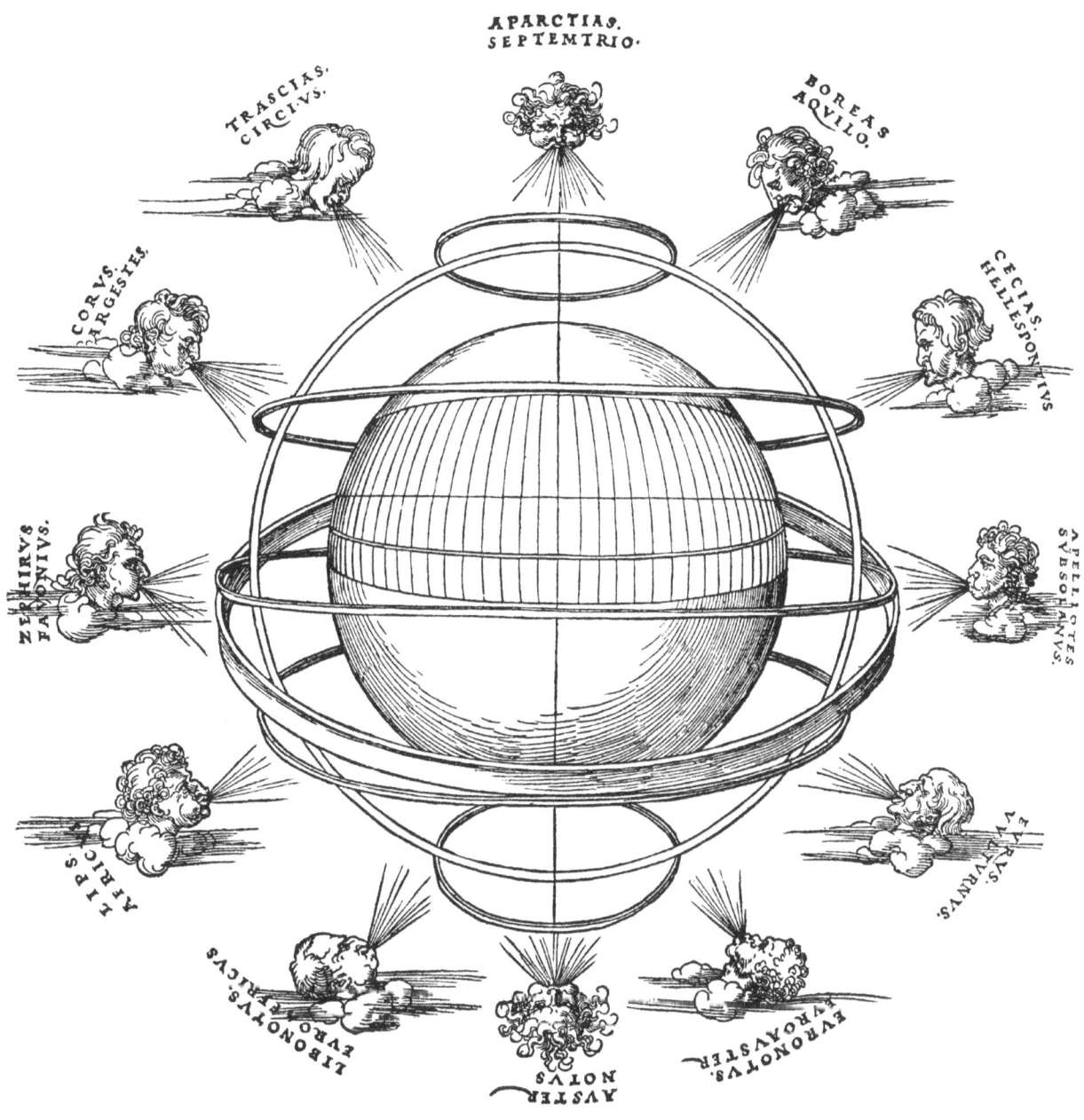

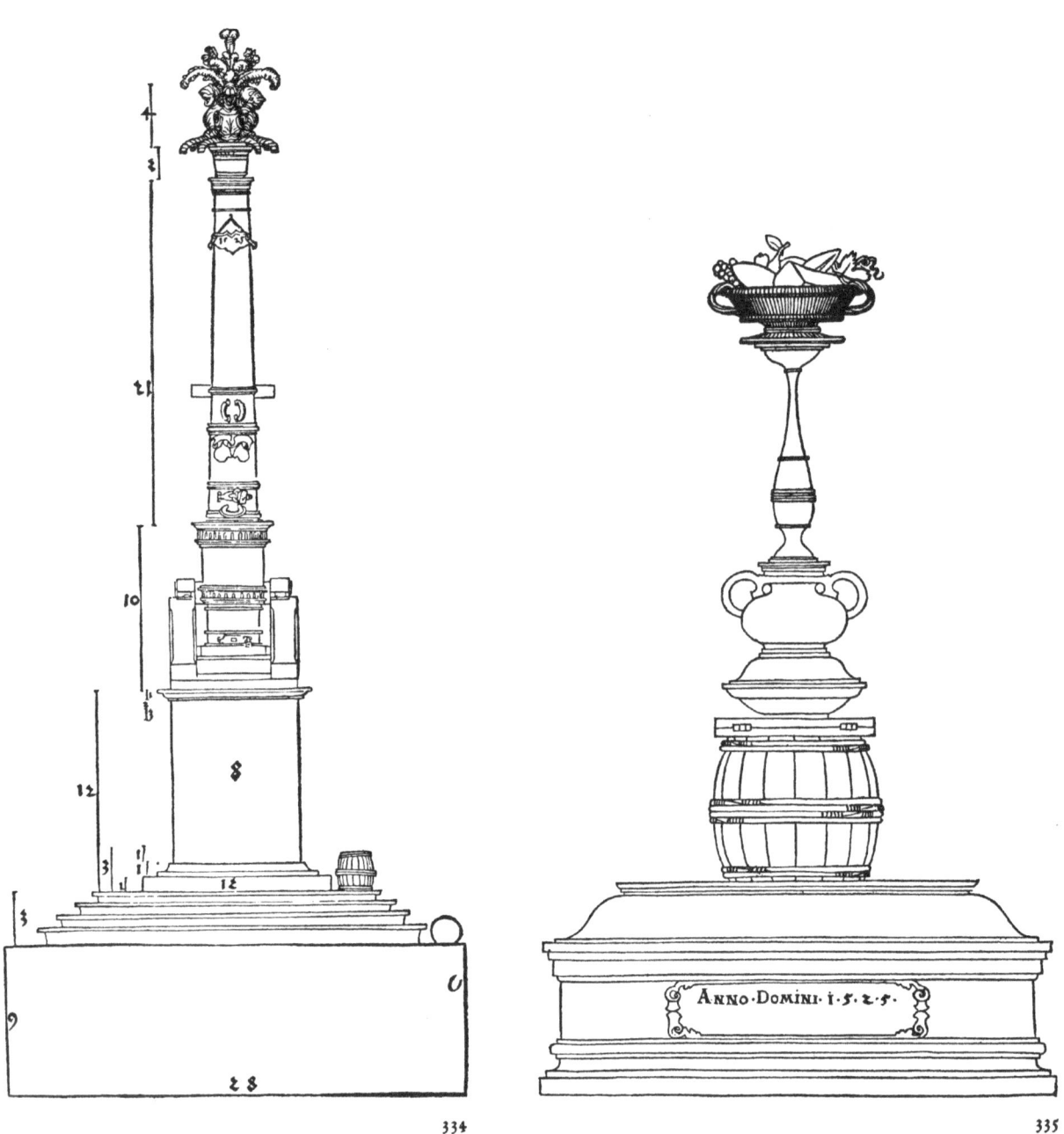

334 335

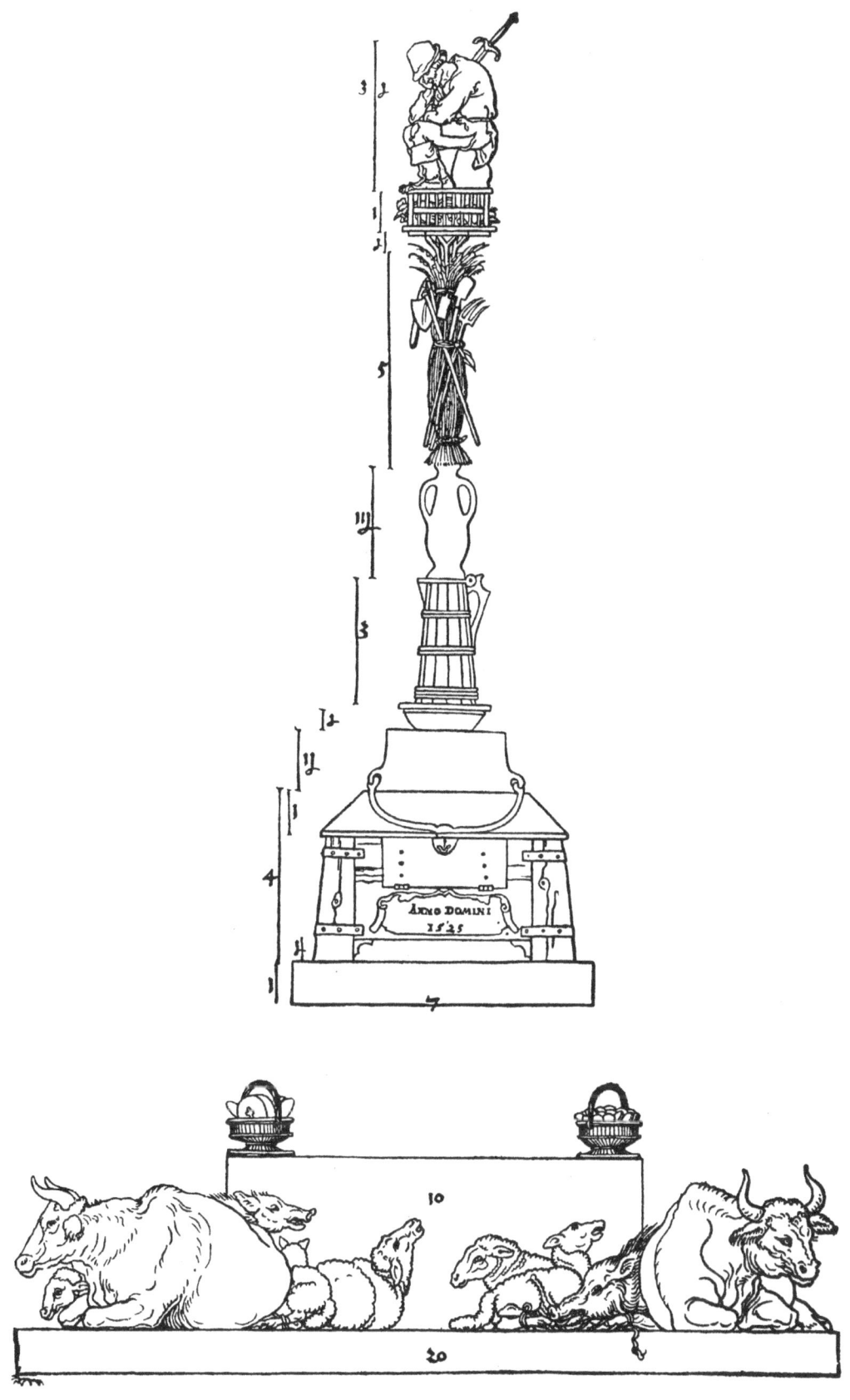

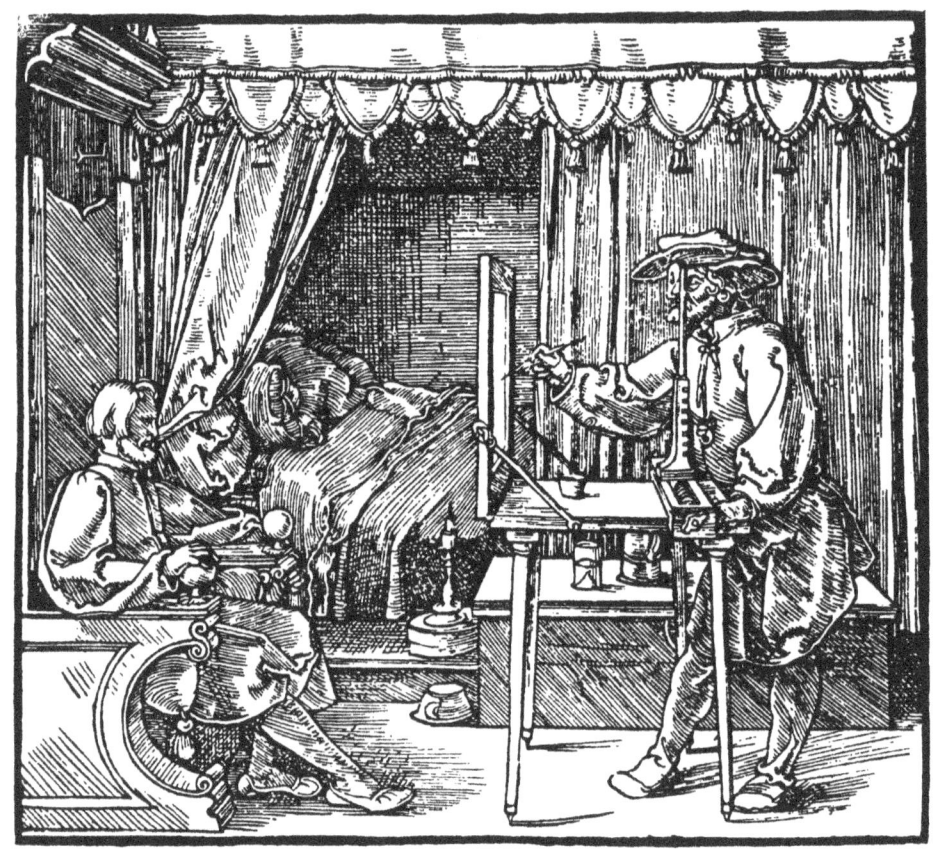

337

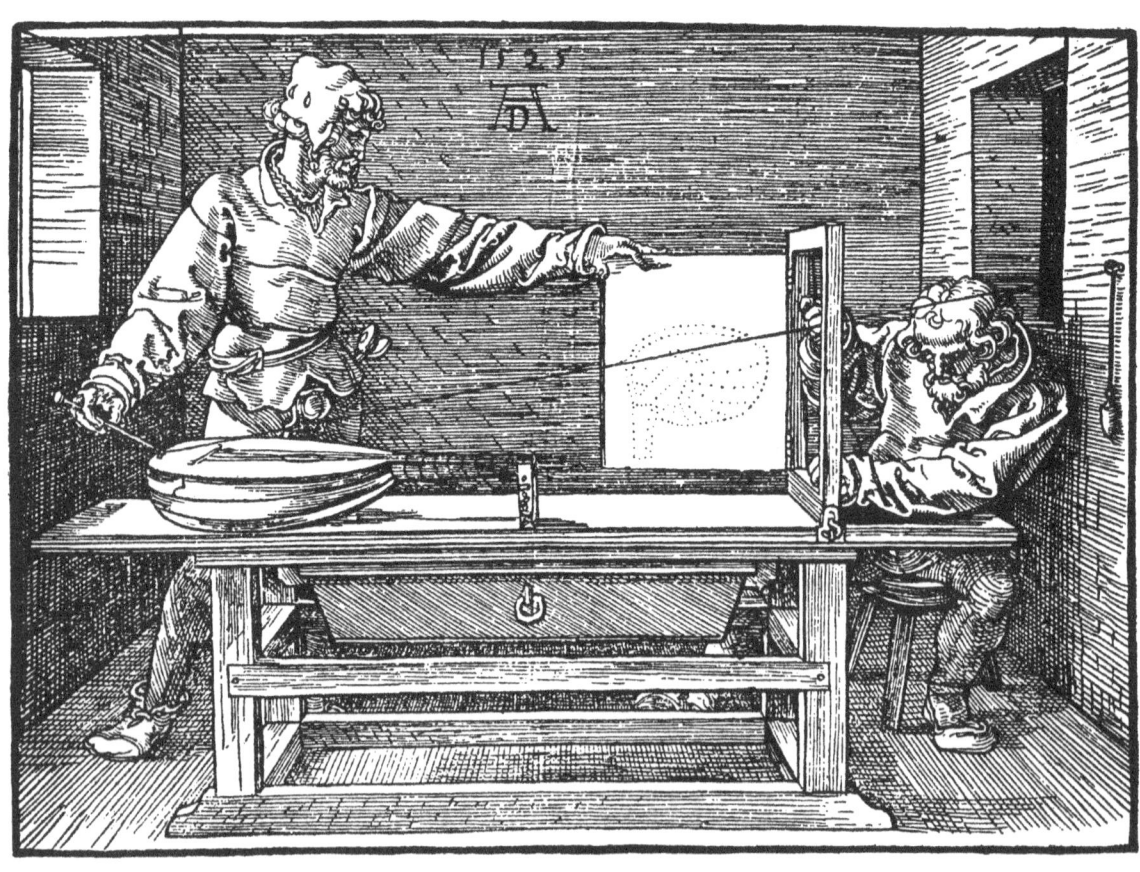

338

{ PAGE 250 }

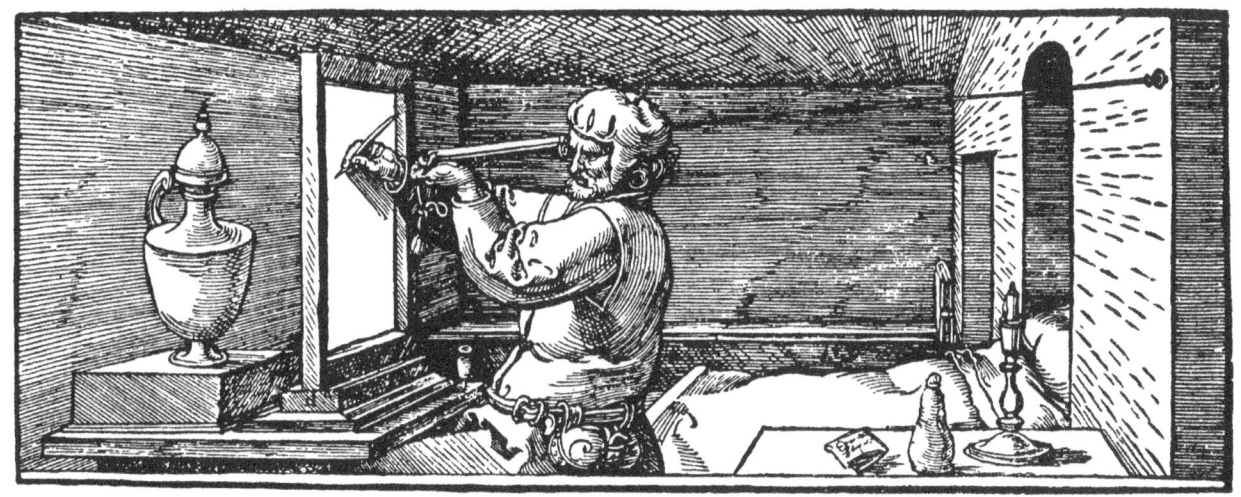

339

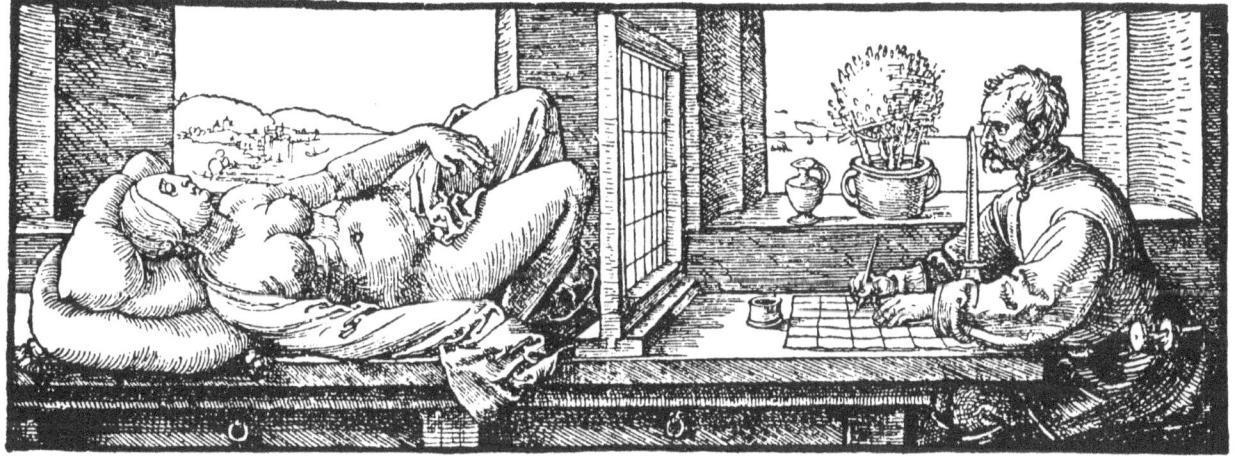

340

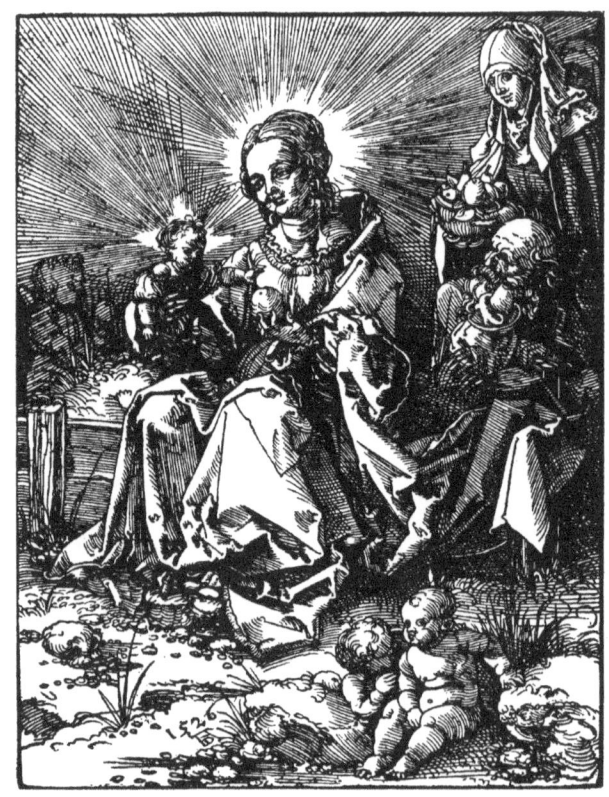

341

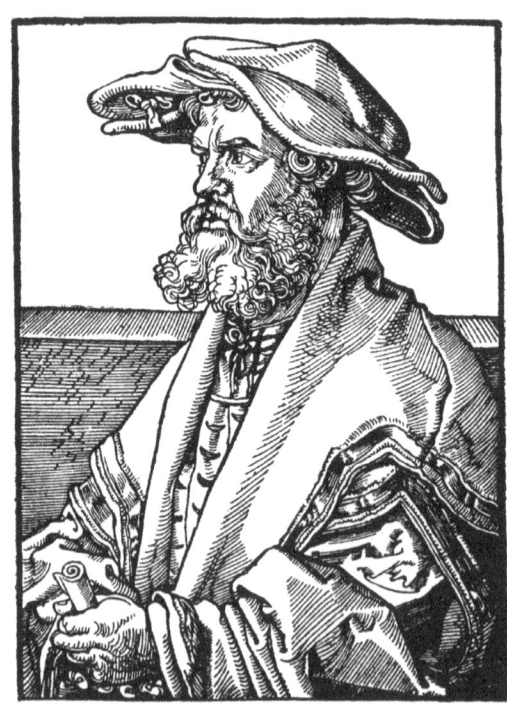

342

{ PAGE 254 }

{ PAGE 255 }

{ PAGE 256 }

www.ingramcontent.com/pod-product-compliance
Lightning Source LLC
Chambersburg PA
CBHW041918180526
45172CB00013B/1328